16 50

MICHELANGELO

MICHELANGELO

SCULPTOR ✦ PAINTER ✦ ARCHITECT

Charles de Tolnay

PRINCETON UNIVERSITY PRESS

Translated from the French by Gaynor Woodhouse

Library of Congress Cataloging in Publication data will
be found on the last printed page of this book

This book has been composed in Linotype Monticello

Printed in the United States of America
by Princeton University Press,
Princeton, New Jersey

First Princeton Paperback printing, 1981

CONTENTS

I. YOUTH

"The great artists," according to Proust, "have never made more than a single work, or rather they have never done more than refract through different settings the same beauty that they bring to the world." These words can be applied to the work of Michelangelo. Throughout his life he seems to have been haunted by a single vision and each of his creations, with its unique quality, carries the message of a higher and hidden world.

With Michelangelo there is no gradual emancipation, in the true sense of the word, from the style of a particular master to complete freedom and originality of expression. His earliest works already contain the seed of his genius and whole future development. In 1488, when he became apprentice to the famous Florentine master Domenico Ghirlandaio, he was thirteen and even then displayed a precocious talent and an independent spirit. Instead of following the style of his master or the refinement of the Florentine artists in vogue at the time (Botticelli and Filippino Lippi), Michelangelo went back to the monumental tradition of Tuscan art: to Giotto two centuries before and to Masaccio, his predecessor by almost a hundred years. Here he found greatness and dignity of feeling expressed in simple, monumental shapes.

The earliest extant drawings, which probably date from the period of his apprenticeship to Ghirlandaio (1488) and the time spent studying in the Medici Garden (1489), are copies of Ghirlandaio, Giotto, and Masaccio. Both copies in red chalk—one of them still at the Casa Buonarroti, where the other was also formerly housed before going to Haarlem—show the timidity of a beginner and at the same time something which is to become a characteristic of Michelangelo's art, namely, his concern to be faithful to the original work while modifying certain secondary details to suit his own taste for simplicity.

Later, however, in a second group of drawings, he was not content merely to imitate his models; he completed them and devel-

oped their inherent tendencies. These drawings express with a hitherto unknown intensity the effect of the thickness and movement of materials, their weight, and, at the same time, the strength of the body which they clothe. In this way Michelangelo has given these figures a new firmness and monumentality. The cause and effect relationship between body and garment, which is scarcely hinted at in his models, becomes the focal point of Michelangelo's interest and, stimulated by the new character which his figures thus acquire, he has also transformed the heads, giving them an expression of psychic intensity and a gravity lacking in his prototypes. The bodies take on an organic rhythm and seem to have been created from a malleable substance. With no gesture to break the line of their compact silhouettes, the figures are filled with a much greater internal vitality by virtue of their volume and weight alone.

197, 198 By imitating Giotto and Masaccio in this way, the young artist created a new picture of the grandeur and dignity of man. He took from his models their overall majesty but substituted for their conventional elements a more exact attention to detail. And yet this new realistic quality in the detail does not reduce the stature of his figures, indeed it only accentuates the reality of their ideal character.

In spite of his three-year contract with Domenico Ghirlandaio, Michelangelo left the workshop after a year, prompted no doubt by the beginning of his vocation for sculpture. In fact, in 1489 Lorenzo the Magnificent allowed him to study sculpture in the Medici Garden among the collections recently installed there under the supervision of the sculptor Bertoldo di Giovanni, the pupil of Donatello.

The young Michelangelo, now fifteen years old, "adopted" by Lorenzo the Magnificent and living in the Palazzo de' Medici, Via Larga (1490-1492), produced two marble reliefs, completely different in style, with a Christian and a pagan subject respectively:

1, 3 the Virgin of the Stairs and the Battle of the Centaurs.

This antithesis in the style of his first two marble works cannot be explained solely by the hesitations of a beginner, if one considers that throughout his youth Michelangelo never ceased to

2

alternate between works opposed to each other in form and inspiration. These oscillations are better understood in terms of the need which the young artist felt to express in disparate works the contrary tendencies of his being: the contemplative, seeking to evoke the internal image of beauty, and the active, seeking to incarnate the turbulent forces of his own temperament. It was only later in his cyclical works that Michelangelo succeeded in reconciling these two tendencies.

The contemplative works are the forerunners of the "grand style," a classical style before its time in the solemn immobility of its figures, the reduction of forms to the essential, and the subordination of space to the human figure. The works which translate the passionate side of his temperament are composed of moving masses full of latent energy. This is a true "proto-Baroque" which was to find its development in the art of Rubens.

The two great artistic styles which were to divide as early as the seventeenth century and come into conflict were already coexistent, then, in the young Michelangelo, like two means (*modi* or *caractères*) of expression; the sign of an artistic mastery that can choose at will the aptest language. An analogy could perhaps be drawn with the way in which the Tuscan poets sometimes used the "vulgar style," and at other times, the "sublime."

Vasari had already noted that the composition as well as the technique of the Virgin of the Stairs were in the style of Dona- *1, 2* tello, a fact which seems immediately evident: from the Virgin seen in profile with her serious and pensive expression; from the motif of the stairs which already appears in Donatello's relief at Lille; and from the very "flattened" (*schiacciato*) technique. Donatello, however, used this technique in a pictorial spirit, to give his reliefs the effect of paintings with landscapes. Michelangelo, on the other hand, takes his inspiration from the shape and texture of the block of marble: on its outside edge he keeps a narrow strip of the original surface; he constructs his composition on three successive parallel planes which correspond to the actual structure of the stone itself. This is really a Donatello Virgin transferred to the purer ideal plane of classical Graeco-Roman art, where gems and funerary reliefs depict women in full-length

3

profile, sitting, straight and pensive, in long transparent robes.

And yet the spectator discovers here and there inventions which are totally personal and characteristic of Michelangelo himself: the sleeping Child's supple, muscular back suggests, as so often in Buonarroti's art, all its potential strength, while the twisting of the body and head, together with the position of the folded arm, are direct precedents for the Herculean back of Day in the Medici Chapel, a work completed some thirty years later. The Infant's bent hand and arm are repeated in the dead Christ of the Pietà in the Cathedral at Florence; the Virgin's hands, transcending their immediate function to become expressive gestures, are found time and again in Michelangelo's art, in particular the hands of Moses in the same position, some twenty-five years later. Finally, the absolute integration of the body of the Child with that of his Mother, so that they form one, was to become a characteristic feature of Buonarroti's Virgin and Child compositions. Protected by encircling hands and the hem of the robe, only the upper half of the Child's body emerges, and seems almost to be born from the very flesh of his Mother. While Donatello uses dramatic gestures to express the Mother's anxiety for the fate of her Child, here the same sentiment is sublimated since Mary seems to foresee her Son's destiny with a restrained and stoic resignation.

One problem of interpretation is still posed by the scene of the children in the background: it seems likely that this is a prophetic allusion to Christ's Passion, a key to an understanding of the Virgin's meditation. In fact, two of the children immediately behind her are holding a sheet which could be Christ's shroud, a theme already familiar in the art of the late Middle Ages and the Florentine Quattrocento, though the children are there depicted as winged angels. The two other children (top left), who seem to be playing or perhaps quarreling, would therefore be introduced as an element of contrast.

In spite of a certain stiffness in the Virgin's pose, and some awkwardness in the arrangement of complementary features which nevertheless add an extra charm to the work of the beginner, here is a vision of the archetypal woman as conceived by

humanity since earliest times. Though small in size, the conception of this lofty image, where woman is at the same time creator of life and guardian of death, is monumental.

The theme of the other relief, known as the Battle of the Centaurs and representing the rape of Hippodameia by the centaur Eurytion, was inspired by Poliziano, the humanist poet at the court of Lorenzo the Magnificent (Vasari). The idea of covering the whole surface of the marble with figures is taken from antique reliefs depicting battles between Romans and barbarians. In Roman reliefs, however, the warriors are clothed and so one cannot discern the vibration of life in their bodies; there are also more gaps between the figures, and the shapes are completely detached from the background. Michelangelo has given a personal interpretation of antiquity, an interpretation which shows that he must have also known the reliefs of Giovanni Pisano.

From each of the figures in the bottom corners, two diagonal lines rise to a point corresponding with the head of the central figure; diagonals drawn from the two figures in the top corners join at the head of the dead lapith in the center; where these two triangles intersect each other, two figures act as lateral axes. This geometric construction, however, is subordinated to a flowing circular movement around the central figure—a movement which will be seen again later in the great multiple-figure compositions, such as the *Battle of Cascina* and the *Last Judgment*.

It would appear that, for the adolescent Michelangelo, the mythological theme was only a pretext for revealing in this rhythmic tangle of naked bodies a primeval struggle for existence. And in fact what we see is not a fixed battle between clearly defined opponents in a clearly defined place: one can scarcely distinguish the centaurs from the lapiths or the men from the women, and the place is indeterminate. For Buonarroti the word "battle" does not mean a fight between opposing forces, one victorious and the other vanquished, as in every battle scene since antiquity: here, the duality of forces is only a manifestation of the indissoluble unity of an event. They are the waves of life's movement, where life is understood as a continuity of forces containing the separate

3, 4

366, 163

destinies of individual existence. Connected as they are both to each other and to the original material, the figures seem to be ramifications of a single organic whole.

Here, in contrast to the calm Virgin of the Stairs in low relief (*rilievo schiacciato*), Michelangelo has chosen the *mezzo rilievo*, a higher relief whose artistic principles Vasari defined as having three planes of figures: first, in the foreground, a series of full-length figures in almost total relief; secondly, and partially hidden by the first, another row of figures in a lower relief; and finally a background in low relief, itself in turn partly hidden by the second. Vasari specifies that this technique comes from the ancients. Starting with Ghiberti's bronze doors, it was developed to perfection in Florence. Michelangelo inherited this tradition as well as the talent for modeling small figures in monumental style. But he differs from his predecessors in that he tries to preserve the unity of the material. He never detaches the figures completely from the original block; the heads, arms, and legs, even in the foreground, remain connected to the rough-hewn background. As a result, the figures seem to be born out of the stone.

In these works, the young Michelangelo is already playing two different instruments according to the melody of his subject. The whole of his future is but a development of the themes of his first two marble reliefs.

THE DEATH of Lorenzo the Magnificent in April 1492 profoundly changed the external circumstances of the artist's life. From the comfort and security of a princely palace he had to return to the poverty of his father's house. When he was about eighteen, he again produced two works which were antithetical in character: a Crucifix for the Prior of Santo Spirito and a Hercules which he sold to the Strozzi family. These were free-standing figures, the first in wood, the other (now lost) in marble.

5 The Crucifix in the Casa Buonarroti at Florence, which is smaller than life-size, was recently identified (Lisner) with the Crucifix of Santo Spirito mentioned by Condivi. The work, of modest dimensions and with the proportions of an adolescent, already reveals on the body the continuous modeling which

Michelangelo could observe in Hellenistic sculpture. The young artist has renewed the theme: instead of the zigzag silhouette of Gothic crucifixes or the axial position of the Italian crucifix in the early fifteenth century, Michelangelo here represents Christ on the Cross in a pose inspired by the classical *contrapposto*: the head and knees are turned in opposite directions, while at the same time they assure the suppleness and harmonious balance of the figure. This is a proto-classic invention which was to have a considerable influence on the Florentine crucifixes of the whole sixteenth century, right up to those of Giovanni da Bologna. The type invented by the young Michelangelo did, in fact, completely supplant the formerly stiff crucifix of the Quattrocento.

We can get some idea of the lost Hercules from a drawing by *6, 7*
Rubens in the Louvre and from the wax model in the Casa Buonarroti. The figure is upright in the *contrapposto* position, the left hand hanging passively with the wrist bent inwards, the right hand holding the club which is resting on the ground behind the right foot. The head is turned in the opposite direction to the leg which bears the weight of the body. The figure, though relaxed, still expresses the potentiality of action. It is a true prefiguration of the marble David, which was to be reversed like a mirror- *34*
image of it. In fact Hercules was, like David, a symbol and patron of Florence.

In contrast with those fifteenth-century Florentine statues of Hercules which represented him with hand on hip in the pose taken from Donatello's David, Michelangelo's figure shows the direct inspiration of antiquity.

It was probably during these years (1493-1494) that Michelangelo attended the impassioned sermons of Savonarola at Santa Maria del Fiore, in which the Dominican foretold the punishment of Florence. There was also the rumor that the French king, Charles VIII, was nearing the town with his army. In a fit of panic, Michelangelo fled (before October 14, 1494) towards northern Italy. He went first by way of Bologna to Venice, but quickly returned to Bologna, where he stayed in the house of the nobleman Gianfrancesco Aldovrandi for a little over a year (until the end of 1495).

9-12 After the great promise of his first works, the three statuettes produced in Bologna at the age of twenty (1495) show a sort of hesitation, which can be partly explained by the nature of the

8 commission: Michelangelo was asked to complete the tomb of St. Dominic left unfinished by Niccolò dell'Arca. However, one can see very clearly that the young sculptor was seeking to be more precise, to eliminate the vague nature of the modeling, especially in the faces of the three figures. He differentiates between these faces according to their emotions: the passionate indignation on

12, 40 the face of St. Proculus anticipates that of David and the intense expression of St. Petronius is echoed in the Prophets of the Sistine Ceiling.

His stay in Bologna was of capital importance to Michelangelo because it was there that he came into contact with the masterpieces of his true spiritual ancestor, Jacopo della Quercia, who, more than half a century before, had incarnated in heroic forms the movements of the soul—"movimenti dell'animo," to use a phrase of Leon Battista Alberti. This inspiration from Quercia is

10 felt above all in the figure of St. Petronius, with its drapery stirred by a mysterious wind. It is the first time in Michelangelo's work that the drapery serves to explain the feelings and the passions of the figures directly—a modest anticipation of the swirling cloth-

69 ing of the Prophets on the Sistine Ceiling. St. Proculus, both in his pose and in his clothing, recalls Donatello's St. George (in the Bargello). In these figures Michelangelo turns resolutely away from the sentimental expression of Niccolò dell'Arca's saints to embrace the heroic ideal of the early Renaissance, probably inspired by Savonarola's sermons: a devotion exalted into a sublime mission in St. Petronius and the hero's scorn for the world of contingency in Proculus. Quercia's inspiration was not a passing episode; it was to play an important role in the artist's future development, especially in the composition of the great histories on the Sistine Ceiling.

As soon as the political situation in Florence became stable, at the end of 1495, Michelangelo returned from Bologna. He stayed in Florence only about six months and produced two works, again antithetical in inspiration: a San Giovannino (the young John

the Baptist) and a Cupid. These were two statuettes representing children, a theme which must have attracted Michelangelo because at this time, and still under the influence of Quercia, he liked malleable masses. Both works have been lost and attempts at reconstruction remain hypothetical.

361-363

Since he had been offered no commission under Savonarola's Republic of Florence, Michelangelo turned to Central Italy. He sold the Cupid to an art dealer in Rome, perhaps already with the idea of trying his fortune there.

On June 25, 1496, Michelangelo, a young man of twenty-one, arrived for the first time in the Eternal City. The artist's imagination, full of grandiose dreams, does not seem to have been very impressed by the Roman antiquities. He expressed his views of Rome in a letter with this laconic phrase (Milanesi, p. 375): "Certo mi pare ci sia molte belle cose" ("Indeed it seems to me there are many fine things").

He seems to have had no relations with the court of the Borgia pope, Alexander VI. His benefactors were the Cardinal Raffaele Riario, Jacopo Galli, a rich banker and collector, and a French cardinal, Jean Bilhères de Lagraulas [de Villiers de la Groslaye].

In the works dating from Michelangelo's first stay of five years in Rome, there is a twofold tendency: on the one hand, a competition with ancient Roman art, and on the other, a concern to measure up to the delicacy and precision of the Florentine sculptors of the second half of the fifteenth century, many of whose works were in the churches in Rome.

Those works of the period which are still in existence are again of opposite character: a Bacchus and probably a Venus (now in the Casa Buonarroti) in the antique style, and a Pietà of Florentine style. The Venus and the Bacchus were probably done before the Pietà, for one can still see in them reminders of the earlier technique. Already, in its surface modeling, the Pietà is all delicacy and precision.

16, 13-15
21

The Venus and the Bacchus were destined to be placed in the middle of a garden of classical statuary and this explains why they offer a multiplicity of views.

The Bacchus is for Michelangelo an incarnation of the sap of

16-20

the vine, the god of wine with a soft and rather effeminate body. Sap seems to rise right through the limbs and up to the head, which bends under its weight. Bunches of grapes grow like hair. The figure symbolizes the overabundance of autumnal nature at the moment of decline. It stands upright but in a heavy, uncertain pose. The mortal aspect of its being is expressed by the lion's mask behind its left foot, its periodical renewal by the little satyr stealing a bunch of grapes. The satyr is behind Bacchus and the mask behind the satyr; these three form a spiral around which the spectator is invited to walk in order to see the group completely. This sort of composition, to be viewed from many angles, is exceptional for Michelangelo, who liked to compose his statues for one main viewpoint. The delicate play of the muscles under the fleshy parts of the body reveals a knowledge of anatomy and antique statuary, and a remarkable technical mastery.

The Pietà (Rome, St. Peter's), the contract for which dates from 1498 (Milanesi, p. 613), belongs to a type created in the thirteenth or fourteenth century in France or Germany—one must not forget that the group was done for a French cardinal and was probably for his tomb—but which had soon become widespread in Italy: it represents the Virgin alone holding the dead Christ on her knees, just as she once held the Child. In the oldest examples of this iconographic type, the dimensions of Christ are sometimes reduced to those of a child. Michelangelo keeps the natural proportions and yet succeeds in achieving the harmonious unity of the two bodies. He enlarges Mary's lap which is covered by heavy drapery. Christ's body is no longer in a rigidly horizontal position in which the head and legs extend beyond the silhouette of the whole, but the line of his body, broken in three places, is adapted to that of the Virgin and to the folds of the drapery, and is subordinated to the triangular contour of the group. It was by these means that Michelangelo succeeded in creating a harmoniously balanced Pietà. On the Virgin's breast, the multiple, agitated folds again recall those of Quercia, but the treatment, with its sharp ridges and deep cavities in the cloak, is of a totally Florentine precision, and in particular recalls Leonardo da Vinci.

10

The work has been carefully carried out down to the smallest detail, and its surface completely polished. This is Michelangelo's most "finished" sculpture. With its triangular composition and its curving lines it is classical in taste. Michelangelo must have known an engraving or drawing of the Christ of the *Last Supper* which Leonardo was finishing in Milan at the time. The Virgin's delicate face and contemplative expression, her gesture of resig- *22* nation, the diagonal band across her chest, Christ's face with its *23* fine features and forehead framed by a triangle of hair, all are echoes of Leonardo's art.

Michelangelo was now master of his technique, a "virtuoso" in the precision and differentiation of the smallest details, yet somewhat at the expense of the spontaneity of his overall vision.

THE FOUR years which the artist spent in Florence, after his return in the spring of 1501 until March 1505, are the period of his full development. In Bologna he differentiated between emotions, in Rome between external appearances; now he becomes master of the representation of the human body in its intimate plastic structure. Without abandoning the exactitude and richness of the details, he subordinates them to the essential vision of the whole. His artistic language becomes stricter. To this strictness of form there corresponds that of the spirit. The passive characters in the grip of their emotions are supplanted by a heroic race. They are no longer the victims of forces beyond their control, but resolute masters of their own destinies.

In Florence on June 19, 1501, Michelangelo signed, rather late, the contract for his last Roman commission, the delivery of fifteen statuettes for the tomb of Cardinal Piccolomini, later Pius III, in *27* the cathedral of Siena. Five were delivered, of which only two (St. Peter and St. Paul) were executed, at least partially, by the *28-31* hand of Michelangelo; two others (St. Gregory and St. Pius) are *32, 33* by Baccio da Montelupo from Buonarroti's designs, and one by Torrigiani. In the severity and simplicity of St. Peter's rectilinear drapery, and in St. Paul's expression and dramatic folds, Donatello's inspiration is clearly visible. This task, however, does not

seem to have interested Michelangelo for long since a much more important commission awaited him in Florence, the production of the gigantic David.

34-40 Work on the block in which Michelangelo modeled his David (now in the Accademia, Florence) had been begun forty years before (1463) by Agostino di Duccio. It belonged to the Opera del Duomo and was originally to have served for the decoration of one of the external buttresses of the cathedral. Agostino had started on a gigantic figure (probably a David), but had abandoned it. Since that time, the cathedral authorities had been looking for an artist capable of finishing the work. In September 1501 such a master was found in the person of Michelangelo, who, between 1501 and 1504, succeeded in producing from this block a finished figure without having recourse to other pieces of mar-

34 ble. From the front, one cannot see that the sculpture has been produced from a block already worked by another artist. The side

37 views, which are too narrow, are the only indications that the piece was chosen not by Michelangelo, but by a Quattrocento master: Michelangelo would certainly have selected a thicker block. Manual dexterity has always been held in high esteem by the Florentines, and the boldness with which Michelangelo surmounted the difficulties, in the face of which all others had failed for half a century, surprised his compatriots and assured his popularity. None of his works has been so admired by the citizens of Florence as the marble David.

The figure's pose seems calm but full of tension, taking up that of the Hercules of 1492-1494. The contrast between the two sides is very marked: all the weight rests on the right leg and this side is strictly vertical and closed. The other side, with its silhouette broken by the lifted arm, is open. This contrast, as J. Wilde has observed, corresponds to a moral distinction which the Middle Ages established between the two sides of the human body: the right, under divine protection and full of assurance; the left, vulnerable and exposed to the powers of evil. Michelangelo was to repeat this distinction later in the Moses.

35, 36 The treatment of the body in the David is new. Instead of accentuating by the rhythm of the outward forms the forces

pulsating within, Michelangelo now seeks to render the anatomical structure with precision. The richness of the details, the differentiation between the bones, muscles, veins, and flesh was never surpassed in his later works. In nature every part of the human body suggests its function by its form, even when motionless. By showing the essential structure of the organs at rest, the artist indicates at the same time the virtuality of action. Though passive, the right hand and arm, for instance, evoke their strength and kinetic potential by means of their muscles and strongly marked veins. This David is not the victorious child of the Bible: he is the incarnation of *Fortezza* (strength) and *Ira* (anger). Now *Fortezza* was considered by the Florentine humanists of the early Renaissance to be the greatest civic virtue. Since the second quarter of the fifteenth century they had exalted the active struggle for the defense of the state. The doctrine of *Fortezza* was complemented by Renaissance writers (those of Florence first, and then of the rest of Italy) with that of *Ira*, the passion of anger. Condemned as a vice in the Middle Ages, it too was raised by them to the level of a civic virtue: it was this which spurred on the moral strength of the courageous man (H. Baron).

37

Michelangelo's David is, therefore, the incarnation of the two principal republican civic virtues: he is a *cittadino guerriero*. Michelangelo has identified David's type with that of Hercules the better to express these virtues: just as one was the symbol of strength for classical antiquity, so the other was the *manu fortis* of the Middle Ages. It is not surprising that Michelangelo should have fused the two in a monument destined to exalt the civic virtues of the republic, especially since from the end of the thirteenth century Hercules had been honored as the patron and protector of Florence and had figured as such on the city seals.

Our interpretation can be confirmed by a phrase of Vasari, showing that the statue was already considered by contemporaries as the representation of a republican political ideal. He says in fact: "Si come egli [David] haveva difeso il suo popolo e governatolo con giustizia, così chi governava quella città dovesse animosamente difenderla e giustamente governarla" ("In the same way that he [David] defended his people and governed them with jus-

13

tice, so those who govern this city should defend it courageously and govern it justly").

The final choice of position for the statue, in front of the entrance to the Palazzo della Signoria, again confirms our hypothesis. Michelangelo was anxious to see his David set up at this precise spot, which was the most appropriate because of its political significance. Donatello had executed the group of Judith and Holophernes for Cosimo de' Medici and the work was at first kept in their family palace. Shortly after the Medici were expelled in 1495, the citizens of Florence decided to erect the statue in front of the Palazzo della Signoria, a politically significant change in which the statue was seen as a symbol of the victory of the republic over the tyrants. The following motto was engraved on the new pedestal: "Exemplum salutis publicae cives posuere 1495." From that date the place in question was, therefore, dedicated to the memory of the victory of civic liberties and the defeat of tyranny, and it was the idea of the defense of republican liberties which Michelangelo wanted to express in a greater and more noble way through his David.

Michelangelo's marble David can be considered as a synthesis of the ideals of the Florentine Renaissance. In the precision of its anatomy one can recognize the scientific spirit of investigation of the Florentines; in the forms, which are full of strength, and in the noble, proud face, one finds the heroic concept of man as a creature who is free and master of his own destiny. Among the Florentine statues of the fifteenth century, the closest is certainly Donatello's St. George. It has long been noted that in this figure certain features herald the David. In fact, in analogous circumstances, when the republic was in danger, Donatello had also portrayed the type of *cittadino guerriero*.

Later (from 1508 onwards), the government of the Florentine Republic wanted a second gigantic statue in front of the Palazzo della Signoria as a pendant to the marble David, again done by Michelangelo and representing Hercules and Antaeus, since, as Vasari said, both David and Hercules alike were emblems (*insegne*) of the Palace. We have already seen that since the Middle Ages Hercules had been considered one of the patrons of

Florence. The inscription on the city seals gives Hercules' symbolic significance: "Herculea clava domat Fiorentia prava" ("With the club of Hercules Florence tames evil"). Hercules, that is, defends liberty against the internal enemy, just as David defends it against the foes from without.

All that remains of Michelangelo's plans for the Hercules and Antaeus are three masterly sketches in red chalk dating from about 1525 and a group in *terra secca* of Hercules and Cacus *102, 103* (Casa Buonarroti, Florence). The sketches show Hercules snatching up Antaeus, who is trying to escape from his hold; the two bodies are intertwined in a spiral.

A second David, in bronze and now lost, must have been made for Pierre de Rohan, Maréchal de Gié. Michelangelo was not completely free here because the Maréchal insisted that the figure should be like that in the courtyard of the Palazzo della Signoria, that is to say, like Donatello's bronze David (see the contract of August 1502, Milanesi, p. 624). In the sketch in the Louvre one *204* can see how Michelangelo followed the general lines of the Donatello, yet at the same time found a new solution to the problem.

In the spring of 1501, when Michelangelo was back in Florence, Leonardo exhibited the St. Anne cartoon in the convent of Santissima Annunziata. The new harmonious manner of grouping the moving figures in this work provoked the admiration of the Florentines and exercised a considerable influence on other outstanding artists of the time. In a pen and ink drawing in Oxford *208* on the subject, Michelangelo is interested in the same problem, but he solves it somewhat differently. In Leonardo's composition, the figures describe a circular movement, their gestures follow a secret rhythm, and each movement anticipates the next. Michelangelo, on the other hand, gives each figure an action that is independent of the others: the ensemble is based on dissonance. Each figure remains isolated and enclosed in its own world of sadness.

Other works which bear witness to Michelangelo's interest in Leonardo's art are the Madonna of Bruges, the two marble tondi, *24, 41, 42* and the panel tondo of the *Doni Madonna*. *47*

The date of the Bruges Madonna is unknown, but the precision of the work, which is rich in realistic observation of detail, *24-26*

15

seems to indicate that it was begun in Florence shortly after the completion of the Pietà, possibly towards the spring or summer of 1501. The artist has progressed slowly: the Child is more developed. The year 1504 seems to us too late a date. The Virgin, seen full face, is sitting in a severe, motionless position, without that charming tilt of the head to be found in almost all the Florentine Madonnas of the fifteenth century. The solemnity is accentuated by the symmetrical, vertical folds over the breast recalling fifth-century Greek draperies, by the veil which covers the head in an almost architectural way, and by the regular features of her grave face (probably inspired by Leonardo). Contrary to tradition, the Child is not seated on his Mother's lap, but is standing between her legs, surrounded by the folds of her gown and protected as it were by this kind of niche. Because of this exceptional positioning, the Child still seems to be contained within the protective womb. At the same time he has the character of a little hero in an antique pose about to free himself and descend into life (the motif, after a lost antique statuette of a child, is recorded in a drawing by Pisanello in the Louvre). The chubby face with its sweet smile expresses childlike innocence. In spite of the cares apparent in her frowning eyebrows and pouting lips, the Virgin's face reveals a sort of determination, again a stoic acceptance of fate.

With the idea of representing the Child in his Mother's womb, Michelangelo's work takes up an old Byzantine type of Virgin, the Platytera, who carries the still unborn Child within her, enclosed in a mandorla. In late Byzantine art, this mandorla was sometimes transformed into drapery, a form which then passed into Western art. It is to be found in Florence in the thirteenth-century Virgin of Coppo di Marcovaldo, and later in Donatello's Virgin at the Santo in Padua. The Child of the Bruges Madonna is also surrounded by drapery. The idea haunted Michelangelo for a long time.

41, 42, 51 The two marble tondi of the Virgin and the St. Matthew show Michelangelo turning away from refinement and richness in the execution of the details, tending now toward a more massive and synthetic art. The Florentine idiom is supplanted by that of

ancient Rome. These are the first works to reveal that the artist has gone beyond the classical balance and is moving toward a new monumental style. It is significant that they should have remained unfinished, for the impression of vagueness in the details serves to accentuate the power of the whole. They are forerunners of the works of Michelangelo's maturity (the Sibyls on the Sistine Ceiling) and at the same time the principal source for the style of Raphael's Florentine Virgins and those of Fra Bartolommeo and Andrea del Sarto. Along with the broader, more majestic forms goes a greater plenitude of interior life. 71, 72

The marble tondo made for Bartolommeo Pitti (Bargello, Florence) was probably done while the artist worked on the David (about 1503 or 1504) and seems to be a little earlier than the one in London. The forms of the body and the folds of the drapery are treated more amply and are more massive than in the Bruges Madonna. The head, although of the same type, is also broader, and close in expression to that of the David. 41, 43-45

The Virgin is seated sideways on a low block. The Child is leaning on an open book in the lap of his Mother who, with a sudden gesture, wraps him in her cloak as if to protect him. (There is a sketch for the Virgin on the verso of the drawing in the Musée Condé, Chantilly.) Her head is raised and she has a distant look: she sees the danger and seems to be prepared for it. Her prophetic nature is also symbolically expressed by the cherub on her forehead which, according to the medieval conception, signifies "the gift of superior knowledge." The Child, whose pose is taken from an antique mourning genius (cf. the one on the Phaedra sarcophagus known as that of the Contessa Beatrice in the Campo Santo in Pisa), is the incarnation of innocent contemplation. He is a real child, unconscious of destiny. Michelangelo has probably modeled the face of the little St. John after young satyrs or centaurs of antiquity. He contrasts with Jesus and seems to incarnate the active principle of life. These two opposing principles, contemplation and activity, are as it were synthesized and sublimated in the head of the Virgin. 207 45 44 43

The folds of the Virgin's robe take a circular form above her ankles and around the Child's left leg. Her silhouette, completed

by the two children, is also circular, and so the form of the tondo corresponds naturally and without artifice to the configuration of the group. It is the composition here which by its structure demands a circular boundary. The form fills the relatively small surface of the marble to the maximum, thereby giving the effect of grandeur.

42, 46 The tondo made for Taddeo Taddei (Royal Academy, London) remains inferior to the one in the Bargello in the quality of the execution of certain details and it is probable that one of Michelangelo's *garzoni* worked over certain of the folds. The little St. John approaching Jesus Christ is playing with a goldfinch which he has in his hands. The Child Jesus is frightened and seeks refuge in the lap of his Mother who sweetly holds back the young St. John with her hand. Michelangelo has copied the Child's broad movement almost exactly from the children on the antique sarcophagi of Medea. The goldfinch is perhaps the symbol of the soul; here, where it is struggling in the hands of St. John, it could be expressing a presentiment of the Passion. The correspondence between the form of the tondo and the rounded silhouette of the group filling it is more developed than in the Bargello tondo. If, in the latter, Michelangelo has taken as a starting point the central figure and completed it with the two children, in the London tondo he works from the circumference towards the middle, accentuating the edge of the circle with the bodies of the Virgin and St. John, and uniting them with the diagonal of Christ's figure.

47-49 The *Doni Madonna* in the Uffizi, the only undoubtedly authentic panel by Michelangelo, was probably done in 1503 or 1504, the date of the marriage of Agnolo Doni with Maddalena Strozzi whose coat of arms is on the frame (G. Poggi). The meticulous, hard, abstract style recalls that of the Bruges Madonna and seems to favor this date. This time it is not a sibylline Madonna but a heroic and virile mother, who lifts her child up on to her shoulder with naked, muscular arms, in the gesture of an amphora bearer. These figures, a family of Spartan giants, appear in a state of serene euphoria, silently enjoying the vigor and suppleness of their athletic bodies. They seem to be formed from a cylindrical

monolith around which the spectator's eye is guided in obedience to the artist's will, following the spiral curve from the Virgin's right foot, up past her knees and Joseph's left leg, and coming forward again through her arms to finish at last at the upper ring described by the little arms of Jesus. The cylinder formed by the group and its surrounding space, whose shape is defined by the semicircular stone exedra in the background, seems to be contained in a sphere of crystal closed on all sides.

The placing of a figure on the shoulder of another was in medieval art a symbol of the victory of a new principle over an old: for example, the apostles would sometimes be set on the shoulders of the prophets. Now the Virgin and St. Joseph belong by their birth to the world of the Old Testament *sub lege*. The Child, whom the Virgin is contemplating with a look of ecstasy filled with adoration and hope, represents the world of the New Testament *sub gratia*. He is no longer the innocent child, but the young victor whose head is bound with the fillet of victorious athletes. He looks at his Mother with the grave expression of a being conscious of his mission. Behind, separated from the Holy Family by a low wall, are two groups of supple-bodied ephebes. On the right, *48, 49* one youth is embracing his friend, while a third shows signs of jealousy. On the left, two other young men are watching this love scene. The ensemble suggests the pagan world with only a vague presentiment of an event whose significance it does not understand. Behind the wall, the little St. John watches the sacred scene alone, in ecstatic admiration. He forms the link between the two worlds.

Michelangelo's Virgins do not seem to have been made for the veneration of simple, often illiterate worshipers seeking chiefly in the sacred image the object of their devotions, the hope of their salvation. They do not include the hieratical type of Madonna. Michelangelo presupposes that those who look at his Virgins will be cultivated spirits who, like Bartolommeo Pitti, Taddeo Taddei, and Agnolo Doni, are able to find a philosophical consolation in contemplating the ideality of form, the nobility of spiritual attitude, and the strength of soul of a Virgin who is upright and thoughtful, unbroken beneath the weight of a mother's grief and

anxiety, stoic precisely as a result of the presentiment of what awaits her.

IN THE autumn of 1503, the Signoria decided to decorate the Sala del Consiglio of the Palazzo Vecchio with scenes of Florentine victories. At first (May 1504), the work was entrusted to Leonardo who, the following spring, began a fresco of the Battle of Anghiari (between the Florentines and the Milanese). Some time after the commissioning of Leonardo, probably in the autumn of 1504, Michelangelo was also asked to paint a fresco in the same hall. He finished the cartoon before February 1505. In May 1506, Leonardo, who was obviously discontented, abandoned the sum which he had originally put down as a guarantee when the contract was signed, and gave up his work.

The subject of Michelangelo's fresco was ostensibly the victory of the Florentine army over the Pisan at Cascina in 1364. The episode is described in Filippo Villani's chronicle. Instead of the battle, Michelangelo has preferred to take as the main theme the moment when one of the Florentine warriors, Manno Donati, realizing the Pisan threat to an unguarded camp, appears among the soldiers who are bathing in the Arno or resting, with the cry 366 "We are lost!" The choice of this moment has given the artist the 212 chance to portray a great number of nude figures in various positions and movements, a real compendium of the human anatomy, following a tradition beloved by the Florentines of the second half of the fifteenth century (cf. the famous engraving, the *Battle of the Nudes* by Pollaiuolo, and a *Battle of Nudes*, now lost, by Ver- 206 rocchio). After having drawn a few sketches of battles on horseback, where he tried to make a composition in harmony with that of Leonardo's horsemen, Michelangelo chose the domain in which he felt surest: that of the portrayal of the human nude. It is typical of his conception of historical pictures that he has accentuated the internal tension preceding the action—the panic which takes possession of the souls of the Florentine warriors, instead of the external action of the battle itself. It is a story without heroes.

Michelangelo created a basically symmetrical composition, deliberately deformed so as to orient it towards the right, whose

configuration is that of a trapezium. It is like a block of marble where the figures are carved on three successive planes, as in a bas-relief. On the left, one can distinguish a triangular group of three figures which corresponds to another triangle on the right formed by the same number. Between them lies the central triangle, composed of five figures enclosed within a rotating movement. Each of these three principal groups is backed by complementary figures, two for the lateral triangles and four for the central one; but the artist purposely upsets the symmetry: the middle group is not in the geometric center of the composition but deviates slightly to the right. Thus in its movement the ensemble corresponds with the position which this composition was no doubt to have occupied in the Sala del Consiglio, the left-hand field of the east wall, while Leonardo was probably to have painted the right. In view of the large dimensions of the field, it is likely that the grisaille of Holkham Hall (the only existing *366* source for the original work) gives no more than the central section of a larger composition, the rest of which we do not know.

Michelangelo gave the historical episode a more general significance. His figures are dual beings taking part at once in the frenzied movement of living bodies and in the immutable and eternal existence of marble statues. Removed from time and a determinate place, they have become motionless in a sort of apotheosis, symbolizing the victory of the sublime over the mundane; an idea which was to be one of the fundamental conceptions of the first histories on the Sistine Ceiling and to have a profound repercussion on European Mannerism.

These two pictorial compositions herald the style of the Sistine frescoes. The Sibyls on the Ceiling are sisters to the Doni Madonna and the ephebes behind her are the precursors of the Sistine Ignudi. The first great historical scenes in the Sistine derive, in their style, from the *Battle of Cascina* and evoke the same ideal race of marble heroes.

IT WAS an external circumstance, the commission for the Tomb of Julius II, which allowed the artist to liberate the possibilities that lay dormant within him and to move towards the grand style.

21

It was in March 1505 that Pope Julius II gave him this commission, the story of which will be taken up later. But the fact should be underlined that Michelangelo's plastic genius was henceforth haunted by the tormented figures which he conceived for this Tomb. We know that as early as April 1506, a year after the order, the artist was obliged to give up working on it. The Pope had changed his mind: he abandoned the project, at least temporarily, in order to give Bramante the commission for the new St. Peter's. Michelangelo was humiliated and fled to Florence on the very day before the first stone was laid (April 18, 1506).

But his frustrated dreams determined the statues for other orders on which he worked during this period. One of these statues is the St. Matthew in the Accademia at Florence which, with its rough, stocky limbs and its bulging shapes, is a return to the primitive, dynamic nudes of the Battle of the Centaurs. Here one can find fresh reminders of Jacopo della Quercia—this time of the prophets in the Baptistery in Siena. What inclined Michelangelo to this new interest in Quercia's dynamic art was probably the discovery of the Laocoön group during his last stay in Rome in January 1506. Michelangelo saw in this, as in the Pasquino which had become one of his favorite works, the justification of his own aspirations.

In the St. Matthew, the static conception of the body which is determined by weight is overcome. Passion models and twists these powerful forms which seem the result of an internal eruption. Not only does it dictate the position of the limbs, but even the shapes of the body are thrust out from within as if by a cataclysm. Between the material being and its animating passion, a commanding correlation is established which primes the physical factors. But a higher will prevents this passion from spilling over; it remains imprisoned within the strict limits of a closed and predetermined outline. The Apostle's left elbow is pressed hard against his side and the fingers of his hand hold the big book in a tight, trembling grip. The right arm closely frames the whole of this side while the thumb of the right hand clasps the belt and seems to be searching for a *point d'appui*, a motif inspired by Donatello or Quercia. The suffering expressed by this statue

seems to have no concrete object: it is the primitive suffering of the soul struggling in the too narrow envelope of its body. If one remembers that, when Michelangelo began this work, he was haunted by the figures of the Slaves for the Tomb of Julius II, it is easier to understand its spiritual essence. Strangely for an apostle, the figure expresses the torment of a being in chains.

The last of the great works before the Sistine Ceiling was the larger-than-life-size seated bronze statue of Julius II, which was erected on the façade of San Petronio in Bologna, above the central door. The statue was to commemorate the victory of Julius II over the Bentivoglio, lords of Bologna, and, at the same time, the reconciliation between the Pope and the artist in Bologna in November 1506. The artist accepted the commission grudgingly and only "per buon rispetto" for the Pope because, according to him, bronze work "non era mia arte." He himself did the model and gave three *garzoni* the job of casting it in bronze. In March 1508, the statue was unveiled and four years later, in December 1511 when the Bentivoglio returned, the people of Bologna destroyed it. According to old descriptions, it belonged to the type of papal commemorative statues, but instead of the conventional dignity of the pose, the right arm was raised "in atto fiero," so that one could not tell whether it was blessing or threatening (Vasari 1568, p. 81). The left hand originally held a book; in the final version, a key. Just as Michelangelo made a "Slave" out of St. Matthew, so in this figure he was expressing another of his dreams for the Tomb of Julius II, that of the great seated figures which he planned for the platform. Only an approximate reconstruction of the statue is possible: a drawing by Bandinelli in the Louvre, the statue of Gregory XIII by Menganti (1578) on the façade of the Palazzo Pubblico in Bologna, and the statue of Julius III by Vincenzo Danti in Perugia may perhaps serve as starting points for this.

367

II. THE SISTINE CEILING

53-90 MICHELANGELO'S youthful aspirations, with their richness of ideas and forms, are clarified and find their ultimate place in the vault of the Sistine Chapel, which reunites in a sort of hierarchy the world of heterogeneous beings who have hitherto appeared in isolation in his drawings, his sculptures, and his few paintings.

The Sistine Ceiling is first a summing-up of Michelangelo's previous plastic researches; again and above all, it represents a new phase in the development of the themes of his youth. In artistic terms, it is a unique and inspired solution to the organization on a curved surface of innumerable different motifs, from which the artist nonetheless succeeds in creating a unity.

53 Like the first project for the Tomb of Julius II, the Ceiling is a symphony of human forms. They are coordinated or subordinated, superimposed and rhythmic, on different scales from giant to child, some naked, some clothed, in marble, bronze or flesh—forms which present themselves in isolation or in groups, acting simultaneously, sometimes jostling each other in a seething mass, but always dominated by the strict lines of the architectonic framework. It is a sublime sight, this *fortissimo* of movement which develops in a crescendo of waves towards the back of the Chapel, gripping the spectator who, even before he has grasped its meaning, feels the sensuous thrill of annihilation in a higher world. In its constantly recurring movement, its mass, weight, and the resulting polyphony, this work can no longer be classified as belonging to the style of the High Renaissance, and yet neither does it belong to the Baroque with its continuous motion and melting forms. Here, everything remains clearly defined and the ensemble is powerfully rhythmic. The style is a personal one which Michelangelo has developed from that of the High Renaissance.

The Sistine Chapel was finished in 1483 by Giovannino dei Dolci. Its flattened barrel-vault, placed on a series of concave

spandrels, was covered with gold stars on a blue background in the fifteenth century, following an ancient tradition which goes back to antiquity and to the early days of Christianity, whereby the vault is considered to be the image of the sky. Pier Matteo d'Amelia's plan for this starry sky is still preserved in the Department of Drawings of the Uffizi. The whole of the pictorial decoration of the Chapel done at the end of the fifteenth century, with the typological correspondence between the scenes of the Old and New Testaments, the row of painted curtains beneath, and the portraits of popes above appears to be a conscious return to ancient Christian decoration and recalls that of the old basilicas of St. Peter and St. Paul.

It was on May 10, 1508 that Julius II commissioned Michelangelo to decorate the Sistine Ceiling. At first it was a question of covering only the actual barrel itself with paintings, but after the preliminary sketches Michelangelo found this solution rather impoverished ("cosa povera") and in August 1508 the Pope consented to the spandrels and adjoining lunettes also being covered with frescoes, thus linking the area with the papal portraits done at the end of the Quattrocento.

In the first drawings, which are still attached to the tradition *213, 214* of coffered compartments using cornices with different edgings, one can already recognize Michelangelo's attempts to express the tensions inherent in the vault. From the outset, the artist accentuates the vaulting, but he does not yet dare to give his ceiling an autonomous, rhythmic composition which would detach it from the rhythm of the pilasters on the walls. In these sketches he starts from the concept that the vault is a sort of roof, resting on the walls of the building. And so, in his earliest drawing (British *213* Museum), which agrees with the first plan he described in a letter (Milanesi, p. 427), he accentuates the axes of the already existing pilasters in the Chapel with gigantic figures of apostles placed in painted recesses above them. At the same time he seeks to emphasize the whole of the curve of the vault: he modifies the traditional cornices, the straight lines of which separate the spandrels from the square expanse above. His forms interpenetrate each other: the apostles' thrones rise above the cornice, while the corners of

the diagonally-turned square fields in the center of the ceiling penetrate the area of the thrones, so that these separate elements are linked in an indissoluble whole.

53 In the final execution, Michelangelo takes his inspiration from the actual shape of the vault and its mass, contrary to his predecessors who had tried to camouflage the shape and material weight of the vaults which they were covering with their frescoes, either by a network of cornices or by illusionist *trompe-l'oeil* paintings. Michelangelo uses the curved surface of the vault as it presents itself to him, creating at the same time an architectonic framework and a world of gigantic figures which are an incarnation of the vital energies latent in the vault. He renders the material weight of this by the volume of his figures and the "relief" of the painted architecture. The forces of thrust inherent in the vault are symbolically expressed by broad, elastic "beams" whose tension is personified by the putti-caryatids which take the place of the pilaster capitals. The forces of cohesion which counterbalance the lateral thrust are expressed by a powerfully molded cornice running around the "beams" or bands, making a ridge on each pilaster and linking the whole system. The neutral areas between the lateral thrust and the forces of cohesion are filled with historical scenes, giant figures, medallions, and bronze nudes. Michelangelo finally finds the plastic symbol to explain—on the artistic plane—the curve of the whole structure by interpreting it as a result of the weight of the Prophets and Sibyls, whose heavy masses pull the gigantic framework downwards. In this way his system expresses the latent energies of the vault: it appears curved by its own weight and held up by its own tension. It is an autonomous world, a complete universe, ruled by its own laws and detached from the architectural structure of the Chapel.

Once this new conception of the decoration of the vault has been recognized, one can understand why Michelangelo had to give up perspective vision from a fixed point for the whole; it would have spoilt the effect of the curvature. The artist has used perspective only to give a sharper relief to the individual shapes. And one can also understand why he renounced all ornament on the architectural forms: it would have destroyed their dynamic value.

Michelangelo was not entirely free in his choice of subject and the order of the frescoes. A quarter of a century before, the Quattrocento masters had already decorated the walls of the Chapel with two cycles, developing the story of Moses on the left wall and, on the right, that of Jesus Christ, subjects represented as corresponding typologically, retracing the history of humanity *sub lege* and *sub gratia*. When Michelangelo also decided to paint historical scenes, he had only one subject left to complete the two previous cycles: the story of humanity *ante legem*. He was also bound by the fact that the artists of the Quattrocento had unfolded their cycles from the altar to the entrance, following the tradition of early Christian art (as in the old basilicas of St. Peter and St. Paul): he had, therefore, to start his iconographic sequence above the altar and finish it above the entrance.

Finally, since the Chapel was divided by a screen (*cancellata*) *162*
into two parts, the lay area and the presbytery for the clergy, it was natural for Michelangelo to take this division into consideration. In fact, he put the fifth band from the entrance exactly above *53*
where the *cancellata* then stood, and this determined the position of the others: there were, therefore, five rectangular fields above *54*
the presbytery, reserved for the story of God or Genesis (*The Division of the Light from the Darkness, The Creation of the Sun* *63, 62*
and Moon, The Division of Heaven from the Waters [of Earth *61*
from the Waters], The Creation of Adam, The Creation of Eve); *60, 59*
and four others above the lay area occupied by the story of sin and its consequences (*The Fall and the Expulsion, The Sacrifice* *58, 57*
of Noah, The Flood, The Drunkenness of Noah). Because of the *56, 55*
limited number of fields, Michelangelo had to abridge his narrative; this explains certain iconographic irregularities in the cycle.

At the same time, Michelangelo seems to have added a new significance to the biblical content of his work. He has deepened the original iconographic program with a philosophic conception of human existence taken from Platonism and Neoplatonism.

THE ARCHITECTURAL framework painted by Michelangelo divides *53*
the vault into three superimposed zones, and a threefold hierarchy of content corresponds with these three topographically and stylis-

tically distinct areas. The artist uses the lower zone formed by the lunettes and spandrels to represent humanity in its daily vicissitudes; this is the level of existence which is not yet spiritually conscious, an idea symbolized by the Genii in this zone: bronze-colored nudes deprived of all spiritual light.

75, 76

In the second zone, which is clearly separated from the first, sit the Prophets and Sibyls who, although they belong to the human race, are at the same time gifted with supernatural faculties; they perceive with the eyes of the spirit the Divinity who appears above their heads.

69-72

In the same zone, the nude adolescents above the seers and at the corners of the historical frescoes seem also to have a vague presentiment of the significance of these scenes.

73, 74

The third zone, visible through the central rectangles as if through windows, contains the gradual revelation of the Divine perceived, as we have said, by the figures in the second. This first appears in the imperfect form of man imprisoned in his body (Noah), then assumes a progressively more perfect shape until it becomes a cosmic being (God).

55-63

There is, therefore, a dual ascension in the Sistine Ceiling: an upward ascension through the three zones symbolizing the three degrees of existence, and an ascension through the historical cycle which runs from the story of Noah to the scenes of the Creation.

The spectator who moves forward from the main entrance to the altar senses, as he passes from fresco to fresco, a gradual ascension: the impression of a successive liberation which is deliberately accentuated by the use of three different styles of composition in the nine scenes of Genesis. By identifying himself with the movement of the Supreme Being, the spectator himself feels delivered from the chains of this earthly life and rises into the realm of absolute liberty. The divine origin of the human soul becomes manifest.

This series of frescoes, then, sets out for us the return to God of the human soul imprisoned in its body (that is, the idea of *deificatio* or *ritorno*). This return to God is but the soul returning to its own source and primary essence, for, according to Neo-

platonism, God is only the Idea of man and is not a transcendent being.

By inserting the theory of progressive deification into the cycle of the vault, Michelangelo was able to offer a comprehensible unity to the spectator entering the Chapel on the side opposite that of the first story from Genesis (without changing the iconographic order already established by the cycles of the Quattrocento frescoes on the Chapel walls).

THE PROPHETS possess the vision of things divine owing to a faculty of the spirit. While the succession of the Prophets from entrance to altar expresses a gradual increase in the gift of anamnesis, the Sibyls, following the same direction, show a gradual diminishing of this faculty.

The Prophet Zechariah above the entrance represents the initial *69, 215* state of contemplation: the bearded old man sitting in a tranquil attitude is carefully leafing through his book, trying to concentrate. Joel, the first Prophet of the lateral series, who has the face of an ancient philosopher, personifies the awakening of anamnesis; he is reading a scroll, yet is distracted by the image which is mentally blinding him. The next Prophet, Isaiah, has already closed the book on which he is leaning, and trembles under the effect of his vision. Ezekiel is in a state of ecstasy; the internal breath of *furor divinus* is accompanied by a mysterious wind ruffling his clothes; in fact, the first picture in which God appears, the *Creation of Eve*, is above him. Daniel, who has been reading from a thick tome, is assailed by the "memory" which he feverishly jots down on a sheet of paper. As for Jeremiah, he is lost in an austere meditation on the Divine. The last Prophet, Jonah, above the *70* altar, is contemplating the Creator not only with the eyes of the spirit but as a visible reality: he stares at the last apparition of God on the Ceiling; when he seeks to grasp it, the vision disappears in a chaos of clouds. God is a reality who reveals himself only to the soul.

The Sibyls, according to ancient Italian tradition, were seers to a limited degree because of their "pagan ignorance."

29

71 The Delphic Sibyl, the first of the series, and represented by
Michelangelo as a young and very beautiful girl, is filled with the
wonder of her inner experience. In the Erythraean Sibyl, one
notices already an abandonment of spiritual strength: this hand-
some, athletic woman seems to be tired after a long day's work,
as she looks idly through the sibylline book. The Cumaean Sibyl,
a haggard old woman, seems to have lost the faculty of anamnesis:
warily she reads the book of wisdom. The Persian Sibyl, of leg-
endary age, is almost blind and makes out the text with difficulty.
72, 216 The last of the Sibyls, the Libyan, represents the loss of the vision-
ary faculty: she is resigned and closes the great book while her
genii abandon her.

Whereas the Prophets, by virtue of their spiritual strength, are
capable of surmounting the contingencies of time and space and
rising to the contemplation of the absolute, of the true reality rep-
73, 74 resented in the rectangular fields of the vault, the nude adolescents
(Ignudi) who appear between the seers and the historical scenes
seem to be intermediate spirits between the Divinity and men.
From the iconographic point of view, they derive from fifteenth-
century putti angels supporting coats of arms or medallions; here,
however, they are represented as adolescents from antiquity, wing-
less and with their brows encircled by the fillet of victory. Unable
to see the central scenes directly, they have nonetheless a vague
presentiment of the events on which they seem to be commenting
instinctively by their mime.

53 The lower zone made up of the lunettes and spandrels, where
Michelangelo treats the subject of Christ's ancestors, is at first
sight excluded from the ideal world of the other two zones and
separated from them by wide frames. Here one has a vision of the
prehistoric life of man multiplying itself unconsciously in an infi-
nite series of generations. In the narrow spaces within the span-
77, 78 drels, Michelangelo has depicted the family life of a nomadic race;
all of them seem to be overcome by a great fatigue, their souls
prey to the fears of the pursued, condemned as they are to con-
83-86 tinual wanderings. In the lunettes, the artist portrays a domestic
humanity and here he reveals the antinomies of family life, the

contrast between men and women in age, physical appearance, social position, and moral qualities.

We have before us a world of eternal "becoming," fugitive, without memories, without a history, without an aim, without hope. There is nothing to indicate that Christ is to emerge from these mud-flats of existence. This interpretation of the ancestors of Christ can be confirmed by examining the four corner spandrels, which also belong to the lower zone: here Michelangelo treats the historical events in a way which reveals his intention to present the world of transition. In fact, the four miraculous interventions on behalf of the chosen people in the scenes of David and Goliath, Judith and Holophernes, Esther and Ahasuerus with the Crucifixion of Haman, and the Brazen Serpent (the last two are a prefiguration of Christ's Passion) are represented by Michelangelo not as heroic events but as tragedies of everyday life, as they unfold unobserved in a spiritual climate saturated with the dangers and anxieties of an ephemeral world.

79

80, 81

82

BEFORE we analyze briefly the style of the Sistine Ceiling, it seems necessary to resolve a question which has hitherto been unexplained. Are the historical scenes to be regarded, as one group of scholars suggests, as imitation tapestries hung between the coffers? Should they be seen as pictures fixed to the vault or are they, yet again, *trompe-l'oeil* glimpses of the sky? In our opinion, these compositions cannot be seen as tapestries because they lack the border which always accompanies Renaissance frescoes imitating tapestries (Raphael, Salviati). Nor can they be considered as paintings mounted on the ceiling: they lack the frame which is always present when frescoes are designed to look like pictures (Baldassare Peruzzi, Raphael, the Carracci). Finally, they cannot be interpreted as illusionist views against a realistic sky: the foreshortened perspective is missing. Yet Michelangelo's intentions appear to be clearly expressed: the bands with their architectural profiles present us with an immense grille through the bars of which we can look into an ideal world. It is neither fiction as in a tapestry or picture, nor *trompe-l'oeil* against the sky like an illu-

sionist painting, but the appearance above us of another reality which superimposes an ideal world on our own.

By the fullness and plenitude of its forms, the Ceiling recalls the majesty of Roman architecture, especially of Roman triumphal arches. This antique character is apparent in many things borrowed from classical statuary. Michelangelo has taken the works of the ancients as his starting point for most of the categories of figures: the putti holding the tablets with the names of the Prophets and Sibyls are the figures of Eros on antique sarcophagi; the putti-caryatids who frame the thrones in pairs evoke the memory of Hellenistic groups of Eros and Psyche; the naked adolescents holding the bronze medallions are variations on the Torso Belvedere and the Laocoön, as well as antique gems and reliefs representing Diomedes; the motifs of the bronze nudes, the use of medallions, and even certain of the scenes depicted in them are inspired by the Arch of Constantine. In the first three historical scenes from the entrance, painted at the beginning, one can detect the concern to render the effect of antique reliefs by the strict style, the composition on parallel planes, the exclusive use of naked figures, and by the coloring which imitates the gray of the marble. The drunken Noah is an ancient river god, the *Sacrifice of Noah* is presented as a pagan holocaust, the *Flood* contains a group inspired by antiquity. In the *Expulsion from Paradise*, Adam's gesture of defense is that of Orestes pursued by the Erinyes; the figure of God the Father creating Adam is inspired by the hovering Victories on triumphal arches; God separating Heaven from the waters is derived from Caelus with his "mantle of the sky." Even the architectural framework and profiles are inspired by Roman triumphal arches. There is no doubt that Michelangelo wanted to give this work a Graeco-Roman aspect.

But the massive, motionless Roman shapes are permeated in Michelangelo by a powerful dynamism which exalts them and gives them a greater potential life. In the dynamism which springs from the bands and which appears in flagrant contradiction with the tectonics of the classical style, this work seems strangely akin to medieval conceptions. In fact, this dynamism has its origins in the ribwork of Gothic buildings. It is again in the Middle Ages

that one finds the idea of a series of isolated figures, as well as the hierarchy of characters expressed by the difference in their sizes. Gothic, too, is the relationship between the figures and the architecture, whereby the latter does not form a setting for the figures, but an ideal framework which determines their position. Medieval inspiration is visible even in the style of certain figures and in that of the compositions. The dramatic gestures of the Prophets and Sibyls derive from Giovanni Pisano and Jacopo della Quercia. The first five scenes are inspired by Quercia's reliefs in San Petronio at Bologna; the Ervthraean Sibyl by Ghiberti and Signorelli; God the Father in the *Creation of Eve* by Masaccio. The intimate structure of the ensemble, which is conceived as a living organism, full of an inherent tension, where every element is determined by and at the same time determines the whole, is not, however, either classical or Gothic: by the introduction of the laws of causality, it is a work of the Renaissance.

The language of the forms varies according to the degree of height which each one occupies in the system of the Ceiling: below, terrestrial heaviness in the figures in the lunettes and corresponding spandrels; forms animated by pulsating interior forces and by a cosmic wind in the clothing, in the Prophets and Sibyls above; and a free unfolding of the organism in the Ignudi at the top. There is also a whole scale of feelings, from the oppression of souls (lunettes and spandrels), through the grip of *furor divinus* (Prophets and Sibyls), right up to the omniscient and omnipotent wisdom of God the Father.

At the same time there is also a crescendo in the forms as they approach the altar: at first the poses of the Prophets, Sibyls and Ignudi are calm, the latter symmetrical, whereas towards the altar their movements become violent and contrasted. In the historical scenes above the lay area of the Chapel (first four pictures), the *55-58* multiple-figure compositions are set out following parallel planes and are enclosed within a limited space; above the presbytery, the *54, 59-63* number of figures is reduced, but they are noticeably bigger and move in a diagonal, evoking and even creating infinite space around them. Whereas the figures in the first pictures are of a marble gray and their substance appears as hard as stone, towards

the altar they take on the look of living flesh, their substance soft and smooth. Even God is progressively transformed from human appearance until he takes on the character of a cosmic phenomenon. In the *Division of Heaven from the Waters*, Michelangelo draws God's body as a series of ever-increasing spirals ending in the vast gesture of his arms which seem to be opening up infinity. Here, by the use of specific shapes, the artist succeeds in portraying a limitless being evolving in measureless space.

This crescendo of pictorial language is partly a consequence of the actual theme which Michelangelo represented, and partly the result of the painter's artistic development during the course of the work. We know that he began the Ceiling near the entrance to the Chapel, that is, near the door leading to the Sala Regia and opposite the altar. In this first part, the style is still constrained, and one can discern a certain hesitation in the painter's technique; it is a graphic style in which the outline is dominant. The closer one gets to the altar, the more the style and technique gain in assurance and in pictorial fluidity.

The figures are generally constructed around a point from which centrifugal forces radiate in all directions and yet are fixed within a closed silhouette. The artist is everywhere seeking to render beauty freed from all contingencies. This universal beauty presents itself to him as a powerfully and completely developed life: strength and beauty are inextricable at this stage of his artistic development.

In its coloring, Michelangelo's work offers a harmony of rare, pale tones, a sort of diffused light. The Italian artists at the beginning of the Cinquecento sought color harmony in two different ways. Leonardo, Fra Bartolommeo, and Correggio enveloped forms in a gentle, hazy veil (*sfumato*), which attenuated the intensity of the local shades and served as a link between the opposing colors of objects and their surroundings. In Venice, on the contrary, Giorgione and Titian intensified the action of colors which they openly juxtaposed, but the choice of primary tones (red, blue, yellow) and especially the warm, even light in which everything was bathed, established the harmony of their paintings. With Michelangelo the different colors are subordinated to

a whitish-gray shade; they are no longer one with the subject, but appear as iridescent reflections on the surface of the original matter, marble-gray in hue. This primary tone is seen in its pure state in the painted architecture of the vault, but it also gleams behind all the colored forms. It is, therefore, natural that with Michelangelo color should sometimes be condensed, and at other times diluted.

The coloring is graduated over three zones, according to the hierarchy of the overall structure. In the upper part, the historical scenes appear in pale shades, very close to the grayish-white of the original material. Even in the first four scenes, where some stronger touches are visible (a golden bronze, a cherry red, an olive green), the dominant impression is made by the light gray of the bodies. In the scenes that follow, the color of the tunic of God the Father dominates—an indescribably delicate tone which shimmers from lilac-blue to lilac-red and silvery blue. Light and shade are no more than the same tone diluted or condensed. Hence the effect of ethereal purity and unity in the colors of the Ceiling.

The Sistine Ceiling is the work of an artist at the height of his powers: it is the titanic flight towards the heavens of a man in his prime. By glorifying the boundless creative force of God, Michelangelo has at the same time made an image of his own supreme aspirations during this period of his activity.

The creative principles which govern the Ceiling were not abandoned in the statues of the two Slaves now in the Louvre and *91-94* the figure of Moses, executed for the Julius Tomb between 1513 *95-97* and 1516; we shall come back to these sculptures later.

III. THE MEDICI CHAPEL

109-133 It was at the age of forty-five, when Michelangelo began the figures for the Medici Chapel, that a marked modification in his style occurred: the overabundant strength seems to be spent. The figures' shapes become slender and refined, passive melancholy and suffering appear on the faces; already it is autumn, the master feels old and has aged before his time. Earthly beauty still exercises all her fascinating charms, but already he sees them as if from afar, bathed in a silvery light. Absorbed in a resigned and dreamy reflection, he contemplates the universal creative force of which he feels that individual beings are only the tools. And so he begins to concentrate his thoughts on death. It was a happy fate that this mood was given a chance to express itself plastically, through the commission for a funerary chapel which allowed Michelangelo to incarnate in figure-symbols his philosophy of death.

Just before undertaking the plans for the Medici Chapel, Michelangelo began for his friend Metello Vari a statue of Christ 98, 99 (the figure now to be seen in Santa Maria sopra Minerva is a second version of it), which was finished and partially spoilt by the *garzone* Pietro Urbano. The master himself retouched the statue. The original contract is dated 1514. The first figure begun by Michelangelo at that time, for which there exists a study in the Brinsley Ford Collection (London), was never finished because of a black vein in the marble. The new statue was made between 1519 and 1520.

According to the contract (Milanesi, p. 641), the sculptor was to carve "a life-size marble figure of Christ, standing naked and holding a cross in his arms, in the pose deemed suitable by Michelangelo."

Michelangelo kept to the contract for the nude standing figure holding a cross. To this cross he added other instruments of the

Passion: the sponge, the "reed" (a bamboo pole), and a length of rope. As for the pose, where the contract left him a free hand, it is in fact far from conventional. His Christ does not show his wounds. He is a naked Apollo figure of noble proportions, standing in *contrapposto* position, holding on his right side the instruments of the Passion with both hands, pushing the cross slightly behind him with his right leg and turning his head in the opposite direction (a movement probably inspired by Leonardo's Leda).

This is a new conception of the Savior who endures and hides his suffering with a noble calm. The instruments of the Passion which he conceals from the crowd are incarnations of the destiny with which Christ identifies himself. The man and his fate are here bound indissolubly and they face the world completely alone.

This solitude, this stoic attitude, this identification with personal fate can be better understood with the help of a poem (Frey, *Dicht.*, x), in which the artist criticizes the corrupt, avaricious, and secularized Church and the practice of simony. Michelangelo seems to want to create an image of the true Christ, the Christ of goodness, of suffering, of patience, in order to establish a contrast with the anti-Christ adored in Rome at the time, where "Christ's blood was sold in handfuls" ("el sangue di Christo si vend'a giumelle"), where "helmets and swords were made out of chalices" ("qui si fa elmi di calici e spade"), where "the cross and thorns became spears and shields" ("e croce e spine son lance e rotelle"). Erected in a Roman church at this period, the statue therefore takes on a special significance: it is a monument commemorating the true Christ in the midst of the corrupt and greedy city. We can see the revival of the Dominican Savonarola's ideas on the internal reform of the Church; nor must we forget that the statue was made for Santa Maria sopra Minerva, the Dominican church in Rome. (An idea of the base and the original tabernacle, which were destroyed in 1848, is given by a drawing now in the Casa Buonarroti in Florence; see Tolnay, *Commentari*, 1969, pp. 43ff.)

ABOUT 1519, Pope Leo X and his cousin, Cardinal Giulio de' Medici, had the idea of establishing an unfinished chapel attached

to the church of San Lorenzo in Florence and forming a pendant
to Brunelleschi's sacristy, as a mausoleum for four or six members
104 of their family: the Medici Chapel. Its construction, probably
started at the beginning of the fifteenth century, was taken up
again in November 1519 (Corti-Parronchi), and Michelangelo
assumed direction of the work: he made a series of projects dur-
ing the months of November and December 1520, and in Janu-
ary 1521, when the final project had already been decided upon,
its execution, or to be more exact, the extraction of the blocks of
marble at Carrara, began.

We know that Michelangelo's first idea was to erect a free-
324 standing monument with four identical sides in the middle of the
Chapel. Letters mention three distinct projects for this: the first
was to be four *braccia* wide, the second, more monumental, of six
326, 327 *braccia*, and the third, whose measurements we do not know,
would have been in the shape of a four-sided arch (like the Arco
di Giano).

As we can see from these letters, Michelangelo was working
325, 328 on the idea of a free-standing monument and on that of wall tombs
at the same time. The latter are no more than derivations and
adaptations of the three types of free-standing monument which
he at first considered. It is only by this affiliation that the origin
of their structure can be explained. The architectural motifs in
the projects for the free-standing tomb are repeated here right
down to the details and make these sepulchers resemble the
façades of buildings.

In the main, Michelangelo wished to follow the architectural
332 example of the Sagrestia Vecchia. The first plan, in the Archivio
Buonarroti, clearly shows this dependence on Brunelleschi. As for
the wall tombs inserted into shallow niches, inspiration for these
could have come from the tomb of Cardinal Jacopo of Portugal
in San Miniato al Monte, the only Quattrocento example of a simi-
lar concept.

The actual construction of the tombs, for which the plans were
established before December 14, 1520, was begun only in the
spring of 1524. The reason for this delay was the slow extraction
of the marble at Carrara. It has been observed, and rightly so,

that the architecture of Lorenzo's tomb is richer in secondary *107*
motifs than that of Giuliano's. It seems clear that the appearance *108*
of simpler forms and greater volumes corresponds to a more
advanced phase of the work, and that we may suppose Giuliano's
tomb to have been completed a few years after Lorenzo's.

The architecture of the tombs is dominated by the specifically
Michelangelesque conflict between the inherent impulse towards
liberty and the rigid yoke imposed on this aspiration by external
limits. The result is an interpenetration of the elements of the
tomb with the architectural elements of the chapel. The tomb is
no longer an organism in itself, standing against the architecture,
a kind of arched gate to Heaven, as in the so-called "niche" tombs
of the Italian Quattrocento, but forms an indissoluble part of the
Chapel interior.

The effect of surprisingly high space in the Chapel, where light *105, 106*
penetrates only from above, is that one feels very low down, as if
in a sort of crypt, far from the domain of day. The impression of
disorientation is heightened by the irrational links between the
white marble architecture of the lower zone and the framework of
pietra serena. Up to this time in Italy there had generally been a
harmony between the actual form of a chapel's walls and the
architectural elements decorating them. Here, the walls seem to
be pierced and dreamlike façades of white marble appear to loom *107, 108*
on every side. It is like seeing through into another world where
relations of height, width, and depth appear fleeting and deceptive
(architecture which vaguely recalls the effects of the frescoes at
Pompeii).

The statues are not simply elements decorating this space, they
are the real lords of the sanctuary. The architecture and the space
are created for them, while the humans who wander around are
only intruders. From his first contact with them, the spectator
must feel that these figures have a mysterious existence of their
own, foreign to ours.

The whole of the Chapel seems to have been conceived by
Michelangelo as an epitome of the universe: below, the realm of
dead souls, then the intermediate zone with its rational architec- *106*
ture, signifying the terrestrial plane, and finally the zone of the

105 lunettes and the cupola which was to represent the celestial
sphere. All this would have been even more evident if the frescoes
which were to have decorated the lunettes and walls had been
executed and those of the cupola by Giovanni da Udine were still
visible. The gradation of light, which streams into the celestial
zone and filters through small windows into the intermediate,
leaving the lower zone with no direct source of illumination, seems
to illustrate the same idea. This hierarchy of superimposed
spheres is already envisaged in the mortuary chapel of Cardinal
Jacopo of Portugal.

The composition of the tombs is a symbol-image of the delivery
of the soul after death from the *carcer terreno*, the body. The alle-
109-112 gories of Time—Dawn and Dusk, Day and Night—and those of
132, 133 the rivers of Hades (which, according to the original project,
were to be placed below those of Time) embody the inexorable
destiny that rules the life of mortals. These athletic figures, reclin-
ing on the sarcophagi which contain the perishable bodies of the
Dukes, seem by their weight to be breaking the lids in the mid-
dle; from the opening thus formed, the immortal souls of the
dead are liberated and rise above them into a region which is
inaccessible to the blind forces of Time (Frey, *Dicht.*, XVII).
Freed from the fetters of the body, the souls of the dead find them-
selves once again in their true essence, through the eternal con-
127 templation of the idea of life as symbolized by the Virgin and
121, 122 Child. The two Dukes are not portrayed as the dead up to this
time had been, reclining on their sarcophagi, but as seated men,
watching the Virgin. Thus a spiritual unity links all the figures
in the Chapel.

106, 127- The Medici Virgin is placed opposite the altar and is the core
129 of the composition of the Chapel. She is seated on a tall, narrow
block, with only one of her feet touching the ground, which gives
her being a strange lightness. Her diaphanous clothing shows the
slender shapes of the body beneath. The naked, muscular Child
sitting astride her knee turns towards her in a violent movement,
clinging eagerly to her breast. His back is turned to the public.
The sap of life flowing in him seems to swell his body with new
strength. The Mother is all abnegation; leaning on her right arm,

she offers her body to the Child. Her head is bowed, the face with its grave features is marked with a pensive expression and a noble tenderness. Mother and son seem to be one single being, embodying a striking image of the cyclic idea of life: eternally exhausted and eternally renewed.

Thus, the Chapel dedicated to death becomes the sanctuary of what is called the true life of the soul. It is an organic unity, a complete world which receives the souls of the dead.

The resemblance between the fundamental ideas expressed in the Medici Chapel and those of Plato on death and the immortality of the soul is evident. In *Phaedo*, Plato describes the life of the soul beyond the grave. Freed from its corporal prison, it returns to the world for which it has always yearned, and where it finds once more its true home. There, it can finally contemplate Ideas, just as Michelangelo's Dukes contemplate the Virgin. In order to show that the soul is born again after the death of the body, Plato uses, among other things, an argument founded on a natural law which he calls "the generation of opposing principles." According to this law, given two opposing principles, there must of necessity exist two opposing "principles of generation." Plato thus quotes as an example the state of wakefulness born from the state of sleep, whose processes of generation are waking and falling asleep. This explains—as Oeri has already observed—why in the allegories Michelangelo did not represent the four states of the soul in their successive order, and why he grouped them in opposite pairs. Moreover, in *Phaedo* we find the four rivers of Hades as symbols of eternal fluctuation, as Michelangelo wanted to show in his original project.

So we see that the elements of the composition of the Medici Chapel have their direct or indirect origin in Plato's myths, especially in his *Phaedo*. But it was Michelangelo who succeeded in uniting these elements in an organic whole, by inserting them into a new, architectonic structure. Starting with the scattered elements of Plato and the iconography of the Christian tomb tradition, he has created a solidly constructed world which reveals to us the secret mechanism of death and the life of the soul thereafter.

41

The solution which the artist found for the problem of the figures lying on the sarcophagi is closely related to classical models. The figures of Dawn and Dusk are inspired by the river gods on the Arch of Septimius Severus, and Night by an antique sarcophagus depicting Leda. Other motifs are simply developments of earlier works by Michelangelo himself: for example, the Dukes, whose types go back to the Prophets in the Sistine Chapel; or the Child Jesus, who repeats the movement of one of the two children in the Jacob and Joseph lunette above the entrance to the same Chapel, and who recalls, too, some of the artist's youthful drawings of the Virgin and Child (Louvre, Albertina).

The proportions of the figures are newly modified: the powerful torsos end in delicate hands and feet; the heads are small. A tendency towards suppleness appears: the shapes are slender, the circular lines transformed into ovals, characteristics particularly visible in the figures of the Virgin and Giuliano. Each figure now describes a curved axis around which it moves in a spiral.

The plastic treatment becomes synthetic, the mass is like a malleable substance in which the individual muscles melt to create a surface fluctuation. Whereas Michelangelo's forms had previously evolved from an interior centrifugal force, which was, however, still contained within them, they have now become vehicles for the forces flowing through them. The mature Michelangelo no longer sees the isolated body as an individual center of energy, but seizes the cosmic force which passes through it. The human frame is seen as a receptacle for forces which come to it from outside, pass through it, and afterwards disappear.

The transformation of wide proportions into tall, slender ones is analogous to the formal ideal of contemporary artists, Mannerists like Pontormo, Rosso, and Parmigianino. It has even been said that in Michelangelo's figures worked about 1515-1530 there is a subconscious concession to Mannerism. However, this hypothesis presents chronological difficulties, since the first works of the Florentine Mannerists to be conceived in the elongated style are contemporary with Michelangelo's figures (1525-1530). The change in Michelangelo's style can possibly be explained as an attempt, once he had returned to Florence, to work in the artistic

110, 109
111

121, 122
127

127, 122

idiom of the city; already, during the second half of the Quattro-cento, it had shown a preference for delicate, elongated forms. The same conscious return to the Florentine tradition is visible in the architecture of the Chapel with its framework in *pietra serena.* This explanation is rendered even more likely by the fact that when Michelangelo returned to Rome in 1534, the ample, robust *156, 183* Roman proportions suddenly reappear in his works.

In the Sistine Ceiling it was through the *ritorno a Dio* that Michelangelo conveyed man's ascension towards divine exist-ence. In the Medici Chapel it is through the soul's life beyond the grave that he evokes an existence spent in contemplating the essence of life which recalls that of the souls in the shadowy region of Hades. These figures are deprived of action and are only shad-ows of the life lived, ghosts of the memory, freed from human tribulations. If the Sistine Ceiling was humanity's past (*genesis*) reflecting the future (*deificatio*), then the Medici Chapel is an image of the future of souls who remain molded by all that has happened. But while the Ceiling, which announced the triumph of creative, active forces, was an "ideal portrait" of the soul of an artist at the height of his powers, the Medici Chapel, filled with the elegiac poetry of contemplative wisdom, is the image of a man who already feels that the end of his life is near.

AFTER THE Sack of Rome in 1527, the heads of the Medici party were obliged to leave Florence once more, and the republican regime, which had been interrupted by the Medici fifteen years before, in 1512, was restored. This was the last Florentine Repub-lic. During the three years which it lasted, Michelangelo was to put into practice the convictions on the virtues and duties of a citizen which he had symbolized in the David, in the *Battle of* *34, 366* *Cascina*, and in the sketches of Hercules and Antaeus. Michel-angelo worked not only as an artist for the republic (a group of Hercules and Antaeus or Cacus); he also contributed directly to its military defense. He worked, in fact, on the city fortifications, in accordance with his intellectual principles which required every citizen to contribute to the defense of the state. In the autumn of 1528, he decided of his own free will to offer his services as an

expert on fortifications "gratis et amorevolmente" (Gaye II, p. 62). This involved completing and improving the works begun by the Medici in 1525-1526. In January 1529, Michelangelo became a member of the Nove della Milizia (the council for the fortifications). In April 1529, he was named head of the Dieci della Guerra (the supreme council of war), with the title "Governatore e procuratore generale sopra alla fabrica et fortificazione delle mura della città di Firenze."

Michelangelo seems to have set to work with ardor and enthusiasm. He produced a series of magnificent plans for the fortification of the walls and gates of Florence (all of them in the Casa Buonarroti).

341-344

However, these plans were not accepted by the Gonfalonier Niccolò Capponi (Busini, p. 103) who was opposed to them. After the resignation of Capponi, his successor, Francesco Carducci, found Michelangelo "troppo timido et sospettoso" when the latter, foreseeing the treachery of Malatesta Baglioni, told the Signoria of his suspicions; a year later these proved to have been well founded. Sensing the danger threatening the town, and seeing that his efforts for forestalling disaster were unsuccessful with the magistrates, in a moment of panic and perhaps also of lassitude, Michelangelo fled in September 1529, suddenly and "molto disordinatamente," according to a letter of Paesano (Symonds I, p. 423), "per fuggire il fastidio et ancora la mala fortuna della guerra."

He went to Venice via Ferrara and, still not feeling safe, thought to flee to France. This episode took place about three weeks *before* the beginning of the siege (October 10, 1529) by the allied armies of the Pope and Emperor. In order to understand Michelangelo's attitude it seems important to insist on this chronological fact as well as on his communication to the Signoria three days after the beginning of the siege (October 13, 1529). The artist made it known that he was ready to return to Florence on condition that he be pardoned. He did, in fact, return towards the end of November when all the southern part of the town was already under siege.

It was to this besieged, yet hopeful and courageous, Florence that Michelangelo returned. First, he was punished for his flight by the Consiglio Maggiore, but the penalty was not harsh. From then on he behaved with courage.

The facts which we have just examined speak for themselves. His flight three weeks *before* the siege was offset by his return at the height of the critical period, as well as by his conduct before and after the episode in his role as head of the town's fortifications.

After the capitulation of Florence on August 12, 1530, Michelangelo hid at first in order to avoid the vengeance of the conquerors. Then, soon pardoned by Clement VII because of his position as a celebrated artist, he was obliged to put himself at the disposition of the new masters of the city. He took up his work on the Medici Chapel again and, supreme humiliation, had to execute orders for the enemies of Florentine liberty: a David or Apollo *100* for the Pope's commissioner, the cruel Baccio Valori, and a cartoon representing a *Noli me tangere* for the Marchese del Vasto, *379* one of the commanders of the imperial army. (The suggestion for the latter work came from del Vasto's aunt, Vittoria Colonna.)

Beneath the right foot of the statue sometimes called Apollo *100, 101* and sometimes David (Florence, Bargello) one can see the outline of a round shape, no doubt the head of Goliath. The left hand seems to be holding the sling, and the right the stone. Instead of conforming to a normal *contrapposto* position based on the laws of balance of the body's strength and weight, the figure seems to live in a dreamlike space. His gestures are unconscious reflections of the life of the soul, like the gestures of a man dreaming; with his face turned to one side and his eyes half open, he is trying to free himself from a nightmare. This is not the representation of *Fortezza* like the marble David, nor of the perpetual victor like the bronze David, but a conqueror who is seemingly troubled by his victory. One wonders whether, in making this strange, dreamy David, Michelangelo did not perhaps wish to remind the new conqueror, Valori, that not every victory is a triumph. Perhaps one can thus understand the ambiguity implicit in the way contemporaries called the statue both David and Apollo. The allusion to David alone would have been seen through too easily.

FOR A more precise idea of Michelangelo's state of mind towards the end of his work on the Medici Chapel, it is necessary to mention his friendship with Tommaso Cavalieri: this began at the end of 1532 and was at its height during 1533 and 1534, before Michelangelo started the *Last Judgment*. The notion of *Fatum* expressed in that work has its preparation in the poems and drawings dedicated at this time to Cavalieri. Tommaso Cavalieri, "a Roman patrician from the Sant' Eustachio quarter," was a young man who, according to the testimony of contemporaries like Varchi, was outstanding for his incomparable physical beauty, his elegant bearing, his eminent intellect, his sense of justice, and his gracious manners. He was a lover of classical antiquities, a fact proved by the inventory which we have of the collection in his palace. He was later named as one of the *Conservatori* of Rome. His correspondence with Michelangelo, of which only eight letters remain, his letters to Duke Cosimo I and Cardinal Alessandro Farnese, and finally his will, which was drawn up in 1580 and in which he shares his goods with such impartiality between the members of his family, all bear witness to the nobility and distinction of his character. From his first meeting with Michelangelo until after the latter's death, he bore him a constant admiration and respect. For Michelangelo this meeting was the effect of *Fatum*. The letters and sonnets which he addressed to the Roman nobleman reveal that it was not merely a case of friendship but one of real passion. Opinions as to the significance of this passion were already divided at the time. To appreciate it correctly, we must remember that friendship between men was a firmly established tradition during the Renaissance. As in the time of Plato, male beauty was considered superior to woman's. Moreover, the form and language of the friendship for Cavalieri are close to those of spiritual friendships in the circle of Lorenzo de' Medici at the end of the fifteenth century.

According to Plato, spiritual love is not accessible to all, but only to a certain number of initiated souls. The poetry which Michelangelo dedicated to Cavalieri shows that he was truly an initiate of supreme love. He wants to see his friend not as the ephemeral being, but as "the immortal and perfect Idea." In Cava-

lieri's corporal beauty he loves the divine idea of which it is the embodiment. If, on the one hand, Michelangelo refuses the name of love to purely sensual love (Frey, *Dicht.*, LXXIX), on the other he affirms just as strongly, in a series of poems, that supreme love is inextricably linked with corporal beauty (Frey, *Dicht.*, CIX, 99). He goes so far as to justify the passion for mortal beauty (Frey, *Dicht.*, LXXXXI). As in Plato, earthly beauty is loved only as a reflection of divine and that is why it awakens the desire to return to God (Frey, *Dicht.*, LXIV). In this ascension, the soul returns to its original home: the *circulus amorosus* closes:

> Dalle più alte stelle
> Discende uno splendore
> Che'l desir tira a quelle.
>
> (Frey, *Dicht.*, CIX, 99)

("From the highest stars falls a splendor that draws desire to them.")

While one finds in these poems all the elements of love according to Plato, translated into a language inspired by Petrarch, by Lorenzo de' Medici, and sometimes by Benivieni and Ficino (though it differs from theirs in its more powerful and sober rhythm marked by an authentic passion), other poems present two more aspects of this supreme love: first, the mystical union of two beings in love, inspired by Christian conceptions, to which two of Michelangelo's most beautiful love poems refer (Frey, *Dicht.*, XLIV; Frey, *Dicht.*, CIX, 19). Their source can, we think, be determined: the outline of the theme is to be found in a letter (dated August 16, 1516) from Fra' Lorenzo delle Colombe to Michelangelo (Archivio Buonarroti, see Tolnay, *Michelangelo I*, pp. 251f.). Since Renaissance Platonism had, before Michelangelo, already united the cult of classical beauty with Christian love (Marsilio Ficino), it is not surprising that Michelangelo was inspired by this religious letter on the love of God to compose two poems about profane love.

The third aspect of love as expressed in Michelangelo's poetry is its tragic side, the feeling of love's fatality (see his poem on the

obsession of love, Frey, *Dicht.*, vi). In one poem he advises lovers to flee the fires of love, showing himself as an example of the painful wounds which it inflicts on the soul (Frey, *Dicht.*, xxiv).

The three aspects of love discernible in Michelangelo's poetry—the aspiration of Platonic love, the union through mystic love, and the fatality of love—have also been expressed by the artist in a series of drawings: the first in drawings of the Resurrection, which were probably done shortly before the meeting between Cavalieri and Michelangelo, a fact which would prove that it was not Cavalieri who inspired Michelangelo's Platonism, but that he was the marvelous realization of the aspirations dormant in the artist's soul; the second in a drawing representing Ganymede and dedicated to Cavalieri; the third in *Tityos* and the three versions of *Phaeton*, all dedicated to Cavalieri.

227-230

235

236, 237

Done in red or black chalk, these drawings are outstanding because of a technique which, in the softness of its *sfumato*, of its chiaroscuro, recalls that of Leonardo and the Venetians of the period (Giorgione). Although the contours are still vigorous, the modeling of the forms, which is supple and delicate, makes the softness of the skin more clearly felt. The bodies seem to be born from a shadow produced by the diagonal hatchings and the stump-drawing, and they emerge towards a filtered, unreal light. Sometimes they appear lit by an irradiation from within which softens without depriving them of their plastic character—an essential difference between these and the drawings of the Venetians where the surrounding atmosphere sometimes went as far as to absorb the forms themselves.

The drawings made for Cavalieri affect an antique character: not only are the subjects which Michelangelo treats taken from pagan mythology, to which he adheres quite closely, more closely than in his youth, but in the objective form, in the composition which is full of the classical spirit and deliberately close to the style of antique reliefs, one also recognizes his concern to rival the art of the ancients. Should one not see in this style—which appears abruptly in Michelangelo's work after the style of the Medici Chapel—the desire to conform to the taste of Cavalieri, who we know was a lover of antiquities? And yet these drawings,

which appear to be among Michelangelo's least personal ones, are veritable admissions of the lover's suffering: their mythological and classical appearance is only a disguise. In their conception of ineluctable *Fatum*, they are preparations for the principal work which Michelangelo executed in Rome between 1536 and 1541, the *Last Judgment*.

IV. *THE LAST JUDGMENT*
THE BRUTUS BUST
THE PAULINE FRESCOES

THE LAST thirty years, from 1534 (his establishment in Rome) until 1564 (the year of his death), constitute a very distinct phase in Michelangelo's life and in his spiritual and artistic concepts. It has long been considered as a period of decline. But in reality, we are concerned not with a falling off but rather with a shift of emphasis in his creative activity: from the figurative arts—painting and sculpture—to the arts of architecture and poetry.

Outwardly the period is first distinguished from earlier ones by Michelangelo's definitive establishment in Rome, then the artistic and intellectual center of Europe. Secondly, there is a marked change in the artist's social status: henceforward Michelangelo was to take his place at the summit of the social hierarchy, a rise which was translated in external terms by the official titles he received; in 1535 he was named "Supreme Architect, Sculptor and Painter of the Apostolic Palace"; in 1549 Paul III also named him "High Commissioner and Architect of St. Peter's," a title confirmed by subsequent popes; in 1537 he was given the rank of Citizen of Rome. A third distinctive characteristic of this period is that the artist had now arrived at the peak of his glory. All his great contemporaries, Leonardo, Raphael, Bramante, Fra' Bartolommeo, Andrea del Sarto, were long since dead; from now on he was without a rival and he dominated the whole of Italian art, the sole survivor of the Golden Age of the Renaissance. Among the young artists of the time, there were many talents but not one real genius; all of them surrounded Michelangelo with their admiration, regarded him as a supernatural phenomenon, called him *Divino*. His works were considered as incarnations of the supreme norm of all art. Everyone imitated him in style, even artists of the northern countries like Frans Floris and Marteen van Heemskerck. From 1540 onwards, European art becomes Michelangelesque.

In the works executed contemporaneously with the Medici
Chapel, like the Christ of Santa Maria sopra Minerva (1519- *98*
1521), the David-Apollo for Baccio Valori (ca. 1525-1530), the *100*
group in clay representing Hercules and Cacus (ca. 1528), and *102*
the Victory for the Tomb of Julius II, one can observe a gradual *151*
lengthening of the proportions. Moreover, all these figures are
composed in spiral or contrasting movements around a slightly
inclined axis. About 1534, when Michelangelo finally settled in
Rome, there was a new change in style heralded by the four Slaves *156-161*
which were formerly in the Boboli Gardens and are now in the
Accademia in Florence, and by the fifth Slave now in the Casa *154*
Buonarroti (stylistically, these must be dated between 1532 and
1534); the change is demonstrated in the *Last Judgment*, the *163*
Rachel and Leah of the Tomb of Julius II (1542-1545), and *182, 183*
finally by the two frescoes in the Pauline Chapel. Nothing now *186, 187*
remains of the slender elegance of the Florentine style, of the
rhythmic sinuosity of the contours, or the easy, harmonious move-
ments. It is no longer the line which determines the effect of one
of Michelangelo's figures, but its plastic volume. His style takes
on a Roman fullness, a new human type emerges which is coarse
and rough, with an almost rectangular thorax, a rectilinear silhou-
ette, wide hips and joints, and limbs like massive columns whose
parallel movements are heavy and full of effort. Michelangelo did
not wish to represent bodies as we see them, but to reveal the
inner reality of life. His nudes are still traversed by a current of *154-161*
life which swells the body's envelope from within. He has boldly
swept aside the anatomical elements which might hide the revela-
tion of this vital flow. This conception, which already existed in
his earliest works (Battle of the Centaurs), is here carried to its *3*
ultimate conclusion. However, the interior force no longer appears
sufficient to radiate freely from the center, as it did earlier in the
Sistine Ceiling, but is confronted by invisible obstacles; the mass
now subjugates the spiritual will (as in the Boboli Slaves).

THE IDEA of decorating the two end-walls of the Sistine Chapel,
the entrance wall with a Fall of the Rebellious Angels and the
altar wall with a Last Judgment, seems to go back to the pontifi-
cate of Clement VII. It would appear that, in the course of a con-

versation which Michelangelo had with the Pope on September 22, 1533, the latter told him of his plans.

It seems that Clement VII had first thought of having the altar wall of the Sistine Chapel painted with a relatively small Resurrection of Christ, which was mentioned in a letter of 1534 (F. Hartt, in *Essays in Honor of G. Swarzenski*, Chicago, 1951, pp. 152ff.) and for which several drawings are still preserved in London and Windsor (identified by Tolnay). In these drawings the risen Christ, with his beardless face and naked, Apollonian body, directly anticipates Christ the Judge in the *Last Judgment*. The gigantic project of the *Last Judgment*, then, would seem to have been born from the more modest one of a Resurrection—just as the other great projects (the Sistine Ceiling, the Medici Chapel) were also born from humbler concepts.

The idea of depicting the Fall of the Rebellious Angels on the entrance wall had already been abandoned by March 1534. In April 1535 scaffolding was put up in order to prepare the wall for the fresco of the *Last Judgment*. Vasari tells how Sebastiano del Piombo, then one of Michelangelo's close acquaintances, persuaded the Pope to have this great composition done not in fresco but in oils, a process which he himself was in the habit of using, and without consulting Michelangelo he gave the order for the wall to be prepared accordingly. Michelangelo let matters proceed without protesting, but when he was about to begin work he declared that oil painting was all right for women and lazy people like Fra' Sebastiano, and he ordered all the coating applied to be taken off. The truth of this story is confirmed by the registers of the Vatican secret treasury: on January 25, 1536 the first coat was removed (Léon Dorez). The preparation of the wall according to Michelangelo's directions was completed about April 10, 1536, *terminus post quem* of the starting date for the painting. On December 15, 1540 the scaffolding on which the artist was working was lowered, which indicates that the upper part of the fresco was then finished. The whole work was completed on November 18, 1541.

IN ORDER to understand Michelangelo's first conception of the *Last Judgment*, it is essential to have some idea of what the wall

looked like when he was planning his work. It has been recon-
structed on the basis of the wall facing Michelangelo's fresco
(Wilde). The zone of the historical scenes painted by Quattro- *162*
cento artists contained, on the altar wall, two frescoes by Perugino
(*The Nativity* and *The Finding of Moses*). Under these was the
altar fresco, also by Perugino, representing the Assumption of
the Virgin to which, in fact, the chapel was dedicated. In the space
above the two historical compositions were two large windows,
apparently false, like those opposite them above the entrance, and
in the corners in two painted niches were St. Linus and St. Cletus.
Under the central corbel was fixed a shield with the coat of arms
of the Rovere, and below that was a figure of Jesus Christ flanked
by St. Peter and St. Paul, both in niches. The two lunettes at the
top, representing the ancestors of Christ, had been decorated by
Michelangelo when he was working on the Ceiling.

The first drawing of the whole composition (in the Casa Buo- *238*
narroti) proves that Michelangelo began by taking into account
Perugino's altar reredos, and above all by respecting the existing
lunettes. In fact, as Wilde has remarked, this drawing shows at
the bottom an empty frame in the middle which corresponds to
the position of Perugino's altar painting. Michelangelo's fresco
was therefore to have surrounded this on all sides, acting as a
frame and background for it. Here, Michelangelo came up against
a conception which was not of his time and which in no way cor-
responded to his own personal ideas. And so, instead of harmoniz-
ing with Perugino's altar painting, he created an independent
composition with its own center, and relegated the former to the
rank of a secondary element. From the outset, he rejected the only
solution which would reconcile the composition of his fresco with
that of the existing altarpiece: the traditional disposition of several
horizontal zones symmetrically organized around a central axis.
He replaced this with a vast, dynamic conception in which all
hierarchy is abolished: Elect and Damned alike are Titans fight-
ing mercilessly for their salvation, all of them prey to a cosmic
catastrophe. The ancient idea of *Fatum* succeeds the medieval idea
of Providence.

The black chalk drawing in which Michelangelo has sought to
determine his conception of the whole is a summary one. The

figures, in lightly sketched yet powerful lines, are distinguished by their contours alone.

162, 163 IN THE fresco as finally executed, Michelangelo rid himself of every restriction imposed on him by the already existing mural decoration. He took into account neither Perugino's altar painting nor the lunettes which he himself had done earlier. He needed the whole expanse of the vast wall and left no room even for a frame, so that the cornices of the lateral walls penetrate his fresco directly.

The spectator's eye plunges into a strange space. It is neither a limited space geometrically constructed according to Euclidean laws, nor is it illusionist space created by pictorial values: it is a void freed of all spatial and temporal contingencies, the boundless space of the universe. Out of infinity, forms rise and gather in dense, ever-thickening "clouds," which are attracted as if by magic to the central figure, banking up in heavy masses before the spectator. The most distant groups, like the nearest, are magnetized by the energy-charged arms of Christ, and form two concentric circles around him. This forward thrust is accompanied by a rotary movement on the surface which draws in all the figures. The rise and fall of this cyclone attracts the eye to the center: an area of stormy calm, irradiated by a yellowish light and swept by the terrifying blast of the curse which falls like lightning diagonally to the right.

The parts in which energy accumulates—where Michelangelo packs his figures into tight groups—alternate with others, empty spaces which are points of calm; these areas complement and balance each other. A rhythm comparable to that of the verses of a poem organizes the whole.

The slightly oblique composition, as well as the orientation of the two large groups which both open out towards the right, direct the spectator's eye unconsciously in the direction of the lightning flash. Even the principal figures near the edges of the fresco emphasize this direction from afar with their diagonal, asymmetric position. At the feet of Christ the figures of St. Lawrence

and St. Bartholomew seem to be making way for the thunderbolt of judgment.

At the bottom left, a livid sky hangs over a ravaged land which *175* seems to vomit forth the shapeless bodies it has so long concealed. Before Michelangelo, only Signorelli (Orvieto) had been inspired by the text of Ezekiel (chapter 37) describing the successive stages of the Resurrection of the Dead: skeletons breaking the earth's crust take on muscles, flesh, and skin, and the winds blow into them a living soul. But whereas with Signorelli the resuscitated dead gather in groups, witnessing to their innocence by their gestures, with Michelangelo shapeless bodies emerge from the earth, bodies made from the same stuff as the soil, whose incomplete trunks seem to be clods of clay detaching themselves with difficulty from the slime. Some, who are still half buried, are resigned as they await the fateful hour; others crawl like larvae, unconscious of what is around them; others again, clumsily trying to rise, are sometimes helped by genii (angels without wings), but the demons of the earth clutch at them and drag them back. Some, however, manage to take flight and their impetus carries them towards the upper sphere.

Above ground level, terrestrial laws no longer operate. Freed from gravitational pull, the gigantic bodies toil painfully upwards. *173, 171* Michelangelo presents them not as the Blessed, but rather as survivors of a shipwreck, swimming blindly in their effort to reach a refuge. It is significant that Michelangelo should have repeated these movements from figures created thirty years before for the *Battle of Cascina*, where soldiers are seen seeking safety on the *366* banks of the Arno. Two Negroes cling to the beads of a rosary, that is, to the faith; in one of his poems (Frey, *Dicht.*, CLI), Michelangelo himself uses the metaphor "la catena della fede." Athletic but exhausted men are helped by others. A crouched body, with eyes closed, seems to be carried upwards by his dream.

The same movements—rescuers stretching out their hands, drowning men trying to grasp them—are to be found again in the left corner of the upper zone. Here, an innumerable throng, com- *169* posed mainly of women of all ages, stands closely packed on the clouds. This has been seen as the chorus of Sibyls, wild-eyed and

exhausted, raising their hands in supplication. Anxious and intent, they listen to the roll of distant thunder. The monumental figure of a matron, a new Niobe, bends over a young girl kneeling at her feet, as if to protect her.

In the center of the fresco appears the athletic figure of a nude *167* Christ who seems gigantic but who is, in fact, a little smaller than *166* the figures of St. John the Baptist and St. Peter on either side of him, who first attract the spectator's eye. As a result, Christ gives the impression of appearing suddenly in the void which takes shape around him: he is the Son of Man come again (Matt. 24:30). He moves forward confidently, raising his right arm in a gesture of condemnation, while the left, folded back across his body, seems to reject all supplication. The gesture of the right arm, which is detached from the closed silhouette and stands out freely against the background, has an extraordinary power of expression. The significance of the movement is again heightened by the body's encircling shroud which prepares the spectator's eye for the terrifying effect of this raised arm. Yet Christ's face reflects neither anger nor passion: with eyes lowered and impassive features, he appears as the executor of a higher duty. The Virgin, who is pressed close to him, is twisted in anguish and turns her face away from this inexorable execution, bending in the pose of the antique Crouching Venus.

Justice and Mercy, the two sentiments with which medieval thought had endowed Christ the Judge, and which were formerly symbolized by the lily and the sword issuing from his mouth, have been separated by Michelangelo and embodied in Christ and the Virgin. The artist takes the faculty of pity away from Christ and transfers it to his Mother, in keeping with her woman's nature. But the two figures are so closely connected that they seem to be two aspects of one higher Being.

The crowd behind them forms a curved halo, its members drawn by the Judge's gesture as if by magic. Those nearest Christ reflect only terror and with movements of entreaty seek to avert the catastrophe. St. John the Baptist and St. Peter stare fixedly at Christ, as if petrified with fear.

170 On the right of the fresco, and corresponding to the Niobe

group, stands a giant with his knee resting on a cloud, who supports a heavy cross on his back with the help of an old man. Perhaps this is the cross raised at the time of Judgment (Matt. 24:30). In that case the cross-bearer would be a personification of Justice on the side of the Damned, while the Niobe group would be a parallel personification of Mercy on the side of the Elect, and a reflection of the Virgin at whom the Niobe figure is gazing.

In the crowd on Christ's left are figures embracing each other, a well-known motif of earlier iconography (Fra Angelico), but here with a new meaning: the embrace no longer signifies the joy of meeting again in Paradise, but seems to express the suffering of an eternal farewell. The athletic men on the extreme right of the fresco have been seen as the Prophets, a group which would correspond to the chorus of Sibyls on the opposite side.

Slightly below these men, one can see the Martyrs seated on clouds, holding the instruments of their passion. They are not, as they have sometimes been interpreted, Martyrs crying for vengeance: sunk in the memory of their terrestrial existence, they repeat involuntarily, with movements as in a dream, the fate which they were obliged to suffer on earth and of which they are the incarnation. At their feet is the tangled knot of the Damned: no longer the passive prey of the demons, but rebellious Titans leading a desperate struggle against their fate. *170, 239*

172, 239-241

Finally, at the bottom, on the leaden waters of Acheron, is the boat laden with the Damned, a dark shape against a fiery, smoky background. A satyr-like Charon stands in the stern and with the look of a madman raises his oar to sweep the Damned into the abyss; the inspiration from Dante's *Inferno* (III, 109-111) seems evident. Terrified, the Damned surge towards the prow and hurl themselves into the gulf of Hell which appears to attract them as if by magic. In the foreground, the figure of Minos rises triumphant. Here, too, Michelangelo follows Dante (*Inferno*, V, 4-12), except that in Dante it is the tail of Minos which curls around his body, whereas in Michelangelo it is a long serpent— a symbol of lechery, the vice which turns itself back on the sinner. *176*

Finally, three groups of genii connect the broad masses of the composition in a circle. Two of them are in the lunettes, the third *164, 165, 174*

57

is in the center at the bottom and forms a link between the two directions of the ascent of the Risen and the fall of the Damned.

Caught in the great circular movement of the composition, the genii in the lunettes seem to be trying ceaselessly to erect the cross of Calvary on the left, and the column of the flagellation on the right, and thus they are continually bringing to life Christ's Passion, the eternal reproach of the human conscience. Carried away by a whirlpool, they cling to the instruments of the Passion like the wreck of a sinking ship. In the left-hand lunette, the artist accentuates the ascending diagonal of the cross, thus continuing the upward movement of the Risen; on the right, the fallen column creates a descending line which is prolonged down the whole right side of the composition. Moreover, the diagonal of the cross, which is parallel to the menacing forearm of Christ, is like a magnified reflection of it, while the line of the column echoes Christ's other arm in the same way.

The genii at the feet of the Judge represent angels blowing trumpets in order to awaken the dead, and the angels of the Apocalypse holding the great book of death and the smaller book of life (Rev. 20:12). Four of the former who are turned towards the left have the chubby mask of the ancient Winds and they seem actually to be blowing souls into the bodies of the Risen.

JUST AS in the *Divine Comedy* Dante introduces into the framework of his voyage through the universe the echoes of his love for Beatrice, so Michelangelo inserts into the cosmic drama enacted around the Judge his own personal tragedy: the "lightning" from Christ's menacing hand falls diagonally towards the right. It pierces first the flayed skin of St. Bartholomew who is seated at the Judge's feet, and then the figure of a desperate outcast, to end finally at the body of one of the Damned hurling himself from the boat into the abyss. The skin held by St. Bartholomew (who looks remarkably like Aretino) carries the tragic mask of the face of Michelangelo himself. The saint is therefore holding in his hands the artist's mortal remains. Should one see in the two other figures touched by the lightning the accomplishment of a curse which the artist felt weighing on his existence? Michel-

angelo seems, in fact, to have incarnated in these two figures two successive phases of the same event. The cursed soul, leaving his mortal envelope in the hands of St. Bartholomew, falls into the gulf.

Once this notion of Michelangelo's "descent into Hell" is accepted, is it too bold to suppose that the woman whose face under the yellow widow's veil can be seen behind St. Lawrence, *166* and who is looking with pity at Michelangelo's mortal remains, might be Vittoria Colonna? This hypothesis can be supported to a certain extent by Michelangelo's poems (Frey, *Dicht.*, cix, 92; Frey, *Dicht.*, xlviii, xcvi).

Again, one might suppose that the young man seen in profile *166* and reworked, who forms a pendant to the woman in the yellow veil and who is just behind St. Bartholomew, is Cavalieri. With his hands together, he seems to be praying for the repose of his friend Michelangelo's soul.

Thus certain details of the work assume a concrete form; yet the personal tragedy glimpsed within the great universal drama remains entirely subordinated to it.

But Michelangelo did not limit himself in this fresco to representing human terror in the face of annihilation. He has superimposed a cosmological significance on the eschatological. He has revealed the laws of the attraction and movement of bodies in universal space. It is the grandiose vision of a heliocentric universe. *163* Christ is the center of a solar system around which all the constellations revolve. It is not by chance that, young and beardless, with his flowing hair and perfect body, he should resemble Apollo. *167* Antiquity had endowed this god, whose personality it had fused with that of Helios, with the two opposing powers of the sun: that of fostering plenty and that of destroying it. Moreover, Christianity had from the beginning identified Christ with the sun and had given him the characteristics of Helios: *Sol Invictus* had become *Sol Justitiae.* So Michelangelo found the idea of fusing Christ and Apollo-the-Sun already in existence. By reserving a central role for the Sun-Christ whose magnetic power commands the unity of the macrocosm, the artist has arrived by his own means at a vision of the universe which strangely anticipates that

of his contemporary Copernicus. The idea of Michelangelo's composition precedes Copernicus's discovery (published in 1543) by seven years. Both, however, take up the heliocentric hypothesis already formulated in antiquity. The cosmological motif, however, does not interest Michelangelo from the scientific point of view as it might have done Leonardo, but only in so far as it shows the destiny of mankind, that is, because of its moral aspect.

The presence of innumerable souls in the heavens is peculiar to the astral myths of antiquity. According to them, every soul must, after death, return to its eternal residence on its star, and every star has its irrevocably determined place in the great rotation of the macrocosm.

This Pythagorean concept was taken up again in the Middle Ages. That it was known to Michelangelo is proved by one of his poems: "Ma poi che'l spirto sciolto Ritorna alla sua stella" (Frey, *Dicht.*, CIX, 12).

Finally, it was the same astral myths which apparently inspired Michelangelo with the rotatory movement of his composition. This movement is not due simply to the adoption of a certain formal aesthetic manner; it renders the sidereal vortex of Uranus, the idea of which has haunted humanity since earliest times. This idea is already depicted in primitive Bronze Age rock engravings in the form of wheels of the sun; it is the basis of the Ixion myth and gave rise to the Manichean wheel "for drawing up souls," as well as to the wheels of Life, of the Sun, and of Fortune.

In the circular forces which flow through the *Last Judgment*, Michelangelo returns to the ancient concept of fatality (*Fatum* equals *Fortuna*). But man is no longer a passive instrument as before. He is a Titan in revolt against the forces of destiny to which he remains subjected in spite of his efforts to the contrary. We can deduce, therefore, that in the typical Renaissance problem of the relationship between liberty and fatality, Michelangelo passes through the Renaissance idea of liberty to arrive at the conclusion of cosmic fatality. The belief in man's strength is obvious in his figures; nevertheless, man is subjugated by the forces of the universe. The artist has gone beyond the optimism of the early Renaissance.

An austere severity governs the range of colors in this fresco. Michelangelo has abandoned the delicate shimmering of the clear shades in the Sistine Ceiling. The tone of the bodies, a dull, smoky brown, stands out against the mat blue background of the sky. Even though it is to be supposed that neither the blue nor the brown is any longer the original shade, this bichromy is intentional; other colors are rare splashes and, devoid as they are of all luminosity, are subordinated to it. Thus Christ's yellow halo is grayish, Mary's blue cloak is discolored and pale, the red of her robe turns to pale violet; all the colors take on an ashen tone which barely disturbs the bichromatic values of the whole.

DURING his long stay in Rome, Michelangelo remained in contact with a great number of Florentine exiles. Among them was Donato Giannotti, "suo amicissimo," the historian who, like Machiavelli before him, had been Secretary of State during the last Florentine Republic, and who used his pen while he was in exile to fight for republican liberty against the tyrants. Giannotti entered the service of another Florentine, Cardinal Niccolò Ridolfi, as his secretary. Michelangelo no doubt used to talk to Giannotti about the tragic fate of Florence; it is very probable that they discussed the problem of tyrannicide. Giannotti broached this theme in many of his works and sided with tyrannicides, especially in the case of Brutus and Cassius. He reproached Dante for having put them in Hell: "Io li vorrei collocare nella più honorata parte del Paradiso."

During the Renaissance, with the Roman Empire seen as the beginning of the decadence of Rome, a veritable cult of Brutus developed. He was held up as an ideal and model every time the Florentines attempted to rid themselves of the Medici. The Florentine who killed or tried to kill a Medici was acclaimed as a "nuovo Bruto." Cola Montano, Pietro Paolo Boscoli, Rinuccini, and Lorenzino de' Medici (the assassin of Duke Alessandro de' Medici) were celebrated in this way.

In the Bargello is a bust representing Brutus which, according 177-179 to Vasari, Michelangelo executed for Cardinal Niccolò Ridolfi at the request of Messer Donato Giannotti; the bust was therefore

61

inspired by Giannotti. The exact date of its execution is unknown, though Giannotti's entry into the Cardinal's service in 1539 gives us a *terminus post quem*. From the stylistic point of view, Brutus's head is akin to the figures of the *Last Judgment* (especially those to the right of Christ). From this we can deduce the approximate date of the work: about 1539-1540. The bust is important for understanding Buonarroti's political convictions.

The strong, thick neck—almost bull-like—is surmounted by a relatively small head with an almost rectangular profile, a low, flat forehead, a nose set in straight, harsh lines, hard lips, and an angular, protruding chin; these simplified facial features are framed by hair which covers the whole of the skull. The head is *177* turned towards the left and is first seen in full profile; the expression seems calm. But if examined more carefully from the front, *178* it reveals anger, disdain, and bitter scorn, all mastered with effort by extraordinary willpower. These passions can be seen in the slightly frowning eyebrows, the lines around the mouth, the dilated nostrils, and the sidelong glance. It is important to note that the two halves of the face are slightly asymmetrical: its right side is calm, though tense; its left is more dramatic and directly reveals the passions which animate it. According to the medieval conception, as we have seen, the right side is protected by God, the left is open to evil; according to modern psychology, the right side of the face is the mirror of the interior life, and the left, that of the social. All realistic art, consciously or otherwise, has reproduced this asymmetry of the human face which is a general law; but it seems that Michelangelo was the first to use the phenomenon consciously to indicate the inner forces which go to make up the *causa efficiens* of this asymmetry.

No preparatory drawing for the Brutus has been preserved, but a preliminary study exists on the bust itself; this is the little relief *179* of a head in profile on the fibula fastening the tunic on the shoulder. Since this detail is hardly visible to the spectator because of its position, we can deduce that Michelangelo worked it for himself, as a sort of study. The head, with its bare neck, is in the same pose as the head of Brutus on Roman coins, but its features resemble those of the bust. However, the profile on the fibula

seems to be a portrait on account of its individual details, while the bust has a more generalized character. We see here the process whereby Michelangelo, starting with a concrete portrait, finally creates a type. One wonders who was the model for the profile on the fibula. The hypothesis that it was Giannotti is the most likely. However, since no portrait of him exists, this cannot be verified.

Michelangelo's conception of Brutus is clearly expressed in this bust: it represents heroic scorn for those who would destroy liberty. Donato Giannotti put the same idea into Michelangelo's mouth in his *Dialoghi* (p. 93): "He who kills a tyrant kills not a man, but a fierce beast in human form . . . and so Brutus and Cassius did not commit a sin by killing Caesar." At the same time, the bust is an ideal portrait of the artist's own spirit.

AFTER the completion of the *Last Judgment*, Paul III commissioned Michelangelo to decorate his private chapel, which had recently been erected by Antonio da Sangallo the Younger, with two frescoes in the two central fields on the lateral walls. This chapel, named the Pauline Chapel, is to the north of the ancient basilica of St. Peter, between the Sistine Chapel and the Sala Regia. In the Pauline Chapel, apparently begun in 1537 at the same time as the Sala Regia, a mass was celebrated as early as January 1540, which indicates that the building was more or less finished by then.

One of the frescoes was started before July 1542, and completed in July 1545, since Paul III visited the chapel on July 12 that year. In August 1545 the money necessary for the preparation of the other wall was paid. The second fresco was begun in March 1546; in October 1549, the Pope again visited the chapel where the paintings were not yet entirely finished. One may suppose this to have been done early in 1550. The documents give us no information as to which of the two frescoes was started first. But from the style there is no doubt that the *Conversion of St.* 186 *Paul*, which is closer in style and composition to the *Last Judgment*, was done before the *Crucifixion of St. Peter*. 187

The choice of subject, the glorification of the two apostles and martyrs who are founders of the Roman Church, was altogether

appropriate for the decoration of a pope's private chapel. What is surprising is that the *Conversion of St. Paul* is not facing a scene of the Presentation of the Keys to St. Peter, but instead, the *Crucifixion of St. Peter*, the logical pendant of which would be a Beheading of St. Paul. In his first edition in 1550, Vasari still speaks of a Presentation of the Keys. It is therefore probable that Michelangelo originally had the intention of putting these two subjects (the Conversion of St. Paul and the Presentation of the Keys) opposite each other, and that it was after finishing the first fresco that he modified the plan. The scenes of conversion and martyrdom thus offer two successive stages of lives dedicated to God.

Both compositions are conceived in relation to the architecture of the chapel: they have a rotatory movement running through them and oriented towards the altar, a type of composition which was to be taken up by Tintoretto, for example, in his two great canvases to the right and left of the choir in San Giorgio Maggiore in Venice, and by Caravaggio in Santa Maria del Popolo in Rome in his two canvases representing the same themes as Michelangelo's frescoes.

The Conversion of St. Paul had been depicted since the twelfth century as Saul falling from his horse: the animal stumbles, and the rider is flung over its head. This was a motif inspired by representations of *Superbia* thrown from its horse. The type was still in existence in the middle of the sixteenth century and was even followed by Rubens well into the seventeenth. However, the Renaissance created another version in which Saul is on the ground while his horse gallops away into the background. It was this type that Michelangelo chose, though he transformed the scene.

186 From the heavy "cloud" formed by the dense throng of hovering genii, Christ suddenly emerges, like a flash of lightning, his right arm extended towards Saul and his left pointing to Damascus, which is seen in the landscape background on the right. A shaft of pale yellow light falls on the terrified group of soldiers and strikes Saul, throwing him to the ground. His companions try to flee on all sides, without understanding what has happened to

them. Contrary to tradition, Michelangelo represents Saul as an old man with a long, white beard. With his mouth wide open, the 188 closed eyes of a blind man, and deep wrinkles in his brow, this St. Paul has the expression of one who with terrifying clarity understands in a single moment the errors of his whole life. Suddenly he becomes a seer in his blindness—a sort of idealized portrait of the artist, an eternalization of the moment when his own soul opened for "conversion." Beyond the particular event one can sense the absoluteness of the drama enacted between eternal forces and the human being. Ineluctable necessity reappears in the great curve going through space. And yet the impression given by this vision is full of hope: the colors are not the sad, earthen tones of the *Last Judgment*; on the contrary, they are of a gentle beauty, with a preponderance of lilac and soft green shades (in the figure of St. Paul), which recall the harmonies of the lunettes in the Sistine Ceiling. The plastic forms are enveloped in a delicate chiaroscuro and the treatment itself becomes soft and gentle.

In the perfect arrangement of the figures on the surface, in the clarity of the main lines of the composition, in the *enchaînement* of the forms, one recognizes the ancient virtues of Italian frescoes, which are heightened here by the dynamic causality introduced by Michelangelo.

In the *Conversion of St. Paul*, all the figures move in a restricted foreground, behind which stretches a vast deserted space. The groups are placed symmetrically opposite each other; the principal figures correspond to one another in *contrapposto* and are animated by a rotatory movement beginning with Christ at the top left, touching the ground in the curve of St. Paul's body and rising again, through the back view of the large figure of a soldier, up to the figures in the sky on the right. As a starting point for the spectator's eye, Michelangelo has taken the soldiers entering the field of the picture on the lower right-hand edge, a diagonal continued by the rearing horse which carries the eye up to the group of angels surrounding Christ. Recognizable in all this are the principles which governed the composition of the *Last Judgment*.

The need to use sharply curved bodies led Michelangelo to look

for models in some of his earlier studies for the Medici Chapel. Thus, in the pose of St. Paul, Michelangelo uses and modifies the
133 motif of the river gods which he planned for the Medici Chapel— a pose he had also used before for Venus in his composition for
378 the lost *Venus and Cupid*. The soldier protecting his head with his shield has a prototype in one of the soldiers in the drawing of
230 the Resurrection of Christ (London), done about 1532-1533. His counterpart on the other side, the soldier seen from the back, derives from the soldier on the right in Michelangelo's second ver-
228 sion of the Resurrection (Windsor).

According to tradition, St. Peter was crucified head down at his own request, because he thought himself unworthy to suffer the same death as the Savior. Michelangelo had to conform to this tradition, but while all his predecessors followed the story literally and represented St. Peter crucified head downwards, which had the disadvantage of obscuring his facial expression, Michelangelo
187 found a solution which allowed him to reconcile tradition with artistic requirements. He has put St. Peter's cross, which is about to be erected, in a diagonal position. The saint's head is turned towards the spectator and becomes the real optical and psychological center of the composition. The executioners are lifting the cross slowly and solemnly by one end. The young man in the center of the middle ground turns to the soldiers' commanding officer with a surprised and inquiring gesture which seems to express the feeling of all those present. The commander, on horseback to the left in the middle ground, appears himself to be asking his neighbor the reason for this cruel death. Not one face expresses hatred; the event unfolds like the realization of a predestined fate, or as the fulfilment of a sacred rite.

The fateful character of the scene is increased even more by the current which carries all the elements of the fresco around in a slow and continuous rotation. From the back on the right comes a group which has just climbed a hill and is advancing towards the place of execution under the leadership of a young man. Its movement is taken up again in the right foreground by a second group at the head of which is the towering figure of an old man with his arms folded, and by a group of mourning women at the

foot who can only be seen from the waist up. By truncating these foreground figures, Michelangelo enlarges the surface area of his fresco: the figures do not give the impression of being fragments, but belong organically to the great circular movement which animates the whole, and which the eye completes on the neutral surface below them. The same movement returns on the left in the group of soldiers seen from behind and in the horsemen beyond them, to end with the central group which describes a last, more rapid and restricted revolution around the cross.

The figures in this fresco do not participate directly in the action. They are there as involuntary witnesses who have come from all points of the horizon; moved and resigned, they file past the crime that is committed. The limits of time and space disappear, the scene is transformed into a place which synthesizes the universe and where the round of humanity eternally passes by. St. Peter is the only one who seems conscious of what is happening. His eyes fix the spectator with a terrible intensity which reveals the extent of his suffering for mankind. 189

Just as in the *Conversion of St. Paul*, Michelangelo has attenuated the cruelty of this scene by a whole range of harmonious colors, which is again a return to the coloring of the Sistine Ceiling. Moreover, one may note here inspiration from the Venetians. In the figures, the primary colors, yellow, red, and delicate shades of blue, predominate, as in the Venetian school of the sixteenth century, while the landscape is kept in an olive-green tonality, above which stretches an evening sky ranging from orange to blue. This sky again recalls certain Venetian paintings of the beginning of the Cinquecento. None of the shades remains isolated, since even the primary colors are attenuated by a white light which puts them in accord with the harmony of the whole. Nevertheless, there is in the composition of both frescoes a certain aridity: no doubt the result of the tendency to abstraction of old age.

The style of the *Conversion of St. Paul*, which shows figures 186 that are still slender and broad-gestured, and which is therefore akin to the *Last Judgment*, is replaced in the *Crucifixion of St.* 163 *Peter* by one that is heavier and more compact. The figures with 187

their constricted gestures are enlarged in relation to the surface, and the groups are set in rectangular blocks with rigid contours. *182, 183* This is the style which appears for the first time in the Rachel and Leah of the Tomb of Julius II (1542-1545) and which was to become characteristic of the works executed up to about 1555.

The same principles of composition in a rotatory movement *250* govern the series of drawings of Christ driving the merchants out of the Temple. These are composed in a semicircle, which suggests that they were connected with a project for the decoration of the lunette above the entrance to the Pauline Chapel.

The *Last Judgment* and the two Pauline frescoes are the last of Michelangelo's monumental paintings. The technique of the fresco demands of the artist a flawless sovereignty of mind and great sureness of hand, promptness of decision and rapidity of execution. Michelangelo for long possessed the necessary skill, but after finishing the second Pauline fresco at the age of seventy-five he had to abandon this technique.

V. THE TOMB OF JULIUS II

THE STORY OF the Tomb of Julius II is in a way an epitome of Michelangelo's artistic and spiritual development from the heroic ideal of his youth to his Christian "conversion" in old age. This fact may justify our treating the different phases of the monument as a whole and at this point in the book.

The Tomb of Julius II to be seen today in San Pietro in Vincoli *181* in Rome is in its structure and iconography only the reduction and transformation of a much vaster original plan. For four decades the master worked on this funerary monument, enlarging or reducing his first ideas. He altered the superstructure in particular; he also changed the statues (except for the figure of Moses which he finally placed in the lower zone), and together with these, the iconographic program. Six versions are known, dating from 1505 to 1545. The story of this work is very complex; many problems still remain to be solved.

ACCORDING to Vasari (p. 63), the first project (1505) surpassed in beauty and opulence, richness of ornamentation, and abundance of statues, all the ancient tombs of imperial Rome. This magnificent construction was never built. The original sources, both the contract containing a detailed description of the monument, and the master's drawings for this initial phase of the idea, have been lost.

We have only secondary sources as a basis for our reconstruction: the descriptions of Condivi and Vasari, and auxiliary sources such as the two drawings for the 1513 project in Berlin and at the Uffizi, which contain elements of the original design. Other auxiliary sources have not hitherto been explored in connection with this problem: a drawing of the catafalque of Michelangelo (Milan, Ambrosiana), and a plan for the tomb of Leo X by Andrea Sansovino (London, Victoria and Albert Museum), which reflect the influence of Michelangelo's first project. Even

if all these sources are taken into account, a reconstruction will obviously remain hypothetical from many points of view, for the copies are only free paraphrases and the measurements of the superstructure are no longer known to us.

According to the descriptions of Condivi and Vasari (probably based on the wooden model or on drawings), the first project was a rectangular, free-standing edifice whose sides were in the ratio of two to three (12 *braccia* to 18; 7.20 to 10.80 m.). The interior of this edifice contained a funerary chamber, a sort of *cella* in the shape of a "tempietto ovale," that is, with columns, and no doubt covered with an oval cupola. In the center of this chamber was a sarcophagus: a *cassa* (Vasari) or *cassone* (Condivi). According to Vasari, entrance was by two doors, one in the middle of each short façade; according to Condivi, by a single door in the middle of the back wall. Vasari's assertion seems more likely for it would better explain the finely ornamented stones of 1505 (still in existence but now partly hidden by the statue of Moses) to the right and left of the central bay, at top and bottom. Before entering the *tempietto* one had originally to pass in front of these ornaments. The lower story of the narrow façades was divided into three parts by four herm-pilasters; between the pilasters there were rounded niches to left and right. In front of each pilaster stood a Slave on a rectangular pedestal. In each of the two niches there were statues of Victories with the vanquished at their feet. According to Condivi and Vasari, the architectural structure and arrangement of the statues on the lower story must then have already been conceived in 1505, as they are seen in the 1513 drawing (Berlin) and in the finished monument. Moreover, on the lower story of this the several ornamented stones already referred to seem from their style to have been done as early as 1505-1506. A sketch for one of these blocks on the left is in the British Museum in London, and this certainly belongs to the first phase of the monument; the character of the writing and the style of Michelangelo's drawing indicate a date about 1505-1506. We also know from one of Michelangelo's letters, as well as from Vasari, that the artist went to Carrara in April 1505 to have stones cut, immediately after signing his contract. He could not have had this work done with-

371

out having previously established the exact measurements for the monument. The proportions of the lower story must therefore be dated from 1505. As soon as the blocks arrived in Rome, Michelangelo began work (Milanesi, p. 429). He got "uomini di quadro" to come from Florence and they apparently started working in January 1506 (Milanesi, p. 493).

While the lateral walls, according to Schmarsow, Burger, and Thode, had two bays like the narrow façades, according to Panofsky there were three, spaced in the same ratio to the intervals as on the front façade (five to three). But in the 1513 contract there were only two bays on the lateral walls and a large interval in the center which was to contain a bronze relief. It may be noted that only four figures were planned for the four corners of the platform, and not six as the hypothesis of three lateral bays would demand.

The four seated figures on the platform were probably placed frontally, for in all Michelangelo's works, even in subsequent versions of the Tomb, the seated figures are never placed diagonally. Moreover, the composition of these figures shows that they are meant to be seen from the front.

Behind the four large seated figures, the construction rose gradually in diminishing steps, with a frieze of narrative scenes in bronze and with other statues, putti, and decoration all round. Crowning the work at the top were two figures: Caelus, the Heavens, smiling, and Cybele, goddess of the earth, "who seemed desolate at having been left in a world deprived of all virtue by the death of such a man," the two supporting a *bara* on their shoulders (Vasari 1568, p. 69). Condivi gives a less detailed description of the truncated pyramid and speaks of two angels bearing an *arca* (tomb, sarcophagus), instead of the allegories of Heaven and Earth supporting a *bara* (coffin or bier).

For a reconstruction of the truncated pyramid above the cornice, the 1513 drawing offers some indications and allows the height of the second step of the pyramid to be established: it is marked by the small pillars decorated with putti which flank the seated statues. The height of the third step of the pyramid is probably given by the bases of the large columns of the *capelletta* in

the 1513 drawing. The second cornice has therefore been placed behind (and not above) the heads of the large seated figures. Michelangelo thus accentuated their relief.

But the most difficult problem is the reconstruction of the top of the monument. For this, we must consider a drawing by Zanobi Lastricati for Michelangelo's catafalque (Milan, Ambrosiana), which bears an inscription alluding twice to the first project for the Tomb of Julius II. It reads: "catafalco quadrato in isola, alla forma del Settizonio di Severo presso a[lle] Antoniane, e come da Mich. Angelo era stato prima disegnato il Sepolcr[o][di] Giulio II in San Pietro in Vincoli . . ." ("a free-standing rectangular catafalque, shaped like the Septizonium of [Septimius] Severus near the 'Antoniane,' as it was originally designed by Michelangelo for the tomb of Julius II in San Pietro in Vincoli . . ."); and again: "Mich. Angelo ist[esso] [in] uno de sua disegni del sepolcro [di] Giulio II haveva fatto il Pap[a] in ischurcio e non fu eseguito . . ." ("Michelangelo himself in one of his drawings for the tomb of Julius II shows the Pope in a foreshortened attitude but this was not executed . . ."). This last piece of information, telling us that the Pope was a recumbent figure, foreshortened and perpendicular to the façade of the monument, is a confirmation of the descriptions by Condivi and Vasari, and contradicts Panofsky's hypothesis that the Pope was represented seated on his *sella gestatoria*.

We may suppose that above the third step of the truncated pyramid was the oval base of the upper part as shown in the drawing of Michelangelo's catafalque, which in the interior of the tomb would correspond to the upper part of the oval cupola of the *tempietto*. Above the oval base in Lastricati's drawing stands an *arca* or *bara*, in the form of a coffer whose volutes and bell-mouthed pedestal recall the shapes of the volutes and bases of the tablets bearing the names of Christ's ancestors in the lunettes of the Sistine Ceiling. On either side of the coffer are two nude figures seated sideways, one looking up, the other down. These probably correspond to Condivi's two angels or to Vasari's allegorical statues of Heaven and Earth. Yet Condivi's figures "carry" the *arca*, and Vasari's "support" the *bara* on their shoulders, while

these are not touching the coffer—proof that the catafalque draw-
ing does not render Michelangelo's figures exactly, even though
their arrangement on right and left and in profile is in the spirit
of the master and corresponds to the poses of the figures in the
lunettes of the Ceiling. No doubt in the project for the Julius
Tomb they were actually touching the coffer. Michelangelo would
then already have conceived in 1505 the forms which he subse-
quently realized in the lunettes of the Ceiling between 1510 and
1512. With the *arca* the two figures make a triangle, a configura-
tion wholly in the spirit of Michelangelo's works around 1505
(see the triangular disposition in the Bargello Tondo and the
three triangles of the *Battle of Cascina*).

In the first project for the Tomb of Julius II, then, the top of
the monument had a triangular silhouette. The approximate
authenticity of the pose of the two allegorical figures in the Lastri-
cati drawing is confirmed in the drawing of 1513 by the two putti *371*
in similar poses at the feet of the Pope, who would thus be relics
of the two supporting figures in the first plan.

On the basis of these considerations, with the help of the 1513
drawings (for the lower story and the seated statues), and the
drawing of Michelangelo's catafalque (for the superstructure),
we can try to reconstruct the 1505 elevation of the monument.
This reconstruction gives us only an approximate idea, but it is *373*
still more exact than previous attempts. The scale of the figures
on the superstructure is hypothetical. The allegories were appar-
ently reversed, that is to say, the one looking down was on the
right, and the one looking up on the left, following the symbolism
of the two sides which Michelangelo always respected.

In essence, this reconstruction consists of three steps of a trun-
cated pyramid, the culminating point of this monumental struc-
ture being in a triangular configuration which is born from the
pyramid itself: the large seated figures on the platform, the alle-
gories, and the recumbent figure at the top are all interrelated.

IN CONSIDERING the 1505 project, one should also take into
account the fact that Michelangelo's ambitious idea likewise
embraced the architectural setting. In order to clarify this point,

the information given by Condivi (ed. Frey, p. 70) must be combined with a passage from Vasari (ed. Milanesi, IV, p. 282; ed. Frey, p. 325). The latter, which has hitherto been too little explored in the literature about the Tomb of Julius II, is to be found in the *Vita di Giuliano da Sangallo*. In these passages we learn that Michelangelo originally thought of putting the free-standing Tomb in the old basilica of St. Peter's, in the then unfinished choir which had been begun under Nicholas V and continued by Bernardo Rossellino under Paul II. Michelangelo is reported to have asked the Pope to have the choir finished for this purpose. But Giuliano da Sangallo thought the site inadequate and suggested erecting for the mausoleum "a special chapel because such a chapel would render this work more perfect." Many architects are said to have made drawings for this funerary chapel; indeed, in the great mass of drawings for buildings with a central plan which are generally associated with St. Peter's, there are several which could perhaps be identified with such a chapel. This problem, posed by Geymüller and Burger, is still awaiting solution.

In any case we must suppose that the mortuary chapel which was to receive the free-standing monument of Julius II was one with a central plan, covered by a cupola. Funerary edifices of this type go back to a very ancient tradition, that of the martyrium, which in turn derives in its plan and vault from mausolea of the imperial epoch, as A. Grabar has shown. The central plan and the vaulted covering were symbolic in the funerary tradition; they were considered as an image of the Beyond, with the cupola as an image of Heaven itself. One can therefore assume that Giuliano da Sangallo proposed to erect around the Julius Tomb the setting which suited it best, namely an edifice signifying the Beyond. And that is probably why he said "che quella cappella renderebbe quell'opera più perfetta."

We learn from Vasari that the modest idea of a funerary chapel was transformed into the grandiose one of remaking the basilica of St. Peter's itself. He says: "In cambio di fare una cappella, si mise mano alla gran fabrica del nuovo San Pietro" ("Instead of a chapel being made, work was set forward on the great undertaking of a new St. Peter's"). The bold idea of abandoning the plan

in the form of a Latin cross of the venerated basilica, and of build-
ing in its place an edifice on a central plan covered by a cupola,
would be explained by the fact that the new St. Peter's was con-
ceived on a gigantic scale as a funerary chapel housing the Tomb
of Julius II at its center. From this it must be concluded that it
was really a desire to conform to funerary tradition which sup-
plied the impulse to abandon the Latin cross and to adopt the
central plan with cupola in the new St. Peter's, and not purely
aesthetic considerations. It was therefore the projected Tomb by
Michelangelo which was the real cause of this change in the plan
of St. Peter's. From the chronological point of view nothing con-
tradicts this supposition. The idea of the free-standing Tomb was
established by Michelangelo in March or April 1505 at the latest.
No central plan for the new St. Peter's is known to have existed
before this date. Its reconstruction on a central plan is mentioned
for the first time on November 10, 1505. The new building itself
was begun according to Bramante's plan on April 18, 1506. The
priority of Michelangelo's first project for the Tomb of Julius II
to the new St. Peter's is, therefore, a certain fact.

We learn from Vasari that, after the Pope's resolve to recon-
struct St. Peter's, several artists produced designs; Bramante's
was the one accepted. This decision by the Pope must have seemed
a personal defeat to Michelangelo. On the eve of the laying of the
first stone, he fled to Florence. His rival and enemy, even while
adopting the idea of a central plan, had prevented the realization
of Michelangelo's project: in the middle of the new St. Peter's he
was to erect an *aedicola* to protect the confession of St. Peter, thus
occupying the place destined by Michelangelo for his work. Bra-
mante's St. Peter's is a martyrium for the prince of the apostles.

Vasari considers that the idea of setting aside the modest plan
for a funerary chapel and rebuilding the whole of St. Peter's
belonged to Julius II. Condivi, on the other hand, quite rightly
says: "Cosi Michelangiolo venne ad esser cagione . . . che venisse
voglia al Papa di rinnovare il resto [di San Pietro] con nuovo e
più bello e più magno disegno" ("Thus Michelangelo came to be
the cause . . . of the Pope's desire to renew the rest [of St. Peter's]
in accordance with a new plan, both finer and larger"). When the

Pope had commissioned Bramante, he suddenly suspended all credit for the Tomb by Michelangelo. He apparently did not dare to have the church built as a funerary chapel for his own Tomb and, while adopting the idea of a martyrium, had that of St. Peter built instead. The core of the whole edifice of the new St. Peter's is the commemorative monument, the confession of St. Peter, directly under the middle of the cupola. In the old St. Peter's, the apostle's confession was at the entrance to the Constantinian apse, under the altar of the church. Recent excavations have revealed that under the basilica was a cemetery with a monument linked with the apostle's memory. Michelangelo would think, therefore, of setting his Tomb of Julius II above this monument. We may suppose that his mausoleum was conceived as a dual commemoration, in honor both of the prince of the apostles and of his spiritual descendant. It was to be the mausoleum of the everlasting pope. Charged with this universal significance, it would become the most important tomb of Christendom.

If this hypothesis is right, one can perhaps understand certain features of the first plan which it has hitherto been impossible to explain. First of all, according to Condivi and Vasari, the free-standing monument contained two coffers or sarcophagi: one in the oval *tempietto*, the other at the top. One cannot altogether dismiss the possibility that the interior sarcophagus was a commemorative one for St. Peter, and that at the top the sarcophagus of Julius II; it is also possible, however, that on top there was a bier, because the word *bara* mentioned by Vasari means bier as well as coffin, and that below there was a sarcophagus in which the body of the Pope was to be buried (Condivi and Vasari). But even in that case, the monument would have served as a dual commemoration, since the "tomb" of St. Peter would be below it. It must be noted that the *tempietto* with the second sarcophagus was suppressed in 1513, at the very moment it was decided not to erect the mausoleum in St. Peter's. This cannot be explained by material reasons, since the 1513 plan was an enlargement of the one in 1505: it was suppressed no doubt because the mausoleum was no longer a double commemoration. It must also be noted that among the large seated figures on the platform St. Peter is miss-

ing; it is St. Paul who forms a pendant to Moses here. One can understand that St. Peter could not be represented as one of the decorative figures while the mausoleum itself was partly dedicated to him. The fact that Michelangelo sometimes identified the reigning pope with St. Peter is confirmed by a letter from D. da Volterra in 1564, where mention is made of a "San Pietro in abito di Papa" (Gotti, I, 358), that is, St. Peter with the papal tiara and cloak. Although this figure was that of Leo X or Clement VII, and not Julius II, the identification of the pope with the apostle is established by this text, and there is nothing strange about the artist's having erected the same mausoleum for them both.

The iconographic program of the mausoleum is better understood if one considers it as a dual commemorative monument. The lower story with the Slaves and Victories, which is distinctly pagan in character, inspired by the *Trionfi* and the triumphal arches of antiquity, seems to represent the triumph of the Apostolic Church over the pagans, that is, over unbelievers. The large seated figures of the second story seem to be symbols of the establishment and diffusion of the true faith, based on the Old and New Testaments (Moses, St. Paul), and of the way of life inaugurated by this faith (Active Life and Contemplative Life). At the very top, above the Earth and the Heavens, that is to say in the empyrean, there was the apotheosis of the Holy Church personified by the apostle-pope. In short, the program is a representation of the victory and diffusion of the Christian faith. It is, therefore, a much vaster project than that of a funerary monument erected to the personal glory of a single pope. It is a triumphal monument to the very principle of Christianity.

This fundamentally simple idea has been somewhat obscured by the interpretations of Michelangelo's first biographers, Condivi and Vasari. Neither of them can be considered as a primary source and the very fact that they contradict each other proves that the idea governing the work had been forgotten fifty years after its conception. According to Condivi, the Slaves are personifications of the liberal and plastic arts (painting, sculpture, architecture), who after the Pope's disappearance have become the prisoners of Death. However, the liberal and plastic arts were personified in

the Quattrocento by female figures (see the tomb of Julius II's uncle, Sixtus IV, in St. Peter's). They were always represented with their attributes. They numbered ten liberal and three plastic arts, not sixteen as Michelangelo planned. Condivi's text can also be read as a compliment addressed to the great Maecenas, Julius II, a compliment expressed not without a sly glance towards the reigning Pope Julius III, probably to stimulate his generosity towards the arts. It is highly possible that Michelangelo himself, fifty years after the conception of the tomb, "explained" his Slaves in this way to Condivi, his faithful but mentally rather limited friend, knowing that Condivi's biography of him would be dedicated to Julius III. Vasari's interpretation, given in 1550, seems less artificial: according to this, the Slaves represent the provinces subjugated by Julius II. The monument would therefore have contemporary significance, celebrating the conquests of the warrior Pope. But it has rightly been pointed out (Springer, Thode) that, when Michelangelo conceived the Slaves in 1505, Julius II had not yet shown himself to be a conqueror. In Vasari's phrase—"Questi prigioni erano tutte le provincie soggiogate da questo Pontefice e fatte obedienti alla Chiesa apostolica" (ed. Frey, p. 67)—there is a vestige of the real program: the unbelieving races subjugated by the true faith. It is possible that, in this first version of the Tomb, there were allusions to the life of Julius II in the large reliefs in the middle of the lateral walls, but these allusions must have been completely subordinated to the general program with its universally Christian content.

The governing idea of the iconographic program was very probably, therefore, the representation of the triumph of the Apostolic Church following the plan of the *Trionfi*, perfected and transformed by Michelangelo while he was working on it. He set aside all partial and particular points of view and sought only the purely human content, leaving behind the antinomy of Christian and Pagan. Thus the Slaves are changed from trophies into symbols of the bitter, hopeless struggle of the human soul against the chains of its body. In the Victory groups he has accentuated the necessary and ineluctable inner defeat of the vanquished; the genii of Victory pass over this tragedy of fallen figures without a strug-

gle, without trampling them underfoot, and also apparently unaware of their triumph. (This last feature, which is not visible in the small Victories on the Berlin and Uffizi sheets of drawings, is clearly expressed in the new version of the Victory in the *151* Palazzo Vecchio.) Thus the lower story signifies the sphere of matter, or the symbol-image of man in his corporal chains, in the "prigione scura" (Michelangelo). The figures of the second story represent the victory of the mind over the body, intelligible existence delivered from the burden of matter and given to contemplation of the Idea. The recumbent figure at the top of the monument represents the soul, beyond bodily struggle and spiritual effort, in eternal peace.

The whole of the monument has therefore become an image of *373* the stages of human existence, or the soul's ascension from terrestrial to celestial life. It is at the same time an epitome of the hierarchy of the universe in its composition of spheres of matter, mind, and soul. Thus Michelangelo seems to suppose—like Dante—that a perfect parallelism exists between the inner life of the soul and the objective structure of the edifice of the universe. It is a mighty pyramid of catharsis. What was originally an ecclesiastical monument is thus transfigured into a vision of the hierarchic image of the world and the states of the soul, in accordance with the idea of the *scala platonica*. This hierarchy is the same as that which Michelangelo was to represent in the Sistine Ceiling and the Medici Chapel.

The idea of the free-standing monument, with a *cella* inside, is a return to the mausolea of imperial Rome. Michelangelo certainly knew the mausolea of Hadrian and Cecilia Metella, and possibly the mausoleum of Diocletian from drawings. He also probably knew of antique medals with representations of the Herôa, and through the drawings of Giuliano da Sangallo he could have known the planes and elevations of other mausolea, like those in the South of France. Michelangelo was the first Renaissance artist to adopt this idea for the architecture of a tomb. In the fifteenth century, only the tomb of Sixtus IV by Pollaiuolo in St. Peter's was a free-standing tomb, but it derives from medieval ledger-tombs and not from mausolea: the *cella* is lacking.

On to this ancient plan Michelangelo has grafted an elevation and a sculptural decoration which seem to be derived from the triumphal chariots of the Renaissance. These also have an elevation in the form of a truncated pyramid, generally with Slaves below, and sometimes with large seated figures on the platform, and a central crowning motif at the top. (The Victories, Slaves and hermae are also found on antique triumphal arches, but not the large seated figures.)

In papal tombs of the fifteenth century, only the idea of superimposed levels is found. Their structure (with the exception of the tomb of Sixtus IV mentioned above) is adapted to the tradition of mural tombs. Their iconographic program was concentrated on a representation of the life on earth, death, and salvation of the soul of the deceased. They are monuments of the cult of the personality, as the Renaissance conceived it. On the lower level, a relief generally recalls the dead man's terrestrial life; above and in the center of the monument, the dead pope is represented lying on his sarcophagus; above that on the top, a relief illustrates his ultra-terrestrial life, in the form of his presentation to the Virgin by his patron saint: his blessed soul is received among the Elect. These stages thus correspond to the life, death, and salvation of an individual and not to the stages of the human soul in general, as in Michelangelo's conception. He has brought in the universality of the idea.

AFTER the death of Julius II, his executors took over the affair. On May 6, 1513 they signed a new contract with Michelangelo (Milanesi, p. 635). The idea of erecting the monument in St. Peter's was now abandoned. Michelangelo drew up a fresh project in which he introduced what he had in the meantime conceived in the Sistine Ceiling, and probably what the Pope's heirs demanded of the artist. This Tomb is an enlargement of the first, requiring more money and time to build. The monument has undergone an essential change: instead of being free-standing, it is to be fixed against the wall on one of its four sides; the *cella* is suppressed. It is no longer a dual commemorative monument. The upper platform is now called upon to support six large statues instead of

four, and the effigy of the Pope is to be accompanied by four figures instead of the two allegories. At the same time, four Slaves and two Victories on the side now attached to the wall are rendered superfluous. Behind the sarcophagus is an exceptionally high niche (35 *palmi*, or 7.8 m.) called a *capelletta* in the contract. This niche, which is rounded at the top, is flanked by two huge columns and contains a mandorla enclosing a Virgin and Child of monumental proportions. On the sides, the columns of the *capelletta* are accompanied by niches holding four statues. The project described in this second contract coincides in almost every detail with the Berlin drawing (Dussler, *Zeichn.*, 374), so that one can say in all probability that this drawing really shows us Michelangelo's second project. The architecture agrees with the 1513 contract; but Michelangelo retains his ideas of 1505 for the sculptures in the lower part. The reason for this is probably that in the wooden model Michelangelo used the lower part of the architecture and the small wax figures from his first project. The problem is to reconstruct, within the framework of this architecture, the figures which Michelangelo created directly for his new project. Certain sketches for these figures have come down to us on a sheet of drawings in Oxford (Dussler, *Zeichn.*, 194). This contains six small sketches of Slaves which are very different from the calm, slender Slaves in the Berlin drawing; yet they must have been done about 1512-1513, as much because of their style as because of the fact that they are very close to the studies for the Sistine Ceiling which are on the same sheet. These violently contorted figures take on the aspect of fettered Titans struggling in their bonds. One of the sketches presents the motif of the Rebellious Slave in the Louvre which Michelangelo began in 1513. These six sketches are preparatory drawings for the Slaves destined for the pilasters on the corners of the monument. They can be seen from two main angles, unlike the Slaves standing in the middle of the façades who are designed for a single main viewpoint. The only exceptions are the corner figures placed at the back against the wall, which could only be seen diagonally. These considerations permit us to situate the six sketches of Slaves on the Oxford sheet with some degree of likelihood. As for the Slaves

371

374

216

93

91 in the middle of the main façade, Michelangelo executed one of them, the Dying Slave in the Louvre, which is clearly frontal. Since it was made at the same time as the Rebellious Slave, it is natural to deduce that they were to be placed side by side—one probably forming the left corner and the other backing on to the left pilaster in the middle. There is a sketch in the Louvre (Dussler, *Zeichn.*, 209) for the pendant to this Slave, probably done in 1505. Again it is a frontal figure repeating the motif of the arm raised above the head, but this time it is the right arm, and the head is bent to the opposite side from that of the Dying Slave.

95 Of the seated figures on the platform, Michelangelo revived for his 1513 project the statue of Moses which he subsequently executed and which is, in fact, completely different from the first version to be seen in the Berlin drawing. Placed on the right, Moses looked out towards the right, like the corner Slaves below. One can assume that his counterpart, probably Contemplative Life (see the 1505 version in the Berlin drawing), was facing left. In 1513 the number of large seated figures was increased from four to six. (On the sheet in the Uffizi a figure suggestive of St. Paul replaces that of Moses.) We have no sketches to enable us to reconstruct the two new figures, which were probably a Prophet and a Sibyl. Nor do we know how far the figure of the Pope was modified in the second project. The statue of the Virgin and Child, which did not exist before and which was to be set up in the newly 371 added *capelletta*, has come down to us in the Berlin drawing. The Virgin is a tall, slim figure who appears to float in a mandorla; she holds the Child in her arms on the left, while her head is turned towards the right. The figure seems to have been inspired by a small Paduan bronze medallion of the fifteenth century. This conception of Michelangelo was used by Raphael in his Sistine *Madonna*. The latter, which is basically much more a plastic conception than a painter's, is without a direct precedent in Raphael's work: he borrowed from Michelangelo the idea for the whole figure, which is slightly in *contrapposto* and accompanied by the rhythmic waves of clothing lifted by the wind. But Raphael transforms the frightened movement of Michelangelo's distrustful Vir-

gin, clutching her Child to her breast, into a broad, calm gesture which seems to offer the Child to the spectator.

OF THE figures for the 1513 project, three were executed, as we have noted: the Rebellious Slave was begun in 1513 (Milanesi, p. 391), and the Dying Slave no doubt at the same time; the Moses was begun in the summer of 1515 (Milanesi, p. 115) and was not yet finished in 1516. The design of this statue probably dates back to 1513, the period when the artist reworked the projects of all the figures.

The Dying Slave in the Louvre has a perfect adolescent body, *91, 92* with flexible contours and powerful, harmonius proportions. The limbs are governed by a new cohesion and become the vehicle of a single force which flows through the body and develops in an unstable equilibrium. This fluid force moves up through the left leg, along the sinuous line of his trunk, and up to the top of his bent elbow. The ascending rhythm of the movement is accentuated by the two bulging muscles on the inside of the forearm nearest the head. The movement travels down again on the opposite side, through the bent head, the right arm folded against the chest, and the contour of the hip, to return to the ground through the foot which seems to be sinking into the material. He is not, in fact, "dying" as he is commonly described: he is an adolescent numbed by sleep and making instinctive movements to free himself from his dream. The band across his chest seems to be the materialization of the weight oppressing his soul, which he vainly tries to remove with the unconscious gesture of his hand. The head is simplified, all its expressive force resumed in generalized forms: the low forehead, the horizontal line of the eyebrows, the heavy volume of the chin, the compact mass of hair which frames the sleeping face.

Behind the body Michelangelo has roughed out in the unpolished stone the vague shape of a monkey. In terms of the original conception of the monument, the animal may signify the fact that these are pagan figures. In antiquity, the monkey was the symbol of lower existence, the distance between monkey and man being

similar to that which exists between man and the gods. It is possible that Michelangelo wished to express by this animal the insurmountable distance separating man chained within his body from the divine. Another interpretation of the detail, which would correspond with Condivi's exegesis, is that this Slave symbolizes the art of painting which, according to art theoreticians of the period, is the "scimmia della natura."

93, 94 The Rebellious Slave is an athletic figure straining all his energy to free himself from his bonds. With his left arm twisted brutally behind his back, he lifts his head in a desperate tension (this movement of the head is visibly inspired by the Titans on antique sarcophagi representing the Gigantomachia), and braces his right foot with all his might against the surface of the block— a movement which reflects his wild longing for freedom. His effort seems to become more desperate as it rises: the titanic back is arched in an enormous mass, but the impulse is condemned to failure. The downward spiral described by his bent left arm, by his right arm, and the cloth which girds his loins, forms a kind of serpent's coil around him. Here again the head has no particular expression: a square block, barely rough-hewn, it shows a face with a low forehead, broad nose, and square jaw. It is not the facial features but the position of this head, thrown back on a bull-like neck, which expresses suffering, despair, and revolt.

95-97 The Moses is the seated figure of a colossus, trembling with indignation: a human cataclysm. Here, the omnipotence of passion unleashes elemental forces. The torrent of his mighty beard, the power of the rugged knee which breaks through the flowing cloak as if through boiling lava, are merely emanations of an inner turmoil provoked by indignation and anger. In this cataclysm, the elements of which, according to the ancients, man is made up are immediately visible: the hair is flame, the beard a waterfall, the limbs and draperies (especially above the right leg) are rocks, that is, earth: Moses is a cosmic being. He lifts his head sharply and looks towards his left but his body moves instinctively in the opposite direction and his right hand fingers the waves of his beard. The explosion of wrath is quelled. In this figure, then, Michelangelo simultaneously embodies the birth of passion, its

climax, and its ebb. Here lies the difference between Michelangelo's and the Baroque conception of passion: the latter gives only a transitory image, with no beginning and no end. As in the David, the psychological theme of which is repeated here, Michelangelo accentuates the contrast between the two sides of the figure: on the left, the side of the evil forces against which Moses rebels, an open, mobile silhouette; and on the right, severe, closed, axial lines, the conscious stability on which he leans. The pathos of the interior drama is translated in the flamelike hair, in the swelling forehead contracted with lines, and in the heavy gaze from the deep-set eyes; but the tremor of the strong, sensual lips with their downturned corners, the angry flaring of the nostrils, express his supreme disdain for human depravity. Here Moses is the symbol of an eternal attitude; no one determinate moment of his life is represented. As in the Proculus, the David, and the Brutus, we see the righteous anger of a superior being in face of the world—a sort of spiritual self-portrait of the artist.

97

12, 40, 178

The three figures carved for the 1513 Tomb have broad, amply developed shapes, still conceived in the style of the Sistine Ceiling from which they differ only in a recrudescence of power and, in the last two statues (the Rebellious Slave and Moses), a certain rejection of harmonious contours.

AT FIRST sight, the essential transformation effected between the 1505 project and that of 1513 seems to be a compromise between the antique style of the lower story in the former and the *capelletta* above in the latter, corresponding to the Christian tradition of mural tombs. But, by the addition of this extremely slender *capelletta*, Michelangelo has succeeded in transforming the original tectonic conception of the truncated pyramid into an ensemble characterized by dynamism. The lower story now becomes, as it were, a slow introduction to the upward movement in which the slimmer, lighter forms of the *capelletta* unfold. Still restrained in the lower setting, this upward movement is accentuated on the platform in the large, seated figures, and is echoed again faintly above them in the niche statues flanking the *capelletta*. But here, suddenly, the rhythm changes: the accent now falls on the center

373, 374

of the composition and the ascending movement is freely developed at the top. The aspiration of Gothic seems to be reborn—with the difference that with Michelangelo this upward thrust is the final result of a struggle between opposing forces as embodied in the lower story. The whole of the architecture of the Tomb now becomes an image of the progressive liberation of the spiritual from the bonds of matter. In this composition of three superimposed zones, it is easy to recognize the triple hierarchy of the Sistine Ceiling, as well as its rhythm in the transfer of accent from the sides to the center.

IN JULY 1516, when Michelangelo was probably already absorbed in the plans for the façade of San Lorenzo, a new contract for the Tomb of Julius II was drawn up (Milanesi, pp. 644-650), based on a modified plan. The monument was now reduced to a single façade with lateral returns, each containing a niche framed by herm-pilasters. The façade of the lower story remained almost identical to that of 1513—only the architrave above the herm-pilasters was suppressed. In fact, one sheet (Dussler, *Zeichn.*, 86) with studies for the church of San Lorenzo also shows a sketch representing one of these very hermae with the cornice resting directly on top of its head; it is, therefore, a sketch for the 1516 project. In the middle field it was planned to have a historical bronze relief. In the niches where the Victory groups were formerly to have stood, Michelangelo wished to place single statues. The top of the monument now extended over the whole width of the lower story, forming a complete floor. Each pilaster on the bottom had a corresponding half-column on an ornamented base above, as stipulated in the contract. These half-columns supported a powerful cornice on which was set a low attic. One drawing (Dussler, *Zeichn.*, 105) represents this upper stage from the side of the left return (Wilde), and can serve as the basis for a reconstruction. On the top and in the middle of the main façade is a *tribunetta* with the Pope held by two figures (the contract does not mention the sarcophagus), and above the Pope is the Virgin. Another drawing (Dussler, *Zeichn.*, 279) seems to convey the artist's ideas for the sarcophagus and the figure of the Pope.

322

375

372

On the monument, which had become flatter, there was no longer room to place the sarcophagus perpendicular to the façade: Michelangelo therefore sets it parallel, while anxious to preserve the effect of depth. The Pope, who is sinking in a semi-upright position and supported under the armpits by two angels (a composition inspired by certain pietàs), is placed with his legs extended towards the spectator. This idea is a transition between the 1513 project (the Pope as a semi-recumbent figure in a foreshortened position) and the version as finally executed (the Pope reclining on the sarcophagus parallel to the façade). In the four niches on the upper story, two framing the *tribunetta* on the main façade and one on each of the returns, Michelangelo intended putting four large seated figures, with a bronze medallion above each to fill the square field between the cornices.

This transformation of the architecture in 1516 into a sort of two-story façade can be explained by Michelangelo's desire to incorporate in the Tomb the idea of the work preoccupying him at the time, the façade of San Lorenzo. There too he erected a gigantic upper story above a raised first floor, so that the bottom of the edifice seems to be crushed under the burden. Moreover, the façade of San Lorenzo was also to finish at the corners with returns consisting of a niche between two columns.

The impression given by this plan is new. In the 1505 project, the truncated pyramid supporting the sarcophagus at the top had a static effect. In the second project, the upper story with its *capelletta* gives a great upward impetus to the whole. In the third project, Michelangelo keeps the dynamic conception of 1513, at the same time getting rid of the upward impetus: the strength and colossal weight of the top section dominate and subjugate the whole. As a result, in spite of its material reduction, the Tomb's dynamic and plastic effect is more imposing than ever.

IN SEPTEMBER 1522, the discontented heirs of Julius II demanded restitution of the money advanced to Michelangelo, together with the accumulated interest. Since this demand produced no results, they threatened him in July 1524 with a court action. Conscious that he was in the wrong, Michelangelo considered selling all that

he had already executed for the Tomb in order to restore the money. But in 1525, he thought better of this and decided it would be quicker to clear himself with the Rovere by rapidly finishing off a tomb in the style of that of Pope Pius II in the old basilica of St. Peter's (letters of September 4, 1525, Milanesi, p. 447, and October 24, 1525, Milanesi, p. 450). At Michelangelo's request, Fattucci sent him drawings after the tombs of Pius II and Paul II (Frey, *Briefe*, pp. 268, 270).

Michelangelo sent the new project to Fattucci on October 16, 1526 (Frey, *Briefe*, p. 289). The impression which it produced on the heirs of Julius II was disastrous, as is testified by a letter from Michelangelo to Fattucci dated November 1, 1526 (Milanesi, p. 454). It seems to us that a reflection of this project can be found in certain of Michelangelo's sketches (in London and in the Archivio Buonarroti). In the London drawings (Dussler, *Zeichn.*, 156) the overall effect of the sketch at the bottom left recalls the tomb of Paul II, and the other sketches on this sheet are only variations on the same theme, combined with reminiscences of antique triumphal arches. A sketch in the Archivio Buonarroti (Cod. IX, fol. 539v) also seems to be related to the tomb of Paul II. When one looks at these sketches, one fully shares the disappointment of the heirs of Julius II: the artist has abandoned not only his 1516 project, but also the use of the stones which had already been worked for the architecture of the Tomb at great expense in 1505 and 1513, as well as almost all the sculptures. The artist probably relinquished this reduced project as soon as he learned of the opinion of the heirs, that is, about November 1, 1526. It is certain, however, that by November 21, 1531 he had definitely discarded it, because on this date the heirs demanded, as a condition of the work being taken up again, that Michelangelo should have all the figures he had executed for the Tomb brought from Florence to Rome, and that he should use the architectural portions which were still in Rome (Milanesi, *Correspondants*, p. 68).

In the architecture of 1525-1526 the contrast between the two superimposed stories is suppressed and the Tomb is transformed into a façade with a central niche intended for a statue of the

Pope, no longer recumbent but seated. This metamorphosis can probably be explained by the artist's desire to bring his new conception as close as possible to the work in which he was absorbed at the time: the tombs in the Medici Chapel and those of the Medici Popes Leo X and Clement VII, which also have a seated statue in the center. We have already noted in the earlier projects for the Tomb of Julius II this need of Michelangelo's to adapt his current work to the dominant idea in his mind at the different periods of his life. But while the transformations previously effected—governed in the 1513 project by his ideas for the Sistine Ceiling, and in the 1516 project by those for the façade of San Lorenzo—had preserved the essence of the initial monumental conception, the adaptation of the Tomb to a simple Quattrocentesque wall decoration in 1525 was a radical change of the original project. It was a desperate makeshift solution which left the artist obviously dissatisfied, and we shall see him returning next to the structure of 1516. The only element of this abortive project which will remain is the reduction of the monument to a tomb placed flat against the wall without returns.

WHEN the work on the Medici Chapel was well advanced, Michelangelo signed, on April 29, 1532, a new contract (Milanesi, pp. 705-706). In this fifth project, Michelangelo promised to finish the monument within three years, and it was decided to place it in San Pietro in Vincoli. All the old contracts were annulled; Michelangelo reserved the right to submit a new model (new apparently in relation to that of 1525), as well as new drawings at his discretion, "a suo piacere." The artist was obviously trying to retain complete freedom. At the same time, he was obliged to deliver all the existing marbles in Florence and Rome, and to finish six figures by his own hand, namely the Moses, the Virgin, the Prophet, the Sibyl, and two Slaves (Milanesi, p. 485). If Michelangelo did not fulfill these conditions, the present contract would be annulled and the artist would have to carry out the one made in 1516. On the one hand, then, it is clear that Michelangelo obtained the right to change the project as he liked, and on the other, that he was forced to put everything he had previously

107, 108
328-331

begun into the hands of the successors of Julius II. It can be concluded from this that the master was thinking at this point of modifying the monument once again. The heirs for their part were anxious to safeguard their interests.

It is not known exactly what the new model mentioned in the contract was like, but it seems to have resembled that of 1516. Indeed, the lower part must also have resembled the first project, since Michelangelo was obliged to use the stones carved in 1505 and 1513. This is proved by a drawing (Dussler, *Zeichn.*, 152) done about 1516 which shows the lower story of the monument. A drawing by Aristotile da Sangallo in the Uffizi probably gives some idea of the upper part which repeats the ornamented bases and the half-columns of the 1516 plan.

No doubt the figures had to be replaced by new ones, some of which have survived. First there is the Victory now in Florence in the Palazzo Vecchio. Its slender proportions are in line with the last statues of the Medici Chapel, like Night, Giuliano, and the Virgin, works done about 1532-1534, and it is apparently in this period that we must place it. The four Slaves which were formerly in the Boboli Gardens and are now at the Accademia, and the fifth which we have recently identified and had transferred to the Casa Buonarroti (see *Commentari*, 1965, pp. 85ff.), were probably intended to decorate the bottom of the new monument. Since they herald the gigantic proportions of the figures in the *Last Judgment*, they can probably be dated to before Michelangelo's departure for Rome, that is, to before September 1534. This supposition is rendered likely by the fact that no work is known to have been executed at this time, by the delay in starting the fresco of the *Last Judgment* (in fact, in September 1534, the artist declared that he was prevented from doing so because he was working on the Tomb of Julius II), and finally by a note in Vasari's second edition in 1568, where he mentions five unfinished statues which Michelangelo had rough-hewn in Florence and a Victory which he had finished.

It has hitherto been held that the Slaves in the Accademia were conceived for a completely different ensemble, as they would be too large to be placed before the entablature of the Tomb in San

Pietro in Vincoli. But this affirmation is not entirely correct. The Titans in the Accademia are rough-hewn statues, and have a thickness of marble above their heads and under their feet which could be removed. If, moreover, their measurements are taken from the top of the head to the sole of the foot, they fit very well on the square bases of the lower story of the Tomb. The height reserved for the Slaves is 2.39 m. to which can be added the 10 cm. of the ovoli, making 2.49 m., while their actual heights are 2.08 m., 2.35 m., 2.38 m., and 2.48 m. Nor is the Victory too big for the lateral niche for which it was intended. It is not surprising with Michelangelo to find the statues extending beyond the limited space indicated by their base. This is often the case in his works, for example, in the Medici Chapel where the bases of the seated *107, 108* figures of the Dukes overhang their niches and where the reclining figures surpass in length and breadth the sarcophagi which support them. The Slaves in the Accademia and in the Casa Buo- *154-161* narroti are carved in the same way as the Slaves in the Louvre: *91-94* those that were to be placed in front of the center pilasters, facing forwards, are worked on successive planes parallel to the surface of the block. These are the Slave in the Casa Buonarroti, the *154* Young Slave whose head is hidden under his folded arm, and the *156* Bearded Slave with a head like the Zeus of Otricoli. The two *157* others, which were designed for the corners, are worked in a *158-161* diagonal direction, the artist having started from the corner edge of the block.

It is possible to determine with some likelihood the position of *376* each of these statues. The Young Slave occupied the center left, *156* replacing the Dying Slave in the Louvre, the design of which he *91* indeed recalls in many respects. The Bearded Slave was therefore *157* at the center right. The figure of the athlete with his right foot *158* on a high step repeats and amplifies the motif of the Rebellious *93* Slave and must have replaced it at the left corner. The barely rough-hewn nude stretching as if roused from sleep must, there- *160* fore, have occupied the opposite corner. As for the Victory, it was *151* probably conceived for the left-hand niche; its counterpart for the niche on the right is known only from a drawing by Michelangelo in the Louvre. The fifth Slave, now in the Casa Buonarroti, exe- *154*

cuted before the Boboli Slaves (because of the smaller measurements of its block), was originally destined to be the center right Slave, but seems to have been rejected by the master himself.

We have no precise information about what the upper story looked like in 1532. However, the return to the general lines of the 1516 project and the fact that the next and final version had a full upper story where the vertical divisions of the base were repeated incline us to suppose that the 1532 project also contained a full upper story with half-columns. It is probable, too, that this project was a flat façade without returns. Documents tell us that, in July and August 1533, the walls and vault of the transept of San Pietro in Vincoli were worked on with a view to erecting the monument. It is still possible today to see a part of what was done: the external wall of the south transept was laterally reinforced with two buttresses. The four small openings on the inside wall had probably already been made at this time, as well as the large lunette looking into the room above the sacristy. (This room, like the sacristy below, dates from the end of the fifteenth century, a fact proved by the coat of arms of Giulio della Rovere at the time when he was still a cardinal, which appears on the cornice above the entrance and on the keystones of the sacristy vault. There are other coats of arms on the vault, those of his uncle Sixtus IV della Rovere. From this one can deduce that the sacristy and the room above it were built shortly before Julius II was elected pope.) It is likely that in 1533, when the wall was prepared, Michelangelo must have decided that the Tomb of Julius II would be used as a sort of private balcony for a visiting pope or for the Franciscan friars to whom the church belonged, who could attend Mass without being seen and without leaving the cloister; the sacristy and the room above are directly linked with the old cloister. The four small openings in the Tomb were therefore intended primarily for a practical purpose; but they also correspond to an aesthetic demand, for the monument, now one with the wall of the transept, is treated as a plastic mass. Because of the openings and the lunette (which, as Salamanca's engraving shows, was to have been open and much larger), the effect of the Tomb is that of a free-standing monument.

180

The "nova sepultura" of 1532 was, therefore, not a simple *376*
arrangement of stones worked during a quarter of a century, but
a carefully thought out and organic transformation of the 1516 *375*
project, with an even greater tendency towards monumentality.

The idea of replacing the statues on the base by heavier statues
was dictated by the modification made to the architecture in 1516,
expressing an increased tension and weight. The lower part of
the monument, rendered more massive by the suppression of the
architrave, was already dominated by the gigantic burden of the
upper story and required figures other than those conceived in
1513. In 1516, the artist even reinforced this effect of crushing
weight by suppressing the molded base, as the drawing shows
(Dussler, *Zeichn.*, 152). In the new, tormented figures, the lat-
est theme of the work is vehemently expressed: domination and
servitude.

The thick-set, shapeless giants in the Casa Buonarroti and *154-161*
Accademia, with their heavy extremities, their huge, boulder-like
heads, their undulating torsos, seem hardly to have emerged from
primeval matter. They appear crushed by the weight of their own
bodies and their own movements: the raised arms of the Young *156*
Slave and the Bearded Slave hammer down on their heads; their *157*
whole bodies are shaken by the blow and seem to sink heavily into
the stone. The "Atlas" and the Slave who appears to be waking up *158-161*
are not yet freed from the matrix: they make unconscious move-
ments, twist and stretch as if gripped by a nightmare. They seem
to suffer from the slime out of which they are formed and at the
same time to be fighting against it. They struggle with instinctive
gestures, but their strength is broken by the weight of their very
existence. They have become symbols of a wholly internal tragedy.
Slavery is no longer conditioned by material bonds, but corre-
sponds to the physical and psychic state of these Titans, who carry
within themselves the yoke of their fate. Michelangelo here
returns to the Platonic conception of life as a mortal prison. Freed
from the moral sense given it by Plato, it is felt as an essential
principle of the human condition. Michelangelo's contemporaries
had already made the distinction between the outer and inner

bonds of the soul. In his "Canto dei greci Schiavi" (in *Tutti I Trionfi*, Florence, 1559, p. 405), Varchi writes:

> I ferri nostri senza alcun ristoro
> legan solo il difuore,
> ma i ferri e i ceppi e le catene loro
> senza dar mai riposo a tutte l'hore
> tengon avvinto e tormentato il cuore. . . .

> ("Our unremitting chains bind us only from the outside, but their irons and manacles and chains imprison and torment the soul at all hours without respite. . . .")

151 The new statue of the Victory represents a tall, slender youth with a small head and elegant extremities, whose left knee is planted on the back of the bearded man he has conquered. The latter, dressed in a cuirass like that of a Roman warrior, bends his sorrowing, thoughtful head under the yoke. A mass of hair lies heavily over his forehead. With his neck and body straining, he appears to be crushed by a greater power than that of his young victor. The latter seems to have forgotten him; he turns his shoul-
152, 153 der away with a sullen look; his face with its regular features expresses sadness rather than triumph, the lips are contracted in a disdainful pout. This is the scorn for success, the bitterness of a conqueror who knows that victory is due to no personal merit but is a gift of fate. The two actors in this tragedy are but incarnations of the same destiny that governs human life: the old man, bent and exhausted under his weight of years, becomes a symbol of age; the young man is then a symbol of youth who, with all his reserves of strength untapped, outdoes the other through no merit of his own. It has been thought that this group is an allusion to the relationship between the aged Michelangelo and the young, handsome friend, Cavalieri, who dominated him. But besides this autobiographical allusion and beyond the material and outward conflict, the work also attains a cosmic significance.

THE LIMIT of three years set down in the 1532 contract came and the monument was far from finished. The new Pope, Paul III,

engaged Michelangelo in his service by entrusting him first with
the execution of the *Last Judgment*, then with the frescoes in the
Pauline Chapel. Shortly after having finished his *Last Judgment*,
Michelangelo devoted himself again to the Tomb. During the
intervening years his conception had changed yet again. The artist,
who was once more discontented with his project, declared that
the Slaves "cannot possibly look good in this ensemble" ("nè a
modo alcuno vi possono star bene"). On August 20, 1542 (Mila-
nesi, pp. 710, 712, 715), Michelangelo signed a final contract
which annulled that of 1532; he received permission to have the
rough-hewn statues of the Virgin, the Prophet, the Sibyl, Active
Life, and Contemplative Life, finished at his own expense by Raf-
faello da Montelupo; and he promised to deliver the Moses. Later,
in spite of the contract, he decided to execute the statues of Active
and Contemplative Life himself. According to Vasari, the statue
of the Pope was done by Tommaso di Pietro Boscoli (on August
21, 1542, Francesco da Urbino promised that Michelangelo would
retouch the face), and the architecture of the upper story by
Giovanni di Marchesi and Francesco da Urbino following Michel-
angelo's drawings (the contract was dated May 16, 1542; the
work was finished at the end of 1544). The escutcheon of Julius
II was made according to Michelangelo's designs by Donato Benti
di Urbino (contract dated February 6, 1543). In February 1545
all the figures were in place. The stones sculpted in 1505 and 1513
were used for the bottom of the monument. In 1542 the base was
raised by a flat gray marble plinth about 50 cm. in height. The
dies which were to serve as pedestals for the Slaves were now
surmounted by volutes. Jacopo del Duca carved the terminals
mentioned in the first projects (contract dated October 5, 1542,
Milanesi, p. 709). The one to the right of Moses, which seems to
be the best, must have served as a model for its counterpart, while
the two others are poorer in quality. The upper story was built
in a white, gray-veined marble, which is not as beautiful as the
ivory-toned marble below it. The simplicity of its style also clashes *181*
with the rich, intricately ornamented stones of the bottom. The
architectural forms above are stiff, cut in sharp edges, and here
the rounded modeling of the earlier projects which included half-

columns, gives way to flat, bare forms—the columns having been replaced by pilasters in the shape of hermae. This architecture with its crystalline style seems to obey rules of its own and is not without grandeur. The impression of the upward movement would be more compelling if the spectator's eye were not distracted by the candelabra with their rich decoration and rounded contours at the top; their conception probably dates from the 1516 project, and they clash with the bare style of the upper story. On a sheet in the Codex Vaticanus 3211, there is indeed the sketch of a candelabrum on a tapering base and without any ornamentation, which probably represents a new idea for these candelabra that has gone no further than the planning stage. If similar candelabra crowned the pilasters, they would form an indissoluble unity with their base and would further accentuate the vertical thrust which dominates the upper story.

323

Out of all the original figures which Michelangelo executed for the earlier projects, only the Moses was finally allowed a place. But instead of being on the right of the upper story he has now become the central figure at the bottom; he must indeed have been set more deeply into the recess than at present, as Salamanca's engraving shows. The Slaves and Victories have been suppressed: in the place of the former, there are, as we have said, volutes; in the place of the latter, Active Life and Contemplative Life, formerly seated figures on the upper story, now stand in the niches. The original positions of Moses and St. Paul in the upper story are now occupied by a Prophet and a Sibyl. So the pagan symbols of the *Trionfi* (the Victories and Slaves) are completely suppressed and what were formerly the religious symbols of the upper story are transferred to the lower. The Virgin holding the Child, which in 1513 was to stand in the *capelletta*, is retained, and now occupies a narrow niche in the center of the upper story. At her feet the Pope is reclining lengthwise on his sarcophagus. In spite of its already reduced dimensions, the sarcophagus is too broad for the niche: it is embedded in the base of the pilasters on either side.

180

In the final version, Michelangelo has established a stricter correspondence between the figures of the two zones: the lower is

now conceived as a reflection of the archetypes represented in the upper (in the earlier projects there were no figures at the top corresponding to the Slaves below). This is, then, the structure of the two worlds according to Plato. The Child in the Virgin's arms holds a goldfinch, which is a symbol of the soul liberated from the body, a liberation which seems to be repeated in the figure of the Pope, whose body on the sarcophagus is sinking while his soul has already attained spiritual deliverance. The two statues of the Virgin and Child and the Pope form a group not unlike the earlier Victories, and are flanked by the Prophet and the Sibyl, recalling images of Justice and Mercy. Below the Pope is Moses, who can *95* now be considered as a terrestrial reflection of Julius II. Below the Sibyl is Rachel, personifying Contemplative Life or *Fides*, and *182* below the Prophet, Leah, personifying Active Life or *Caritas*. *183* Thus the two stories correspond to each other, the lower reflecting the Christian way of life on earth, and the upper, its archetypal virtues in heaven.

Furthermore, in the final version of the Tomb, Michelangelo has used the experience gained in the composition of the *Last Judgment*, which explains the more intimate fusion of all the figures in the monument. This is obtained by a rotatory movement as in the *Last Judgment*, rising on the left, passing through the Virgin, and descending on the right, which encompasses all the statues. Today, the difference between the style and color of the material of the two stories is too conspicuous when seen from the front. It is only by looking at the monument laterally from the right that one succeeds in wholly grasping the grandeur of the conception. The artist himself seems to have allowed for this view- *181* point, which is dictated by the positioning of the Tomb on the right wall of the transept; it is, indeed, first seen from the right side when approached from the main entrance. This explanation enables one to understand the difference in size of the statues on the upper story: the Prophet, nearer the entrance to the transept, is smaller than his pendant, the Sibyl, who appears behind him in the background. In this way the artist sought to attenuate the effect of a foreshortened perspective, as was his habit. Seen from the right, the upper story, which is usually flooded with light,

becomes more airy and seems almost to float. The thrust of its verticals draws the eye upwards. The calm of the upper story then appears not as the organic equilibrium of natural forces, but as a transcendent immutability, rigid and timeless; yet the sneering masks which crown the shafts of the herm-pilasters animate this abstract architecture with a mysterious life. It serves as an impressive frame for the figures with their gentle, compassionate expression.

The statues of the upper story, which were executed by Montelupo's pupils and Boscoli, are but a feeble reflection of Michelangelo's ideas. Their treatment is hard and summary, for example in the folds. They are statues made to be seen at a distance, and entirely in silhouette. The Madonna (rough-hewn in 1537, continued by Domenico Fancelli, and finished by Montelupo) is an approximate mirror image of the Madonna of the 1513 project, but she lacks the heroic, sibylline inspiration which can be seen in the 1513 sketch. She no longer seems to be sheltering the Child from danger; the 1537 conception was apparently one of a celestial vision of goodness. With her head slightly tilted, she looks down with an expression similar to that which the artist has given his statue of Leah on the same monument. At the Virgin's feet the statue of the Pope is a half-reclining figure (neither a Quattrocento corpse, nor sleeping as in the work of Andrea Sansovino) in the pose of a river god. Here Michelangelo repeats a motif of Etruscan tombs, by creating a figure leaning on one elbow. The Pope's head drops forward on his chest and his eyes, which seem to be dreaming, are closed. His cope slips from his shoulders, becoming a vague shroud. His two hands rest before him, inert and heavy. The once warlike Sovereign Pontiff has become a feeble old man vanquished by life. He seems to have his thoughts fixed on a Madonna similar to the statue above him.

Rachel and Leah, executed by the master himself (except probably for the hair and face of Leah), give a precise idea of the change in Michelangelo's style about 1542-1545. Rachel, or Contemplative Life, is a figure in nun's clothing, who is half kneeling on a rectangular base on the right while her body and gaze are turned to the left. The ardor of her prayer is expressed in the

182

ascending movement of her body and even in her clothing. The long converging folds of her robe prepare and accentuate the gesture of the hands joined in prayer. And the aspiration of her feelings is embodied in the spiral of the veil enveloping her head and repeating once again the upward impulse of her body. Everything in the figure aspires upwards and everything terminates in diminishing vibrations which seem to go beyond it. The artist conceives Faith as a dissolution of the being in a higher sphere. The reduction of the modeling of the body to a few simple planes and essential lines, the simplified, almost mask-like face where the forehead *184* and nose form a single surface, emphasizing even more the delicate tremor at the corners of the lips and around the deep eyes, are characteristic features of this period.

Leah is a broad-hipped woman, standing in a calm, relaxed *183* pose; her left hand hangs down, holding a crown of laurel, while in her raised right hand is an object difficult to identify—a mirror according to earlier writers, but more probably a diadem entwined with a tress of hair. The incarnation of abundance and fertility, the solid quality of her thick, matronly body is heightened by the torrent of flat folds falling from her waist to the ground. This abundance is not only physical: she takes the diadem from her bowed head as if to offer it as a gift and regards the spectators *185* with an air of tender goodness. What remains of material plasticity in the Rachel here disappears: the deep folds are transformed into optical planes, which endows the figure with a more intense spirituality. The soft, shaded modeling of the folds on the bottom of the robe and on the surface of the oval base gives the marble itself the figure's dominant characteristic—gentleness.

The aged master has composed his figures to be seen at a distance. The modeling on the surfaces is getting poorer: only the principal planes and main lines stand out. The marble is now treated like a soft, malleable substance; nothing remains of the rock-like character of the Moses.

The mausoleum, originally patterned on the antique, has thus been transformed in its final execution into a "mirror of Christian life."

VI. THE FINAL PERIOD

MICHELANGELO's religious "conversion" during the last period of his life was a consequence of his preoccupations concerning the salvation of his soul, which grew at the same time as his presentiments of the approach of death. The art of dying with dignity was the great problem which absorbed him for almost thirty years. One finds a similar evolution in Lorenzo de' Medici and the humanists of his circle, Ficino, Pico, and Landino, who all began with a pagan outlook, and ended their days as good Christians.

Two factors in particular favored this evolution in Michelangelo: the spiritual atmosphere of the period generally (the Council of Trent), and more particularly, the artist's friendship with Vittoria Colonna. This friendship was of the utmost importance, not only for their personal lives, but also for the spiritual and religious development of the time.

Vittoria Colonna was a descendant of one of the oldest noble families in Italy. She was born in 1490, fifteen years after Michelangelo. Until the death of her husband, Francesco d'Avalos, Marquis of Pescara, Vittoria Colonna was simply a distinguished woman with an Italo-Spanish education. Her marriage was not a happy one: she loved her husband but was not loved in return. She led a rather lonely life, seeking only the friendship of humanists and poets like Molza, Castiglione, and later, Tasso. At this period she wrote poems inspired by classical authors like Ovid. The death of the Marquis of Pescara marked a break in her life. She renounced the world and retired to convents "per poter attendere a servire Dio più quietamente" ("to be able to serve God more quietly"; Carnesecchi, p. 331). She meditated on religious problems, and began to write her *Canzoniere Spirituale*. She used to say: "Scrivo sol' per sfogar l'interna doglia . . ." ("I write only to free myself from my inner grief . . ."). From that moment she preferred the company of high ecclesiastical dignitaries of noble

character. She arrived in this way at serene and balanced religious views. Her masterpiece is not her poetry but her life itself.

Vittoria Colonna was without a doubt a remarkable personality: she edified all those who came into contact with her, revealing to them "the solid basis of faith," as Marguerite d'Angoulême, Queen of Navarre, said. According to Cardinal Giberti (*Epistolario*, II, p. 39): "Not only does she surpass all other women, but she also seems to show the gravest and most famous men the guiding light to the haven of salvation."

But it was Michelangelo who raised this woman to the level of the great inspirers of spiritual love: Beatrice and Laura. And while Beatrice and Laura had to die in order to be completely transfigured in the eyes of their poets, Dante and Petrarch, into angelic beings, incarnations of divine grace and knowledge, Vittoria Colonna experienced this spiritualization during her lifetime, through the poems of Michelangelo.

She is for the artist the instrument of his moral perfection: it is due to her that he feels "rinato"—reborn—and his rough, imperfect being seems to be completed thanks to her virtue (Frey, *Dicht.*, CXXXIV). She is the dispenser of divine grace, and the mediator between the Godhead and himself (Frey, *Dicht.*, CIX, 82). Michelangelo sets her in the celestial spheres. Her beauty seems to him divine (Frey, *Dicht.*, CIX, 8), her face angelic and serene, "volto angelico e sereno" (Frey, *Dicht.*, CIX, 46). He asks her help along the steep road which leads towards her, because his own strength is insufficient:

> A l'alto tuo lucente diadema
> Per la strada erta e lunga
> Non è, Donna, chi giunga,
> S'umiltà non v'aggiugni e cortesia:
> Il montar cresce, e'l mio valore scema,
> E la lena mi manca a mezza via.
>
> (Frey, *Dicht.*, CIX, 76)

("At your high and shining diadem, by the steep, long road, there is none who arrives, Lady, unless you join humility and kindness; the climb stiffens,

101

my strength fades, and I am breathless at half-
way.")

One finds in these poems the Platonic ardor of the verses which
Michelangelo once wrote to his friend Cavalieri, but this time
purified of all their sensual elements. The love for woman here
appears as an image of the love for God. It is a religious attitude
recalling the ideals of love in the High Middle Ages, the philo-
sophical basis for which is to be found in the writings of St.
Thomas Aquinas—an attitude which found its poetic expression
in the *dolce stil nuovo* of the fourteenth century. But, while in the
Middle Ages spiritual love was considered as an absolute ideal
valid in any circumstance and only to be attained by an unnatural
asceticism, Michelangelo discovered the personal value of the
sentiment at a period in his life when it harmonized with his own
development.

Michelangelo's earlier loves for women are known to us only
from his poems, which reveal that in his youth and in his mature
years he experienced passionate love, and that he suffered because
of it. The lines written for the "Donna bella e crudele" (ca. 1534-
1537) show that his passion was unrequited. Vittoria Colonna
was probably the first woman to give her friendship to Michel-
angelo. The poems and letters which the artist addressed to the
"Alta Signora" or the "Divina Donna," as he called her, are writ-
ten in a tone of deep humility and respect. He feels himself to be
"indegno" before this admired being. His humility goes beyond
the conventional forms of sixteenth-century courtesy; it is the
result of a spiritual attitude and the expression of a real abasement
in pride. The artist bows not before the woman of social standing,
but before the sublime personality.

Michelangelo may well have exaggerated the qualities of Vit-
toria Colonna in certain respects. Her "divine beauty" was often
extolled during her life, not only by himself but also by the
Petrarchist poets, especially those of Naples. At the time such
praises were a general convention due to every woman of high
birth. The rare authentic portraits of the Marchesa show a woman

with a long, masculine nose, and a slightly protruding lower lip. On the whole, it is an energetic face which has been rightly called "the feminine incarnation of masculine force." Indeed, Michelangelo exalts this masculine aspect of Vittoria in one of his madrigals (Frey, *Dicht.*, cxxxv). The artist is also full of admiration for the Marchesa's poems, but one must admit that her poetic talent does not exceed that of the average conventional verse of the time, derived from Petrarch. The metaphors which she uses are generally rather artificial. There is no comparison with the ardent quality of Michelangelo's poems and their completely original rhythm.

It was through Vittoria Colonna especially that Michelangelo came into contact with the most important religious current of this period: the "Italian Reformation."

After the death of Savonarola, his pupils carried on the struggle for an internal reform of the Church, which was the great subject of the Councils of Pisa (1511) and the Lateran (1512). Men of a deeply religious life founded the Oratory of the Divine Love (*Oratorium Divini Amoris*) with the same intention of renewing the faith. Many members of this congregation later played a part in the movements of the Italian Reformation and Counter Reformation (Sadoleto, Giberti, Carafa, Contarini—later Pope Paul IV, etc.). After the Sack of Rome (1527), the Oratory of the Divine Love was dissolved and a large number of its members fled to Venice where they met other ecclesiastical dignitaries (Cortesi, Priuli, and Pole). Eight years later (1535), several members of this group were named cardinals by Paul III and constituted the *Consilium de emendanda ecclesia*.

Meanwhile, the movement of the Reformation had reached Naples with Juan Valdès, who had come from Spain about 1531, and lived first in Rome (until 1534), then in Naples until his death (1541). Valdès had been under the influence of Erasmus before his departure for Italy, as the researches of Marcel Bataillon have shown. His belief that the soul which relies on its own strength cannot be justified was based on St. Paul: "Therefore we conclude that a man is justified by faith without the deeds of the

law" (Rom., 3:28). The idea, which had already been expressed by Savonarola in his *Trattato dell'Umiltà*, was the starting point of the doctrine of justification by faith alone.

A narrow circle of cultivated men and women drawn from high ecclesiastical and secular society formed around Valdès. After his death the group was transferred from Naples to Viterbo, to the cloister of Santa Caterina, where it was dominated by the figure of Cardinal Reginald Pole. In the circle at Viterbo were also to be found Flamini, Carnesecchi, Vittorio Soranzo, Alvise Priuli, and Vittoria Colonna.

The essential point of the group's belief was a new conception of salvation. Valdès and his circle believed in justification by faith alone, independent of religious works and practices. This doctrine was a spiritualization of the dogma of salvation. The accent which had hitherto been placed on the material fact of the *infusio gratiae* through the sacraments and the mediation of the priest was now placed on the attitude of the believer's soul with regard to the sacrifice of Christ; grace depends on man's faith. The radical way in which this doctrine was expressed is indicated by a small book which was widely circulated in Italy at the time, entitled *Trattato utilissimo del beneficio di Giesù Cristo Crocifisso verso i cristiani*, published anonymously, but written by Fra' Benedetto da Mantova. In it is the following passage on justification: "The justice of Christ is sufficient to make us children of grace, without any good works of ours; these cannot be good if we have not previously been made good and just by faith." At the same time the soul becomes conscious of its helplessness to save itself through its own works. It was this pessimistic aspect of the dogma which was to play a part in the poems of Vittoria Colonna and Michelangelo.

Like all the other members of the Valdès circle, Vittoria Colonna accepted this doctrine. Certain of her poems are a paraphrase of it. As, for example, when she says:

> Con la croce, col sangue e col sudore,
> Con lo spirto al periglio ognor più ardente,
> E non con voglie pigre ed opre lente,
> Dee l'uom servire al suo vero Signore.

<div align="right">(LII)</div>

("Through the cross, through blood and sweat,
with a spirit ever more burning for trial, and not
with idle wishes and sluggish deeds should man
serve his true Lord.")

Another passage where she reaffirms God's will for justifica-
tion by faith alone is:

Il Padre Eterno del ciel . . . vuol la nostra
Virtù solo per fede.

(XXXI)

When Valdès settled in Naples in 1534, Vittoria Colonna was
leaving for Ischia and it is not known whether she had the chance
to meet him personally. Even if not, she certainly knew his ideas
through Ochino, who was the Marchesa's spiritual director from
1534 to 1541, or else through Giulia Gonzaga, her friend and an
ardent disciple of Valdès. Vittoria Colonna's position with regard
to justification by faith alone was defined by Carnesecchi before
the tribunal of the Inquisition when he was questioned in 1566.
Carnesecchi said (*Carteggio di Vittoria Colonna*, p. 332): "[Vit-
toria Colonna] attribuiva molto alla gratia et alla fede in suoi
ragionamenti. E d'altra parte nella vita e nelle attioni sue mos-
trava di tenere gran conto dell'opere, facendo grande elemosine e
usando charità universalmente con tutti, nel che veniva a osservare
e seguire il consiglio, che ella diceva haverli dato il Cardinale
[Pole], al quale ella credeva come a un oracolo, cioè che ella
dovesse attendere a credere come se per la fede sola s'havesse a
salvare, e d'altra parte attendere ad operare come se la salute sua
consistesse nelle opere. . . ." This compromise—"that she should
believe as though only by faith could she be saved, and on the
other hand she should do works as if her salvation consisted of
works [alone]"—allowed for a conciliation between the external
and the internal, between traditional beliefs and new ideas. This
was also precisely the attitude of Michelangelo.

It is not known exactly when Michelangelo met Vittoria
Colonna for the first time, but it is thought to have been in 1536
(Steinmann) or 1538. During those years Vittoria Colonna was
living in the convent of San Silvestro in Capite. In 1538 they met

every Sunday at San Silvestro a Monte Cavallo, a Dominican convent where they discussed, among other things, religious problems. A Portuguese painter called Francisco de Hollanda described these discussions somewhat freely in his *Four Dialogues on Painting*, written about ten years later. According to de Hollanda, they read together the Epistles of St. Paul, the starting point of the doctrine of justification by faith alone.

In one of his letters to Vittoria Colonna (probably dating from 1540), Michelangelo writes: "[Ho] riconosciuto e visto che la grazia di Iddio non si può comperare e che'l tenerla a disagio è peccato grandissimo"—"[I have] understood and seen that the grace of God cannot be bought and that to hold it in disregard is a very great sin" (Milanesi, p. 514).

In a poem dedicated to Vittoria Colonna, Michelangelo expresses his doubt about the value of good works:

> Chieggio a voi, alta e diva
> Donna, saper, se'n ciel men grado tiene
> L'umil peccato che'l soverchio bene.
> (Frey, *Dicht.*, CIX, 97)

("I ask you, high and divine lady, to know whether in heaven humble sin has less value than excessive good.")

In a whole series of poems of the artist's last period, the doctrine of justification by faith alone appears again:

> O carne, o sangue, o legnio, o doglia strema,
> Giusto per vo' si facci el mio peccato.
> (Frey, *Dicht.*, XLVIII)

("O flesh, O blood, O wood, O extreme suffering, through you may my sin be made just.")

Or again:

> Tuo sangue [Signor] sol mie colpe lavi e tochi.
> (Frey, *Dicht.*, CLII)

("May thy blood alone [Lord] wash and touch my sins.")

The same idea is expressed again when he says:

> Col tuo sangue l'alme purghi e sani,
> Dall'infinite colpe e moti umani.
>
> (Frey, *Dicht.*, CLXV)

("With thy blood thou dost purify and heal souls
from the infinite sins and actions of men.")

See also: Frey, *Dicht.*, CXXIII.

In another poem Michelangelo paraphrases Valdès's idea that good works are only the manifestation of the action of God through the human soul:

> Tu sol [Signor] se' seme d'opre caste e pie.
>
> (Frey, *Dicht.*, CLIV)

("Thou alone [Lord] art the seed of chaste and
pious works.")

This conception goes back to St. Augustine and was upheld in the very heart of the Church itself, during the Council of Trent. It must not be attributed exclusively to the Lutheran Reform. Jean Baruzi has rightly insisted on this point.

All these verses show that Michelangelo knew the doctrine of justification by faith alone; he even illustrated it in his *Last Judgment*. When he conceived the first projects for this (ca. 1535-1536), he did not yet know Vittoria Colonna, but it was during the execution of the fresco that he became a friend of the Marchesa, and she left her spiritual mark on the final conception.

As we have seen from the first sketch in the Casa Buonarroti, *238* Michelangelo initially conceived his Last Day *sub specie* of the ancient myth of the Giants' assault on Olympus. This is the struggle of a titanic race to scale the clouds of the heavens and Christ is represented as a thundering Zeus. The Virgin is the leader of humanity struggling to conquer the heavens, and in her pose and gestures Michelangelo still follows the traditional motif of intercession. In the actual fresco, what the artist represents is the com- *163* plete powerlessness of the human race against the terrible forces of *Fatum*.

The influence of the ideas of the *Spirituali* and Vittoria Colonna

seems evident in the details of the fresco. The crowd of saints
166 around Christ, who are trying to stop the execution of judgment,
are helpless before this Judge: intercession is in vain. Here it is
certain that Michelangelo followed the same concept as Vittoria
Colonna: we know from the records of the case brought by the
Holy Office against Carnesecchi that she believed that "the Saints
do not intercede" (Lanckorónska). In the final version of the *Last*
167 *Judgment*, the Virgin is, in fact, no longer represented as inter-
ceding for humanity, but crouching in fear.

On the left of the fresco there are, for the first time in a Last
173, 175 Judgment scene, figures rising without wings or external assist-
ance, and with an expression of ecstasy. Others mount with the
help of the rosary (that is to say, prayer), and others by charity.
It is a slow and difficult ascent without the aid of supernatural
beings: accomplished only by faith alone and by the magical
attraction of the Sun-Christ. This part of the fresco seems to be
a real illustration of the doctrine of justification by faith alone.
172 In the group of rebel Damned, on the right, one can see the
struggle of souls who are proud of their own strength, instead of
believing in the strength of God. This explains why they are aban-
doned by cosmic forces. Here, Michelangelo expresses the notion
that without faith and God's help even the strongest are power-
less. This is only another aspect of the doctrine of justification by
faith alone.

From the point of view of religious history, then, the final ver-
sion of the *Last Judgment* can be considered as a remarkable
expression of the fundamental doctrine of the Italian Reformation.

IN THE plastic works which Michelangelo executed for Vittoria
Colonna between about 1538 and 1547, some of them known to
us only from copies, the new religious ideas are expressed mainly
by a transformation of the traditional iconographic types. All
these changes tend to accentuate the sacrifice of Jesus Christ—a
crucial point in the doctrine of justification by faith alone. At the
same time, there exists in these works a certain contradiction
between the religious content and the classical forms. The figures
still belong to the powerful and almost pagan race of the *Last*

Judgment and are not in harmony with the new spiritual content.

To judge from the Marchesa's letters, she seems not to have been able to appreciate the peculiar boldness of Michelangelo's style. In one (written apropos of a drawing by Michelangelo of Christ Crucified) she says: "Non si può vedere più ben fatta, più viva e più finita imagine" ("One cannot see a better executed, more lifelike, and more finished image"). She particularly praises the fact that it is "sottilmente e mirabilmente fatta" ("subtly and marvelously done") and goes on to say: "Non vidi mai più finita cosa" ("I have never seen a more finished thing"). These phrases reveal that Vittoria Colonna, like Cavalieri before her, was unable to appreciate the *non finito* in Michelangelo's art and liked only what was carefully finished. It should be pointed out that the works done for the Marchesa, like those for Cavalieri, are in fact similar in style to the cold classicism of Michelangelo's contemporaries, like Bronzino and Vasari. From this one can deduce that he made concessions to the taste of the woman he loved. He offered gifts which he knew would please her. So in this way Vittoria Colonna had a certain influence on Michelangelo's style.

One of the works mentioned in the correspondence between the artist and the Marchesa about 1540 (*Carteggio di Vittoria Colonna*, pp. 206, 208, 209), and also described by Condivi, was a Christ Crucified "in the attitude of a living being, with his face 245 turned towards God the Father, and between two angels" (Condivi, p. 202). These indications are sufficient to identify the composition with the one in the London drawing (Dussler, *Zeichn.*, 329). Renaissance tradition was to depict the crucified Christ as dead. Michelangelo shows him still alive, with his body twisted by suffering, and his eyes turned pathetically towards heaven. The two angels, like echoes of this suffering, are weeping beside him, and one of them points to the wound in Christ's side. In earlier compositions of this kind, such angels had the function of collecting Christ's blood in chalices—they did not express the intense suffering of his sacrifice. The new idea of showing him on the cross not yet dead, but still undergoing his agony, becomes understandable if we realize that the artist's intention was to make the greatness of Christ's sacrifice palpable.

Later, in a letter from the Bishop of Fano to Cardinal Ercole
Gonzaga in 1546, mention is made of a drawing representing a
Pietà—a drawing of which Vittoria Colonna and Cardinal Pole
each possessed copies. This composition is also mentioned by Con-
divi. Numerous copies of it still exist today and there is a drawing
in Boston (Isabella Stewart Gardner Museum) which may be the
original. Here again the artist has modified the iconography. The
Pietà which he did in his youth for St. Peter's presented a tradi-
tional composition: the dead Christ lying in the Virgin's lap with
the accent placed on the Virgin. In the *Pietà* drawing for Vittoria
Colonna, on the other hand, it is Christ who becomes the center
of the composition. He is placed between the Virgin's knees in a
vertical position, and his arms are supported by two angels. His
silhouette recalls the shape of a cross. The Virgin expresses her
suffering by a gesture like that of the *orantes* in early Christian
art, but here one of despair, and seems to evoke the immensity of
the sacrifice. The same idea is expressed by the inscription on the
cross in Giulio Bonasone's engraving, which according to Vasari
was also on the original: "Non vi si pensa quanto sangue costa"
(from Dante's *Paradiso*, XXIX, 91; "We do not think how much
blood it costs").

Michelangelo arrived at this new solution through the integra-
tion of the theme of the Pietà with traditional representations of
the Holy Trinity. It is possible that the inspiration came from
Dürer's woodcut of 1511 representing the Holy Trinity, or from
an engraving by Agostino Veneto after Andrea del Sarto, where
Dürer's Trinity is transformed into a Pietà about thirty years
before Michelangelo's work. The harmonious beauty of the group
in the first Pietà is absent in the second version. This has an
abstract symmetry and an almost geometric regularity. It is no
longer the artistic transposition of a concrete, human situation into
a plastic group, but a religious symbol, a sort of diagram.

In a red-chalk drawing of the Holy Family known as the
Madonna del Silenzio (Duke of Portland Collection) which dates
from the same period, it is again Jesus and not the Virgin who
is the center of the composition. With his head on his Mother's
knee, the sleeping Child is an object of adoration and meditation

for those about him. The Virgin, St. Joseph (whose pose repeats that of the Prophet Jeremiah on the Sistine Ceiling), and the young St. John, all contemplate the Child as if they had a premonition of his Passion. His pose recalls that of the dead Christ in the *21* Pietà in St. Peter's. Again, it is not a historic scene that is represented but a quintessence of every act of adoration of the Savior. Thus, in each of these cases Christ's sacrifice is the real theme, even at the expense of the organic unity of the composition.

Another work which Michelangelo did for Vittoria Colonna is mentioned in one of her letters dated July 20, 1541: Vittoria Colonna prays to the Lord that after her return she will find that Michelangelo still has the image of Christ in his soul, as he has represented it so well in his drawing of the Samaritan Woman. This lost work is known only from copies, the best of which seems to be the engraving by Béatrizet (Bartsch, no. 17). As in the *380* other works for Vittoria Colonna, the composition is reduced to three vertical axes. In the center is Jacob's well, with a tree behind marking the central axis; on one side is Christ, and on the other, the Samaritan Woman. Michelangelo has followed St. John's Gospel quite closely (4:3ff.). The tired Christ sits on the well and asks the woman of Samaria: "Give me to drink." She is surprised that a Jew is willing to take water from a Samaritan. This is obviously a symbol of the new Christian brotherhood and also the expression of an immediate contact between man and God. But it is also the image of the "living water" of faith, which the Son of God reveals with the gesture of his hand while the woman points to the water in the well. It is the contrast between the inner faith and the outward creed. A sonnet by Vittoria Colonna (LXXXIX) on the theme of the Samaritan Woman is closely related to this composition. According to the poem, "in spirito et verità doveasi orare, et non più al tempio antico o al Sacro Monte" ("one should pray in spirit and in truth, and no longer in the ancient temple or on the Sacred Mountain"). These lines reveal that Vittoria Colonna interpreted this passage from the Bible in the spirit of Valdès: that is, that prayer should be made direct and not with the Church as intermediary.

The composition *Christ on the Mount of Olives* is not men-

111

tioned in the correspondence between Michelangelo and Vittoria
Colonna, yet it is likely that the first version was done for the
Marchesa. The sketches in the Codex Vaticanus (3211) for two
of the apostles seem, from their style, to have been executed about
1545 (Tolnay, *Cod. Vat.*, pp. 176ff.). About ten years later,
Michelangelo took up the theme again and then drew the sketches
on the Oxford sheet (Dussler, *Zeichn.*, 202), which can be dated
approximately from those for the Rondanini Pietà. From this
period, ca. 1555, is a large drawing, called *cartonetto*, represent-
ing the same theme, in poor condition, in Florence, Uffizi (see
Wilde, *Burl. Mag.*, 1959, pp. 378ff.). Among the extant copies
384 the best is probably the one by Marcello Venusti in the Galleria
Doria in Rome. The artist takes his inspiration from a medieval
convention in neglecting the unity of space and time, and repre-
senting Christ twice in the composition. First, on the left, he
kneels in prayer on the Mount of Olives, saying: "O my Father,
if it be possible, let this cup pass from me: nevertheless not as I
will, but as thou wilt" (Matt. 26:39). It is important to note
that the angel which appears in St. Luke's version of this scene
(Luke 22:43) is not shown. Here, when he prays directly to God
in his agony, Christ is in complete solitude, without any help or
intercession. The influence of the ideas of the *Spirituali* and Vit-
toria Colonna seems evident.

At the side of this figure, Christ appears a second time: he has
risen from his knees and comes towards the disciples, saying:
"What, could ye not watch with me one hour? Watch and pray,
that ye enter not into temptation" (Matt. 26:40-41). This is the
next episode in the Gospel story. The significance of the scene
becomes clearer when one reads a sonnet by Vittoria Colonna
(CXXIII) where the awakening of the disciples is a symbol of the
awakening of faith in humanity.

246 The cartoon known as the *Epiphany* in London (British
Museum) also has an abstract symmetrical composition, consist-
ing of three parallel verticals, which recalls the works on religious
subjects done for Vittoria Colonna. Originally, this cartoon by the
aged Michelangelo comprised three principal figures (cf. the 1564
inventory of Michelangelo's effects). In the poor copy by Ascanio

Condivi on panel (Florence, Casa Buonarroti), one can also see heads added behind these figures. The Virgin, of athletic proportions, is sitting full face in the center of the composition. Below her and between her legs, as if hidden, the Child Jesus sleeps. This is evidently a development of the idea which Michelangelo had already expressed during his youth, in the Bruges Madonna. This *24* time the position of Jesus is that of a new-born child. The young St. John approaches and seems to discover the Savior. St. Joseph is behind the Virgin to the right; on the other side is a young man, possibly St. John the Evangelist, or, according to the hypothesis put forward by Thode, the Prophet Isaiah who foretold the feast of the Epiphany. This young man draws near to the Virgin with a questioning gesture, probably to ask her where the Savior is. The Virgin seems to be keeping the secret to herself and also to be forbidding St. Joseph to reply, for she holds him back. The Savior's presence is esoteric: he exists only for the initiated, for those to whose souls he has been revealed; he does not appear to those who seek him in outward form. For Michelangelo, the Lord's Epiphany is a purely spiritual revelation.

This composition was probably executed about 1550 when Michelangelo had just finished the *Crucifixion of St. Peter* in the *187* Pauline Chapel. In fact, the figure on the left recalls one of the gigantic young men in the background on the right of the fresco. However, in the cartoon the technique seems to be more developed in the direction of the spiritualized style characteristic of the last period: the light and shade are delicately rendered, giving the overall effect of a vision.

The friendship between Vittoria Colonna and Michelangelo had a common basis in religion; it was, as Vittoria herself said, "tied by the bonds of the Christian knot." Both of them came from a liberal, humanist, and highly cultured Catholicism—that of the Renaissance. Through Valdès and his moral attitude, it was transformed and in a sense brought closer to northern Protestantism, without becoming identical with it. On the other hand, this liberal Catholicism clearly differed from the militant Catholicism of the Jesuits and the Counter Reformation. Vittoria Colonna's influence on Michelangelo lay above all in this deepened Catholicism, ori-

ented towards a reform of the souls of the faithful and towards an internal reform of the Church.

In 1542, with the Inquisition, the Counter Reformation was under way. Intimidated by the Inquisition, Vittoria Colonna henceforth followed the current of the Counter Reformation, abandoning her religious past. For fear of being declared a heretic by the Holy Office, she broke with those friends (like Ochino and Carnesecchi) who became Protestant, and at the end of her life associated herself with the Jesuits and Capuchins. Michelangelo, on the contrary, whose soul had been fortified by Vittoria Colonna in the early part of their friendship, remained faithful to his religious ideas. He was almost the only representative of this liberal, humanist Catholicism to survive the establishment of the Inquisition. Out of all the public figures who had belonged to the circle of Valdès, Michelangelo alone was never bothered by the Holy Office and forced to choose either the Church or the Reformation. This privileged position was probably due to the universal admiration in which his art was held, and to the fact that his great age and solitary life made him appear inoffensive. Nevertheless, a few malicious rumors accused him of heresy, as is proved by the letters from Aretino and the anonymous letter dated March 19, 1549 (Gaye, II, p. 500). This was written on the occasion of the inauguration of Baccio Bigio's Pietà in Santo Spirito in Florence, which was an exact copy of Michelangelo's in St. Peter's, and it says: "In the same month [i.e., March], a Pietà sent by a Florentine was unveiled in Santo Spirito, and it has been said that its author was the inventor of obscenities, a respecter of art but not of devotion, Michelangelo Buonarroti. To imitate Lutheran caprices of this kind, all the modern painters and sculptors sculpt and paint for today's Holy Churches only figures which entomb faith and devotion; but I hope that one day God will send his Saints to cast down idolatries like this one."

But the Church, as we said, did not pursue these denunciations.

IT WAS during the last two decades of his life, *after* the death of Vittoria Colonna in 1547, that Michelangelo created his most beautiful religious poetry and works of art. Freed from his defer-

ence to the monumental taste of the High Renaissance, he could now express his religious sentiments more freely and in a more spiritualized style than before.

Michelangelo's spiritual life during this last period oscillates between two opposite poles: sudden flashes of burning faith and an inner void, the feeling of an intimate communion with God and the despair of being abandoned by him. The whole of his religious poetry expresses the torture of waiting. It was only written in what he called the *intervallo*—the moments of moral depression—and it ignores the divine praise. This poignant poetry comes from the supplications of a desperate man who no longer has faith in himself and who is weighed down by the burden of his sins (Frey, *Dicht.*, XCVII, CLI, CXL).

In another group of sonnets, Michelangelo sums up his life. He thinks regretfully of the time uselessly spent and ends by imploring divine compassion (Frey, *Dicht.*, CXLVII, CL, CXLVIII, CLV, CLVI). The poems in this last group seem to be paraphrases of Petrarch's sonnet no. 365. But in Michelangelo, Petrarch's harmonious, easy rhythm takes on a grave cadence which mounts from stanza to stanza, rolling forward in a flood of irresistible power. The despair of one who seeks grace, but is without hope, is echoed not only in the ideas but also in the music of the words, and it is this state of mind which forms the real atmosphere of these poems, just as once metaphysical nostalgia had been the climate of his Platonic love poetry.

Michelangelo's feelings of beatitude and grace, on the other hand, were reserved for plastic expression, in works of art and especially in drawings. He came to transform his style in order to make it the instrument of his new religious conceptions. These works are incarnations of mystical visions of the divine, created by a spiritual effort which is intended to raise the artist's soul above his instincts. In effect, it is as if furnishing his soul with these inward images appeared to the elderly Michelangelo as a means of attaining salvation. Even in their formal character, they offer a striking resemblance to the religious visions of every age, as we know them from the descriptions of the mystics and the works of art of certain visionary painters. The religious images of

Michelangelo appear translucent, lit by a troubled glow within, and seem to exhale a faint mist which renders their contours fluid and isolates them. Through this phosphorescence the artist creates a light proper to mystical visions, which rises on the habitually somber depths of the soul. The bodies lose their material character, their contours are simplified, becoming almost rectilinear; at the same time they are slightly blurred and the strength which once animated them fades and dies. These images are realities of the soul and draw their substances only from the artist's imagination. They spring into being on paper, independent of all determinate space: around them everything grows indistinct. This is a characteristic which stems from the very mechanism of the creation of visionary images: the spiritual effort which engenders them cannot bring into simultaneous existence the many elements required to make a complete and homogeneous world.

The change in Michelangelo's art can be seen in the series of drawings representing Christ on the Cross between the Virgin and St. John, which from their style may be dated approximately between 1550 and 1556. The culminating point of these compositions is no longer Christ and his suffering, but the human sentiments caused by his death and embodied in the grieving figures of the Virgin and St. John. The real purpose of these drawings is to show how the Crucifixion is reflected in the conscience of man. At first the artist evokes (as in his poems) the remorse, the feeling of guilt, and the weight of responsibility which the human race bears for this crime.

247 In a drawing in Oxford (Dussler, *Zeichn.*, 204), two centurions replace the Virgin and St. John on either side of the cross, and seem to be fleeing the place of execution in horror. One is pressing his hands to his head as if unable to realize what has happened, and the other looks like an assassin pursued by his remorse. The two figures appear to bear all the responsibility for the crime which has been committed.

In another drawing at Windsor (Dussler, *Zeichn.*, 243), Mary and St. John have apparently collapsed under the burden of their sin. The Virgin seems to be trembling, and with her arms crossed on her breast, she covers her mouth with one hand, while St. John

is quivering at the expectation of punishment. It is as if Michelangelo has consciously wanted to show, not the feelings of suffering and grief, but rather, horror, fear, and despair. Indeed, he has chosen for these figures the same attitudes as for two in the *Last Judgment*: the young man with his hands raised, at the top left of the fresco, and the Virgin, both of whom express unequivocally sentiments of terror.

In one of the last drawings of this group in London (Dussler, *Zeichn.*, 175), the feeling of fear and hopelessness is finally surmounted. The Virgin and St. John are pressed close to Christ's legs as if seeking in him a remedy for their despair. They feel secure under the arms of the Crucified stretching above them like a shelter. The death of Christ now assumes its full significance, as the symbol of humanity's redemption through grace.

Several other drawings confirm the change in Michelangelo's art. One of the most characteristic is a drawing in the Ashmolean Museum, Oxford (Dussler, *Zeichn.*, 205), which, from an inscription on the same sheet, can be dated between 1556 and 1560. This had until recently been described as an *Annunciation*, but Pfeiffer (*Art Bulletin*, June 1966, p. 227) has convincingly argued that it represents the appearance of the risen Christ to his Mother on Easter morning. In fact, examination of the drawing suggests that Michelangelo originally drew it as an *Annunciation* in the spiritualized style of his late period, and then transformed the scene into one of even greater poignancy. Earlier, in about 1547, he had worked on an *Annunciation*, which is known from the preparatory drawings in the British Museum (Wilde, *B.M. Cat.*, nos. 71, 72, 73) and from two *cartonetti*, one in the Uffizi and the other in the Pierpont Morgan Library in New York (Wilde, *Burl. Mag.*, 1959, pp. 379ff.). But at the time he had conceived it as a dramatic scene, inspired probably by one of Vittoria Colonna's sonnets (CIV); this would explain the gesture of the Angel in that version, as Vittoria Colonna says that he "imprints the lofty message on the virginal heart."

In the Oxford drawing, the Virgin is seated motionless. Her rather broad and clumsy figure is that of a mature woman, though in the first version her face appears younger. The lectern beside

249

252

381

her, on which her left hand seems to rest, is a common feature in scenes of the Annunciation (cf., for instance, Michelangelo's two *Annunciation* drawings in the British Museum). Before her appears a dreamlike vision, a light, immaterial being who floats above the ground and seems to have come from afar. Originally, the figure's left leg touched the ground, in a pose corresponding to the more common iconographic tradition for the Angel Gabriel. Only in a *pentimento* did Michelangelo change this into a hovering figure, thus spiritualizing his composition. On the palm of the right hand (though not in the left hand or feet) is an indication of the nail wound of the crucified and risen Christ.

253 Perhaps the latest drawing we have of the master, one which has been traced by a trembling hand, represents the Virgin and Child and is to be found in London (Dussler, *Zeichn.*, 161). The Virgin has an awkward, barely defined body and is standing with her knees slightly bent; she appears to be completely nude, but in fact there is a floating veil around her body. The Child is embracing her with impetuous tenderness. The Virgin's form seems to give off a soft light. The indefinite lines of the black chalk, which have been almost worn away, envelop the figure like a halo and give it a dreamlike quality. This is a vision of woman and maternal love freed from all contingency, a return to the primitive Eve. The almost total abandonment of plastic language revealed here is the pure expression of Michelangelo's spirituality, and it explains the rarity of the sculptures done by the artist towards the end of his life. Sculpture, indeed, in its material and technique is much less suited to translating visions of this kind. Nevertheless, Michelangelo did try to express them in the only two marble
190 sculptures which he executed during his last decade, the Pietà in
195 Florence Cathedral and the Rondanini Pietà, and in the small
194 wooden model of a crucifix in the Casa Buonarroti.

190-192 LIKE THE *Pietà* drawn for Vittoria Colonna, the group in Florence Cathedral also derives from the Holy Trinity type. It is synthesized with a kind of Pietà of which an earlier example is the one attributed to Fra' Filippo Lippi (Cherbourg Museum). The dead body is supported vertically under the arms by two figures, while

a fourth person behind Christ dominates the group. The role of the two angels in the *Pietà* for Vittoria Colonna is now played by the Virgin and Mary Magdalen, while the Virgin's place is occupied by the hooded figure of Nicodemus; this, according to Vasari, is a portrait of the artist himself (letter from Vasari to Lionardo Buonarroti, dated March 18, 1564). *244* *192*

The rigid, abstract symmetry of the composition for Vittoria Colonna, which is enclosed in a hexagon, here becomes a group full of life and suppleness, with the figures drawn closer together. The general configuration is that of a slender cone. The artist has tried to attenuate the effect of the material solidity of the bodies as much as possible: their forms are no longer massive as in his earlier works. Tall, thin, almost skeletal, they are seen not from their broadest side but from a narrow angle. Christ's body, bent in two places (this was even more visible before the left leg was destroyed by the master), seems to be slipping down, and the Virgin with her eyes closed, transfigured by a supernatural joy, receives him into her arms. Their two heads touch, the Mother's serving as a support for her Son's. Nicodemus is shifting the body of Christ with his right hand from Mary Magdalen's side to that of the Virgin; at the same time, he seems to be drawing the Virgin closer with his left hand, which he lays on her back in a tender *191* gesture of protection. Once more the symbolism of the two sides plays its part: the right side, Mary Magdalen's, is the side of life, and the left, the Virgin's, is the side of death. With profound emotion Nicodemus, the personification of divine providence, performs the reunion between Mother and Son as desired by Mary, like a priest in a *sposalizio*. The human suffering seems to be surmounted: those who are alive are filled with the same sense of bliss that can be read in the serene features of the dead Christ. The individual bodies are fused: they merge with one another and are united like their feelings. Each figure is but a nuance of the beatitude which results from participation in divine love. This new conception of the Pietà proves that Michelangelo has come to terms with the idea of death, which now appears to him as the supreme deliverance of the soul.

The technique of the Florentine Pietà shows an alternation

between polished and rough surfaces. On the latter, the light is broken up and diffused, giving to the heads of Nicodemus and the Virgin, for example, the translucent aspect which we have observed in the master's last drawings. It seems that here Michelangelo has consciously left the surfaces unfinished: in their roughness he has found an appropriate means of expressing the spirituality of these figures and their inner light.

The conception of the group and the begining of its execution can be dated between 1545 and 1550, since Vasari cites it in his first edition which was finished in 1545 and published in 1550. The artist must still have been working on the Pietà in 1553 since Condivi mentions it as being unfinished. Before the death of his pupil Urbino (December 1555), Michelangelo was dissatisfied with the work and partially destroyed it (Vasari, 1568). Tiberio Calcagni gathered up the fragments (except for the left leg of Christ) and restored it. He also finished the figure of Mary Magdalen which Michelangelo had only rough-hewn.

195, 196 The Pietà which was formerly in the Rondanini Palace, Rome, and is now in the Castello Sforzesco in Milan, is Michelangelo's last plastic work. In his second edition Vasari reports that, having mutilated the Pietà now in the Duomo in Florence, the artist took up a marble in which he had formerly rough-hewn a Pietà. In a letter from Daniele da Volterra (Daelli, 34), we learn that Michelangelo was still working on this group six days before his death.

251 To judge from their style, the preparatory sketches on the Oxford sheet (Dussler, Zeichn., 201) can be dated between 1550 and 1556. It seems, therefore, that the first version of this marble composition must date back to this period, that is, just after he abandoned the Florentine Pietà, and that the artist remade the group completely in the last year of his life.

195 In the marble group Michelangelo abolished the antithesis still visible in the Oxford sketches, between the passive weight of the dead body and the effort of the live figure holding it. Christ's thin body cannot be supported by his legs which are hanging limply; nevertheless it rises, braving the laws of gravity, and becomes a support for the figure of Mary who leans against him and seems to draw the warmth of life from his inert form. They are so closely

united that they become one; indeed, the final version of Christ is sculpted directly from the block containing the Virgin. The image of Mary's suffering is thus transformed into a vision of the supreme union between Mother and Son, through divine love.

Once again Michelangelo has subordinated physical beauty to the irradiation of the soul. The forms of these two bodies appear singularly impoverished and bereft of all physical perfection. Their silhouettes are angular and rectilinear, and their surfaces (except in the parts executed for the first version and not retouched by the master) show the rough treatment already noted in the Florentine Pietà, which Michelangelo uses to attenuate the too obvious effects of light and shade, mysteriously bringing out the diffused radiance within.

THE STATE of religious beatitude at which Michelangelo arrived, and which he succeeded in achieving in his last works, is not the fruit of the candid assurance of medieval man, nor of an artificially cultivated ecstatic discipline, as in the Counter Reformation. Profoundly alone, Michelangelo sought for himself the way which was to lead him to bliss. It is these long uncertainties and searchings which give his last works their moving depth. In them the feeling of joy seems always to be tinged with the suffering he had endured to attain it.

The drawings and the two Pietàs of the final period can be called "orations" or inward prayers. The outward and material image of Christ is supplanted by the spiritual image which is directly inspired—as the Italian Reformers would say—by the Holy Spirit.

Savonarola, in his little book *Della orazione mentale*, had already said: "The Lord wants the inward worship without the outward ceremonies," and "Ceremonies are like medicine for souls which have no real fervor." The idea of this inward worship was again explained by Valdès in his *Cento e dieci divine considerazioni* (no. 63), and this passage throws further light on the character of Michelangelo's last works. Valdès says that the image of the Crucified should evoke in the soul the suffering of Christ. Once this evocation is attained, the eyes of the body turn away from the

external representation and the eyes of the spirit focus on the mental image of the suffering. Faith is no longer founded on the "relation" which tells of the suffering, but on the "revelation" which unveils it; as Valdès himself says, not upon the *relazione* but on the *revelazione*.

MICHELANGELO was no longer the simple artisan-artist, as were the Florentine masters of the fifteenth century. He even protested once at being called *scultore*: "I have never been a painter or sculptor like those who keep shop; for the honor of my father and my brothers I have always been careful to avoid that" (Milanesi, p. 225).

He felt himself, therefore, socially superior to the artisan-artists of former times. On the other hand, he was not the artist-prince living sumptuously in his palace and leading a worldly life, like most of the great masters in the sixteenth and seventeenth centuries. Rather, he was the artist-philosopher, the artist-poet, an aristocrat of the spirit. What Leonardo da Vinci (*Trattato*, paragraph 63) recommended to the artist, "to live in solitude in order to concentrate better on the essence of things," Michelangelo fully and perfectly realized in his life.

The driving force of his personality was *l'ardente desio*, the ardent desire for the upper spheres. "Al ciel sempre son mosso," "Al cielo aspiro" ("To heaven always I am driven," "To heaven I aspire"), he said in his poems.

An audacious spirit, full of pride, with an uncontrollable temperament when young, he renounced these early qualities and became a thinker (the period of the Medici Chapel), then simply a humble Christian. In his youth he represented the plenitude of the Florentine genius at its height. At the end of his life, in attaining a Christian universality, he transcended it.

From the beginning, Buonarroti's art was directed to the quest for the Idea which appears through visible forms. For him the work of art was not a representation of appearances, but an evocation of the essential nature of things. He sought always to express things not as seen by the human eye, but as they are in essence, accessible only to the spiritual vision.

This conception of art led to a new notion of the artist. He was no longer an imitator subordinated to his model—to nature—but a second creator, almost a god, who by his works transcends visible nature to attain "true nature." In the last period of his life, however, Buonarroti rejected this proud, sublime conception of the artist when he became a Christian. Then, instead of the world of archetypes, he recreated in his works the vision of the divine, yet without renouncing the creation of a second reality which is superior to ours.

It was not without effort that he attained the higher spheres, and it was only through a gradual catharsis. This progressive sublimation is the fundamental form, the "archetype" of Michelangelo's soul, and we find it as much in his works as in the development of his personality.

VII. THE ARCHITECT

MICHELANGELO's activity as an architect consists of two creative periods. At the age of forty-one he made the projects for his first independent architectural work, the façade of San Lorenzo, but it was only at seventy-one that he turned decisively to architecture, when he started on his plans for St. Peter's. There is a noticeable difference in his conception of architecture between these two periods. While the effort of the mature artist was concentrated particularly on the creation of a new language of architectural forms conceived as plastic symbols of vital forces, in his old age he sought to model space itself as if it were a living organism.

THE TWO great architectural commissions of Michelangelo's maturity were intended to complete existing edifices. He was required first to apply an exterior façade to the church of San Lorenzo in Florence, and next to construct rooms in the interior of the San Lorenzo monastery to house the Medici library—the Biblioteca Laurenziana or Laurentian Library. The fact that he did not have to invent whole new buildings from the beginning simplified his task.

The projects for the façade of San Lorenzo are Michelangelo's first purely architectural undertaking, although there exist earlier works where he treated the architecture as a framework for the composition of the figures (the Tomb of Julius II and the Sistine Ceiling). The artist began his task with enthusiasm: "Farò la più bella opera che si sia mai fatta in Italia" (Milanesi, p. 394; "I shall make the finest work that was ever made in Italy"). And in another letter he indicates in a few words the program of the work which he wanted to be "d'architettura e di scultura lo specchio di tutta Italia" (Milanesi, p. 383; "the mirror of architecture and sculpture in all Italy"). This phrase reveals the intentions of the artist who still saw the architecture as a setting for sculptural works. He wanted to make a sort of *sacra conversazione*, bringing

together the statues of the most venerated saints of all Italy as well as the patrons of the Medici family.

At the end of December 1515, Leo X conceived the project of giving his family church a façade (Vasari, ed. Milanesi, VII, p. 188). Many important artists seem to have furnished drawings (Baccio d'Agnolo, Antonio da Sangallo the Elder, Andrea and Jacopo Sansovino, Raphael—all mentioned by Vasari—and also Giuliano da Sangallo, six of whose designs for the façade are in the Uffizi). Through the agency of Buoninsegni, Michelangelo and Baccio d'Agnolo also presented themselves (before October 7, 1516), and Pope Leo X and Cardinal Giulio de' Medici agreed to entrust them with the task. Before deciding on the project, however, they insisted that the artists should go to Montefiascone together to confer with the Pope. Thereupon, Michelangelo, suspecting that Baccio d'Agnolo wanted to exploit him, declared that he could not go, and gave Baccio "chomessione libera" (November 3, 1516). It was only after Buoninsegni had suggested to him that he could take over the whole work, and choose another collaborator instead of Baccio, that Michelangelo decided to go to Rome. There he made a drawing (December 1516) to which the Pope immediately gave his consent. Back in Florence he gave the design to Baccio d'Agnolo for him to make a model. But Baccio's model differed from the drawing of Michelangelo who called it a "cosa da fanciulli"; he had the model remade in 1517, but was still not satisfied. Between March and May 1517, with his *garzone* La Grassa, he undertook the execution of a clay model after a new enlarged plan. This model was also a failure. Between August and December 1517 he made a wooden model with wax figures in collaboration with his pupil Pietro Urbano. The latter took it to Rome where the Pope and the Cardinal appeared satisfied with it. It was only then, after the wooden model had been finished, that the contract was concluded on January 19, 1518 (Milanesi, p. 671). Preparations were made for putting the work in hand, new foundations were built, and extraction of the marble at Carrara and Pietrasanta began. In spite of all this, two years later, on March 10, 1520, the contract was annulled by the Pope. This

was a "vituperio grandissimo" which Michelangelo could never forget.

The first project is represented in a rapid sketch by Michelangelo on a sheet in the Casa Buonarroti hitherto overlooked (Barocchi vac., Dussler vac., on the verso of Barocchi no. 250); this is in all probability a *pensiero*, earlier even than the so-called "primo disegno." The sketch is important because it shows that the point of departure of Michelangelo's conception was not the earlier or contemporary façades of other artists but the cross-section of the church, i.e., the effective silhouette of the unfinished façade, with its triple gradation and the inclined lines of the roofs. It is interesting to note that there is as yet no influence from Giuliano da Sangallo's façade projects for the same church.

The inspiration from the silhouette of the unfinished façade is characteristic of Michelangelo's creative process in general; his marble statues were also conceived as if imprisoned in the rough block from which he freed them.

In the sketch mentioned above, we note that on the lower level Michelangelo has already articulated the façade by eight double columns in three bays, in the center of each of which he indicates a door. There are no places so far for sculptural decoration, a fact which also speaks in favor of the very early dating. This order of columns supports a powerful cornice. The intermediate level is not yet articulated, except that Michelangelo separates the central part from the laterals by two vertical lines. Above this level (which is a sort of attic) rises the upper part, corresponding to the upper area of the central nave and crowned by a triangular pediment (Tolnay, *Commentari*, 1972, pp. 56-57).

A variation of this first sketch is illustrated in a drawing in the Uffizi, No. 1923A r/v, attributed there to an anonymous draftsman of the sixteenth century. A copy of the same project can be found in Lille, Musée des Beaux Arts, in the *Taccuino* of Aristotile da Sangallo, which shows that it was well known in the Cinquecento. Here the pyramidal gradation is made up of three horizontal levels one above the other, i.e., the diagonal lines of the roofs of the façade are hidden. The ensemble recalls a ziggurat.

The order of double columns is now repeated on the second and third levels. We note that on the lower level there are five instead of three bays, and that the lateral doors are not indicated. Here too we are close to the triple gradation of the original silhouettes of the unfinished façade, though corrected according to the exigencies of the classical column orders.

The next phase of the development of the idea was to reduce the triple gradation of the unfinished façade and of the first sketch into two floors. This is quite visible in the so-called "primo disegno" of the Casa Buonarroti (No. 45A), of which there exist several copies (Modena, Lille, Munich). The two lower levels are united by a central portico, the columns of which rise to the large cornice above, and by the tabernacle niches in the corners crowned by segmental pediments. Above the portico, corresponding to the main nave, rises the second story, crowned by a triangular pediment.

This project is somewhat inorganic and seems to have served Baccio d'Agnolo for the execution of his model, which Michelangelo did not accept and called "cosa da fanciulli." In another version of this idea, for which there still exist three original sketches, one in ink (Dussler, *Zeichn.*, 86) and two in red chalk (Dussler, *Zeichn.*, 123 and 89), the main cornice is laid above the lower level; above it rise a high attic of the same width, with tabernacle niches in the corners crowned by segmental pediments, and finally the central part corresponding to the main nave crowned by a triangular pediment. The most developed version (Dussler, *Zeichn.*, 89) has a giant order of columns, which rise from the main cornice through the attic up to the second cornice, crowned by the triangular pediment.

318, 319

319

In this project there was room for ten figures: four standing figures below, as many seated statues in the attic, and "in cima" two standing statues in the lateral bays (the two openings in the central bay are obviously windows). This design was done between December 20 and 22, 1516. The three original sketches just mentioned correspond to the particulars mentioned in the documents (on the other hand, the number of figures in the so-called

"primo disegno" could have also been ten, if there were two figures on the lower level in the lateral bays, united in one niche, as the drawing indeed shows it).

The clay model dating from March to May 1517 relates to an enlarged project, for Michelangelo raised the cost of execution by 10,000 ducats; twenty-four figures were to be placed on the façade, sixteen on the front and eight on the returns. This speaks in favor of the supposition that a narthex was now projected, a fact pointed out by Ackerman. The arrangement of the figures is mentioned in the contract (Milanesi, p. 671); and the drawing in the Casa Buonarroti (Dussler, *Zeichn.*, 85) corresponds to these data. It also shows the placement of the "due storie in quadri, e due in tondi" ("two rectangular histories and two round") mentioned by the contract; actually there is even place for three "storie in quadri."

320

The wooden model in the Casa Buonarroti is a simplification of the drawing which served as a basis for the contract, a simplification directed at the zone of the plinths of the pilasters on the top story. The plinth is now integrated with the attic of the lower order. The weight resting on the ground floor is thus somewhat lightened. The proof of this model's authenticity is given by the existence on its right lateral façade of a base for one of the seated wax figures of the attic. There were, therefore, two wooden models, a fact confirmed in a letter written by Michelangelo in 1555 (Milanesi, p. 312), where the artist mentions both of them, saying that he is thinking of offering them to Cosimo de' Medici. (The existence of the two models is mentioned again by G. B. Nelli, in 1687, in a drawing made after the models, Uffizi 3696A/B, 3697A/B.)

257, 258

The starting point for these projects was Giuliano da Sangallo's designs for the same façade. Michelangelo's first drawing was done a month after Giuliano's death, so the hypothesis that he influenced Giuliano must be rejected. The structure of Giuliano's façades belongs to the Tuscan tradition of basilican churches (San Miniato al Monte, Santa Maria Novella, etc.), while their details derive from ancient monuments; in one design, for example, the

pilasters, columns, and architrave go back to the Emilian Basilica in the Forum.

With the lower level divided into a rhythmic sequence of bays, with the attic and its lateral tabernacles surmounted with segments, and with the top story with its three bays crowned by a pediment corresponding to the central nave, Michelangelo's project offers the same architectural ensemble as one of Giuliano da Sangallo's drawings. But Michelangelo determines the relation between the weight and the supports in a new way: instead of attempting to establish an equilibrium between the two, he tries to make the weight predominate over the supports. He plants the ground-floor colonnade on barely elevated bases, raises the attic, and gives a new emphasis to the lateral tabernacles. The powerful mass of the attic threatens to crush the weak ground floor. In the most advanced drawing of the first project, the artist accentuates *319* the width of the mass by the angular accents of the tabernacle niches, but he also develops the attic and the order of the columns on the top story which is now built on the first cornice, right across the attic and beyond it. It is no longer a question of distinct stories as in Sangallo, but of an interpenetration of opposing masses and forces locked in an irreconcilable tension—the masses horizontally, the forces vertically. The neutral fields serve as places for the sculptures and reliefs; as a result of the enlarged attic, Michelangelo gains four supplementary places for the figures, making ten places instead of six as in Giuliano da Sangallo. He moves away from Sangallo's classicist style (in the latter's design the lower story is an imitation of a triumphal arch), at the same time grasping more powerfully the unity of an animated mass.

Michelangelo's third and last project is also linked with one *320* of Sangallo's ideas. Here again it is the same type of façade, with two orders disposed in rhythmic bays, and with the upper story built over the whole width of the ground floor. Michelangelo reinforces the weight of the mass by inserting a powerful attic and a zone of plinths between the upper and lower stories. His façade stands with all the formidable weight of a monolith; the orders no longer show a system of supports and weights which can be

detached from the body of the whole, but symbolize the forces of the mass itself, which they seem to buttress. The tension between mass and force is resolved: both are only different manifestations of a higher unity. This is a mass permeated by vital energy.

321 The opulent sculptural embellishment planned for this façade would certainly not have attenuated the oppressive effect of the mass, for the statues and reliefs would no doubt have been conceived by Michelangelo as anthropomorphic symbols of the inherent forces dominating the mass itself. If one tries to integrate the statues into the niches, the whole façade expresses the idea of a *sacra conversazione* of all the important saints in Italy and the patron saints of the Medici family, and that is why Michelangelo could say that his façade would be "a mirror of all Italy." The program had, in fact, been conceived by Cardinal Giulio himself. On the ground floor, from left to right, were planned: St. Lawrence, patron saint of the church; St. John the Baptist, patron saint of Florence; SS. Peter and Paul, the saints of papal Rome. Above, from left to right, there were to be the seated figures of the evangelists, SS. Luke, Matthew, John, and Mark, and on the top story from left to right, SS. Cosmas and Damian, patron saints of the Medici. (The reliefs probably represented the legend of St. Lawrence, and the medallions, to judge from the drawing by G. B. Nelli, the Crucifixion of St. Peter and the Conversion of St. Paul.)

Michelangelo's projects for the façade of San Lorenzo saw the light of day at a time when Italian architecture had experienced a series of individual solutions to the problem of the façade without becoming attached to any one definite type (for example, San Francesco in Rimini, Santa Maria Novella in Florence, Sant'Andrea in Mantua by L. B. Alberti). Here the façade is no longer, as in Romanesque art, a reflection of the cross-section of the church; it already constitutes an independent decorative wall. But it was Michelangelo who first gave it a dynamic life of its own. Except in his first project he masked the triple lateral gradation of the entrance wall of San Lorenzo with a high attic, and by the order of the columns endowed the façade with its own dynamic

320 life, independent of the vertical section. In his last project, he went further and gave the façade an independent structure by

means of the returns. These are a sculptor's ideas and were too personal to have an immediate following.

The inventor of a new type of façade which became universally popular from about 1570 was not Michelangelo but an architect by profession, Antonio da Sangallo the Younger. His façade of Santo Spirito in Sassia, done in 1538, was the model for that of the Gesù by Vignola. The forms of the new "Jesuit" type of façade symbolize the gradual increase in the forces and the mass from the sides to the median axis, where the main doorway and the relic tribune are to be found. The façade of the Counter Reformation answers practical, liturgical needs: it calls the faithful to the church entrance and exposes the relics to their view; it has ceased to be, as in Michelangelo, a structure containing a series of gigantic statues and at the same time an expression of the vital conflict between the inert masses and the ascendant forces.

Michelangelo's last project for San Lorenzo did not, however, remain completely without effect: as well as a small number of façades which betray an immediate dependence on it (those of the cathedral of Reggio Emilia, and San Luigi dei Francesi in Rome, with the returns), its influence consisted in the fact that from that time the Italian façade achieved a greater independence in relation to the cross-section of the edifice, while the different elements of its architecture took on a more definite relief.

AUTUMN 1523, after the election of Cardinal Giulio to the papacy, is probably the date of the first discussions on the subject of the new Library in the cloister of San Lorenzo, where the immense treasure of manuscripts and books belonging to the Medici family was to be brought together. Michelangelo was chosen as the architect. Three main periods can be distinguished in the history of this work. Before the final plans were drawn up, it was necessary to determine its position in the cloister. We know that on January 21, 1524, Michelangelo sent a plan (now lost) of San Lorenzo to Rome, from which the Pope decided to place the Library on the south side "vòlta a mezodi." From Rome came the reply that the Pope wanted a new plan with an indication of the rooms in the cloister. On February 9, 1524, the new plan reached the Pope who

refused it because it would have entailed the destruction of seven rooms. In the Casa Buonarroti there is a red-chalk drawing by Michelangelo which must be related to the second plan, for one can see the Library (*Libreria*) situated near the arcades to the south of the cloister, and an indication of the different rooms (*chamere*), the gardens (*orto*), and cloister (*chiostro*). The drawing shows what stage this conception of the Library had reached in the artist's mind at the beginning of 1524. The project already differed from tradition. Italian libraries in the fifteenth century (Cesena, Biblioteca Maletestiana; the Library at Monte Oliveto; Biblioteca Marciana in Florence) are vaulted rooms with three aisles. Here, on the other hand, a single, long, rectangular room was to replace the three traditional naves. But these plans are not yet differentiated. They show no trace of a vestibule or of supplementary rooms (*studietti*). Having refused this drawing, the Pope asked for a new plan on March 10, 1524, in which the

334 Library was situated on the east side, on the Piazza San Lorenzo. It was at this date that the idea for a vestibule and two *studietti* at the far end of the reading room originated. At last the Pope

259 chose the final position in the west (on the side of the south transept and the Sagrestia Vecchia); this project was accepted on April 3, 1524. Nanni di Baccio Bigio was named superintendent of the work, which began in the month of August 1524 and lasted almost two years, until June 1526. On account of political troubles, the work was then stopped for four years. It was only at the end of 1530 that it was taken up again, to continue until 1534, the date when Michelangelo finally left Florence. At that time the staircase and ceiling of the vestibule had not even been begun. The interruption lasted until 1550, when the idea of having the staircase done by Tribolo according to Michelangelo's advice was revived. In 1555, Vasari intended to finish the work on the Library, but this never got further than the planning stage.

265 Finally, in 1560, Ammannati built the staircase of the *ricetto* (vestibule).

259-268 Of Michelangelo's architectural works the Laurentian Library is the one in which his originality of conception is perhaps expressed most clearly. For the first time in the history of art, the

interior of a library is seen not as an application of the ideas of religious architecture, but in terms of a concept which corresponds to its function. Michelangelo's intention was to create in his library a place suitable for intellectual concentration. In the final version the vestibule and reading room are conceived in contrast with each other.

The vestibule is a sort of prelude. The visitor is meant to be *260-265* taken out of the external world by its strange architecture in *pietra serena* and by its subdued lighting. The light of day and the noises of everyday life remain at the threshold and one enters a tranquil domain, cool and dim, a Purgatory, a place of catharsis in which to prepare for the well-lit reading room of the Library, whose sim- *266* ple, austere architecture is conceived as an appropriate frame for thought. Originally this contrast was not foreseen by the artist; the change of plan may be supposed to date from February 1526.

Inside the *ricetto*, the walls take on the aspect of plastic masses, *262-264* in which there are columns in niches seemingly imprisoned. These columns symbolize the inherent forces struggling to deliver them-selves from the matrix; their downward pressure is embodied in the volutes, while their upward thrust finds an echo in the pilasters above.

As for the genesis of the idea for the reading room, a draw-ing (Dussler, *Zeichn.*, 84) affords some clarification. This draw- *335* ing has wrongly been considered as representing the vestibule, whereas it is one of the first projects for the architectural structure of the reading room. The absence of the high base of the vestibule and the presence of a second bay, lightly sketched in black chalk on the right, which can only be placed on the long wall of the room, support this assertion. The drawing shows bays composed of pairs of columns set back into the wall, alternating with bays composed of tabernacles—a structure which anticipates that of the final version of the *ricetto*. Such a richly decorated room was rather ill suited to the intellectual demands of a library. The ensemble lacked the austerity and simplicity necessary for col-lected thought. And so Michelangelo decided to simplify the proj-ect. In its executed form, he substituted plain, flat, rigid pilasters *266* for the pairs of columns, and for the rich tabernacles, plain frames

without pediments. This simplicity helps to give the room a severe aspect favorable to purposes of study.

Letters tell us that rooms adjacent to the main reading room had been planned. At first, in March 1524, it was a question of two *studietti*; then in April of the same year there was talk of four, two at the far end of the room and two at the entrance. Then, a few days later, there was to be a transept, a project which was refused by the Pope. The fourth project consisted of making a chapel (*cappella*) at the back of the room, for which a drawing in the Fenwick Collection, now at the British Museum, may be considered as a sketch. In it the structure of the walls is analogous to the first project for the main room and the last project for the vestibule. Thus, the rich, plastic style born out of the projects for the chapel and the reading room were finally transferred to the vestibule. The project for the chapel was refused by the Pope on April 12, 1525.

333 The first projects for the *ricetto* (a plan in the Archivio Buonarroti and Dussler, *Zeichn.*, 121) show the stairs placed against the walls; this may have given the artist the idea of dividing the walls into four bays, the two middle ones of the same length as the stairs, and the two outer ones each corresponding to the upper and lower landings. At the same time as he refused the chapel in April 1525, the Pope asked for a staircase occupying the whole width of the vestibule to be built. This inspired Michelangelo with the idea of a free-standing staircase, later, therefore, than April 12, 1525. It was the first example of a free-standing staircase in the center of an enclosed space, an innovation which gained many adherents in the architecture of the seventeenth and eighteenth century on both sides of the Alps. Sketches for the free-standing staircase exist (Dussler, *Zeichn.*, 124). The adoption of this idea allowed the wall to be freely divided, and nothing then prevented Michelangelo from transferring the motif of the chapel to the vestibule. The union of the motif of a free-standing staircase with that of the structure of the walls in the project for the chapel

336 appears in a drawing (Dussler, *Zeichn.*, 90): the walls are divided into three parts, the second level is conceived as an attic and not as a complete story, and a vault crowns the whole; the analogy

with the drawing of the chapel is striking. In the executed version, Michelangelo has suppressed the frontal pilasters framing the double columns, and transformed the attic into a complete second story. The motif of the double columns set back into the wall (perhaps inspired by Roman edifices, for example, one of the tombs formerly on the Via Appia which we know from a sketch by Giuliano da Sangallo in the Vatican) first appears, therefore, in the reading room, then in the chapel, and finally finds its place in the vestibule.

260, 261

In the vestibule, the architectural forms of the Renaissance have lost their traditional expression of symbolizing the resistance of the supports to the weight of the load. The walls do not rise in space but penetrate it; the columns, instead of supporting the architrave, as we have said, embody forces which tend to dissociate the material which imprisons them. The volutes on the bases seem to be not supports but bulges of stone squeezed out by the pressure of the columns, and the cornices are transformed into sharply-profiled metallic bands which link the forces and masses together. In the middle of the vestibule is a staircase (built, as we have seen, by Ammannati according to the main lines of Michelangelo's plan) which, instead of indicating an upward direction, seems in the center to run down and spread like a cascade of lava, contained only by the secondary stairs on either side. The visitor who steps through the small door leading from the cloister to the vestibule experiences the strangest sensation. In this lofty but relatively confined hall, where a diffused light enters from the top and which the columns seem to people with superhuman beings, he feels enclosed in a higher reality which both terrifies and exalts. This architecture is not in proportion to man and is not made for him. It has independent dimensions and carries within itself a peculiar and more powerful life. It is the spiritual preparation for entrance to the reading room. This impression would have been even more striking if Michelangelo had been able to sculpt the gigantic statues intended for the tabernacle niches. These statues were probably to represent illustrious men in the arts and sciences of antiquity and the Renaissance.

264

262

265

261

In addition to the Laurenziana, Clement VII asked Michel-

angelo in October 1525 to design a ciborium for San Lorenzo in the form of a stone canopy placed over the altar and supported by four antique columns; the preliminary ground-plan for this is in the Casa Buonarroti and a sketch for the ensemble in the Archivio Buonarroti. However, the project was abandoned and about 1531-

269, 270 1532 Michelangelo planned a tribune for the relics on the inner façade of San Lorenzo above the main portal, a work which still exists today and for which we also know of two preparatory drawings by the artist (Dussler, *Zeichn.*, 112 and 199).

AT THE beginning of 1529, the Florentine Republic, fearing that Clement VII would gain power in Florence, decided to have the town's fortifications finished, and for this purpose they approached Michelangelo, as we have mentioned earlier in Chapter III. Twenty-three drawings for the fortifications of the city gates are preserved in the Casa Buonarroti and testify to the fact that Michelangelo was a bold innovator even in this domain. In place

341-344 of the traditional geometric bastions, he created zoomorphic forms recalling the transverse sections of crustaceans with long antennae. The new curved shape prevented the enemy from approaching the city gates and breaching the walls of the fortifications with his cannons. At the same time it provided the artillery on the inside of the town with active and effective defense. The sketches were not meant to be carried out in stone because of the complexity of their fantastical forms, but in beaten earth. The influence of these drawings (all published by Tolnay, *Art Bulletin*, 1940, pp. 227-237) was considerable: for example, the greatest engineer of fortifications in the seventeenth century, Vauban, took them very much into account.

AFTER THE execution of the plans of these works in Florence, there was a pause in Michelangelo's activity as an architect, and it was only in 1546 that he returned to architectural projects which from then on were to assume an ever-increasing importance. There were many reasons for this preoccupation with architecture in his latter years. First, a purely practical one: the execution was

in the hands of other artists, while Michelangelo, his strength diminished by his great age, was able to reserve for himself simply the role of directing the work; secondly, the language of architecture corresponded to the inclination of age towards reasoning and abstraction (D. Frey). This tendency towards abstraction can, in fact, already be observed in Michelangelo's last frescoes and sculptures; he was therefore consistent with himself in turning next almost exclusively to architecture.

The architectural works of the last period comprise religious and secular buildings. In the first domain, Michelangelo worked on central and longitudinal edifices. In the secular field his scope went from palace architecture (façades and courtyards), city gates, and fortifications to town planning—in the creation of a piazza. Certain stylistic features characterize this last period: now he prefers flat shapes to plastic, free-standing forms, and plain, wide, flat profiles to rich, finely-chiseled edges; gigantic systems appear instead of superimposed orders. In these late works, the development moves from the concept of conflict between empty space and the mass enveloping it, to a dematerialization of the mass and a fluctuation of space around the architectonic members.

While in the earlier architectural works the artist had been inspired by the projects of his older friend Giuliano da Sangallo (plans for the façade of San Lorenzo in the Uffizi which influenced those of Michelangelo for the same façade, and for the vestibule to the sacristy of Santo Spirito, which inspired Michelangelo's *ricetto* in the Laurenziana), the works of his last period stem from the projects of Antonio da Sangallo the Younger. In fact, Michelangelo reaped the heritage of this master, who died on October 1, 1546: St. Peter's, the Farnese Palace, and San Giovanni dei Fiorentini were all edifices which Antonio da Sangallo the Younger had begun or planned, and certain ideas, as, for example, the clustered pilasters, come from this artist. But whereas in the case of Giuliano da Sangallo Michelangelo had only to render more dynamic his somewhat cold, classicist style, in that of Antonio da Sangallo the Younger, the master felt obliged to set aside what was too rich and confused, and to return to a classical simplicity

and clarity. We know from his correspondence that Michelangelo bitterly criticized Antonio da Sangallo the Younger (Milanesi, p. 535).

With the pontificate of Paul III, a period of immense activity opened for the aged master. This Pope was a great admirer of Michelangelo, and particularly of his architecture, and he entrusted him with the greatest and most responsible tasks that could be given to an architect: the reconstruction of the religious *273-293* center of Rome (St. Peter's) and its civic center (the Capitol). These two works were finished only after the death of Michelangelo, but largely according to his plans, and they show a very different style from the works he had done in Florence. They are characterized by their simplification of the lines of the masses, obtained by adopting, for the first time with Michelangelo, gigantic travertine orders instead of the linear bichromy of the Florentine period.

THE HISTORY of the new St. Peter's begins as far back as Julius II with the idea of erecting a martyrium above the tomb of the Prince of the Apostles (see Chapter V). There was probably a competition between the most celebrated architects, which was won by Bramante. His plan on parchment in the Uffizi represents only an ideal design, for it is unrealizable from the static point of view. It consists of the grouping of two spatial systems: a Greek cross with a cupola at the center, and four small spaces covered with cupolas in the diagonal axes (these have apses only on the outer walls and so are not completely symmetrical). The system is one of geometric figures where the negative forms, like the positive, create equivalent arabesques. This concept goes back to Byzantine architecture which was well known throughout the Middle Ages in Italy, and particularly in northern Italy (for example, San Lorenzo in Milan) where Bramante lived before he came to Rome. But Bramante conceived the edifice as a real martyrium, that is, with a view to being able to move right around it; there are entrances even in the four main apses. Bramante maintained this idea in his second plan where the walls and pillars supporting the cupola are reinforced, the naves brought together

into a single bay, and the lateral parts made more symmetrical.

Giuliano da Sangallo's project (in Vienna) shows a tendency to close the edifice and to inscribe the whole plan in a rectangle with only the apses protruding. When Bramante died, the four pillars of the central cupola and the arches joining them had already been erected. He was succeeded by Raphael, with whom there appeared the idea of a compromise between the central and the longitudinal edifice. (Raphael's plan is generally identified with that of Antonio da Sangallo in 1516.) This is not, however, a return to the ancient longitudinal basilica, but the development of a longitudinal plan with Bramante's central idea as a starting point: the west part of this plan corresponds almost exactly to Bramante's second plan. The remainder of the longitudinal nave is nothing more than a rhythmic repetition of the motifs of the west part. It is more a succession of central edifices than a genuinely longitudinal one.

Among Raphael's assistants were Fra' Giocondo and Giuliano da Sangallo whose plans also show this transformation of Bramante's central plan into a longitudinal edifice. At the same time as Raphael, Baldassare Peruzzi of Siena made central plans in which one can see the transition from the rich silhouette of Bramante's plan towards a more compact silhouette heralding Michelangelo.

After the death of Raphael, Antonio da Sangallo the Younger was named chief architect (from 1520 to 1546). His project is known from the wooden model formerly in the Museo Petriano and from four engravings by Labaco. He returned to the Greek cross, suppressed the entrances in the apses, and closed the silhouette, effecting a compromise with the longitudinal plans by putting an open vestibule at the east end and lengthening the nave on this side (the old basilica of St. Peter's was unusual in being oriented to the west). As for the exterior, he was inspired by the orders of the Colosseum and the Theater of Marcellus. Inside, he applied the system of colossal pilasters.

After the death of Antonio da Sangallo the Younger in 1546, Michelangelo took the direction of the work in hand. He strengthened the four pillars of the central cupola and had the work on the

north and south apses begun. Later, in a letter (Milanesi, p. 535) he praised Bramante's project and criticized that of his immediate predecessor: "Non si può negare che Bramante non fussi valente nella architettura, quanto ogni altro che sia stato dagli antichi in qua. Lui pose la prima pianta di Santo Pietro non piena di confusione, ma chiara e schietta, luminosa e isolata attorno, in modo che non nuoceva a cosa nessuna del palazzo, e fu tenuta cosa bella come ancora è manifesto; in modo che chiunque s'è discostato da decto ordine di Bramante come à fatto il Sangallo, s'è discostato dalla verità; e se così è chi à occhi non appassionati, nel suo modello lo può vedere. Lui con quel circolo che e' fa di fuori, la prima cosa toglie tucti i lumi alla pianta di Bramante; e non solo questo, ma per se non à ancora lume nessuno . . ." ("It cannot be denied that Bramante was as worthy an architect as any since ancient times. He made the first plan of St. Peter's, not full of confusion, but clear and simple, full of light and entirely freestanding, in such a way that no damage was done to the palace and it was considered a beautiful thing, as is still evident; so that whoever departs from this order of Bramante, as Sangallo has done, has departed from the truth; and that this is so, anyone with dispassionate eyes can see in his model. With that [semi]circle which he puts outside, he first cuts off all the light from Bramante's plan; and not only that, but in itself it has no light at all. . . .")

It follows from these considerations that, according to Michelangelo, Bramante's plan was better on account of its clarity, its luminosity, and its structural independence; Sangallo's plan with the ambulatory was valueless because it was dark and because it necessitated destroying a series of buildings in the Vatican. For Michelangelo the problem of the site for the new St. Peter's lay in keeping the integrity of the complex of existing Vatican buildings, while at the same time assuring the isolation of the new church. He worked on this problem in a rapid sketch in the Codex Vaticanus 3211, a sketch which shows moreover the portico that he wanted to add at the east end, as a sort of façade. According to this plan, none of the Vatican's old buildings had to be sacrificed; they were only to be completed with respect. The memory

347

of the ancient basilica that had been sacrificed was to live on in the addition of an atrium. This rapid sketch gives indications for the reconstruction of Michelangelo's first model for St. Peter's. We learn from Vasari that after the death of Sangallo (between, therefore, September 29 and November 27, 1546 when the wooden model was started), the artist made a model to show the errors of his predecessor and to prove that the edifice could be built at much less expense. This model was made in fifteen days and cost only 25 scudi; it must be concluded that it was merely a preparatory terracotta model of the whole of the building. According to Vasari, in this model Michelangelo has simplified ("ridotto") Sangallo's church into the form "che si vede oggi condotta." And from this remark one can conclude that his first model must have been, if not identical, then at least very similar to the actual execution. These similarities can be indirectly deduced from the criticisms which Michelangelo had made of Sangallo: in his model Michelangelo must have suppressed the ambulatory which darkened the church as Sangallo had planned it. Instead of the "troppi ordini di colonne" of Sangallo, he must have used a gigantic order, and instead of the towers with their "risalti e guglie e tritumi di membri," he must have erected on the entrance side a simple portico in the antique style. Michelangelo's drawing in the Codex Vaticanus shows this first conception of the façade: it is a simple portico like that on the Pantheon. In the Feltrinelli Collection in Milan there is a drawing attributed to Etienne Dupérac which 273 seems to be a copy of this first terracotta model. The medals of Popes Gregory XIII and Sixtus V also show the portico with six columns in the style of the Pantheon. Until now these models have been considered faithful testimonies only to the cupola, while their façades were regarded as inexact, a fact which has been explained by the rapidity of the medallist's work. But it seems wrong to accept only certain details of these medals and reject the others. The two medals testify rather to the fidelity of the façade reproduced in the Feltrinelli drawing.

The creative principles of the first model can be briefly resumed thus: the fundamental form of the edifice, the square, is accentuated by the four small cupolas and by the shape of the attic, which

is still differentiated from the attic above the apses. The other parts of the edifice, the portico and the apses, are subordinated to the square. The portico differs from that of the Pantheon which inspired it by the fact that the interval between the middle columns is wider than the intervals between the others. Michelangelo has thereby accentuated the axis of the entrance. The portico has a few steps as a base and supports a powerful pediment. The apses are differentiated from the square, as we have said, by their attic, which has rounded arches instead of the massive forms of the parts which surmount the central mass of the edifice.

104

The central cupola is a synthesis of Sangallo's ribbed cupola and Bramante's round one. Its lantern does not yet have the double columns, but a simpler shape recalling the lantern of the Medici Chapel. The rich exuberance of Sangallo's forms is suppressed in favor of a sober edifice whose fundamental shape, the square, becomes immediately evident. The secondary bodies no longer hide certain parts of the central structure (as Sangallo's towers did), but accentuate it.

On the basis of the terracotta model, Michelangelo made a second, larger model in wood of the whole edifice. On the question of its genesis, we have information in the *ricordi* from November 27, 1546 until September 2, 1547. Condivi (p. 198) mentions it as having received papal praise and approval ("lodato ed approbato dal Pontefice").

274, 277, 278

The three engravings by Dupérac have been considered by many scholars to have been done from a model and this hypothesis has been sustained with the help of decisive arguments formulated by Alker. The model is probably model II, of 1546-1547, since the engravings give the whole of St. Peter's and after those years Michelangelo made no more models of the ensemble. However, in the opinion of other scholars (Körte, Wittkower, Coolidge), the engravings by Dupérac were done from many sources: the lower part from the 1546-1547 model, the cupola from the 1558-1561 model, and the façade from the drawings of the Fabrica di San Pietro.

Model II is a revision of model I and not an exact repetition of it. It is again a model of the whole edifice of St. Peter's: the lower

part of the church has, in fact, been executed according to it (only in the shape of the windows of the attic can one observe a slight difference between the project and its realization). From this time onwards, Michelangelo's interest was to be concentrated on the form of the cupola.

In the second model, the whole lower part of the edifice is conceived as a single powerful mass. In it the apses and the central *274* square are united by wide diagonal sections. By the repetition of the alternating rhythm of the lower structure and by its very uniformity, the attic no longer gives the impression of a separate *277* member, superimposed on the mass of the edifice, but of the edge of the homogeneous mass which is encircled, as it were, by the large cornice. The façade seems to be integrated into the unity of the edifice. Its columns are nearer the wall and serve only to accentuate the bays; they are no longer a separate body added to the front of the mass. The stepped base has taken up the whole width of the entrance side and has thus become, instead of a mere base for the colonnade, a part of the construction itself, while the pediment, which is reduced to the width of the four center columns, is but a discreet accentuation of the main entrance. The lantern of the cupola now has the motif of the double columns and thus appears as a reduced repetition of the drum, a sort of *tempietto*. It is indeed a little temple, because inside a floor separates it from *278* the cupola. On the outside, a kind of balcony surrounds it and is reached from the drum by means of the stairs in the ribs. The cupola is therefore like a spherical mountain with a small temple at the top. Thus the ensemble of the edifice is given a new artistic content. It consists of three different levels. Below, the mass of the building stands with all its weight, held taut from inside by centrifugal forces which on the outside are resisted by the gigantic system of pilasters backing on to the bands. Above, through the "crater" of the drum with its solid, relatively low buttresses, rises the cupola with its elastic ribs pressing against the drum yet remaining in a suspended position. At the very top, in the lantern, the form of the drum reappears, smaller and lighter, a sort of "celestial temple."

Thus, there is conflict between energy and matter below; bal-

143

ance between energy and matter in the drum at the center; and at the top, energy liberated from conflict with matter. Instead of the Renaissance principle of the grouping of geometric bodies, we see here the principle of sublimation by degrees of an animated organism. The whole of St. Peter's, as conceived by Michelangelo, is an image of the universe: the cupola was by tradition considered as a symbol of the celestial sphere and it is evidently this idea which Michelangelo wished to express in plastic terms by its suspended form above the drum and by his plans for the interior decoration; the lower part of the edifice is conceived as a symbol of the terrestrial world (J. Bony), with the four apses corresponding to the four cardinal points of the compass.

A month before having finished model II (September 2, 1547), Michelangelo asked his nephew Lionardo in a letter dated July 30, 1547 (Milanesi, p. 211) for the measurements of the cupola of the Duomo in Florence: "Vorrei che tu avessi l'altezza della cupola di Santa Maria del Fiore, da dove comincia la lanterna insino in terra, e poi l'altezza di tutta la lanterna." He was, therefore, especially interested in the relation between the lantern and the overall height of the cupola. Since model II (if Dupérac's engravings were really taken from it) shows no influence of the Florentine proportions, we must conclude that it was made according to the project in force when this model was begun (November 27, 1546). Michelangelo's interest in the cupola of Santa Maria del Fiore would therefore signify a third phase in the development of his ideas. The study of the Florentine dome was not limited to its dimensions, but extended to its form, and consequently it changed the shape of the cupola and lantern from those of model II. This is

349 confirmed by two sketches for the lantern on a sheet in the Casa Buonarroti. Instead of the round lantern with sixteen pairs of columns, here we see the octagonal form as in Florence, and instead of the conical ending, a low gored roof and a spire in the center. Only the wide, low proportions recall the earlier version.

During the next ten years nothing is known of Michelangelo's preoccupations on the subject of the cupola. On July 3, 1557, we learn from a *ricordo* that a terracotta model had been finished of the cupola only: model III. Vasari (ed. Frey, p. 224) describes it

as follows: "Diede principio e ne condusse a poco a poco un piccolo modello di terra per potervi poi con l'esemplo di quello e con le piante e profili, che haveva disegnati farne fare un maggiore di legno" ("He began and executed little by little a small model in clay, so as to be able with this, and with the plans and profiles he had drawn, to make a larger model in wood"). A sketch of the cupola with lantern in Oxford (Dussler, *Zeichn.*, 207) appears to be related to model III. The silhouette of the lantern in this sketch is almost identical to the one in the Casa Buonarroti drawing: clearly recognizable are the attic of the lantern, the low gored roof, and the spire. For ten years then, Michelangelo retained the Florentine shape for the lantern and it is likely that the third model, for which the Oxford drawing is a preparatory sketch, was crowned by a lantern of this shape. The only change to be observed between the Casa Buonarroti and Oxford drawings is that the wide, low proportions have been replaced by tall, slender ones.

A final model of the cupola in wood (model IV) was made between 1558 and 1561. Today, it is generally thought that the drum and the internal calotte of this model were identical to the model in the Vatican (Körte, Wittkower). The external calotte *281, 282* of this model for the cupola was modified by Giacomo della Porta or Vanvitelli. For its reconstruction we have as sources Vasari's description (pp. 288ff.), the *ricordi* published by K. Frey, two anonymous drawings in the Casa Buonarroti by a pupil of Michelangelo, and seven drawings by Antonio Dosio in the Uffizi. These sources do not correspond exactly with each other, but the divergences are slight. According to Vasari the internal calotte in the shape of a hemisphere was to have a thickness of 4½ palms; the thickness of the outside calotte was to decrease from 4½ palms at its base to 3½ palms at the top. The distance between the two calottes increased, according to Vasari, from 4½ palms at the base of the cupola to 8 palms at the top. To construct the profiles of the two calottes, Michelangelo took three centers forming a triangle— A : B : C—C being the center for the two profiles of the inner $\begin{smallmatrix} A & B \\ & C \end{smallmatrix}$ calotte, B for the exterior profile and A for the interior profile of the outer calotte. From Vasari's description and Dosio's drawings,

145

it is evident that the 1558-1561 version of the dome was a return
to that of the 1546-1547 model (Dupérac). But reminders of the
cupola of Santa Maria del Fiore in Florence are also visible: the
cupola of model IV is not completely identical with that of Dupé-
rac, for Dupérac shows the inner and outer calottes as pure hemi-
spheres. The center of the outer calotte is a little higher than that
of the inner, but the idea of raising the outer calotte appears only
in the last model. The lantern also differs slightly from that of
Dupérac: between the pillars and columns there is now a gallery
which was missing in model II; between the volutes above the
columns there are little niches instead of shells. According to the
ricordi, there was a balustrade, probably above the volutes. The
high plinth of the columns is suppressed and the colonnade is now
placed directly on the calotte. Preparatory sketches for most of
these elements are on a sheet of drawings at Haarlem. The motifs
are all inspired by Brunelleschi's lantern, and so this last model
of the cupola is a synthesis of the 1546-1547 version and the stud-
ies of the cupola of Santa Maria del Fiore. The recently discov-
ered drawings after the model of the dome in the Scholz Scrap-
book, Metropolitan Museum, New York (Tolnay, *Akten des 21.
Int. Kong. 1964*, II, pls. 23, 24), also show that the outer calotte
is higher than in the Dupérac engraving. (The same conclusion
was reached by Cesare Brandi, 1968.)

To sum up, Michelangelo made four models for St. Peter's:

I. A terracotta model of the whole edifice executed between Sep-
tember 29 and November 27, 1546;

II. A larger model in wood of the whole edifice, made between
November 27, 1546 and September 2, 1547;

III. A clay model of the cupola, which was fired on July 3, 1557;

IV. A large wooden model of the cupola, made between Novem-
ber 19, 1558 and November 14, 1561.

The studies of the Florentine Duomo cupola took place before
model III was begun, and its influence is visible in that model and
to a lesser degree in model IV.

The new feature of Michelangelo's final conception is perhaps
the contrast between the material mass of the edifice and the

277, 278

348

351

cupola, which detaches itself from the interior and reaches for liberty through the "crater" of the drum.

The essential elements of this Michelangelesque conflict were preserved by Giacomo della Porta in the actual building: he has 280 not suppressed the interruption between the drum and the attic of the cupola. Certain differences between the execution by della Porta and the last model correspond, nevertheless, to Michelangelo's intentions: the increase in the height of the outer calotte, the volutes in front of the plinths of the columns in the lantern, and the candelabra on these columns, are found in Michelangelo's sketches in Haarlem, and their introduction by della Porta has not 348 essentially changed the spiritual content of the cupola as planned by Michelangelo.

That these details corresponded to Michelangelo's innovations can also be deduced from the fact that the other cupolas of Giacomo della Porta, those of Santa Maria ai Monti and of the Gesù, are static octagons with a low, flattened form. The idea of raising the cupola was not, therefore, part of della Porta's artistic thinking or that of his generation, which preferred the shallow cupola. The raised, slender form returns only with the Baroque. However, in Baroque cupolas, the calotte is joined to the drum which is of relatively high, thin proportions, and the ensemble looks like a sail swollen from the inside. The conflict so characteristic for Michelangelo, between a low, muscular drum and centrifugal tension in the calotte, is suppressed.

The development of the architectural concept of St. Peter's, as we have tried to present it here, is hypothetical, based on an interpretation of written sources (Vasari) and drawings (five original drawings and several copies by Dosio and an anonymous master). This reconstruction has, in fact, been contested on several grounds. But even if one rejects the succession of the phases, there would remain the fact that Michelangelo oscillated for a long time between the idea of a hemispherical calotte (Dupérac's engraving) and a slender cupola (drawings at Haarlem, Lille, and 277
348, 350 Oxford dated 1557), and also hesitated for a long time over the form of the lantern (drawings at Haarlem, in the Casa Buonarroti, and at Oxford). But the differences between the versions 348, 349

could not have been very important since the measured drawing of the plan of the drum (Dussler, *Zeichn.*, 457) already contains, as Wittkower has remarked, the final dimensions.

276 When Michelangelo died, the south arm of the transept with its apse (the Cappella del Re di Francia) was built, the north had got as far as the vaulting, and a large part of the drum was already

279 finished, while the west apse was hardly begun. The parts completed, therefore, prove that the whole structure of the lower part of the edifice and the drum corresponds to Michelangelo's proj-

280-282 ects. Only the calotte of the cupola and the lantern were done entirely after the death of the master, between 1588 and 1590, under the direction of Giacomo della Porta. The authenticity of this part is, in fact, the most discussed, but we have seen that, although Giacomo della Porta transformed Michelangelo's projects in the decorative details and the profiles, in the main he followed the master's ideas. The slightly raised form of the cupola is due not to him, but to Michelangelo, as the latter's drawings testify. The problem most discussed is whether the raised project is Michelangelo's initial or final version. The latter hypothesis is favored by the fact that in Michelangelo's last plastic works one can observe a tendency to verticality; nor does it seem likely that Giacomo della Porta, who was constrained by the Popes to follow Michelangelo's model, would put into operation one of the master's earlier ideas. Moreover, De Stefani has recently demonstrated that the curve of the dome executed by Giacomo della Porta is identical to that planned by Michelangelo, the only difference being that the former is five meters higher at its lowest part.

In his ground plan, Michelangelo has simplified that of his predecessors. A person standing inside the church now, near the middle under the cupola, can still appreciate the artist's intentions.

283 The centrifugal forces first radiate from the center through the four "tunnels," but on reaching their furthest bounds, they flow back in the positive forms, accumulating in the four great central pillars. From there they rise and radiate upwards through the pendentives and the ribs of the cupola as far as the lantern. (Michelangelo had planned—as Körte has remarked—an inner

278 lantern, smaller than the outer; see Dupérac's engraving.) It is a

grandiose organism animated by the alternating rhythms of dilation and contraction, like the respiration of a living being. The central-plan edifice, hitherto immobile, thus becomes a dynamic space. Michelangelo probably found the origins of this conception in his drawings for the fortifications of Florence in 1529.

341-344

There never existed a definitive plan by Michelangelo for the façade of St. Peter's. But we know from a sketch in the Codex Vaticanus 3211, folio 92, and from the drawing attributed to Dupérac in the Feltrinelli Collection, Milan, that he first thought of a portico like that of the Pantheon with six columns supporting a triangular pediment (see Tolnay, *Cod. Vat.*, pp. 160f.; Thoenes, *Festschrift H. Kauffmann*, Berlin, 1968, pp. 333ff.).

273

IN 1551, the Chapter of Padua Cathedral asked Michelangelo for a design and model for their choir (see the documents in the Cathedral Archives at Padua). The project was then carried out with the help of Andrea della Valle. Building was begun in May 1552 and the church was almost finished by about 1570. The gigantic order of the Corinthian pilasters in the choir repeats the style of St. Peter's and the Capitoline Palaces, but the execution is less careful. The ensemble of the choir is grandiose. The plan of the cathedral itself with its two transepts follows the taste in church building of northern Italy and has no direct connection with Michelangelo.

301, 302

THE IDEA of the foundation of San Giovanni dei Fiorentini in Rome goes back to Julius II and Bramante, in the summer of 1508 (Nava). Leo X then supplied the decisive impulse by instituting a competition (about 1518) in which Raphael, Peruzzi, Jacopo Sansovino, and Antonio da Sangallo the Younger took part (Vasari). Except for Raphael's projects, the designs for the church by all these masters are still extant and in the Uffizi. It seems that the winner was Jacopo Sansovino, whose two drawings—attributed by Nava—in the Uffizi show central-plan edifices with four apses inscribed in a square, one of which is inspired by San Lorenzo in Milan. It was then decided that the site of the church would be near the Tiber, which necessitated the erection

of costly foundations. After Sansovino, it was Antonio da San-
gallo the Younger who took over the direction of the work, and
he made a series of plans, first central, then longitudinal. An edi-
fice reduced in size was built under Clement VII, following the
longitudinal plan and without a choir. After the Sack of Rome,
this first period of activity came to an end.

It was only under Julius III in 1550 that thought was once
more given to San Giovanni dei Fiorentini. Following the sugges-
tion of Bindo Altoviti and Michelangelo, the Pope wanted to erect
the funerary monuments of two of his Del Monte relatives in the
church. The idea was that he would have the choir built, and the
352 Florentine merchants six chapels. A plan in the Uffizi, probably
Michelangelo's project for this church (the red-chalk lines are by
his hand) shows a wide, longitudinal nave obviously barrel-
vaulted, with chapels on both sides, a transept with the tombs of
the Del Monte, and a rounded choir. Here Michelangelo took his
inspiration from the church of Sant'Andrea in Mantua, a work by
L. B. Alberti. It anticipates the Gesù type of church, and in fact
it seems that four years later Michelangelo offered the plan to St.
Ignatius of Loyola. Vignola, in his 1568 plan for the Gesù, was
inspired by this idea of Michelangelo's (A. E. Popp, 1927).

In the middle of 1559, the Consuls and Counsellors of the
Florentine nation once more considered putting the work in hand
again. At Michelangelo's request, Duke Cosimo I agreed to give
the scheme his protection. Michelangelo was asked for a design
and a model. He accepted and, while refusing an enlargement of
the surface area, completely rejected Sangallo's provisional build-
ing. According to Vasari, Michelangelo made five designs, three
353-356 of which are still preserved in the Casa Buonarroti, together with
several sketches. They all show that Michelangelo conceived the
plans for a baptismal church with the font in the center. Indeed,
the church is dedicated to St. John the Baptist. Tiberio Calcagni
was entrusted with making the terracotta model and then a
306 wooden one, which can be seen in an etching by Le Mercier
(1607) and in another by Régnard (1684) which is less exact.
For want of the necessary means, this project was not executed

either. Finally, in 1588, Giacomo della Porta built the longitudinal church which still exists today.

Michelangelo's starting point was a series of geometrical combinations evidently inspired by the central plans of Peruzzi and Antonio da Sangallo the Younger. One of the first projects (Dussler, *Zeichn.*, 143) shows a rectangle with a circle inside it which extends slightly beyond two sides. Within the circle there is an ambulatory with columns, inspired by Santo Stefano Rotondo. In the direction of the two principal axes are low walls going from the doors up to the columns of the ambulatory. — *353*

A sketch in the Casa Buonarroti shows an octagon inscribed in a square whose four sides end in apses in the direction of the principal axes. This is quite a faithful repetition of an idea of Peruzzi which Antonio da Sangallo had already imitated (in the Uffizi). More complicated, but still inspired by geometric combinations, is the drawing of an octagon with unequal sides, which in the diagonal axes is traversed by a St. Andrew's cross ending in apses (Dussler, *Zeichn.*, 142). Here the diagonal tension has the same importance as that in the principal axes. The difficulty of the cupola vaulting in such a plan is evident. On the same sheet of drawings in the Casa Buonarroti as the sketch mentioned previously, is another in which Michelangelo abandons geometric combinations for a plastico-dynamic conception. The circular form recalls the early drawing already referred to (Dussler, *Zeichn.*, 143) but here the diagonal axes are accentuated by round chapels which receive the centrifugal forces. The principal axes remain without accentuation. From this it was only a step to the final project (Dussler, *Zeichn.*, 145). The form of the circle is preserved but the conflict between the expanding forces of the empty spaces and the mass of the walls is again augmented: the forces penetrate not only the diagonal but also the principal axes. This last plan is a development of that of St. Peter's. Here too the fundamental form of the church appears as a result of conflict between the expanding forces which swell the spatial confines and the contracted mass of the walls which resist them. But while in St. Peter's the expanding forces penetrate only the four arms of the — *355 354 355 353 356*

Greek cross, and the four adjacent spaces behind the buttresses are hidden and play no artistic role, in San Giovanni dei Fiorentini, with the suppression of the four buttresses, the forces radiate from the center into all eight spaces, flowing back again even more impressively.

Seen from an imaginary point in the center under the cupola, the forces would seem to rise through the ribs along the walls and the cupola up to the lantern. To get some idea of this effect, we must consult G. A. Dosio's drawing in Modena, Biblioteca Estense (Luporini, *Critica d'Arte*, 1957, p. 458), or Le Mercier's 1607 etching representing the wooden model of the church in cross-section.

According to Vasari, Michelangelo said of this church that "nè Romani nè Greci mai ne' tempi loro feciono una cosa tale," and his remark probably refers to the dynamic conception of the whole, which gives the ribbed cupola a unity that the "monolithic" coffered cupola of the Pantheon did not have.

Finally, the difference between the treatment of the exterior and interior of the model should be noted. The former is of a studied simplicity, in contrast with the richly-articulated interior. The outer cupola does not correspond exactly to the inner; it is lower, with the cornice placed higher than on the inside; the calotte has no ribs, and is a massive body resting its whole weight on the lower part of the edifice. Inside, the same cupola is, as we have said, a synthesis of ascending forces. Michelangelo therefore treats the exterior and the interior independently, from a wish to give both aspects of the building a complete artistic autonomy. This can probably be explained by his sculptural conception of architecture.

In 1561 Pius IV gave the Carthusian order the Baths of Diocletian out of which to construct a church and cloister: Santa Maria degli Angeli. According to Vasari, Michelangelo made his plan for this project in competition with "molti altri eccellenti architetti." In the Uffizi there are still designs by Baldassare Peruzzi (Uffizi, no. 161) and Giuliano da Sangallo (Uffizi, no. 131) for the conversion of the Baths of Diocletian into a church. Both have

divided the space by a horizontal cornice into two superimposed zones and have tried to diminish the effect of the gigantic hall by the introduction of relatively small orders. Both have also separated the four adjacent spaces of the great hall with small columns. It seems that Michelangelo was the winner of the competition since it was he who was finally entrusted with the execution of this task. The work was not finished until about 1568, four years after his death. In 1749 Vanvitelli completely transformed the interior décor, disregarding Michelangelo's ideas and in many respects returning to the earlier projects of Peruzzi and Sangallo. 307 308, 309

To judge by certain contemporary sources (the manuscript of M. Catalani, Codex Vaticanus Lat. 8735, the contents of which were published by Pasquinelli, *Roma*, iii, 1925, pp. 349ff.), there can be no doubt that the orientation of the church towards the east was still the same in Michelangelo's time as it is today, and that consequently Bottari and Titi were wrong in asserting that the present orientation of the church was due to Vanvitelli's reconstruction.

Bottari and Titi assumed that the main entrance in Michelangelo's time was on the south side of the tepidarium and the high altar on the north side, whereas in fact Michelangelo's church had three entrances with three vestibules, two on the narrow north and south sides of the tepidarium, and one on the west side with a round vestibule which is the existing entrance. The four adjacent spaces of the tepidarium were still open at this time and were separated from the great hall only by low walls with doors. The presbytery and choir were in the same place as today. An idea of Michelangelo's church before Vanvitelli's alterations is given by an engraving made on the occasion of the laying of the meridian, under Clement XI (1703), that is, forty-six years before the alterations were carried out. This view corresponds to and completes Catalani's description. One can recognize in this print a few slight changes since Michelangelo (for example, the entrance to the Catalani Chapel and the small epitaph on the right side, both at the beginning of the presbytery). 307

Other changes which are not visible in the engraving are mentioned by the written sources, as for example, the erection on the

north wall of the tepidarium of the altar of St. Bruno in 1700.

307 The only decoration on the whitewashed walls of this enormous space bequeathed by antiquity was the eight colossal columns. The lateral areas, temporarily separated from the principal one by low walls, were intended to be transformed later into chapels (Bottari). Through the central east bay can be seen the presbytery and apse which were built according to Michelangelo's plans (Catalani). They form a long barrel-vaulted corridor reached by three steps and framed at either end by semicircular arches on fluted pilasters. Titi describes it as "un pezzo di larghissimo corridore e lungo che finisce in un mezzo circolo" ("part of a very broad, long corridor which ends in a semicircle"). There is an obvious disproportion between this long, narrow choir and the vast, majestic space of the tepidarium. From the artistic point of view, only the latter was important for Michelangelo. The form and dimensions of the presbytery can best be explained by practical reasons; because of its long shape, Michelangelo has succeeded in joining the church directly with the cloister, for the two small doors at the back of the choir which are visible in the engraving open directly on to the cloister. Also, this simpler, smaller area was more suitable for the devotions of the Carthusians than the gigantic space which probably served only for solemn occasions. Indeed, Vasari saw this practical side when he said that Michelangelo's plan was executed "con tante belle considerationi per commodità de' frati certosini" ("with such fine consideration for the convenience of the Carthusian friars").

309 In the great hall of the tepidarium, Michelangelo sought to preserve its antique character by keeping the colossal columns and reconstructing the ancient vaulting. The vaults seem to swell like full-blown sails overhead, held in place only by the masts of the columns. They appear not as static forms, but rather as created on the one hand by their ballooning upwards and on the other by the downward pull of the columns. In this dynamic conception, which reveals the creative forces of the architectural forms, the work is akin to Michelangelo's previous achievements. However, the relationship between the space and the walls is new: in St. Peter's and in San Giovanni dei Fiorentini we saw that to every

thrust of empty space corresponded an equally strong counter-thrust on the part of the mass. In Santa Maria degli Angeli the effect of the mass is eliminated: the limits of space are demate-rialized and the swollen sails of the vault, evoking the celestial "tent" (Isa. 40:22), do not exercise a counterthrust. Perhaps the reason is that here Michelangelo was tied down in his conception by the fact that he had only to modify an existing space, a legacy from classical times, but it is also possible that a new principle of composition was at work. The latter hypothesis is favored by Michelangelo's last composition for an interior space: the Sforza Chapel in Santa Maria Maggiore.

THE SFORZA CHAPEL was built by Cardinal Ascanio Guido Sforza. The design was by Michelangelo, but its material execu- *313-317*
tion was in the hands of his pupil Tiberio Calcagni. We do not know the exact date of this commission; Calcagni was introduced to Michelangelo in 1556, which would be a *terminus post quem.* After the death of Calcagni in 1565, the Chapel was finished by another artist, supposedly Giacomo della Porta. The plan is sur- *314*
prisingly original: the main space is covered by a sail vault sup-ported by four diagonal clusters composed of pillars and com- *316*
posite columns, which make as it were interior buttresses. On both sides are apses in the form of segments which are wider than *315, 317*
the distance between the buttresses concealing their two ends. Opposite the entrance there is a rectangular choir with a barrel vault. The effect is based on the contrast between the buttresses and the development of the curved walls. The isolation of the diagonally placed buttresses means that the dimensions of the walls and even the shape of the space escape the spectator's eye; the space appears unreal and its limits indeterminate. Indeed, Bottari said in a letter in 1748: "Non vi sembra di vedere una cosa vera, ma un'idea astratta o figurata col pensiero o veduta in sogno di un edificio, il più singolare e magnifico che sorpassi le forze del pensiero umano" ("We seem to see not something real but an abstract idea of a building, either pictured by the mind or seen in a dream; a building so singular and splendid that it exceeds the power of human thought"). It is the fluid substance

of the hollow space swelling in the middle and penetrating from the center into the apses, to flow back again towards the center, which is here the major theme of the composition. Instead of a dynamic organism, there is a movement of the ether of which the apses and the "celestial tent" of the vault seem to be only echoes. This dematerialization and suppression of conflict, already visible in Santa Maria degli Angeli, are characteristic also of Michelangelo's last sculptures and drawings.

The Chapel originally had a façade in travertine, destroyed in 1748, which opened on to the interior of the lateral nave of the church. Writers up to the eighteenth century were full of admiration for the beauty of this little façade. It can still be reconstructed
313 on the basis of two drawings, one in the Castello, Milan and the other in the Bibliothèque Nationale in Paris: it was a severe, classical structure consisting of three fields divided by pilasters and clusters of pilasters, and crowned by a triangular pediment.

WE TURN now to the secular buildings of the aged Michelangelo. Ever since the visit of Charles V to Rome in 1536, the Senate had intended an improvement of the Capitol, but the financial means for works on a large scale were lacking. It was first decided, in 1538, to transfer the equestrian statue of Marcus Aurelius from the Lateran square to the Capitol, an idea which at the time was not to Michelangelo's taste. However, the statue was temporarily erected there on a rectangular plinth recalling the old base in front of the Lateran; it was only later, in 1561, when work was started on executing the new oval plan for the piazza, that this base was
291 destroyed. In 1565, after the work was finished, an oval base was erected, no doubt from a design by Michelangelo; this must have been done by 1548 (1538 according to Künzle, but in any case before 1548), for in that year Béatrizet's engraving showing the statue of Marcus Aurelius with the oval base was published. The equestrian statues of the fifteenth century (Gattamelata, Colleoni) had very high bases suggesting funerary chambers. The one which Michelangelo designed is low, in order to increase the effect
292 of the size of the statue itself. The oval base contrasts with the rectangular slab directly supporting the statue, which seems

lighter as a result. With this small base Michelangelo has succeeded in accentuating the center of the piazza without destroying its unity, and also in enhancing the effect of the equestrian monument.

It was somewhere between 1546 and 1550 that the new double flight of steps to the Palazzo dei Senatori was built, after the old stairs and loggia on the right had been destroyed. In 1561 the balustrades were erected. Between 1561 and 1564 the convex oval in the middle of the piazza was constructed, raised all round on three steps.

293

287

In 1563 a start was made on the Palazzo dei Conservatori which was finished in 1576. Rebuilding of the Palazzo dei Senatori began the same year. Direction of the works was first in the hands of Guidetto Guidetti and then in 1564 it was entrusted to Giacomo della Porta (who, according to the documents, was already working on the Capitoline project in 1563, that is, while Michelangelo was alive). He directed the construction of the Conservatori from the beginning. The large window in the center, which was not planned by Michelangelo and which has been attributed to Jacopo del Duca, is also della Porta's work and dates from 1576 (see the documents in the Capitol Archives). The palace opposite the Conservatori (the Palazzo Nuovo) was not built until the late sixteenth and early seventeenth century.

289, 290

In 1567 the ground plan of the Capitol as designed by Michelangelo was published, and a year later the first view of the whole piazza by Dupérac appeared. Plan and elevation correspond to each other. In 1569, Dupérac published a second engraving of the view of the piazza which is not identical in detail to that of 1568 and does not seem to be as exact. In the 1568 engraving the composition is more unified. Between the three palaces there is a close relationship owing to the uniformity of the windows, which all have segmented pediments.

285

286

When Michelangelo assumed responsibility for the works, the piazza on the Capitoline Hill lacked artistic unity and had no architectural link with the city below. It had two buildings, the palaces of the Senators and the Conservators, with different façades, and a plain wall on the south side, behind which could

be seen the church of Santa Maria in Aracoeli. Michelangelo's idea was to transform this assortment into an ensemble of three completely symmetrical edifices surrounding a strongly unified piazza with a central plan. In addition, he linked the main axis of the piazza to the city below by a wide *cordonata*. The architecture of the Tuscan Renaissance had tended towards symmetrical piazzas since the fifteenth century (see Leonardo's projects for Pienza). Michelangelo applied this idea more strictly: for him symmetry was no longer to be approximate but as near perfect as possible. He also conceived the piazza as a space enclosed on all sides, and here one can recognize the same principles which guided him in his interior architecture.

Anyone coming from the narrow streets of the city and climbing slowly up the majestic *cordonata* would find at the top of the hill not chaos but a world ruled by order.

285 Michelangelo's composition is based on the opposition between the oval in the middle of the piazza and the trapezoidal space formed by the three buildings and the balustrade. Instead of subordinating the plan of the piazza to the space created by the buildings, he has given it a different shape, so that the two spaces are *287* found one inside the other. While the oval at ground level with its star-shaped decoration symbolizes centrifugal forces, in the buildings a magic centripetal force is at work. This is not a composition in perspective (in fact, the two lateral palaces diverge) but an organism animated by inherent forces. It is interesting to note that the idea for the convex oval seems to stem from the purely utilitarian gutters which were dug in the piazza, as can be seen, for example, in the earlier drawings of the Capitol before Michelangelo, in the Louvre and at Brunswick. It seems that this entirely practical and transitory detail inspired Michelangelo to transform it into a permanent form of artistic and even symbolic significance.

The idea expressed by this composition is not purely architectural; Michelangelo wished it to embody the very essence of the *286* Capitol, which signifies *caput mundi*. The convex oval in the middle of the piazza seems to be the top of the terrestrial globe, while the palaces beyond rear above it a higher sphere, a second world inhabited by the statues of ancient divinities.

Throughout antiquity, the Middle Ages, and the Renaissance, a universal notion attached to the Capitol. It was not just a Roman piazza, but the spot from which Rome, and with it the whole world, had once been governed. From the *Mirabilia Urbis Romae* of about 1142, and the *Graphia aureae Urbis Romae* of about 1155, to Renaissance Humanists like Rucellai and Poggio, this remained a living idea.

In his symbolic interpretation Michelangelo has moreover followed the aesthetic of his century, which demanded that the character of a work of art should correspond to the "quality" of the place where it is found. This is the theory of *convenienza dell'opera alle qualità dei luoghi*, expressed, among others, by Armenini and Annibale Caro.

In the façades of the lateral palaces, the Michelangelesque conception of architecture as an incarnation of conflicting forces is manifest, for the artist has almost suppressed their walls and has largely composed them of members signifying force: columns, pilasters, architraves, cornices. Verticals and horizontals meet with no transition. Later Palladio, who was inspired by the motifs of the columns on the Conservatori, transformed this severe contrast by inserting semicircular arches above the columns.

288, 289

Below, a portico with columns supports the load of a floor with tabernacle windows, but a colossal system of pilasters and bands seems to have descended on these two floors forcibly uniting them. It stops the movement and gives an immutable character to the whole. The fact that the gigantic pilasters were not conceived here as supports, but as bonds girdering the mass, is clearly indicated by the wide bands against which they are backed. Restrained by this colossal yoke, the small columns on the ground floor seem to be pushed into the corners, their Ionic capitals are painfully intertwined, as if cramped, and the position of the tabernacle windows is fixed forever. The ensemble takes on the aspect of immobility, of eternity.

THE EARLY history of the construction of the Farnese Palace is still not clear. In 1495, Cardinal Alessandro Farnese acquired the land on the Campo dei Fiori, and about 1517 (Lotz) Antonio da

Sangallo the Younger began to erect a palace there. But the work progressed very slowly. When Alessandro became Pope Paul III in 1534, only a part of the first two stories and the courtyard had been begun. Sangallo then decided to reconstruct the Palace on a larger plan. Gnoli (*Mélanges d'archéologie et d'histoire*, Ecole française de Rome, 1937, pp. 200ff.) has published a document according to which the work was started at the beginning of 1541; the new Palace was intended for Pier Luigi Farnese, Duke of Castro, the Pope's son. A letter dated 1547 from his agent, Prospero Mocchi, specifies what stage the work had reached at that point: the façade had been erected as far as the cornice. Paul III then asked the best architects in Rome to tender plans for the cornice: Pierino del Vaga, Sebastiano del Piombo, Michelangelo, and Vasari took part in this competition (Vasari). It was Michelangelo who won, a fact which deeply hurt Sangallo's pride. It was probably then that he had the letter written bitterly criticizing Michelangelo's cornice, which he describes as "barbaric," and contradicting all the laws of classical architecture and the Vitruvian canons (this letter was in general wrongly attributed to Michelangelo as criticizing Sangallo's cornice, until S. Meller showed that it was written by the *setta sangallesca* and directed against Michelangelo). On October 3, 1546, Sangallo died and

295 Michelangelo was named as the architect of the Palace. In 1547 he finished the cornice, of which a wooden model in the actual size had first been erected on one of the corners of the building. According to Vasari, Michelangelo was also the author of the large window above the entrance, and of the coat of arms above

299 it. He apparently erected the third story of the court, enlarged the
300 great hall (*salone*) and made the vestibule in front of it. Finally, he planned a bridge in the axis of the Palace to join it with the garden on the opposite bank, the Orti Farnesiani. His intention would thus have been to create a grand perspective from the Campo dei Fiori to the Trastevere. This last project was never executed.

296 The cornice, which is influenced by antique and fifteenth-century Florentine models, nevertheless differs from them greatly. It does not seem to be placed above the mass of the edifice, like an

isolated member, but is conceived as a dynamic swelling of the mass caused by the encircling frieze. The contrast of forces, between the frieze which embraces the mass and the graduated swelling of the substance above, is symbolized by the progressive increase in volume of its constituent elements: the teeth, the ovoli, and the volutes which seem to be bodies corresponding to the lions' heads in the sima. At the same time, the sima and its base constitute a limit to this process of movement. The whole of the cornice gives an effect of oppression.

The engraving by Béatrizet in 1549 shows what may be an earlier version. Here the elements are still conceived according to tradition, that is, like horizontal series of isolated forms. They are not yet the stages in a single movement. *294*

According to Vasari, Michelangelo "made the large marble window with beautiful columns of variegated marble which is above the main doorway of the Palace, with a large, very beautiful coat of arms of Pope Paul III in different marble." However, in the execution Michelangelo's project was not completely carried out. It is Béatrizet's engraving which shows his intention. The window is framed on both sides by clusters of three columns symbolizing the swelling of the mass, while the pairs of free-standing columns in the window opening and the three projections of the cornice accentuate the depth. A small balustrade, Quattrocento-like in shape, and a slender coat of arms above, contribute to the same effect. By this shape of window, Michelangelo has broken the surface rhythm of Sangallo's windows. As executed, the window was flanked on both sides by clusters of pilasters with one column and the cornice has only a single projection. The tendency to depth is thus suppressed. (The balustrades now to be seen on the balcony are nineteenth-century.) A drawing of this Palace in Munich, probably by Antonio da Sangallo, already shows above the door a large window framed by clusters of pilaster-columns, and above that, the cornice with a single projection as in the final building. It must, therefore, be supposed that these architectural forms had already been constructed during Sangallo's time and that it was decided not to replace them with forms corresponding to Michelangelo's new plan. Thus Michel- *295* *294*

angelo contented himself with alien architectural members which he tried to adapt to his own conception. He did, however, suppress Sangallo's semicircular arch to replace it with a horizontal architrave. The free-standing green marble columns in the window opening, although they already exist in Sangallo's drawing, nevertheless seem to have been done at the time of Michelangelo (note the more delicate execution of the capitals).

298 The engraving showing the courtyard of the Palace reveals that, according to Michelangelo's project, three of the second-story arcades opened on to the courtyard and five on to the Tiber, and that all five at ground level were open to the garden, creating a loggia with a fine view over the Tiber.

While in earlier Roman palaces (for example, the Cancellaria), the third story of the court was conceived as lighter than the lower floors, a concept returned to again after Michelangelo (cf. Bernini, Barberini Palace façade), Michelangelo conceived it as a sort of

299 load or attic above the two lighter floors below. This weightiness would have been rendered even more impressive by the opening of a part of the arcades underneath. In the axes of the lower orders, Michelangelo has placed on the third story clusters of

297 three pilasters, and between them windows with powerful rounded pediments which seem to float above the strange frames of the window openings. These stone frames appear to have been executed in metal and serve aesthetically to confine the openings.

VASARI asserts that in 1550 Michelangelo remade Bramante's

303, 304 small stairway in front of the exedra on the north side of the Cortile del Belvedere, by replacing his predecessor's circular stairs with a straight, double flight of steps: "In Belvedere . . . si rifece la scala, che vi è hora in cambio della mezza tonda, fatta già da Bramante, che era posta nella maggior nicchia in mezzo Belvedere. Michelangelo vi disegnò e fe' fare quella quadra coi balaustri di peperigno, che vi è hora molto bella" ("In the Belvedere . . . the present staircase was rebuilt in place of the semicircular one made previously by Bramante and set in the largest niche in the middle of the Belvedere. Here Michelangelo designed and had built the very fine square one with a *peperino* balustrade which is

there now"). However, it seems unlikely that Michelangelo's alterations were reduced to this relatively insignificant detail, and it is more probable to suppose that they included, if not the composition of the ensemble of terraces, then at least the unification of the other stairways. This hypothesis seems to us to be confirmed by a drawing (attributed to Dupérac) in the Feltrinelli 305 Collection which shows a view of the Cortile looking north. The stylistic resemblance between the great central stairs and those of the Palazzo dei Senatori, the motif of the spheres familiar from the Porta Pia, but above all the indissoluble unity between the central stairway and the upper, which Vasari himself attributes to Michelangelo, seem to us to argue in favor of Michelangelo's authorship of the whole. The general disposition of the two terraces with three stairways already existed in Peruzzi's project (Windsor), but each stairway was there treated as a separate entity. It was Michelangelo who had the idea of unifying the three stairs to form a whole which is independent of the rest of the architecture of the Cortile. By virtue of this vast conception of terraces and stairways in the Belvedere, Michelangelo was the creator of the architecture of terraced gardens which was to have so great a future in Italy, France, and Germany from the end of the sixteenth century to the eighteenth.

ACCORDING to Vasari, Pope Pius IV asked Michelangelo to remodel the gates of Rome, and Michelangelo apparently made numerous designs; only the Porta Pia, however, was built according to his plan. It was in 1561 that Michelangelo took up the problem, and Vasari states that he made three projects from which the Pope chose the least expensive. The actual works were directed by P. L. Gaeta; the coats of arms were sculpted by Jacopo del Duca. The architecture of the gateway remained unfinished and old prints of the eighteenth century show that in fact the superstructure was then only half built. It was not until 1853 that Pius IX had this completed according to a neo-Baroque project, which was inspired by the Porta del Popolo and has nothing to do with Michelangelo's idea. Several of the master's sketches are still preserved at Haarlem and in the Casa Buonarroti. There is also a

medal of Pope Pius IV (Bonanni, I, p. 270) showing a different project, probably one of the three which the artist had presented to the Pope. Here the opening is terminated by a broken-segment *358* pediment (a drawing in the Casa Buonarroti—Dussler, *Zeichn.*, *357* 134—shows the same project). In another sketch in the Casa Buonarroti (Dussler, *Zeichn.*, 128 and 473), it is crowned by a broken triangle. This sketch is probably for the second project *310, 312* presented to the Pope. In the final execution one can see a synthesis of the two types: a broken segment beneath a triangle. If one looks on the opening as enclosed by the rustic jambs, the whole of the upper part appears as a unity, a sort of crown whose teeth bite into the capitals of the pilasters; but if one considers the architectonic forms independently of the jambs, if one follows the movement of the members, then the ascending forces of the pilasters penetrate the architrave as far as the segment where they break up and twist into volutes. As a result of the gradual enlargement of the forms towards the top, this breakdown of forces appears to be a necessity inherent in the forms themselves; the triangular pediment is not the cause of movement being stopped, but only an exteriorization of the forces' internal limits. The city gate, instead of being a way that opens, becomes a symbol of the ineluctable defeat of the life force: an enormous *memento mori* looming up before the passer-by.

310 The authentic shape of the superstructure is known only by an engraving dated 1568. In this the pinkish-yellow brick wall makes *311* a discreet background which, with its relatively small windows, increases the illusion of grandeur in the opening. With its battlements, this architecture goes back to the medieval idea of fortified town walls and gates. The superstructure with its triangular pediment is here only a discreet echo of the architecture of the opening.

By virtue of its closed, stern character, further accentuated by the mask on the architrave, this gateway recalls the entrance to Dante's Hell: "Per me si va nella Città dolente" ("Through me you enter the city of sorrows").

MICHELANGELO's architectural works were judged by his contemporaries in two different ways. On the one hand, they were

vehemently criticized by the Vitruvian classicists: his forms were treated as the bastard offspring of antique systems, his conception as barbaric. "Qui si vede . . . dispensato ogni cosa a caso, e secondo il cappriccio" ("Here you see . . . everything dealt with at random and according to caprice") : such was the judgment expressed in a letter written by Giovanni Battista da Sangallo il Gobbo (Milanesi, p. 500), which reported the criticism of Antonio da Sangallo the Younger of the cornice on the Farnese Palace, as S. Meller has shown. But the Mannerist group of architects was full of admiration. According to Vasari, it was one of Michelangelo's greatest glories to have opened up new perspectives in architecture, in contrast with antiquity, with Vitruvius and his contemporaries: "Gli artefici, gli [*scil*. Michelangelo] hanno infinito e perpetuo obbligo, avendo egli rotti i lacci e le catene delle cose che per via d'una strada comune eglino di continuo operavano" ("Artists are infinitely and forever indebted to him [Michelangelo] because he broke the ropes and chains of the things that they used continuously and in common"). Elsewhere he says that "nella novità di sì belle cornici, capitelli, . . . fece assai diverso da quello che di misura, ordine e regola facevano gli uomini, secondo il commune uso, e secondo Vitruvio e le antichità" (ed. Milanesi, VII, p. 193; "in the innovation of his beautiful cornices, capitals, . . . he worked with great diversity where others were working by measure, rote, and rule, according to common usage and following Vitruvius and the ancients"). Evidently the feeling here, as in the previous quotation, was that there had been a break with tradition and the beginning of a new style in architecture.

This break, however, does not mean a complete absence of links with what had gone before. Roman antiquity, which his contemporaries took as a model, and the Gothic Middle Ages, which sometimes survived unconsciously in their work, were majestically integrated by Michelangelo in his new and personal style. Antiquity for him no longer signified, as it did for Bramante, Giulio Romano, Peruzzi, and the Sangallo family, a system of canonic orders, but the domination of gigantic masses. It was not the Colosseum or the Theater of Marcellus that were Michelangelo's models, but the Baths, the Basilica of Maxentius, and the Pan-

theon. The antique aspect in St. Peter's, San Giovanni dei Fioren-
tini, Santa Maria degli Angeli, and the Capitol is not so much the
external order—he uses the individual forms in a different way
from that of antiquity—but the substance of the building's plastic
body and its colossal dimensions. For Michelangelo Gothic was a
ferment not to enrich classical sobriety with bizarre forms, as in
the towers of Bramante and Sangallo, but to animate the "antique"
architectural members with an inner dynamism.

He applied the order of antique pilasters to the outside of his
edifices not as a symbol of supports and weights, but as bands
binding the masses (St. Peter's, San Giovanni del Fiorentini, the
Capitol). Consequently, the apses of St. Peter's recall those of
medieval buildings in which the classical tradition survives in the
masses, although these are already contained by a system of gen-
uinely medieval bands (as, for example, the apses in Parma and
Verona), or those of Renaissance edifices which are still but-
tressed in the Gothic style (for example, Como Cathedral). The
difference lies in the fact that with Michelangelo neither the mass
of the edifice nor the system of buttressing are the remains of a
tradition, but two elements used in a conscious and sovereign man-
ner. In this way, his buildings acquire a character of balance and
necessity which was lacking in earlier structures. The medieval
element also plays an essential role in his most important interiors.
The inside of San Giovanni dei Fiorentini is basically only the
Pantheon seen through an edifice like the Baptistery at Parma.
Here the vertical ribs, unknown to antiquity, derive from the
architecture of the Middle Ages. The fundamental conception of
the interior of Santa Maria degli Angeli, which is determined by
the vaults and not the walls, also seems to be a heritage from the
Middle Ages. From Sant'Ambrogio in Milan to Verona Cathedral,
this method of constructing the interior is often to be found in
medieval architecture, especially in Northern Italy; the same prin-
ciple also governs buildings certainly known to Michelangelo, like
Florence Cathedral, Santa Maria Novella, and Or San Michele.
Even the cornice of the Farnese Palace, which is strictly antique
in its individual forms, is akin in its ensemble to the cornices of
the Middle Ages: for it is not a horizontal covering, but a vertical

crowning of the mass of the edifice, recalling the battlements of the medieval palaces in Florence (Bargello, Palazzo Vecchio). It is true that it is not, as in the latter case, fixed to the exterior mass of the building, but seems to be an emanation of the mass itself. Nothing is more indicative of the importance of the Middle Ages in Michelangelo's final architectural style than the Porta Pia which, instead of belonging in type to the antique triumphal arch, repeats the idea of medieval crenellated city gates.

In antiquity, Michelangelo discovered the substance of the body of the building, and in the Middle Ages the dynamic function of its architectural members. But into the rigid mass of the classical edifice he breathed a living force, while to the dematerialized functionalism of the Middle Ages he gave the role of embracing and binding the mass.

This new function of mass and force led him to conceive the edifice as an organic body animated by the vital forces which govern the universe. And since man is nothing but the image of the macrocosm, Michelangelo was able to express himself thus in one of his letters: "È cosa certa che le membra dell'architettura dipendono dalle membra dell'uomo" (Milanesi, p. 554; "It is certain that architectural members depend on the members of man"). This conception of the edifice as a reflection of the harmony of the universe goes back to antiquity and is found in Vitruvius (Book III, ed. Kröhn, p. 59). The theoreticians of the early Renaissance, Filarete and Alberti, speak only of a proportional correspondence (*commensus responsum*) between the architectural members of the temples and the human body. Michelangelo, on the other hand, refers to a dependence (*dipendenza*) between the human body and the architectural members. This idea is already anticipated, under the influence of Leonardo, by the *Divina proporzione* of Fra' Luca Pacioli (ed. Winterberg, p. 138) which speaks of a *derivazione* of the architectural members from the human body.

The architecture of the Italian Renaissance, from Brunelleschi to Bramante, conceives the edifice as an envelope for man. For the first time since Greek antiquity, building dimensions harmonize with the dimensions of man. The architectural members are used to give the effect, illusory though it may be, of a clear, rational

articulation, as a result of which the spectator has the impression that he himself could construct the edifice. However, the true static conditions are completely different from this artistic, rational interpretation. Baroque architecture, on the other hand, takes its starting point from the actual space filled by the atmosphere. It conceives the edifice as an element of the landscape. It dissolves the substance of the mass, and twists the forms so that they are penetrated by the air and enveloped by light and shade; it even opens up interiors by an illusionist trick, as if they formed an indissoluble unity with infinite space. For the Baroque, architecture is an element of atmospheric space. Assimilated by the universe, it has ceased to be an autonomous sphere.

Michelangelo's buildings are neither envelopes for man, nor decorative elements of the infinite space of the universe, but autonomous entities, symbol-images of an essential world, animated by the forces of the macrocosm. The architects of the Italian Renaissance, like Alberti, had already sought to imprint the "sweet harmony" of the macrocosm on their edifices, through the ratio of proportions. But the effect is that of a harmony composed solely for man's delight, and the cosmic aspect is not apparent. Michelangelo abandoned the proportional ratios of the Renaissance to bring out more forcibly in his architecture the cosmic aspect to which man is subordinate.

Between the two periods of the Renaissance and the Baroque, both oriented towards the empirical world, Michelangelo's architecture marks a renewal of the medieval tendency to create in buildings a metaphysical universe, but at a time when belief in the Beyond, in the medieval sense, had disappeared. That is why, instead of the celestial realm of the cathedrals, Michelangelo's buildings incarnate the true reality of the universe: Plato's οὐσία.

ages has been, through an analysis
l content of Michelangelo's art and
ge.

d 1951, but based on preparatory
925 on, this book first appeared in
d in French in Paris the same year.
he Italian version, while a second,
was published in 1970. The most
search, both by the author and by
porated in the present English edi-
on new photographic material.

ss his special thanks to the staff of
d to its director, Mr. Herbert S.
oodhouse for her translation of the
g of Princeton University Press for

Charles de Tolnay

Casa Buonarroti, Florence
December 1971

At the time of going to press, the Bibliography has been
updated to the end of 1973 and certain additions have been made
to the text. Ch. de T.

BIOGRAPHICAL NOTE

AMONG contemporary biographies, the most dependable is the one by Michelangelo's pupil and friend, Ascanio Condivi, published in 1553. The richest, liveliest portrait is painted by Vasari, whose first edition was published in 1550; his second edition, in 1568, was augmented and completed by the information given in Condivi's biography and other sources. A brief summary of the biographical dates is to be found in Benedetto Varchi's funeral oration (1564). Since the last quarter of the nineteenth century, the publication of archive documents, Michelangelo's correspondence, his poems and the contracts for his works, has allowed the profiles drawn by contemporary biographers to be retouched.

Michelangelo (Michelagniolo di Lodovico di Lionardo di Buonarroto Simoni) was born on March 6, 1475 in Caprese, Valle della Singerna, now called Caprese Michelangiolo. His father, Lodovico di Lionardo Simoni, was then *Podestà* of Caprese and Chiusi (later for a time *Ragioniere della Dogana*). Michelangelo's mother was called Francesca di Neri di Miniato del Sera. He lost her when he was six, and this premature loneliness probably influenced certain somber traits in his character. Of the five sons of this marriage, Michelangelo was the second. The Buonarroti Simoni family was of old Florentine stock and belonged (with only a few exceptions) to the Guelphs. The first known ancestor, Bernardo, lived in Florence about 1138. Michelangelo was proud of this ancestry and often said: "Noi siamo cittadini discesi di nobilissima stirpe" (Milanesi, p. 197). The family had lived since the thirteenth century in the Santa Croce quarter, for which Michelangelo himself retained a predilection. When he was in Florence he preferred to live there, and later bought several houses in the district. Most of the Buonarroti had been in a trade like the Arte della Lana, or were money-changers. The sole exceptions were a soldier and a Dominican friar (Fra' Bene, who died in 1344); documents reveal that the family retained links with the

Dominicans in the fifteenth century. There is no artist known in the family before Michelangelo.

During the second half of the fourteenth and the first half of the fifteenth century, the financial situation of the Buonarroti was a flourishing one; their social rank was high during this period, since numerous members of the family figured among the *Priori* of Florence and the *Buonomini* of the Santa Croce quarter. However, with Michelangelo's grandfather, Lionardo, there began a financial decline, caused chiefly by the large dowry of his eldest daughter. One of Michelangelo's declared aims in life was to restore the family fortunes. What is more, he succeeded, leaving a large inheritance to his nephew, Lionardo; he also raised the family socially into the Florentine aristocracy by marrying his nephew and niece into the Ridolfi and Guicciardini families. To assure his material situation and that of his family, he kept buying property in Florence and land round about from January 1506 onwards. He also saved money which he deposited in Florence at the Hospital of Santa Maria Nuova. He helped his family, too, by gifts of money, and in July 1513, he bought a shop (*bottega*) for his brothers. As for himself, he spent little and led a very sober life.

Michelangelo's father first wanted him to study under the humanist Francesco da Urbino (Condivi), but the inclination towards art was already apparent and, encouraged by his young artist friend Francesco Granacci, six years his senior, Michelangelo used to draw and even to frequent the studio of the Ghirlandaio brothers. On April 1, 1488, he was apprenticed to Domenico and Davide Ghirlandaio for a period of three years. The contract between the artist's father and the Ghirlandaio brothers is quoted by Vasari. In their studio Michelangelo made drawings after the works of older masters (Giotto, Masaccio), after Ghirlandaio, and from nature, drawings which surprised his master and which, according to Condivi, aroused his jealousy. However, at the end of a year, in 1489, probably in the spring, Michelangelo left the Ghirlandaio studio to continue his studies in the Giardino of the Casino Mediceo, near San Marco, a sort of *école libre*, the artistic director of which was the sculptor Bertoldo di Giovanni,

the pupil of Donatello. It was probably then that Michelangelo discovered his taste for sculpture. He made some small terracotta figures and the marble Head of a Faun in the classical style (all of which have been lost). According to Vasari, it was at this time that Torrigiani broke his rival's nose. In any case, Michelangelo felt himself marked, and he suffered from his "ugliness" until the end of his life.

Noticed and protected by Lorenzo the Magnificent, Michelangelo was his guest from 1490 until Lorenzo's death in April 1492, and lived in his palace on the Via Larga. It was probably there that he met the circle of humanists who surrounded the Magnificent: Poliziano, and no doubt also the Neoplatonists, Ficino, Benivieni, Landino, and Pico. It was then that he created the Virgin of the Stairs and the Battle of the Centaurs.

With the death of Lorenzo the Magnificent (April 1492), Michelangelo returned to his father's house and carved a wooden Crucifix for the Prior of Santo Spirito in acknowledgment of the fact that the latter procured bodies for him to dissect, thereby enabling him to study anatomy. It was at this time that he made his first free-standing marble figure, a Hercules, larger than life-size, on his own initiative, probably to attract attention to his talent and to find himself a new patron. It was during this period (1493-1494) that he seems to have followed at Santa Maria del Fiore the fiery sermons of the Dominican Savonarola, which impressed him deeply and determined his future religious concepts.

Foreseeing the political troubles which were soon to lead to the fall of the Medici, Michelangelo fled before October 14, 1494. He went first to Venice, where he stayed only a short time, and then to Bologna, where he spent about a year (until approximately the end of 1495) as a guest of the Bolognese nobleman Gianfrancesco Aldovrandi. The artistic activity of his stay is limited to three statuettes on the tomb of St. Dominic, which reveal the inspiration of the works of Jacopo della Quercia in San Petronio. He also took to literary studies, reading in particular the great poets of the *lingua volgare*, Dante, Petrarch, and Boccaccio.

Stability was restored in Florence with the Republic of Savona-

rola, and at the end of 1495 Michelangelo returned. But he stayed only about six months, until June 1496, probably because he could find no commissions. He executed only two statuettes, both of children, a San Giovannino (the young John the Baptist), and a Sleeping Cupid.

Michelangelo's first stay in Rome dates from the end of June 1496 until the spring of 1501. His patrons were Cardinal Raffaele Riario, Jacopo Galli, who bought his Bacchus, and Cardinal Jean Bilhères de Lagraulas, who commissioned the Pietà now in St. Peter's. A cartoon of a Stigmatization of St. Francis for San Pietro in Montorio has been lost. Probably even earlier than the Bacchus is the Venus with Two Cupids (Florence, Casa Buonarroti). There seems to have been no relationship between the artist and the Curia of Alexander VI. The fruits of this stay were to be visible only in his Florentine works.

The first great creative period is marked by Michelangelo's stay in the Florentine Republic from the spring(?) of 1501 until that of 1505. The young artist was already famous, his reputation was established, his name appeared in print for the first time (Pomponio Gaurico, *De Scultura*, January 1504). His patrons were now the magistrates of the City-Republic (the Gonfalonier Pietro Soderini was his friend), the Opera del Duomo, and the powerful corporations (the Arte della Lana). He developed his classical style in the heroic figures of the marble David (1501-1504), the Bruges Madonna, the *Doni Madonna* (1503), and the cartoon of the *Battle of Cascina* (1504). At the same time, there was competition with Leonardo da Vinci, whose *St. Anne* inspired one of his drawings and several of his early works representing the Virgin. Donatello supplied the inspiration in his bronze David for Pierre de Rohan, Maréchal de Gié, now lost.

Under the pontificate of Pope Julius II, a character akin to Michelangelo in the boldness of his views and his fiery temperament, a new era began for the art of the Renaissance and of Michelangelo. This great patron gathered the best artists of all Italy around him in Rome, and his attention was quickly drawn to Michelangelo's talent by Giuliano da Sangallo, the architect of the Vatican.

In March 1505, the Pope invited Michelangelo to Rome to begin work on his funerary monument which was to surpass even the ancient mausolea. The artist threw himself enthusiastically into this task, going immediately to Carrara for eight months to have the necessary marble extracted, and in December 1505 he returned to Rome, to await impatiently the arrival of the stone. His workshop was near St. Peter's, behind Santa Caterina. Meanwhile, however, the Pope had changed his mind and was now thinking of having the new St. Peter's erected by Bramante, abandoning the commission for the tomb. It seems that as compensation he wanted to give Michelangelo the work of painting the vault of the Sistine Chapel, a project already mentioned in May 1506 (Steinmann, *Sixt. Kap.*, ii, p. 695). Michelangelo was not received at the papal court when he came to ask for the money necessary for the monument; he was hurt and on August 17, 1506, the eve of the solemn laying of the first stone of the new St. Peter's according to Bramante's plan, he fled to Florence where he stayed until the month of November. Through Giuliano da Sangallo, he offered to work the stones for the Pope at Florence. The St. Matthew probably dates from this time. At the end of November 1506, there was a reconciliation between Julius II and Michelangelo at Bologna, reconquered by the Pope. The artist was asked to execute the model of a colossal seated statue in bronze of Julius II for the façade of San Petronio. The wax model was ready in April 1507, and the monument erected in February 1508 (to be destroyed in 1511).

In March or April 1508, Michelangelo was in Rome and there Julius II commissioned him to paint the vault of the Sistine Chapel *a fresco*; the contract (now lost) was dated May 10, 1508. He worked on this reluctantly from the summer of 1508 until October 31, 1512. It was a solitary period of his life, devoted almost exclusively to his task. At the same time, Raphael was working on the Stanze and transformed his style under the influence of Michelangelo's frescoes. After the completion of the Sistine Ceiling, Michelangelo intended to finish the Tomb of Julius II. In February 1513, the latter died and in May 1513 the artist signed a second contract with his heirs. In that year he executed the

Rebellious Slave (Milanesi, p. 391) and probably the Dying Slave, and between 1515 and 1516 the Moses. He worked in his house at the Macello dei Corvi, near the Foro Traiano (his property since 1513 and until his death). At this time, 1513-1516, the artist was a member of a small Florentine group in Rome which met at regular intervals to dine: Giovanni Gellesi, Changiano, Giovanni Speziale, Bartolommeo Verrazzano, and Domenico Buoninsegni. In July 1516, there was a third contract for the Tomb of Julius II, with a view to a smaller monument.

Meanwhile, Leo X had been elected pope (March 1513-December 1521). The second son of Lorenzo the Magnificent, he had known Michelangelo well ever since his youth. In December 1515, as a sign of his friendship for Michelangelo, he conferred on Buonarroto, one of the artist's brothers, the title of Conte Palatino, with permission to insert one of the Medici palle with three lilies and the papal monogram on his coat of arms. Leo X himself preferred the harmonious art of Raphael to the powerful art of Michelangelo. Despite, however, keeping the latter away from his court, which was Raphael's domain, he was unwilling to lose Michelangelo's services and asked him to undertake a large-scale work in Florence: the façade of the Medici family's parish church and burial place, San Lorenzo (September-October 1516?). Michelangelo accepted, reluctantly at first; then he started making models with enthusiasm (May-December 1517). The contract dates from January 19, 1518, and was already annulled in March 1520. During this period Michelangelo, far from Rome, was kept up to date on the events of the Curia, the artistic life of the papal court, and on Raphael's works by his friends Leonardo Sellaio and Sebastiano Luciani, later called del Piombo, who represented his interests in Rome at the time. His friendship with Sebastiano del Piombo began in 1515 or 1516 and lasted until 1533, when it ended lamentably.

Michelangelo spent the years 1516-1517 mainly at Carrara, and 1518-1519 at Pietrasanta near Seravezza (Florentine territory where new marble quarries had been discovered), in order to procure the marble necessary for the façade of San Lorenzo. He widened a road between Carrara and Seravezza (April-September

Autograph manuscript of Michelangelo's sonnet on the painting of the Sistine Ceiling ("I'o già facto un gozo in questo stento"—"Already I have grown a goitre in this drudgery"), with marginal sketch of the artist at work; ca. 1508-1512.
Florence, Archivio Buonarroti

Three menus written and illustrated by Michelangelo, 1518.
Florence, Archivio Buonarroti

1518). The exploitation of Pietrasanta was to render the Pope independent of the lords of Carrara, which is why he insisted that Michelangelo should use it. But this meant a conflict for the artist with his undertakings vis-à-vis the people of Carrara, and led to a series of difficulties for him. In 1518-1519 he had three workshops in Florence: one in the Via Mozza (now Via San Zanobi), one near San Lorenzo, and one on the Piazza Ognissanti.

In 1519 the artist took up again his work on the Tomb of Julius II. In October of that year he offered to execute in Florence, free of charge, the tomb of Dante, of whom he was a great admirer (Gotti, II, p. 82). It was at this time, between the second half of 1519 and December 1521, that he did the second version of the Risen Christ in Santa Maria sopra Minerva, the first version of which had been started in June 1514 and never finished.

The real reason for abandoning (temporarily) the façade of San Lorenzo was no doubt the lack of funds in the papal treasury. Cardinal Giulio and Leo X consequently wanted to bind Michelangelo to a less costly undertaking. This was to complete a chapel in San Lorenzo and transform it into a burial chapel for four members of their family, the two *Magnifici*, Lorenzo and his brother Giuliano, and the two last male members, Lorenzo, Duke of Urbino, and Giuliano, Duke of Nemours. But the artist was offended and at first refused the task. In November 1519, he finally assumed direction of the work on the Medici Chapel (G. Corti and A. Parronchi).

On April 6, 1520, Raphael died and Michelangelo's Roman friends, especially Sebastiano del Piombo, urged him to come to Rome, since the road to the Vatican was free. Michelangelo, however, wished to stay in Florence.

It was probably in November 1520 that Michelangelo did the first plans for the architecture and the statuary decoration of the Medici Chapel. He asked to be freed from the Tomb of Julius II, but afterwards accepted his new task unconditionally, like the façade of San Lorenzo earlier. Simultaneous execution of two great works was again to lead to conflict.

Later (1524) Clement VII wanted the tombs of Leo X and of himself also to be placed in the Chapel, but this was never done.

Michelangelo devoted himself to work on the Medici Chapel from 1519 until about 1527 and from 1530 to 1534. At the same time, the Pope also entrusted him with the execution of the Laurentian Library (1524-1526, 1530-1534).

Under Hadrian VI (January 1522-September 1523) the heirs of Julius II demanded the restitution with interest of the money already paid to Michelangelo or the immediate completion of the Tomb. They repeated this demand several times, and in 1525 (April) they threatened Michelangelo with a lawsuit. The artist admitted being at fault and wanted to sell what he had done and pay back the money. However, in the autumn of 1526, he had the idea of reducing the monument to one like the fifteenth-century tomb of Pius II and Paul II. He submitted a project along these lines, which had a catastrophic effect on the heirs; again they threatened court action. Michelangelo then asked the Pope to allow him to work exclusively on the Julius Tomb, but Clement VII refused. Michelangelo's friend in Rome, Giovanni Francesco Fattucci, *cappellano* of Florence Cathedral, acted as his agent during these negotiations and continued to look after his affairs in Rome.

At the same time he did the projects for the Hercules and Antaeus (1525) and for the ciborium of the choir of San Lorenzo (October 1525). In May 1527 the Sack of Rome by the imperial forces took place, and Clement VII was imprisoned. In Florence the Medici party was dismissed and the republican regime instituted (May 1527). The artist, who was a republican by tradition, put himself at the disposal of the republic and directed the fortification of the town against the army of the Pope and the Emperor. In 1528 he was overcome by grief at the death of his favorite brother, Buonarroto. In January 1529 he was named a member of the Nove della Milizia and in April, governor-general in charge of the fortifications. He was sent on a mission to Ferrara (July-August 1529) to study the famous fortifications there. Duke Alfonso d'Este received him with honor and asked him for a work; in response, Michelangelo executed a cartoon for a painting of *Leda* (about 1530).

Sensing the treachery of Malatesta Baglioni, the governor-

general of the Florentine Republic, Michelangelo fled in a moment
of panic to Ferrara and Venice towards the end of September
1529, and the republic declared him a rebel (September 30,
1529). The city was besieged from October 10, 1529 by the
united armies of the Pope and the Emperor, but nevertheless
Michelangelo returned to Florence in November and behaved val-
iantly during the siege. On August 12, 1530, the Florentine
Republic, betrayed by Baglioni, capitulated: Clement VII was
once more master. The artist hid in the tower of San Niccolò
(Vasari), but was soon magnanimously pardoned by Clement VII
(August 1530). He had to take up his work on the Medici Chapel
again, and was forced to make a sculpture (the David-Apollo)
and the plan of a house for Baccio Valori, the Pope's commis-
sioner. He executed the cartoon of *Noli me tangere* (October
1531) for the Marchese del Vasto, and one representing *Venus
and Cupid* for Bartolommeo Bettini. He also did the project for
the Medici reliquary tribune at San Lorenzo (October 1531-July
1533). In April 1532, there was a new contract with the heirs of
Julius II concerning his Tomb, which it was decided to erect in
San Pietro in Vincoli. It was no doubt for this project that Michel-
angelo made the Victory (ca. 1530-1532), and a little later, the
Four Slaves in the Accademia and the one in the Casa Buonarroti.

It was probably in the summer of 1532 that he met the young
Roman nobleman whose beauty is celebrated by his contempo-
raries: Tommaso Cavalieri. Passion rejuvenated Michelangelo,
and he wrote love letters and moving poems inspired by Platonic
ideas (Frey, *Dicht.*, XLIII, XLIV, XLV, XLVI, L, LI, LII, LV, LXIV,
LXV, LXXVI, LXXIX). As gifts for Cavalieri he made drawings of
mythological subjects, which at the same time were symbols of
his love: *Ganymede, Tityos, Phaeton* (in three versions), *Saet-
tatori* or *Arcieri,* and *Infant Bacchanalia.* This friendship lasted
until the artist's death. As a result of his passion Michelangelo no
longer wanted to live in Florence and he decided to settle perma-
nently near Cavalieri in Rome. This voluntary exile probably had
political motives apart from reasons of sentiment: the old repub-
lican had no wish to live in a Florence transformed into a Grand
Duchy of the Medici. Later, however, the reasons for his exile

became religious: he felt himself morally obliged to stay in Rome until St. Peter's was finished. A return to Florence was nevertheless among his plans towards the end of his life: in 1554 he expressed the desire to be buried near his father in his native town. In the summer of 1534, his father, Lodovico, died at the age of ninety-one; Michelangelo was at his side.

By chance, the death of Clement VII coincided with Michelangelo's definitive establishment in Rome. Around 1534 we find him there in a highly cultivated and socially distinguished circle which included the main figures of the *fuorusciti*, Cardinals Ridolfi, Salviati, and Gaddi, and Bartolommeo Angiolini, a man of letters whom he had known since 1521. Besides Sebastiano del Piombo, there were relationships with other artists; we may note the names of Andrea del Sarto, Pontormo, Giovanni da Udine, Antonio Mini, Jacopo Sansovino, Benvenuto Cellini, Montorsoli, Silvio Falconi, Vittorio Ghiberti, and Valerio Belli.

With the pontificate of Paul III (October 1534-November 1549), who liked and admired Michelangelo, an extremely productive period opened for the artist, and he rose to the highest ranks of society. The Farnese Pope was a humanist and lover of the arts like his Renaissance predecessors; at the same time he was a man of religious spirit and a reformer of the Church. He raised to the cardinalate men of high culture and great moral probity, like Sadoleto, Contarini, Carafa, etc. In confirming the institution of the Jesuits (1540) and in establishing a supreme tribunal against heretics (1542), he was the initiator of the Inquisition and the Counter Reformation movement which, however, remained moderate during his pontificate. The sober atmosphere of this is reflected in the works of art done during the period. Paul III first asked Michelangelo to decorate the two end walls of the Sistine Chapel with a Fall of the Rebellious Angels (never done) and the *Last Judgment*. The cartoon for the latter dates from the autumn of 1535, the fresco was begun in April-May 1536, and finished in November 1541. It is a gigantic work, the importance of which cannot be overestimated in the religious history of the sixteenth century. At the same time Michelangelo executed a bust of Brutus at the instigation of his friend, the Floren-

Michelangelo aged 60, 1534, artist unknown.
Rome, Private Collection

tine republican Donato Giannotti, for another Florentine exile, Cardinal Ridolfi.

In general one can observe that his friends in Rome were often recruited from among the Florentine exiles: for example, Niccolò Martelli, Luca Martini, Roberto Strozzi, and especially Luigi del Riccio, a descendant of a noble Florentine family in exile who looked after Michelangelo's affairs and took care of him when ill, and with whom the artist exchanged ideas on politics. Del Riccio's nephew, Cecchino Bracci, was a boy of great beauty who died very young (in 1544) and whom Michelangelo adored. His relations with Vasari and with the Florentine academician Varchi were more formal. Henceforth a worldwide celebrity, his correspondents included the most influential personalities of his day: the Pope, Duke Cosimo I de' Medici, King François I, Catherine de' Medici, etc.

It was in 1536 or 1538, during the execution of the *Last Judgment*, that Michelangelo made the acquaintance of Vittoria Colonna, widow of Francesco d'Avalos, Marquis of Pescara, a noble spirit, full of religious fervor. His friendship with this extraordinary woman inflamed and deepened the artist's faith, and his spiritual conversion dates from this time. Vittoria Colonna was familiar with the ideas of Juan Valdès and was in contact with his circle: Ochino, Pole, Giulia Gonzaga, etc. It was probably through her that Michelangelo adopted the doctrine of justification by faith alone, as certain of his letters and poems testify. The conversations between the artist and the Marchesa at San Silvestro in Monte Cavallo in 1538 were freely reconstructed some ten years later by Francisco de Hollanda in his *Dialogues*. Michelangelo addressed a series of moving religious poems to the Marchesa, and made her several compositions on religious subjects (*Christ Crucified, Pietà, Christ and the Samaritan Woman*, etc.).

After the *Last Judgment* Michelangelo hastily finished the Tomb of Julius II (1542-1545), which he transformed into a purely religious monument; and he decorated the Pontiff's private chapel, the Pauline Chapel, with two frescoes, *The Conversion of St. Paul* (1542-1545) and *The Crucifixion of St. Peter* (1545-1550), which are at the same time personal confessions. Michel-

angelo's activity as an architect under Paul III was also important: he completed the Farnese Palace (1546), and from 1546 onwards undertook the planning of the Capitol and St. Peter's of which he was named architect-in-chief in 1547; both these were finished after his death.

Julius III (1550-1555) was an ardent friend of the Jesuits, and one of the presidents of the Council of Trent; at the same time, he was a hedonist in the style of the great popes of the Renaissance. During his pontificate Michelangelo did the projects for San Giovanni dei Fiorentini (1550) and probably those for the Cortile del Belvedere, while he offered to make the plans and model of the Gesù (1554) for Ignatius of Loyola, "per sola devozione." The Pietà of Santa Maria del Fiore, begun about 1546-1547 and executed during this pontificate, is the expression of his deepened faith.

Under Paul IV Carafa (1555-1559), nothing remained of the humanist spirit of the former papal court. He perfected the Inquisition and instituted an inflexible rigor in the persecution of heretics; in art a spirit of prudery reigned. It was under his pontificate that Michelangelo was denounced as a heretic ("Lutheran") and that the Last Judgment figures in the Sistine Chapel were repainted to hide their nudity. It was during this period that Michelangelo executed the first version of the Rondanini Pietà (ca. 1555) and a series of moving drawings on religious subjects (Christ on the Cross between the Virgin and St. John, The Appearance of the Risen Christ to his Mother [or Annunciation], Christ Driving the Merchants out of the Temple, probably an allusion to the purification of the Church). In 1556 he planned a pilgrimage to Loreto; eleven years earlier he had wanted to go to Santiago de Compostela.

Under Pius IV (1559-1565), reaction set in against the reign of Carafa. The Pope was surrounded by a brilliant court and alarmed the population with his profane behavior. However, he consolidated the movement of the Counter Reformation by re-establishing the Council of Trent (1560-1563) and by approving the Index. He was a great patron and gave the aged Michelangelo important commissions in the realm of architecture: the rebuild-

ing of the gates of Rome, of which only the Porta Pia was done (1561) according to Michelangelo's plans, the transformation of the Baths of Diocletian into the church and monastery of Santa Maria degli Angeli (1563-1566), and the Sforza Chapel in Santa Maria Maggiore (1564).

A few days before his death on February 18, 1564, Michelangelo reworked the Rondanini Pietà. On February 19, 1564, his body lay in state in the Santi Apostoli in Rome; according to the wishes of his nephew, Lionardo, it was then transported to Florence in secret, the Romans being anxious to keep Michelangelo's mortal remains. His body arrived on March 10, 1564, and on March 12 it lay in state in Santa Croce before being buried there. On July 14 a solemn memorial service was celebrated in San Lorenzo, of which a description can be found in *Esequie del Divino Michelangelo*, Florence, 1564. The funeral orations of Varchi, L. Salviati, and G. M. Tarsia were published in separate opuscules in Florence in 1564.

CATALOGUES

I. EXISTING SCULPTURES AND PAINTINGS

1. VIRGIN OF THE STAIRS

1, 2

> Florence, Casa Buonarroti.
> H. 55.5 cm. W. 40 cm.
> *Rilievo schiacciato* (very low relief) in marble.

The earliest existing plastic work by Michelangelo, done while the artist was the guest of Lorenzo the Magnificent, about 1490-1492; probably a little earlier than the Battle of the Centaurs. The work is mentioned by Vasari (1568, p. 27) and its attribution by Benkard to the school of Bandinelli must be rejected. It is also unlikely that it was done at a later date, as proposed by Longhi and Pope-Hennessy.

Technique inspired particularly by the reliefs of Donatello (and not Bertoldo di Giovanni). Besides Donatello, the motif of the Virgin is probably also influenced by antique steles or gems representing a seated woman. Concerning the symbolic meaning of the stairs (a symbol of the Virgin herself), see G. Bandman, *Das Münster*, 1972, pp. 365ff.

Michelangelo's nephew, Lionardo Buonarroti, inherited this relief and offered it to Duke Cosimo I de' Medici between 1566 and 1567; in 1617 Cosimo II returned it to the Buonarroti family, that is, to Michelangelo Buonarroti the Younger, for the Galleria Michelangiolesca in the Casa Buonarroti.

2. BATTLE OF THE CENTAURS

3, 4

> Florence, Casa Buonarroti.
> H. 90.5 cm. W. 90.5 cm.
> *Mezzo rilievo* (high relief), marble; the surface of the block was originally convex; unfinished. The back of the block was later smoothed.

Probably executed at the beginning of 1492, after the Virgin of the Stairs, while Michelangelo was the guest of Lorenzo de' Medici, shortly before the latter's death in April of that year.

Mentioned by Condivi (pp. 26ff.) and Vasari (pp. 27ff.), both of whom state that the theme was inspired by Poliziano; according to Condivi, the relief represents the Rape of Deianira and the Battle of the Centaurs; according to Vasari, the Battle of Hercules and the Centaurs. The subject, however, is probably the Rape of Hippodameia according to Ovid (*Metamorphoses*, XII, i, 210).

The composition of the work is inspired by antique sarcophagi representing battles between Romans and barbarians, as, for example, the one in the Museo delle Terme (Helbig, no. 1320), by the battle relief of Bertoldo di Giovanni (Florence, Bargello), and by the *Battle of the Nudes* (engraving) by Pollaiuolo.

The wide band of rough-hewn marble above the heads was, according to Kriegbaum, to be used by the artist to represent the architecture of a hall, as in Donatello; however, we believe rather that Michelangelo chose a block which was too high for his composition and subsequently he could not bring himself to mutilate it, because of his respect for the material.

5 3. THE SANTO SPIRITO CRUCIFIX

Florence, Casa Buonarroti.
H. 1.35 m. W. 1.35 m.
Wood.

The work was probably executed after April 8, 1492, the date of Lorenzo de' Medici's death, and before 1496, the year of Michelangelo's departure for Rome. Mentioned by Condivi as having been made for the Prior of Santo Spirito. Identified by M. Lisner in 1962 (*Kunstchronik*, 1963, pp. 1ff.). The attribution of this crucifix to Michelangelo, although contested by several art critics, seems to us very likely since several data correspond to Condivi's description. The *contrapposto* pose of Christ is an innovation by the young Michelangelo which was followed by almost all the artists up to and including Giovanni da Bologna. See also M. Lisner, *Holzkruzifixe in Florenz und in Toskana*, Munich, 1970.

8-12 4-6. KNEELING ANGEL, ST. PETRONIUS, ST. PROCULUS

Bologna, San Domenico, Tomb of St. Dominic.
4. *Angel*: H. 51.5 cm. (with base).
5. *St. Petronius*: H. 64 cm. (with base).
6. *St. Proculus*: H. 58.5 cm. (with base).
Statuettes in polished marble.
The head of St. Petronius has been detached and replaced.
The statue of St. Proculus fell and broke before 1572 and the pieces had already been put together at the end of the sixteenth century; originally there was a lance in the right hand.

Michelangelo was commissioned by Gianfrancesco Aldovrandi, a Bolognese nobleman, to finish the sculptural decoration of the tomb of St. Dominic, the sarcophagus of which had been executed by Niccolò Pisano and Fra Guglielmo da Pisa (1265-1267), and the other

decorative figures by Niccolò dell'Arca (1469-1473). Michelangelo did the three statuettes which were lacking between autumn 1494 and winter 1495. Condivi (p. 36) and Vasari (p. 35) mention only two of them: the Angel and St. Petronius. St. Proculus was attributed to Michelangelo by Leandro Alberti (1535). The Kneeling Angel by Michelangelo, on the right, is the pendant to the Kneeling Angel by Niccolò dell'Arca on the left, which in the nineteenth century was wrongly considered to be that of Michelangelo.

The attitude of the Kneeling Angel, carved first, is inspired by the Tuscan kneeling angels of the fifteenth century, for example, those by Luca della Robbia (Florence, Santa Maria del Fiore, Sagrestia Vecchia). The drapery is in the style of Quercia. The figure of St. Petronius is influenced by Quercia's St. Petronius on the main door of San Petronio in Bologna. St. Proculus is inspired by Donatello's St. George (Florence, Bargello).

7. VENUS AND TWO CUPIDS *13-15*

> Florence, Casa Buonarroti.
> H. 1.82 m.
> Marble in the round, unfinished.

The statue is not mentioned by any source; because of its style it was attributed to Michelangelo by Matteo Marangoni, 1958; however, H. Keutner has attributed it to Vincenzo Danti, 1958. We believe that the two Cupids were certainly rough-hewn by Michelangelo. The Venus is an imitation from antiquity. It is work of his youth, perhaps done by Michelangelo in Rome in the summer of 1496, from a block of marble which he had acquired then, as we know from a letter. On the question of its attribution, see Tolnay, in *Commentari*, 1966, pp. 324ff. The statue was originally exhibited in the Palazzina della Meridiana of the Pitti Palace, and was transferred to the Casa Buonarroti at the request of Charles de Tolnay.

8. BACCHUS *16-20*

> Florence, Bargello.
> H. 2.03 m. (with base).
> Marble in the round, finished and originally polished.
> The right hand was broken off at the beginning of the sixteenth century and put back before 1553 (Condivi).

Executed in Rome for Jacopo Galli, a collector of antiques and patron of Michelangelo, probably between the summers of 1496 and 1497, that is, before the Pietà.

On the subject of its affinities with the Bacchi of antiquity, see

191

Tolnay, *Michelangelo I*, p. 143, and Horster, *Festschrift U. Middeldorf*, Berlin, pp. 218ff.

Acquired in 1572 by Francesco de' Medici, and later (probably in the seventeenth century) transported to Florence. In the eighteenth century in the Gallery of the Grand Duke (Bottari); since 1873 in the Bargello.

21-23 9. PIETÀ

Rome, St. Peter's.
H. 1.74 m. W. 1.95 m. (base).
Marble in the round, polished.
Four fingers on the Virgin's left hand were broken and restored in the eighteenth century. In May 1972, a deranged man attacked the Pietà with a hammer and badly damaged the Virgin's face and left underarm. Fortunately, all the marble fragments were found and the sculpture has been perfectly restored.

Commissioned by the French Cardinal Jean Bilhères de Lagraulas, before November 18, 1497; the contract is dated August 27, 1498 (Milanesi, p. 613); the intermediary between the Cardinal and Michelangelo was Jacopo Galli. Finished about May 1499, the group is stylistically more developed than the Bacchus. It is the only work signed by the artist; the signature is to be found on the diagonal band across the Virgin's chest: MICHAEL · A[N]GELUS · BONAROTUS · FLORENT[INUS] · FACIEBA[T].

The group was first erected in the old St. Peter's, in one of the chapels of St. Petronilla, and subsequently transferred to the Cappella della Vergine Maria della Febbre. Gregory XIII had it transported to the choir of Sixtus IV. Since 1749 it has been in the first chapel on the north side of St. Peter's, the Cappella della Pietà. For its successive positions, see D. R. de Campos, *La Pietà giovanile di Michelangelo*, Milan, 1964. On the subject of the interesting copy in a neo-Gothic Botticellesque style (grisaille) in the Galleria Nazionale, Palazzo Barberini, Rome, see Zeri, *Paragone*, 1953, no. 43, pp. 15ff.

24-26 10. THE BRUGES MADONNA

Bruges, Church of Notre-Dame.
H. 1.28 m. (with base).
Polished marble in the round.

Executed in Florence, to judge by its style, from the summer of 1501; Michelangelo probably made slow progress since the style of the Child, which is more developed than that of the Virgin, indicates

192

a date around 1504. The style and technique of the Virgin are precise, still close to the Pietà.

The statue was sold by Michelangelo in 1506 to the heirs of Giovanni and Alessandro Moscheroni (also called Mouscron) in Bruges, Dürer saw the group there in Notre-Dame on April 7, 1521 (*Tagebuch der Reise in die Niederlande*).

Sketches probably related to this Virgin (see Tolnay, *Le Madonne di Michelangelo*, 1968; Wilde, *B.M. Cat.*, no. 4). *210*

11-14. St. Peter, St. Paul, St. Pius, St. Gregory *27-33*

Siena Cathedral, Piccolomini Altar.
H. approx. 1.20 m.
Polished marble statuettes.

The architecture of the altar is a work by Master Andrea Bregno, executed from 1481 (Gaye, I, p. 273) to 1485 (inscription) for Cardinal Francesco Todeschini-Piccolomini (later Pope Pius III).

For the sculptural decoration, the Cardinal seems to have approached first Pietro Torrigiani (who did the statuette of St. Francis), then Michelangelo. The first document relating to the statuettes which Michelangelo was to carve is a letter from the artist dated May 22, 1501 (Milanesi, p. 615). The contract is dated June 5, 1501 (Milanesi, pp. 616ff.); Jacopo Galli signed it as a guarantor. According to the contract, Michelangelo was to execute fifteen statuettes in three years: the Cardinal would decide which saints and apostles they were to represent. After the death of Pius III, a new contract was ratified with the heirs, on October 11, 1504. Michelangelo had already furnished four statuettes (the four which are still on the monument today) and he was due to complete the eleven others in the course of the two following years (Milanesi, p. 627). The four statuettes delivered by Michelangelo were partly executed by Baccio da Montelupo, as is indicated by a letter from Ludovico Buonarroti to Michelangelo, dated June 28, 1510 (Steinmann, *Sixt. Kap.*, II, p. 715). The letter (Milanesi, pp. 616ff.) mentions that the design of the statuettes was Michelangelo's. The St. Paul and St. Peter, which are superior to the two others, were conceived and probably retouched by the master. The face of St. Paul recalls the features of Michelangelo and may be a self-portrait (Kriegbaum).

The Virgin and Child in the central niche at the top is earlier, and has been attributed to Jacopo della Quercia's youth by Enzo Carli (*Critica d'Arte*, 1949, pp. 17ff.).

The present arrangement of the statuettes is due to a change in

recent times, placing St. Peter and St. Paul on the bottom left and right respectively, and St. Francis on the top left.

34-40
202, 204

15. DAVID

Florence, Accademia delle Belle Arti.
H. 5.35 m. (with base); 5 m. (without base).
Marble in the round, originally polished—the polish has disappeared as a result of weathering.
In 1527 the left arm was broken and subsequently restored under Duke Cosimo I. One of the fingers on the right hand, which was restored at a later date, was probably also broken at the same time.

Commissioned by the Opera del Duomo in August 1501 (Milanesi, pp. 620ff.), the statue was begun on September 13, 1501 and finished in April 1504. In January 1505 (Gaye, II, p. 455) a commission was assembled to decide where to put it. Among the members of the commission were the greatest artists of Florence, Leonardo da Vinci, Botticelli, Filippino Lippi, Giuliano and Antonio da Sangallo, Andrea della Robbia, Cosimo Rosselli, Andrea Sansovino, and others. Opinions differed and the final decision to put the statue in the place of Donatello's Judith, near the main entrance to the Palazzo della Signoria, probably corresponded to Michelangelo's own wishes. The original was transferred from that site to the Accademia in 1873, and a copy stands in front of the palace today.

Work on the block of this statue had been begun in 1464 by Agostino di Duccio, and then abandoned. It was to stand on one of the buttresses of Santa Maria del Fiore, and was probably always intended as a figure of David, but clothed. The block was already called "Il Gigante" at that time. In 1476 the Operai of Santa Maria del Fiore commissioned Antonio Rossellino to finish it, but this plan came to nothing. Finally, in the summer of 1501, Michelangelo was asked to complete the block.

The motif of the statue was inspired by an antique type of Hercules to be found on sarcophagi representing the Labors of Hercules (Tolnay).

47-49

16. THE DONI MADONNA

Florence, Galleria degli Uffizi, no. 1456.
Diam. vertical 91 cm., horizontal 80 cm.
Tondo-shaped panel in tempera. The contours of the naked parts are drawn in red. Cracks across the Virgin's right arm and St. Joseph's left leg have been restored.

Executed for the marriage of Agnolo Doni and Maddalena Strozzi, in 1503 or at the beginning of 1504 (G. Poggi). In 1635 the panel was in the *tribuna* of the gallery of the Grand Duke of Florence.

The composition is inspired by Signorelli's tondo, the *Virgin and Child* in the Uffizi. St. Joseph's head is based on studies from nature in Oxford (Dussler, *Zeichn.*, 192, 193), but also recalls ancient portraits of Euripides. The Virgin was no doubt drawn from a male model (see her muscular arms); she heralds the Erythraean Sibyl of the Sistine Ceiling. A red-chalk drawing (Dussler, *Zeichn.*, 48) is related to the Virgin's head and at the same time to the head of Jonah on the Sistine Ceiling.

The original frame, which contains the crescents of the Strozzi coat of arms, is still preserved (G. Poggi; see also M. Lisner, *Festschrift Theodor Müller*, Munich, 1965, pp. 167ff.). According to Lisner, the heads on the frame are by Baccio da Montelupo.

The coloring is composed of cold, clear tones, with little shadow. These colors change: in the light, pink tends towards pale yellow, blue to white, green to golden yellow, and yellow to orange. The mountains in the background and the sky are of a limpid pale blue. This range of colors was to inspire Pontormo, Rosso, and Bronzino.

17. THE BARTOLOMMEO PITTI MADONNA

41, 43-45

Florence, Bargello.
Diam. vertical 85.5 cm., horizontal 82 cm.
Marble relief, tondo, unpolished.

Executed in Florence, in our opinion, about 1504-1505. On the question of the date, which is not known, opinions are divergent. According to Kriegbaum, the tondo dates from around 1508.

The work, executed according to Vasari for Bartolommeo Pitti, was subsequently given by Fra Miniato Pitti to Luigi Guicciardini. It remained in the Guicciardini family until 1823, when it was acquired by the Gallery at Florence. In 1873 it was transferred to the Bargello.

The pose of the Infant Jesus is inspired by antique mourning genii, as, for example, the one on the sarcophagus "of the Contessa Beatrice" (Pisa, Campo Santo). The figure of the Virgin, especially the drapery, seems to be inspired by Jacopo della Quercia's Prudence (Siena, Fonte Gaia). The overall composition reveals reminders of Signorelli's tondo in the Uffizi.

There is a preparatory sketch for the Virgin at Chantilly, in the Musée Condé (Tolnay, *Archivio Buonarroti*, pp. 450ff.). The Virgin's head resembles that of the David and at the same time anticipates the Delphic Sibyl on the Sistine Ceiling.

207

For the technical procedure, see Grünwald (*Florentiner Studien*, pl. XXIV).

42, 46 18. THE TADDEO TADDEI MADONNA

London, Royal Academy of Fine Arts.
Diam. 1.09 m.
Marble relief, tondo, unfinished.
The Virgin's right hand, barely rough-hewn, is touching the shoulder of the little St. John who holds in his hands a bird, probably a goldfinch. Certain details, like the faces of the Virgin and Child, and the drapery of the Virgin, seem to have been retouched by some other hand, probably that of a pupil (see Tolnay, *Thieme-Becker*, 1930, p. 518).

No doubt executed about 1505-1506, after the Bargello tondo (Wölfflin's opinion, which is also ours). According to Kriegbaum, on the contrary, noticeably earlier than the tondo in the Bargello.

Two preparatory sketches for St. John the Baptist are in London, British Museum (Dussler, *Zeichn.*, 169v).

According to Varchi and Vasari, done by Michelangelo for Taddeo Taddei. At the beginning of the nineteenth century, in the Wicar collection in Rome. Bought in 1823 by Sir George Beaumont and donated by him to the Royal Academy.

The composition seems to have been inspired by a bronze medallion attributed to Donatello. The motif of the Infant Jesus is inspired by a child on the antique sarcophagi of Medea (W. Horn), a motif already assimilated into Renaissance art in the *Madonna of Tarquinia* by Fra Filippo Lippi and to be found after Michelangelo in several works by Raphael (*Bridgewater Madonna*, London, and *Galatea*, Farnesina).

51, 52 19. ST. MATTHEW

Florence, Accademia delle Belle Arti.
H. 2.71 m.
Marble in the round, unfinished.

This statue forms part of the commission by the Consoli dell'Arte della Lana to Michelangelo in April 1503: twelve apostles for Santa Maria del Fiore (Milanesi, pp. 625ff.). The other figures were never begun. The contract was annulled on December 18, 1505 (Gaye, II, p. 477). But in the summer of 1506, it appears that Michelangelo was working on an apostle, according to a letter from Soderini, dated November 1506. The statue was probably rough-hewn at this date

(Ollendorf). The figure only half emerges from the block which is still intact at the back. With the Slaves in the Accademia and the one in the Casa Buonarroti, this statue is the best example for studying Michelangelo's working methods, using planes parallel to the surface of the block. The expression of suffering on the face is probably inspired by the Laocoön (Ollendorf) and also by Quercia's Prophets on the baptismal font in the Baptistery of Siena.

Study for St. Matthew's right arm, Louvre (Dussler, *Zeichn.*, 214v). There is a sketch in the British Museum (Dussler, *Zeichn.*, 170r), probably for one of the other apostles in this series. 205 206

The statue was originally in the Opera del Duomo (Vasari, Varchi), and was transferred to the Accademia in 1834.

20. THE CEILING OF THE SISTINE CHAPEL 53-90

Vatican, Rome.
L. 40.23 m. W. approx. 13.30 m.
Fresco.

For its state of preservation, see Tolnay, *Michelangelo II*, p. 193, and R. Salvini, *La Cappella Sistina in Vaticano*, Milan, 1965. The first restoration, by Domenico Carnevali, dates from about 1566-1572 (he retouched the *Sacrifice of Noah* and repainted the left hand of God in the *Division of Heaven from the Waters*). In 1797, a powder explosion at the Castel Sant'Angelo damaged the whole of the body of the Ignudo to the left of the Delphic Sibyl and a part of the sky to the right of the *Flood*. From 1903 to 1905 and from 1935 to 1938, the frescoes were cleaned and fixed.

The original documents relating to the frescoes have been published by Pogatscher in Steinmann, *Sixt. Kap.*, ii, pp. 690ff. and by Tolnay, *Michelangelo II*, pp. 217ff. The frescoes were commissioned by Julius II in March-April 1508. The idea of having the Ceiling decorated by Michelangelo, however, goes back as far as May 1506 (see the letter published by Steinmann, *Sixt. Kap.*, ii, p. 695).

Michelangelo made several projects. According to the first, which is still in existence in London (Wölfflin, *J.d.p.K.*, 1892, p. 178 and Dussler, *Zeichn.*, 163), there were to be the twelve apostles in the pendentives and on the top of the vault a system of varied cornices. The subsequent projects (Dussler, *Zeichn.*, 5 and 325) show the simplification and unification of the system. 213 214

The preparation of the vault was begun on May 10, 1508, the date of the signing of the contract. Until the beginning of January 1509 the artist probably outlined sketches and prepared the cartoons. It was

only then that he embarked on the actual work and by the middle of September 1509 he had executed a first section (probably comprising the *Drunkenness of Noah*, the *Flood*, and the *Sacrifice of Noah*, together with Zechariah, Joel, the Delphic Sibyl, Isaiah, and the Erythraean Sibyl, the corresponding Ignudi, the spandrels of David and Judith, and the corresponding spandrels of the ancestors).

The second section, which is smaller, was probably done between the middle of September 1509 and the end of September 1510 (Michelangelo's journey to Bologna to obtain the necessary sums of money from the Pope). This section comprised the *Fall and Expulsion* and the *Creation of Eve*, Ezekiel and the Cumaean Sibyl, together with the corresponding Ignudi and the two adjacent spandrels.

The third section was probably executed between January 1511 and August 14, 1511 (date of the first unveiling) and comprised the last four histories, Daniel, the Persian Sibyl, the Libyan Sibyl, Jeremiah and Jonah, with their Ignudi, the corresponding spandrels of the ancestors, and the spandrels representing the *Crucifixion of Haman* and the *Brazen Serpent*.

A fourth section, probably done between October 1511 and October 1512 (date of the dedication of the vault), comprised all the lunettes. The cartoons of the first eight, however, seem to have been done earlier, between January and August 1511.

The difference in style and coloring between these four phases is clearly visible. For this chronology, see Tolnay, *Michelangelo II*, pp. 105ff. K. Oberhuber's recent chronology differs in part from ours.

215, 216 There remain several original drawings for the vault. All the cartoons have been lost.

The screen (*cancellata*) of the chapel was originally about five meters nearer the altar, on the step leading to the *quadratura* of the cardinals. The presbytery was enlarged in the late sixteenth century by moving the *cancellata* back to the place where it stands today. Its original position inspired Michelangelo's division of the vault and his iconography (see Chapter II above).

On the subject of the overall composition of the vault, see also the remarks of Wilde, *Proceedings of the British Academy*, 1958, pp. 62ff.

For the thematic interpretation, see Chapter II above and Tolnay, *Michelangelo II*, pp. 20ff. F. Hartt ("Lignum Vitae in medio Paradisi," *Art Bulletin*, 1950) proposes an interpretation partially different from ours, which we cannot, however, accept.

See also Wind, *Measure*, 1950, p. 411 and von Einem, *Michelangelo*, Stuttgart, 1959, pp. 49ff.

21. THE DYING SLAVE *91, 92*

> Paris, Louvre.
> H. 2.29 m.
> Marble in the round, polished in front but not behind; base and
> monkey behind the leg, rough-hewn.

Executed for the second project for the Tomb of Julius II (1513).
A letter (Milanesi, p. 391) testifies that Michelangelo was busy that
year on the Rebellious Slave. The Dying Slave must have been begun
a little before. The figure was probably to be placed in front of the
center left pilaster. There is a sketch for the pendant Slave—never
executed—in the Louvre (Dussler, *Zeichn.*, 209v).

Behind the figure is the outline of a monkey, holding in its paw a
round object, perhaps a mirror or a shield.

The statue is known as the Dying Slave (Springer), but seems
rather to be that of a sleeping man overwhelmed by tiredness (Ollen-
dorf). The chest and shoulders are strapped by bands which form a
sort of yoke. The motif has analogies with the Laocoön (Ollendorf).

In 1542, Michelangelo thought of putting the two Slaves, now in
the Louvre, in niches in the lower zone of the Tomb, on each side of
the Moses; however, in the same year he had the idea of replacing
them with the two statues of Rachel and Leah. In 1544, Michelangelo
offered the two Slaves as a gift of thanks to the Florentine Roberto
Strozzi, an exile in Lyons, in whose house in Rome he had stayed dur-
ing his illness. In 1546 or 1550, Roberto Strozzi gave the statues to
the French king, François I, who in turn gave them to the Connétable
Anne de Montmorency. The latter placed them in the niches on the
façade facing the courtyard of his Château d'Ecouen (Vasari, 1568),
reproduced in the print by du Cerceau (1578). Maréchal Henri II de
Montmorency gave them in 1632 to Cardinal Richelieu who had them
transported to his château in Poitou (engraving by Jean Marot). In
the middle of the seventeenth century, the two statues are described
as ornamenting the gateway of Richelieu's château, by Desmaret de
Saint Sorlin, *Promenades de Richelieu ou les vertus chrétiennes*, Paris,
1653, p. 3 (Dörken, p. 9), by La Fontaine, *Lettres à sa femme*, Sep-
tember 12, 1663 (Dörken, p. 10), and by M. Vignier, *Le Château
de Richelieu à Saumur*, 1676. Before 1749 the statues were already
in Paris. The widow of the last Maréchal de Richelieu banished them
to the stables. In 1793, they were sequestrated and were to be put up
for sale, when in 1794 Alexandre Lenoir saved them (Lenoir,
Description des ouvrages de la sculpture française, nos. 5 and 7); they
then entered the Louvre.

93, 94 22. THE REBELLIOUS SLAVE

> Paris, Louvre.
> H. 2.15 m.
> Marble in the round, partly polished (legs, left arm, and back).
> Michelangelo began the polishing from the bottom, on the feet
> and legs, while the neck and head remained rough-hewn. On the
> block near the left knee, one can see the outline of a monkey's
> head (Panofsky).

Executed for the second project for the Tomb of Julius II (1513),
it was probably meant for the pilaster on the left corner.

Michelangelo's work for this figure in 1513 is proved by a letter
(Milanesi, p. 391). The style is a little more evolved than that of the
Dying Slave. A vein of marble runs across the head as far as the left
shoulder; this is perhaps why Michelangelo did not finish the figure.
The main view is in profile; the back is flat, because it was to stand
against a pilaster. Bands on the arms and drapery on the right leg.

According to Kriegbaum (*Bildwerke*, p. 36), the block on which
the Slave places his right foot is a roughly-hewn capital, and the
figure would thus represent an allegory of architecture—an unlikely
hypothesis, however, since this block is oval in shape.

There is a sketch for the statue on a sheet in Oxford (Dussler,
Zeichn., 194): behind the figure are a breastplate and helmet. It
therefore originally represented a vanquished warrior.

For the history of the statue, see the Dying Slave, No. 21 above.

95-97, 23. MOSES
180, 181

> Rome, San Pietro in Vincoli.
> H. 2.35 m.
> Marble in the round, the front polished except for a few small
> parts, for example, the right of the neck. Trapezoidal base.

Executed for the second project for the Tomb of Julius II (1513),
perhaps begun in the summer of 1515 (Milanesi, p. 115) and still
not finished in 1516. In this project, the position of the figure was to
be on the second story, above the right-hand niche. In the last project,
Michelangelo placed it in the central niche on the bottom, further back
than it is today, as can be seen in Bonasone's print. It was moved
forward in 1816, when a copy of the statue was made (Stendhal,
Histoire de la peinture).

The motif had probably been used already in the bronze statue
(destroyed) of Julius II for San Petronio in Bologna, and a second
time in the Prophet Joel on the Sistine Ceiling. Michelangelo was to
repeat the motif of the legs in his Giuliano de' Medici. The position
of the hands is heralded by that of the Virgin of the Stairs.

For the symbolism of the two sides, see Michelangelo's poem (Frey, *Dicht.*, CIX, 97).

The statue has been famous since its execution, and has been copied by the greatest artists, as, for instance, Leonardo in a drawing at Amsterdam, Fodor Museum (see Valentiner, *Burl. Mag.*, XCI, 1949, p. 343). In the *Wedding at Cana* by Veronese in the Louvre, the figure with the viola da gamba is inspired by the drapery of Moses.

24. The Risen Christ *98, 99*

> Rome, Santa Maria sopra Minerva.
> H. 2.05 m.
> Marble in the round, polished on the front.

The first version was commissioned by Bernardo Cencio, Canon of St. Peter's, Maria Scapucci, and Metello Vari, on June 14, 1514 (Milanesi, p. 641). It was begun but subsequently abandoned by Michelangelo because of a black vein in the face, and was given by the master to Metello Vari in 1522. This rough-hewn statue is lost. A drawing in London, Brinsley Ford Collection (Dussler, *Zeichn.*, 182), is related to this statue.

In 1518 Michelangelo ordered a new block on which he worked during the second half of 1519 until the beginning of 1520. In April 1520 the statue was finished and in March 1521 it was sent from Florence to Rome where it arrived in June 1521. In July-August of the same year, the *garzone* Urbano retouched the statue awkwardly, thus spoiling it; because of this Michelangelo dismissed him and charged Federigo Frizzi to repair the damage and finish the work. He himself retouched certain parts spoilt by Urbano. However, the master, dissatisfied with the statue, proposed a third to Metello Vari; the latter refused politely. On December 27, 1521, the statue was unveiled.

Its best parts are the torso, in particular the abdomen and the whole of the back, the arms, and the knees, which are probably by Michelangelo's own hand, while the *garzoni* did the drapery behind the left leg, the instruments of the Passion, and probably the face.

As for the original base and the tabernacle behind the figure, executed by Federigo Frizzi in 1521 and destroyed in 1849, see Tolnay, *Commentari*, 1967, pp. 43ff.

25. David-Apollo *100, 101*

> Florence, Bargello.
> H. 1.46 m.
> Marble in the round, unfinished.

According to Vasari (1550, p. 141; 1568, p. 145), it is "uno Apollo che cavava una freccia del turcasso." According to the inventory of the collection of Grand Duke Cosimo I (1553), the statue is "uno Davit . . . imperfetto." From this collection it was transported to the Boboli Gardens, then to the Uffizi, and finally to the Bargello.

The statue was probably begun in 1525-1526 (Popp). Opinions as to its subject are divergent: according to Thode, Knapp, Mackowsky, and Popp, it is a David (Popp supposes that the statue was executed for the top left-hand niche of the tomb of the *Magnifici* in the Medici Chapel).

We believe that the contradiction in its designation may be explained by the following hypothesis. When Baccio Valori, governor of the town of Florence under the victorious Medici, asked Michelangelo for a work, around autumn 1530, the latter transformed his rough-hewn David into an Apollo: the object on the figure's back, originally a sling, was changed into a quiver for arrows; the round object under his right foot, which was to be Goliath's head, became a rough-hewn sphere of the sun.

102, 103 26. HERCULES AND CACUS/ANTAEUS
 (or SAMSON AND THE PHILISTINE)

Florence, Casa Buonarroti.
H. 41 cm.
Model group in clay, fragmentary. Certain pieces broken off (for example, the heads of the figures) were successfully restored to the group by Johannes Wilde in 1928.

Study for a monumental group five meters high, which was to be erected in front of the Palazzo della Signoria as a pendant to the David. The model was probably done in 1528. Michelangelo began, but never completed, the marble group; it was Bandinelli who continued the same block and altered its composition, making the Hercules and Cacus which now stands in front of the Palazzo della Signoria.

The idea for the group goes back as far as May 10, 1508, the date on which a large block of marble was ordered by Pietro Soderini, the Gonfalonier of Florence. From this it was Michelangelo's wish to make a Hercules and Cacus for erection on the piazza near the marble David. In 1525, however, Clement VII gave the block to Baccio Bandinelli. But the Signoria of Florence wanted its execution entrusted to Michelangelo, and after the fall of the Medici in August 1528 they decided to give the block, which had already been half worked by Bandinelli, back to Michelangelo. According to Vasari, Michelangelo then abandoned the idea of a Hercules and Cacus group in favor of one of Sam-

son and the Philistine. After the fall of the Florentine Republic, Clement VII again commissioned Bandinelli to finish the group. It was unveiled on May 1, 1534. Nothing remains of the 1508 concept; the group of the father with his dead son in the fresco of the Flood on the Sistine Ceiling is perhaps a reflection of it. The red-chalk sketches representing Hercules and Antaeus (Dussler, *Zeichn.*, 159r, 196) are related to the 1525 version.

This original clay model probably relates to the 1528 version. (A projected and somewhat different group of Samson with Two Philistines probably dates from after 1529-1530; see Catalogue II, No. 14.)

Springer (*Raffael u. Michelangelo*, II, pp. 36 and 354, no. 10) and Wilde (*J. d. Kh. S.*, 1928, pp. 199ff.) have formulated the hypothesis, which is not wholly convincing, that the model is a Victory group for the Tomb of Julius II, that is, a pendant to the Victory group now in the Palazzo della Signoria.

27. MEDICI CHAPEL

104-108
324-329,
332

Florence, San Lorenzo.
Architecture.

The walls are articulated by a double system of Corinthian pilasters and architraves in grayish-black *pietra serena*. The architecture of the tombs, doors, and tabernacles is in white marble. The walls are whitewashed, but were originally to have been at least partially decorated with frescoes—in any case the tondi of the pendentives and the coffers of the cupola (the latter frescoes were actually begun by Giovanni da Udine, but as they did not please Pope Clement VII they were whitewashed). The lunettes above the tombs were no doubt also to contain frescoes. According to Popp's hypothesis, the sketches representing the Attack by Serpents and the Healing by the Brazen Serpent 231 (Dussler, *Zeichn.*, 195r) are projects for the frescoes on the lunettes above the tombs of the Dukes, and the drawings of the Resurrection 227-230 of Christ (Dussler, *Zeichn.*, 168, 210, 239) are projects for the lunette above the Virgin. This tempting hypothesis has only one drawback: the numerous figures would seem to be very small in comparison with the large sculptures below. There are important comments by Wilde in *Journal of the Warburg and Courtauld Institutes*, 1955, pp. 54ff.

The plain base on which are set the statues of the Virgin, St. Cosmas by Montorsoli, and St. Damian by Montelupo, which was done according to a design by Michelangelo (Vasari, *Carteggio*, II, p. 461), is in fact the bottom zone of the white marble architectural

decoration of this wall, which was never finished. The mortal remains of Lorenzo the Magnificent and of his brother Giuliano were buried in this sarcophagus-base in 1559.

110, 114, 117

28. DAWN (AURORA)

Florence, Medici Chapel, Tomb of Lorenzo de' Medici.
W. of block 2.03 m.
Marble in the round, polished except for the feet and drapery.
Behind, the block is rough-hewn in the shape of a rock.

The statue was begun in October 1524; in 1526 it was almost finished. On June 16, 1531, the statue reached its present state.

Dawn is mentioned for the first time in a letter from Giovanbattista di Paolo Mini dated September 29, 1531. (Gaye, II, pp. 228ff. See also: Vasari 1550 and 1568, p. 133; Doni, *I Marmi*, III, pp. 22ff.; Borghini, *Il Riposo*, I, pp. 65ff.; Bocchi-Cinelli, pp. 533ff.; Thode, *Kr. U.*, I, pp. 526ff.; Steinmann, *Geheimniss*, p. 89; Popp, *Med. Kap.*, p. 143; Panofsky, *Studies in Iconology*, p. 207; Tolnay, *Michelangelo III*, pp. 132ff.)

The pose is inspired by the river or mountain god on the Arch of Septimius Severus and had been used by Michelangelo in the Abia lunette of the Sistine Ceiling (Steinmann, *loc. cit.*).

The body of the statue is virginal in character. The attributes of Dawn are the veil on the head, a symbol of mourning, and the band across the chest, a symbol of slavery or oppression.

109, 113, 118

29. DUSK (CREPUSCOLO)

Florence, Medici Chapel, Tomb of Lorenzo de' Medici.
W. of block 1.95 m.
Marble in the round, partly unfinished (the head, hands, and legs).

The statue was begun in October 1524 and was almost finished in 1525; on September 29, 1531 it had reached its present state. The figure is a development of the bronze-colored nudes above the Ezekias spandrel on the Sistine Ceiling (Tolnay, *Michelangelo II*, p. 70), which were inspired by the river and mountain divinities on the Arch of Septimius Severus. The figure has no attributes.

For the literature, see Dawn, No. 28 above.

111, 115, 120

30. NIGHT (NOTTE)

Florence, Medici Chapel, Tomb of Giuliano de' Medici.
W. of block 1.94 m.
Marble in the round, polished except for the left arm, both hands,

and the tress of hair. The left arm was probably already damaged during execution (Doni, *I Marmi*, 1552).

The statue was begun between March and June 1526 and reached its present state in August 1531. The character of the body is that of a mother, no doubt symbolizing the fertility of Night (Bocchi-Cinelli, p. 533). The attributes are the crescent moon and the star on the diadem, the owl, a mask, and an unfinished garland, probably of poppies. The pose is derived from an antique sarcophagus representing Leda (now lost and known only from sixteenth-century drawings in the Codex Phighianus, Berlin). Michelangelo used the same classical motif for his cartoon of *Leda*. Mentioned for the first time by Michelangelo himself as "Notte" in a note by his own hand (Frey, *Dicht.*, XVII).

A superb drawing with studies for the arms of Night is at Haarlem, in the Teyler Museum.

In 1545 a young humanist, Giovanni Strozzi, wrote an epigram on Night (Frey, *Dicht.*, CIX, 16), to which Michelangelo replied (Frey, *Dicht.*, CIX, 17).

For the literature, see Dawn, No. 28 above.

31. DAY (GIORNO)

112, 116, 119

> Florence, Medici Chapel, Tomb of Giuliano de' Medici.
> W. of block 2.85 m.
> Marble in the round, unfinished (the head and right hand are only rough-hewn).

The statue was begun between March and June 1526 and reached its present state probably after July 1533.

Mentioned for the first time by Michelangelo himself as "el dì" in a note by his own hand (Frey, *Dicht.*, XVII) of around 1523. The statue's pose (the back, left arm, and head) is derived from that of the Infant Jesus in the Virgin of the Stairs. One of the bronze-colored nudes on the Sistine Ceiling also heralds the motif of Day. The modeling of the torso is probably inspired by the Torso Belvedere.

Several preparatory drawings by Michelangelo are at Oxford and Haarlem.

For the literature, see Dawn, No. 28 above.

32. LORENZO DE' MEDICI

121, 123, 125

> Florence, Medici Chapel, Tomb of Lorenzo de' Medici.
> H. 1.78 m.
> Marble in the round, not completely polished. The collaboration of Giovanni Antonio Montorsoli is attested by Vasari. The

breastplate, helmet, and bat's mask on the casket are probably by Montorsoli. The face, hands, and breastplate are not polished.

The statue, probably begun in October 1524, seems to have been in the process of execution in October 1525 and was still not finished in September 1531. Since the sixteenth century this figure has been called "Il Pensieroso" (Vasari).

Lorenzo de' Medici, Duke of Urbino (1492-1519), was the nephew of Leo X and the son of Piero de' Medici. Machiavelli dedicated his *Prince* to him. Michelangelo has not sought a resemblance to the dead man, as the portraits of Lorenzo testify. The motif of the figure is a development of the prophet Isaiah on the Sistine Ceiling. The left elbow is leaning on a casket decorated with the mask of a bat. This casket has generally been interpreted as a symbol of the Duke's parsimony, but it seems more likely to represent the casket of obols, that is, to be an emblem of death. The gesture of the left hand, whose fingers are touching the lips, is the traditional expression of silent contemplation. (See Tolnay, *Michelangelo III*, pp. 139ff.)

122, 124, 33. GIULIANO DE' MEDICI
126
Florence, Medici Chapel, Tomb of Giuliano de' Medici.
H. 1.73 m.
Marble in the round, partly polished. The face, hands, and knees were finished by Michelangelo; some secondary details, like the decoration of the breastplate and the fringe, by Giovanni Antonio Montorsoli (Vasari). The latter worked on the statue in 1533. On both sides of the cuirass is a mask.

Begun between March and June 1526; still not finished on July 25, 1533.

An earlier version is known from a drawing in the Louvre (a copy after Michelangelo). In it Giuliano is represented naked, with a sceptre in his hand, as in representations of the apotheosis of the hero in antiquity.

Giuliano de' Medici, Duke of Nemours (1479-1516), was the brother of Leo X. He was the friend of Castiglione who made him one of the protagonists of his *Cortigiano* (*The Courtier*). The portraits of Giuliano show that in his statue Michelangelo was not seeking a resemblance to the deceased. The attitude of the figure is a development of that of the prophet Joel on the Sistine Ceiling and of the Moses on the Tomb of Julius II. On his knees he holds the "baton of the Holy Church," in his left hand various coins, generally interpreted as an allusion to the Duke's munificence, but which probably represent the obols and are thus a symbol of death.

We know Michelangelo's interpretation of this tomb from the fragment of a poem in his own hand on a sheet in the Casa Buonarroti, Florence (cf. Frey, *Dicht.*, XVII).

The small model, now lost, represented the Duke naked, as in the drawings by Tintoretto in Oxford, Christ Church, done from this model or from a copy. An original drawing for the hand is in the *226*
Casa Buonarroti (Tolnay, *Archivio Buonarroti*, p. 431).

(See also Tolnay, *Michelangelo III*, pp. 141ff.)

34. VIRGIN AND CHILD *127-129*

Florence, Medici Chapel.
H. 2.26 m. (with base).
Marble in the round, unfinished except for the Child.

The block is mentioned in 1521, and the statue was still being worked after September 1531. The present statue seems to be a second version. The block was originally wider, as can be seen from the base. Michelangelo retained the contour of this block on the left side, while on the right he cut away a lot of material, thus transforming his first version.

There are two pen and ink sketches for the Virgin, dating from *220*
about 1524 (Dussler, *Zeichn.*, 149r). The motif of the Child is a development of the Child in the lunette of Joseph on the Sistine Ceiling.

As for the development of the idea of this Virgin which haunted Michelangelo, see Tolnay, *Le Madonne di Michelangelo*, Accademia Nazionale dei Lincei, Rome, 1968.

35. CROUCHING YOUTH *130, 131*

Leningrad, Hermitage.
H. 54 cm.
Marble statuette, unfinished.

Executed about 1524. Originally it was to be placed on the entablature of the tomb of Lorenzo (Popp, *Med. Kap.*, p. 142). It is recognizable in the drawing for this tomb (Dussler, *Zeichn.*, 151r). However, the actual monument provides no room in the entablature for statuettes.

Of high quality, probably executed by Michelangelo's own hand. According to Kriegbaum, the work is by Tribolo; according to Wittkower (*Burl. Mag.*, 1941, I, p. 133), by Pierino da Vinci.

In the eighteeneth century the statuette was in the Medici Collection. It was acquired in 1787 by Lyde Brown, and from there went

to the Academy of Fine Arts in St. Petersburg. In 1851 it was transferred to the Hermitage.

133
223
36. Model of a River God

Florence, Casa Buonarroti.
Actual W. 1.47 m. (according to a document of the period, the complete figure measured 2.32 m.).
Clay, wood, wool; fragment.

Michelangelo made large models of two river gods which in the sixteenth century were placed below Dawn and Dusk (Doni, *I Marmi*, III, p. 24). They are mentioned for the first time on April 4, 1524 (Frey, *Briefe*, p. 223). In June 1526, the execution in marble had still not been started. The model in the Casa Buonarroti was probably executed in 1524-1525. (It has sometimes been attributed with not very convincing arguments [Karl Frey and Popp] to the school of Michelangelo.) It was placed on its present base by Ammanati, in a position different from that intended by Michelangelo, which can perhaps be reconstructed from various early copies: the right elbow and leg were supposed to touch the plinth (Wilde, *Belvedere*, 1927, p. 43, note).

The model was in the collection of Grand Duke Cosimo I who made a gift of it to Bartolommeo Ammanati; he in turn offered it to the Accademia dell'Arte del Disegno in 1583. It was transferred in 1965, at the request of Charles de Tolnay, to the Casa Buonarroti.

On the subject of the different versions of river gods by Michelangelo, see Tolnay, *Michelangelo III*, pp. 148ff.

132
37. Small Model of a River God

Rotterdam, Boymans-van Beuningen Museum.
L. 15 cms.
Red wax. Fragmentary torso (both arms and the lower part of the legs are missing).

This model was attributed by Brinckmann (*Barock-Bozzetti*, I, Frankfurt a.M., 1923, pp. 40-41, pls. 6-8) to a follower of Michelangelo. It was published as an original by Michelangelo by Tolnay ("Alcune recenti scoperte e risultati negli studi michelangioleschi," Rome, Accademia Nazionale dei Lincei, Quad. 153, 1971, pp. 12-13). Tolnay identified it as a model for the River God which was intended to be below the Day in the Medici Chapel. It is noteworthy that the position of the Rotterdam model corresponds exactly, with the
224 left arm raised, to that of a working drawing in the British Museum, in which Michelangelo has sketched this River God, seen from two

sides, with light, rapid outlines. The attribution to Michelangelo of this small model seems confirmed by the quality of the continuous and fluctuating modeling of the surfaces, although the face now (1974) suggests to us a replica made in Venice.

In Darmstadt, Hessisches Landesmuseum, we have been able to identify two drawings of the mid-sixteenth century which were executed from the plaster cast of this model. These drawings, which also lack the head, testify that the *bozzetto* was famous at an early date.

This small model in Rotterdam permits us to reconstruct the aspect of the River God for the tomb of Giuliano, and completes our knowledge concerning the River Gods of the Medici Chapel.

The model came from the collection of Dr. Fritz Goldschmidt, Berlin.

38. VICTORY

<div style="text-align: right;">*151-153*</div>

 Florence, Palazzo della Signoria.

 H. 2.61 m.

 Marble in the round. Most of the figure of the youth is polished (not, however, his face, where the right pupil only has been executed). Wittkower (*Burl. Mag.*, 1941, I, p. 133) not very convincingly attributes this head to Vincenzo Danti. The old warrior is only rough-hewn.

Carved for the Tomb of Julius II, probably for the fifth project of 1532. The statue was no doubt to be placed on the bottom story in the niche to the left of Moses. In the victor's hair a crown of oak leaves, the emblem of the Rovere.

Opinions are divergent as to the date. According to Kriegbaum (*Bildwerke*, p. 35), the figure dates from 1506, from the first project for the Tomb—not a convincing opinion; according to Thode, 1519; according to Popp (*Burl. Mag.*, 1936, II, p. 207), 1527; and according to Justi, from the end of the Florentine stay, 1533-1534. Cf. also Wilde, 1954.

The position of the arm repeats the motif of the David-Apollo. The proportions are elongated.

After Michelangelo's death (March 1564), Lionardo Buonarroti and Daniele da Volterra proposed using this figure and other blocks for the master's tomb. Vasari wrote (March 18, 1564) that Duke Cosimo I was in agreement. At the end of 1564, the statue was moved to the Salone Regio in the Palazzo della Signoria; in 1868 to the Bargello; and in 1920 back to the Palazzo della Signoria.

The group by Giovanni da Bologna, Virtue Triumphing over Vice (Florence, Bargello), was made as a pendant to this, for the Salone Regio in the Palazzo della Signoria (Vasari, *Vita di G. da Bologna*).

39. SLAVE

> Florence, Casa Buonarroti.
>
> H. 2.34 m. (overall); 2.12 m. (without base).
>
> Marble in the round, rough-hewn.

The statue originally formed part of the collection of the Grand Duke of Florence, and was locked up in a brick shelter in the second courtyard to the left in the Pitti Palace. It was then (1963) exhibited against the wall in the same courtyard; at the request of Tolnay, it was moved in June 1965 to the Casa Buonarroti.

Attributed to Michelangelo and identified as one of the Slaves for the Tomb of Julius II by Tolnay in *Commentari*, 1965, pp. 85-96. Here it is pointed out that the statue was already mentioned by Vasari, who said that Michelangelo had rough-hewn five blocks of marble for the Tomb of Julius II, that is, the figure in question and the four Slaves now in the Accademia. A pupil seems to have overworked the surface of the torso (note the irregular "hatchings" of the toothed chisel).

40. THE YOUNG SLAVE

> Florence, Accademia delle Belle Arti.
>
> H. 2.57 m. (overall); 2.35 m. (without base).
>
> Marble in the round, rough-hewn. The bottom of the block has been completed with plaster.

Probably executed for the fifth project of the Tomb of Julius II, between September 1530 and April 1534, and intended for the front of the monument, center left. Other suggested dates: 1519 (Justi, Thode, Kriegbaum, Laux, von Einem), 1527-1530 (Popp).

Its quality makes it an original Michelangelo and not, as Adolf Hildebrandt and Kriegbaum assume, a statue done by a pupil of Michelangelo on the basis of one of the master's large models.

The motif is partly a development of the Dying Slave in the Louvre. A diagonal band lies across the chest, a symbol of slavery. There is a wax model attributed to Michelangelo in London, Victoria and Albert Museum. (See J. Pope-Hennessy, *Catalogue of Italian Sculpture in the Victoria and Albert Museum*, London, 1964, no. 444; in our opinion this is a copy after the unfinished statue—see Tolnay, *Michelangelo IV*.)

After the death of Michelangelo, the four Slaves in the Accademia and the one in the Casa Buonarroti were given by his nephew Lionardo Buonarroti to Grand Duke Cosimo I (Baldinucci, *Notizie de' Professori del disegno*, Florence, 1681, VIII, 29; Bocchi-Cinelli; Soldini). Cosimo I commissioned Buontalenti to use the four Slaves as atlantes in his grotto in the Boboli Gardens (Soldini, *Il Reale Giardino di*

Boboli, n.d., p. 132). In 1908 they were transferred to the Accademia delle Belle Arti.

41. THE BEARDED SLAVE *157*

> Florence, Accademia delle Belle Arti.
> H. 2.63 m. (overall); 2.48 m. (without base).
> Marble in the round, rough-hewn. The bottom of the block has been finished with plaster.

Probably executed for the fifth project of the Tomb of Julius II, between 1530 and 1534, and intended for the front, center right. Other suggested dates: see the Young Slave, No. 40 above.

The rectangular head resembles that of the Otricoli Zeus. The body is tied with bands, symbols of slavery.

Popp (*Burl. Mag.*, 1936, LXIX, pp. 202ff.) suggests that a small terracotta model of high quality in the British Museum was used for this figure. The origin of the motif goes back, according to Popp, to 1505 (see the drawing by a pupil, a copy from Michelangelo, Paris, Louvre; Popp, *ibid.*, pl. I, 5).

For the history, see the Young Slave, No. 40 above.

42. THE "ATLAS" SLAVE *158, 159*

> Florence, Accademia delle Belle Arti.
> H. 2.78 m. (overall); 2.08 m. (without base).
> Marble in the round, rough-hewn. Original block trapezoidal in shape. The bottom has been completed with plaster. Worked diagonally in the block, two sides of which are still intact.

Probably executed for the fifth version of the Tomb of Julius II, between 1530 and 1534, and intended for the left corner of the main façade. Other suggested dates: see the Young Slave, No. 40 above.

Behind, on the corner of the block, can be seen a barely outlined shape which seems to be an acanthus. The face is barely roughed in above the left hand; only the eyes, the forehead, and part of the nose are visible. There is a band on the left knee, and another on the right knee, fainter. The modeling of the torso is of a very high standard.

On the back of this figure, a caricature of a head seen in profile is engraved in the stone.

For the history, see the Young Slave, No. 40 above.

43. THE WAKING SLAVE *160, 161*

> Florence, Accademia delle Belle Arti.
> H. 2.67 m. (overall); 2.38 m. (without base and upper part).
> Marble in the round, rough-hewn. Worked diagonally in the

block, two sides of which have remained almost intact. The block is in the shape of a parallelepiped. The bottom of it has been finished with plaster.

Probably executed for the fifth project of the tomb of Julius II, between 1530 and 1534. Intended for the right corner of the main façade. Other suggested dates: see the Young Slave, No. 40 above.

Michelangelo apparently wished to sculpt a band above the right leg. The modeling of the torso, with its triple undulation, is of the highest quality.

For the history, see the Young Slave, No. 40 above.

177-179 44. BUST OF BRUTUS

Florence, Bargello.
H. 95 cm. (overall); 74 cm. (without base).
Marble bust, not completely finished. The tapering base is sculpted in the same block of marble as the bust, which is hollowed out at the back.

Made in Rome after 1539, on the advice of Donato Giannotti, for Cardinal Niccolò Ridolfi (Vasari). The *garzone* Tiberio Calcagni finished the drapery, part of the neck, and the concavity behind (Vasari, Grünwald).

On the base, a bronze plaque engraved with a distich, attributed by Richardson to Cardinal Bembo, by R. Ridolfi to Giannotti himself:

M. DUM · BRUTI · EFFIGIEM A.
SCULPTOR · DE · MARMORE · DUCIT
IN · MENTEM · SCELERIS · VENIT
B. ET · ABSTINVIT F.

"The sculptor, as he carves the image of Brutus out of the marble, recalls his crime and desists." (M.A.B.F.: Michael Angelus Bonarotus Fecit.)

This interpretation of the unfinished state of the bust obviously does not correspond to Michelangelo's real motives.

According to Vasari, the model was an antique intaglio belonging to Giuliano Cesarino. The draping and the movement of the head turned to the left are inspired by Roman busts of Caracalla, Naples, Museo Nazionale (Thode) and Popienus, Rome, Museo Capitolino. The head in profile on the fibula is inspired by antique medals representing Brutus. Portheim believed that the head of the bust was an idealized portrait of Lorenzino de' Medici, the murderer in 1537 of Alessandro de' Medici, and assumed that Michelangelo thus erected a monument to Lorenzino, "a new Brutus." The head on the fibula is

perhaps a portrait of Giannotti (see Tolnay, *Burl. Mag.*, 1935, pp. 23ff.).

On the asymmetry of the two sides of the face and the symbolic significance of the right and left, see Bachoffen, *Mutterrecht*, p. 98, and P. Abraham, "Une figure, deux visages," *Nouvelle Revue française*, 1934, pp. 409ff. and 585ff.

The bust was acquired between 1574 and 1587 by Grand Duke Francesco de' Medici, for his villa La Petraia, near Florence (*Rep. f. Kw.*, xix, p. 418). In the eighteenth century it was in the Sala delle Iscrizioni of the grand-ducal collection.

45. THE LAST JUDGMENT

<div style="text-align: right">*162-176*</div>

Vatican, Sistine Chapel.
H. 17 m. (with wall below). W. 13.30 m.
Fresco.
For its state of preservation, see Biagetti (in De Campos-Biagetti, *Il Giudizio Universale di Michelangelo*, i, pp. 130ff.). The figures of St. Blaise and St. Catherine have been completely repainted so as to hide their nudity; D. da Volterra also added drapery to others. Their original state can be reconstructed on the basis of a copy of the *Last Judgment* by Marcello Venusti, Naples, Galleria Nazionale di Capodimonte, and several early engravings. The blue (ultramarine) of the background of the fresco has changed color with the passage of time. (There has been a recent cleaning of the lower part of the sky to the left.)

In autumn 1533 (probably September 22), Clement VII commissioned Michelangelo to paint the entrance wall of the Sistine Chapel with a Fall of Rebellious Angels and the altar wall with a Resurrection of Christ. The project of the Fall had already been abandoned in March 1534. Paul III renewed the order to decorate the altar wall, not with a Resurrection but with a Last Judgment. In April 1535 scaffolding was put up in order to prepare the wall for the fresco. The cartoon for the *Last Judgment* was finished in September 1535. Michelangelo began the fresco, according to Dorez, in April 1536 (in June-July 1536, according to Biagetti).

The upper part of the fresco was finished on December 15, 1540, for on this date the scaffolding was lowered. The almost completed fresco was unveiled on October 31, 1541 (Dorez); it was finished on November 18, 1541. The documents concerning the history of the *Last Judgment* have been published by Pogatscher, in Steinmann, *Sixt. Kap.*, ii, pp. 742ff., and by A. Mercati, in De Campos-Biagetti, *op. cit.*, i, pp. 167ff. Also important is L. Dorez, *La Cour du pape Paul III*, Paris, 1932.

238 The first sketch of the whole of the composition (Dussler, *Zeichn.*, 55), in the Casa Buonarroti, does not yet include the lunettes at the top. At the bottom in the center, the artist has still taken into consideration Perugino's altar, around which he has drawn his groups (cf. Wilde, *Die Graphischen Künste*, 1936, p. 8).

The gesture of condemnation of Christ the Judge is inspired by certain earlier *Last Judgments* (for example, Pisa, Campo Santo; medallion by Bertoldo di Giovanni [Bode]; Giovanni di Paolo, Siena, Pinacoteca). The artist has himself used this gesture for the fulminating Zeus in his drawings of the Fall of Phaeton. Several motifs among the Elect on the left are taken from the *Battle of Cascina*. In the Resurrection of the Dead, the influence of Signorelli has been observed. Several motifs are inspired by classical statuary (St. Bartholomew by the Torso Belvedere; Christ the Judge by the Apollo Belvedere; the Virgin by the Crouching Venus and Amor group, Naples, Museo Nazionale [G. Coor]).

The wall space below the fresco was to be covered by a Flemish tapestry but this was never executed. The canvas painted by Pierino del Vaga as a temporary decoration is today in the Galleria Spada, Rome.

239-242 Several sketches and studies for the *Last Judgment* have been preserved (see Tolnay, *Michelangelo V*).

Certain authors have thought mistakenly that the most important source of inspiration is to be found in the medieval hymn "Dies irae, dies illa" (Hettner, Thode, De Campos). This thesis has been rightly refuted by showing that the "Dies irae, dies illa" inspired the Pisan fresco, while in Michelangelo's the whole of the second part of the hymn has no parallel (Lanckorónska, *Annales Institutorum*, v, Rome, 1932-1933, pp. 122ff.). The direct influence of Dante's *Divine Comedy* (exaggerated by some authors like Borinski and Steinmann) can only be seen in the scene of Charon and Minos, bottom right, even though a general affinity is obvious in the whole conception. For the influence of the doctrine of justification by faith alone, the Bible, and astral myths, see Chapter IV above.

182, 184 46. RACHEL (CONTEMPLATIVE LIFE)

Rome, San Pietro in Vincoli.
H. 1.97 m.
Marble in the round, polished. Finished by Michelangelo himself and not by Raffaello da Montelupo to whom Michelangelo had thought of giving it for completion.

Begun by Michelangelo before July 20, 1542; according to Wilde (*Windsor Cat.*, p. 253), in 1532-1533. Intended for the bottom left

niche in the last project for the Tomb of Julius II, the place first assigned to the Victory, then to the Dying Slave in the Louvre. The molded base in the niche, like that in the corresponding one, was added when the statues were put in place in order to diminish the height of the niche (Kriegbaum).

Condivi and Vasari call the figure "Vita contemplativa." According to Condivi it is inspired by Dante (*Purg.*, XXVII, 97ff.). See also Landino, *Disputationes camaldulenses*. The motif of the statue is inspired by representations of Hope or Faith on earlier tombs (Burger). The execution, as well as the simplification of the planes, reveals that Michelangelo worked both statues intending them to be seen at a distance.

Bronze copy in Rome, Sant'Andrea della Valle, Strozzi Chapel.

47. LEAH (ACTIVE LIFE)

183, 185

Rome, San Pietro in Vincoli.
H. 2.09 m.
Marble in the round, polished (hair probably done by a *garzone*).

Like the preceding statue, executed before July 20, 1542 and intended for the bottom right niche on the Tomb of Julius II, in the place first assigned to the Victory, then to the Rebellious Slave.

Vasari and Condivi call the figure "Vita attiva." According to Condivi, it is inspired by Dante (*Purg.*, XXVII, 97ff.). The object in the right hand has been interpreted as a mirror (Condivi, Vasari, and Ripa, *Iconologia*, 1603, p. 513), but seems to be a diadem (Thode). In her left hand she holds a crown of laurel, Dante's "ghirlanda." In the copy in the Strozzi Chapel at Sant'Andrea della Valle, the object in the right hand seems to be an oil lamp or a perfume flask.

The motif of the figure was apparently inspired by representations of Charity on earlier tombs.

Bronze copy in Rome, Sant'Andrea della Valle, Strozzi Chapel.

48. THE CONVERSION OF ST. PAUL

186, 188

Vatican, Pauline Chapel.
H. 6.25 m. W. 6.61 m.
Fresco.
For the state of preservation, see Baumgart-Biagetti, pp. 39ff.

The plan of Paul III to have his private chapel decorated with frescoes is mentioned for the first time on October 12, 1541, in a letter from Cardinal Alessandro Farnese. The work began at the end of October or the beginning of November 1542 (Milanesi, p. 488). One of the frescoes was finished on July 12, 1545 when the Pope visited

the chapel. This was most probably the *Conversion of St. Paul*, for its style is closer to the *Last Judgment* (see M. Dvořák, *Geschichte der Italienische Kunst*, Munich, 1928, ii, pp. 129ff.; Neumeyer, *Z.f.b.K.*, 1929, pp. 173ff.; Baumgart-Biagetti, p. 17). In 1545, a fire in the chapel damaged the roof but apparently left the fresco relatively unharmed. Documents on the Pauline Chapel assembled by Baumgart-Biagetti, pp. 69ff.; Frommel in *Zeitschrift für Kunstgeschichte*, 1964, pp. 1ff.

Engraving by Béatrizet, Bartsch, no. 33.

187, 189 49. THE CRUCIFIXION OF ST. PETER

Vatican, Pauline Chapel.
H. 6.25 m. W. 6.61 m.
Fresco.
For the state of preservation, see Baumgart-Biagetti, pp. 39ff.

Begun in August 1545 (according to De Campos); on October 13, 1549 the fresco was still not completely finished when the Pope visited the chapel. Probably finished in 1550 (see Baumgart-Biagetti, p. 17).

There is a sketch for one of the figures to the top right of the group in Haarlem, Teyler Museum (Dussler, *Zeichn.*, 148 and 296), identified by Baumgart, *op. cit.*, p. 31. There is a piece of the cartoon for the bottom left corner of the fresco in Naples, Galleria Nazionale di Capodimonte (Steinmann, "Cartoni di Michelangelo," *Bollettino d'Arte*, 1925, pp. 11ff.). Documents on the Pauline Chapel assembled by Baumgart-Biagetti, pp. 69ff.

Etching by Michele Lucchese; engraving by G. B. de' Cavalieri (see Tolnay, *Michelangelo V*, figs. 302, 303).

190-192 50. "PIETÀ" (DEPOSITION OF CHRIST)

Florence, Santa Maria del Fiore.
H. 2.26 m.
Marble group in the round, partly polished (body of Christ and Mary Magdalen; the latter, however, by Tiberio Calcagni).

Begun before 1550, since it is mentioned in Vasari's first edition of 1550, already composed ca. 1546-1547. In 1553, Condivi mentions it as still unfinished. Before December 3, 1555, the date when the *garzone* Urbino died, the group was mutilated by Michelangelo himself (Vasari). In 1561, Michelangelo gave it to his servant Antonio, who later sold it to Francesco Bandini.

Cosimo III had the group brought to Florence. This transfer must have taken place between 1652 and 1674, for in 1652 the statue is mentioned as still being in Rome "nel giardino che fù del Signore cardinal Bandini à Monte Cavallo" (see Ottonelli and Berrettini, *Trat-*

tato della pittura, Florence, 1652, p. 210). In 1674, the Pietà was placed in the crypt of the church of San Lorenzo in Florence, although P. Falconieri wanted to exhibit it in the Medici Chapel (see his letter of 1674, published by Poggi in C. Mallarmé, *L'ultima tragedia di Michelangelo*, Rome, 1929). In 1721, it was erected behind the high altar in Santa Maria del Fiore, and in 1933 was transferred to one of the chapels in the north tribune.

Michelangelo originally intended this group for the altar of his funerary chapel, which was to be in Santa Maria Maggiore in Rome (Vasari, *Carteggio*, II, p. 59; Vasari 1568, p. 218). It was mutilated and abandoned by Michelangelo, and restored and continued by his pupil Tiberio Calcagni. Mary Magdalen, begun by Michelangelo (see her back), was finished and spoilt by his pupil. Michelangelo himself destroyed Christ's left arm and leg (the latter is missing); the fragments of the left arm were pieced together by Tiberio Calcagni who also restored the right hand and left breast of Christ.

Michelangelo's inventory, dated April 5, 1566 and written by Daniele da Volterra (*Il Buonarroti*, I, 1866, p. 178), lists: "Un ginocchio di marmo della Pietà di Michelangelo," no doubt the knee of the missing left leg (see Steinmann and Wittkower, *Bibliographie*, p. 145).

The composition is a development of the *Pietà* drawn for Vittoria Colonna and is also inspired by certain Quattrocento *Pietàs*, like the one in Cherbourg Museum, attributed to Fra Filippo Lippi or the young Botticelli. Here the dead body is supported in a vertical position by the same figures as in Michelangelo's statue: the Virgin and Mary Magdalen to the right and left, and in the center, behind Christ, Nicodemus. The pose of Christ's body is perhaps inspired by Dürer's woodcut of 1511, representing the Holy Trinity. The face of Nicodemus is, according to Vasari, a self-portrait of Michelangelo.

Christ's left leg can be seen in the fairly numerous copies. For example, Lorenzo Sabbatini, Rome, San Pietro; Santa Maria dei Monti in Rome, third chapel to the right, ca. 1560-1570; Giacomo Cortese, called Borgognone, copy without Mary Magdalen, Rome, Accademia di San Luca; finally, the anonymous engraving, Bartsch, XVII, p. 58, no. 23.

51. RONDANINI PIETÀ

 Milan, Castello Sforzesco. *195, 196*

 H. 1.95 m.

 Marble group in the round, unfinished.

The first version was begun around 1552-1553; the second about 1555, after the mutilation of the "Pietà" now in Santa Maria del Fiore.

The third version dates from shortly before the artist's death in 1564 (letter from Daniele da Volterra dated June 11, 1564; Daelli, no. 34).

Belonging to the first version, rejected by Michelangelo himself, are the polished legs of Christ, his right hip, a fragment of his polished right arm which is now detached from the body, and finally a rough-hewn piece of the Virgin's face turned to the right, in which one can recognize the forehead, eyes, nose, and veil. While in this version the figure of Christ was finished, the Virgin seems to have remained at the rough-hewn stage. A sheet with three sketches for the first version is in Oxford (Dussler, *Zeichn.*, 201).

251

In the last year of his life, Michelangelo reworked the Virgin's head, which is now facing forward, and sculpted the new head of Christ from the Virgin's right shoulder. Christ's left arm and his new right arm (clearly visible from behind) have been rough-hewn from the Virgin's body. It can be noted that the two bodies become progressively more and more emaciated (see Tolnay, *Burl. Mag.*, 1934, pp. 146ff.).

At a later date, the base was partly cut away in front, destroying the toes on Christ's right foot, and the inscription SS PIETA DI MICHEL ANGELO BUONAROTA was carved on it.

The first version was probably inspired by a medieval type of Pietà in which the Virgin and Christ are standing. One such example is the *Pietà* of the Catalan school in Vercelli, Museo Borgogna (published in *Bollettino d'Arte*, 1938, p. 120). There was also a type of Holy Trinity in the late Middle Ages in which God the Father stands holding the body of Christ (as, for example, the *Holy Trinity* of the Master of Flémalle in Frankfurt), a composition which heralds the Rondanini Pietà.

The group is mentioned in the inventories of Michelangelo's effects of February 19 and March 17, 1564 (Frey, *Handz.*, p. 114, and Gotti, I, p. 358).

A free copy of the first version by Taddeo Zuccari is in Rome, Borghese Gallery.

194 52. SMALL MODEL OF A CRUCIFIX

Florence, Casa Buonarroti.
H. 26.4 cm. (overall); 20.5 cm. (figure).
Wood, only partially worked on the back. The surface is unfinished; it has been worked with a small concave implement, giving a rough effect to the whole.

The work can be dated in the summer of 1562, one and a half years before Michelangelo's death. In two letters of August 1 and 2, 1562,

Michelangelo asked his nephew Lionardo in Florence to send him the wood and implements necessary to execute a larger than life-size wooden crucifix. This small carving seems to be a model precisely for this project. The two letters addressed to the nephew Lionardo are published by Barocchi in *Michelangelo, Mostra di disegni ecc.*, Florence, 1964, pp. 192, 193.

In our opinion the model is a completely original work of the highest quality. Michelangelo abandons all movement in his rendering of the figure of Christ, to arrive at an image even more moving and expressive of the spiritual drama than in his earlier crucifixes which are more dramatic in pose.

The importance of the work and its dating have only recently been recognized. It is mentioned for the first time, without any attribution, in Fabbrichesi's guide to the Casa Buonarroti (Florence, 1865 and subsequent editions), and again without any attribution in the *Ricordo al Popolo Italiano*, Florence, 1875, p. 178. Thode (*Kr. U.*, III, p. 280) describes it as made of wax and considers its attribution to Michelangelo as "very doubtful." Brinckmann (*Barock-Bozzetti*, I, Frankfurt a.M., 1923, p. 37) attributes it to Michelangelo but describes it as a wax model for a Slave. Finally, Tolnay has attributed it to Michelangelo, dated it, and shown its stylistic relationship with the master's last group of drawings of the crucified Christ, for example, that in the collection of Count Seilern in London (Tolnay, *Akten des 21. Int. Kong. 1964*, II, pp. 71ff., and *Commentari*, 1965, pp. 93ff.). 193

The model has always been the property of the Casa Buonarroti.

II. WORKS LOST, OF DOUBTFUL IDENTIFICATION, OR PLANNED BUT NOT EXECUTED

1. TEMPTATION OF ST. ANTHONY

359
360
Copy after Schongauer, lost. Mentioned by Condivi and Vasari as one of the earliest works. A small panel representing this subject which is in the style of Ghirlandaio, especially the landscape, was sold in December 1960 at Sotheby's in London. Attempts have been made to identify this picture as Michelangelo's lost work. Private collection. See Tolnay, *Alcune recenti scoperte*, 1971, p. 5f.

2. HEAD OF A FAUN

Formerly in Florence, Giardino Mediceo; lost. Marble. Executed about 1489. Vasari 1550, p. 23; Condivi, pp. 20ff.; Vasari 1568, pp. 23ff. Reproduction (probably free) of this lost work in the fresco by Ottavio Vannini, Florence, Pitti Palace (cf. Tolnay, *Michelangelo I*, pl. 253). In 1746 Mariette attributed a mask of a faun to Michelangelo and tried to identify it with the above mentioned Head. This mask was, until its disappearance during the last war, in the Bargello in Florence (Tolnay, *op. cit.*, pl. 252). Judging from the style and the technique (a drill is used), it seems close to Michelangelo's Bacchus.

3. HERCULES

6
7
Formerly in Fontainebleau, Jardin de l'Estang; lost. Marble. H. 4 *braccia* (approx. 2.52 m.). Mentioned by Condivi, p. 28 and Vasari 1568, p. 29. The statue was executed after the death of Lorenzo de' Medici in April 1492 and before 1494, when Michelangelo left Florence for Bologna. There is a wax model of the figure in the Casa Buonarroti. A drawing by Rubens in the Louvre shows the front view (cf. Tolnay, *G.d.B.A.*, 1964, pp. 125ff.). The motif heralds that of the marble David. Reproduced from the back in an engraving by Israël Silvestre representing the Jardin de l'Estang at Fontainebleau. Bayersdorfer (cf. Justi, *Michelangelo N.B.*, pp. 43ff.) tried to identify this lost statue as the Hercules in the second niche to the left of the amphitheatre in the Boboli Gardens in Florence. (Cf. also Liphart-Rathshoff, *Rivista d'Arte*, xv, 1933, pp. 93ff.) Concerning the later history of the Hercules in France, see Châtelet-Lange in *Pantheon*, 1972, pp. 455ff.

4. SAN GIOVANNINO (THE YOUNG JOHN THE BAPTIST)

Formerly in the possession of Lorenzo di Pierfrancesco de' Medici, Florence; lost. Marble. Dimensions unknown. Executed at the end of 1495 or during the first half of 1496. Mentioned by Condivi, p. 36 and Vasari 1568, p. 37. The motif of this statuette is possibly reproduced in a drawing of St. John the Baptist by Bandinelli in the Louvre (Inv. 7625). Other hypotheses as to its identification: according to W. Bode (*J.d.p.K.*, II, 1881, pp. 72ff.) a San Giovannino in Berlin is that of Michelangelo; it is, however, a statue of the late sixteenth century done in the style of Francavilla. According to W. R. Valentiner (*Art Quarterly*, 1938, pp. 25ff.) a statuette of San Giovannino in the Morgan Library in New York is Michelangelo's; it was attributed by Middeldorf to G. F. Rustici (*Burl. Mag.*, LXVI, 1935, p. 72); we believe, however, that it is a work by Silvio Cosini, one of Michelangelo's *garzoni*. Gomez-Moreno (*La Escultura del Renacimiento en España*, Barcelona, 1931, pl. IX) thought he had found the lost statuette in the San Giovannino at Ubeda, Capilla del Salvador, which 361 was destroyed during the 1936-1939 civil war. R. Longhi (*Paragone*, 1958, no. 101, pp. 59ff.) proposed to identify Michelangelo's lost statuette with a San Giovannino of very poor quality in the church of San Giovanni dei Fiorentini in Rome. Alessandro Parronchi (*Studi Urbinati*, 1969, pp. 3ff.) believes it to be the St. John in the Bargello, hitherto attributed either to Donatello or, more correctly, to Francesco da Sangallo. Finally, F. de' Maffei (*Michelangelo's Lost St. John*, New York, 1964) suggests a seated San Giovannino, formerly the property of the dealer Tozzi in New York, a statuette which we do not think can be attributed to Michelangelo.

5. SLEEPING CUPID

Formerly in the possession of Isabella d'Este, Mantua; lost. Marble. H. 4 *spanne* (approx. 80 cm.). Probably executed in April-May 1496. Mentioned by Vasari 1550, p. 37; Condivi, p. 36; Vasari 1568, p. 47. A reproduction of this can possibly be recognized in the Cupid in 362 Tintoretto's work *Venus and Mars Surprised by Vulcan*, Munich, Alte Pinakothek (see Tolnay, *Thieme-Becker*; Wilde, *Eine Studie*, p. 53). There is a Sleeping Cupid in marble in exactly the same pose as Tinto- 363 retto's in Lord Methuen's collection at Corsham Court, Wiltshire. Valentiner (*Commentari*, 1956, pp. 236ff.) and P. F. Norton (*Art Bulletin*, 1957, pp. 251ff.) retrace the statuette's history. Other attempts at identification: Symonds (*Michelangelo*, London, 1893, I, pp. 50ff.) proposed the statuette of the Sleeping Cupid in Mantua,

Accademia Virgiliano; Conrad Lange (*Z.f.b.K.*, XVIII, 1883, pp. 233ff. and 274ff.), the Sleeping Cupid in the Museo Archeologico, Turin. A. Parronchi (*Opere giovanili di Michelangelo*, Florence, 1968, pp. 113ff.) thinks the figure was in the pose of an antique hermaphrodite.

6. CUPID-APOLLO

Formerly in Rome, commissioned by Jacopo Galli and in his collection; lost. Marble. Life-size. Executed by Michelangelo in Rome between June 1496 and spring 1501. Mentioned by Condivi, p. 42; Vasari 1568, p. 41. There is no reproduction of this figure, though Michelangelo's drawing of Mercury-Apollo in the Louvre (Dussler, *Zeichn.*, 209r) is probably related to it. Maclagan (*Art Studies*, 1928, pp. 3ff.) identified it with a statue in the Victoria and Albert Museum in London, which according to Kriegbaum, however, is by Vincenzo Danti (*J.d.K.S.*, III, 1929, pp. 247ff.). More recently, Pope-Hennessy (*Burl. Mag.*, 1956, pp. 403ff.) has shown that this is a classical work restored in the sixteenth century, probably by Pierratti. Moreover, it represents Narcissus, not Cupid, as Horne had observed. Parronchi (*Opere giovanili di Michelangelo*, Florence, 1968, pp. 131ff.) identifies the lost figure with a seated Cupid in a private collection in Switzerland.

201

7. STIGMATIZATION OF ST. FRANCIS OF ASSISI

Formerly in Rome, San Pietro in Montorio, first chapel on the left; lost. Panel, tempera. Michelangelo did the cartoon in Rome between 1496 and 1501. Mentioned by Vasari 1550, pp. 39ff. and 1568, p. 41. In the first chapel on the left in San Pietro in Montorio is a fresco by Giovanni de' Vecchi representing a Stigmatization which, although far from Michelangelo's style, could reflect the main lines of the lost composition. A medal of the late eighteenth or early nineteenth century, as well as a panel painting in a private collection, represent this scene. The attribution, however, remains doubtful.

8. BRONZE DAVID

Formerly in France at the Château de Bury and later the Château de Villeroy; lost. H. 2¼ *braccia* (approx. 1.42 m.). Commissioned on August 12, 1502. The sketch in the Louvre (Dussler, *Zeichn.*, 213r) is probably related to it. The statue was finished only in November 1508 by Benedetto da Rovezzano. In two engravings by

204

Ducerceau (*Les plus excellents Bâtiments de France*, 1576, folios 124 and 125), representing the Château de Bury, Michelangelo's statue can be seen, though very small, in the middle of the courtyard. Attempts have been made to identify certain works as reductions or models of this statue. Courajod (*Gazette archéologique*, x, 1885, p. 77) thus identified the bronze statuette of David formerly in the collection of Charles de Pulszky, and now in the Louvre; a hypothesis recently taken up again by Boeck in *Mitteilungen des Kunsthistorischen Instituts*, Florence, 1959, pp. 131ff. M. A. Pit (*Revue de l'art ancien et moderne*, ii, 1897, pp. 455ff.) suggested a bronze statuette of David in the Rijksmuseum, Amsterdam. Bayersdorfer (*Leben und Schriften*, Munich, 1902, pp. 84ff.) proposed a wax model in the Casa Buonarroti in Florence; in fact, this is a model for the Fontainebleau Hercules (cf. Tolnay, *G.d.B.A.*, 1964, pp. 125ff.).

364

9. The Twelve Apostles

Statues planned for Florence, Santa Maria del Fiore, but not executed. Only the St. Matthew was begun; see No. 19 in Catalogue I above.

206

10. The Battle of Cascina

Cartoon for a fresco of nudes larger than life-size in the Sala del Consiglio of the Palazzo della Signoria, Florence; divided and lost. The exact date of the commission is not known. According to a later letter from Michelangelo, it was in the second year of the pontificate of Julius II. In December 1504, Michelangelo was working on the cartoon which was finished before February 28, 1505. The fresco had already been begun in November 1506.

Between the summer of 1515, the year when it was transferred from the Sala del Papa near Santa Maria Novella to a large hall on the second story of the Medici Palace, and the spring of 1516, the cartoon was cut into several pieces and dispersed. The only existing source for the overall composition is a grisaille in the possession of the Earl of Leicester, Holkham Hall, Norfolk, a panel probably identical with the copy which Bastiano da Sangallo executed in 1542 at Vasari's instigation. There are several drawings related to the figures in this composition (see Köhler, *Kunstgesch. Jahrbuch d.K.K. Zentralkommission*, i, 1907, pp. 115ff., whose reconstruction, however, is not completely convincing); and also Wilde, *The Hall of the Great Council of Florence*, 1944, pp. 65ff., and Isermeyer, "Die ʌrbeiten Leonardos und Michelangelos . . . ," 1963, pp. 83ff.).

366

212

11. Bronze Statue of Julius II

Formerly on the façade of San Petronio in Bologna; destroyed. Larger than life-size. Probably commissioned after November 28, 1506. At the same time Julius II commissioned from an unnamed artist a stucco statue for the façade of the Palazzo degli Anziani; it also represented Julius II seated. This second statue, probably after a model by Michelangelo, was destroyed on May 22, 1511. The wax model for the bronze statue was finished in April 1507. In February 1508, the finished bronze was placed on the façade of San Petronio. Destroyed by the people of Bologna, after the return to the city of the Bentivoglio, on December 30, 1511. The pose can be reconstructed approximately from the statue of Gregory XIII by Menganti on the Palazzo Pubblico at Bologna, or from that of Julius III by Vincenzo Danti in Perugia, and from a drawing by Bandinelli in the Louvre. The coat of arms which decorated the pedestal can probably be identified with that of the Museo Municipale at Bologna (Tolnay, *Michelangelo I*, p. 223).

12. Dagger

Formerly in the possession of Filippo Strozzi, Florence; lost. Mentioned in letters dated December 19, 1506, January 22, 1507; February 1, 1507; February 24, 1507; and March 6, 1507.

13. Marble Group for the Piazza della Signoria

Not executed. H. 8½ *braccia*; W. 2½ *braccia*. The history of this group (1508-1534), which was finally executed by Bandinelli, is given in Catalogue I above, under No. 26 (a model probably relating to Michelangelo's version of 1528).

14. Samson and Two Philistines

Model, possibly in clay, made probably after 1530. Original lost. Brinckmann, *Barock-Bozzetti*, Frankfurt a.M., 1923, pp. 32ff., attributes the group to Pierino da Vinci, because we know from Vasari that Pierino wanted to make two statues "5 *braccia*" high on the basis of some sketches by Michelangelo, and that before the arrival of the marble he executed different models of Samson slaying a Philistine with the ass's jaw. A clay model in the Musée Bonnat in Bayonne was later published by Brinckmann as an original in *Belvedere*, xi, 1927, pp. 155ff. Other copies in bronze and in drawings are listed in Thode, *Kritische Untersuchungen*, 1908, and in Tolnay, *Michelangelo III*, pp. 186f. This group was renowned as an atelier model, as can be

seen in a painting by Willem van Haecht in the Mauritshuis, The Hague.

15. LEDA

Executed for Alfonso d'Este, Duke of Ferrara; later given by Michelangelo to his pupil Antonio Mini; lost. Mentioned by Vasari 1550, p. 141; Condivi, p. 142; Vasari 1568, pp. 145ff. Known by copies, the best of which is the engraving by Cornelius Bos. Numerous *377* painted copies (see Wilde, in *Memorial Essays in Honour of Fritz Saxl*, London, 1957, pp. 270ff.).

16. NOLI ME TANGERE

Cartoon; lost. First mentioned in April 1531. The composition was executed originally for Vittoria Colonna (see Wilde, *B.M. Cat.*, no. 67), no doubt for one of the Case delle Convertite—homes for reformed courtesans—which she promoted (see Seilern, *Italian Paintings and Drawings at 56 Prince's Gate*, London, 1969, v, text pp. 10ff.). For the historical data, see Tolnay, *Michelangelo III*, pp. 197-198. Known from copies, the best of which, probably by Pontormo, *379* is in a private collection in Milan and is reproduced here; it seems likely that Pontormo began his painting in November 1531 and finished it early in 1532. Two copies, one attributed to Battista Franco and the other by Longhi to Bronzino, are in the Casa Buonarroti. Another, attributed by Pouncey to Battista Franco, was exhibited in 1971 at the Heim Gallery in London. Yet another, without landscape and attributed to Allori, is in the Leo Steinberg Collection in New York. Two drawings may represent preparatory versions for the figure of Mary Magdalen: Casa Buonarroti 39Fr, with a copy in the Louvre, Inv. 690; the copy of a different version at Windsor Castle, attributed by Wilde to Daniele da Volterra (Wilde, *Windsor Cat.*, no. 263). Michelangelo was commissioned to make the cartoon for this work by the Marchese del Vasto, Alfonso d'Avalos, who acted on behalf of his aunt, Vittoria Colonna.

17. VENUS AND CUPID

Cartoon; lost. Probably done about 1532-1533. Mentioned by Vasari 1550, p. 170 and 1568, p. 250. The painting was executed *378* by Pontormo from Michelangelo's cartoon, and is in the Uffizi, Florence. Preparatory sketch in the British Museum (Wilde, *B.M. Cat.*, no. 56).

18. RESURRECTION OF CHRIST

Fresco planned for the Sistine Chapel below the Jonah, for which several drawings are still in existence. See the report of Agnello, March 20, 1534 (Pastor, *Geschichte der Päpste*, IV, Pt. II, p. 567, n. 2, to which F. Hartt called attention) and the drawings probably connected with this project in Tolnay, *Michelangelo V*, pp. 175ff., and *Commentari*, 1964, pp. 3ff.

19. MODEL FOR A SILVER SALT CELLAR

With animal feet, festoons, masks, and a figure on the lid, made for Francesco Maria, Duke of Urbino. Mentioned in a letter from Girolamo Staccoli, July 4, 1537 (Gotti, II, p. 125); lost. A drawing related, according to Robinson, to this project is in the British Museum and was published by Popp, *Z.f.b.K.*, 1927-1928, pp. 15ff.; cf. Wilde, *B.M. Cat.*, no. 66. An exact copy of the British Museum drawing is today in the Victoria and Albert Museum, London.

20. SMALL BRONZE HORSE

Made for Francesco Maria, Duke of Urbino, 1537; lost. Some studies of a horse are probably related to this project (Oxford and Casa Buonarroti). The documents are published by Gronau, *J.d.p.K.* (*Beihefte*), XXVII, pp. 7ff.

21. CHRIST HOLDING THE CROSS

Small marble statue. Unfinished; lost. Mentioned in the posthumous inventory of Michelangelo's belongings (Gotti, II, p. 150) and in a letter from Daniele da Volterra, dated March 17, 1564.

III. ARCHITECTURE

A more detailed catalogue of the architectural works of Michelangelo can be found in J. S. Ackerman, *The Architecture of Michelangelo*, and in Portoghesi-Zevi, and will be included in Tolnay, *Michelangelo VI*.

1. Façade of the chapel of Leo X in the Castel Sant'Angelo, Rome, 1514, attributed to Michelangelo since the mid-sixteenth century (see drawing by Bastiano da Sangallo, Lille, Musée des Beaux Arts; and also Portoghesi-Zevi, pp. 165ff., figs. 139-148).

2. Windows—"finestra inginocchiata"—for the ground floor of the Medici Palace in Florence, ca. 1517. The original drawing for this work is in the Casa Buonarroti, Florence, no. 101.

255

3. Project for the façade of San Lorenzo in Florence. Competition in 1515; contract, January 1518; contract annulled by Leo X in 1520 (see Chapter VII above). The wooden model made by Pietro Urbano is in the Casa Buonarroti, Florence (see Tolnay, *Commentari*, 1972, pp. 83ff.).

318-321

257, 258

4. Medici Chapel, San Lorenzo, Florence, begun in November 1519 and abandoned in 1534. (See Catalogue I, No. 27, and Chapter III above.)

104-108

324-329,

332

5. Laurentian Library (Biblioteca Laurenziana), monastery of San Lorenzo, Florence. First negotiations, autumn 1523; work begun during the summer of 1524, suspended between 1526 and 1530, and resumed from 1530 until the beginning of 1534. Michelangelo left the work unfinished when he went to Rome. Yet in 1550 the intention was to continue it (Vasari); in 1560 Ammanati executed the staircase in the vestibule. The second order of the vestibule was finished in accordance with Michelangelo's plans only at the end of the nineteenth century. (See Wittkower, *Art Bulletin*, 1934.)

259-268

333-338

6. Reliquary Tribune of the Medici family, San Lorenzo, Florence. Above the main entrance inside the church (ca. 1531-1532). Drawing (Dussler, *Zeichn.*, 199) of a ciborium for San Lorenzo; see Tolnay, *Archivio Buonarroti*, pp. 398ff.

269, 270

7. Plans for the fortifications of Florence, 1529. Twenty-three drawings, Casa Buonarroti, Florence. (See Tolnay, *Art Bulletin*, 1940, pp. 127ff.)

341-344

8. Plans for the Casa Buonarroti in Florence, via Ghibellina; four drawings, Casa Buonarroti. (See Tolnay, *G.d.B.A.*, 1966, pp. 193ff.)

271, 272
345, 346

9. Tomb of Cecchino Bracci, Santa Maria in Aracoeli, Rome. The project by Michelangelo dates from 1544, the year of Cecchino Bracci's death at the age of fifteen. The monument was identified by Steinmann, *Monatshefte für Kunstwissenschaft*, 1909, I, pp. 963ff.; for the documents, see Frey, *Dicht.*, p. 356. Michelangelo's final version was inspired by the tomb of Cardinal de Vincentini in the same church, attributed to the school of Andrea Sansovino. He modified its flat forms according to his own plastic idiom, giving it heavy volutes and characteristically inserting an attic above the cornice which confers the effect of weightiness. For the traditional figure of the Virgin, he substituted a bust of the dead youth. The execution of both monument and bust was in the hands of Pietro Urbano, who was responsible for the rough profiles of the tomb; he also simplified Michelangelo's design in the attic (cf. the anonymous mid-sixteenth-century drawing in the Casa Buonarroti, in our opinion a copy of the lost original drawing by Michelangelo, where two protruding *lesene*—pilasters without a capital—are shown). The Scholz Scrapbook in the Metropolitan Museum in New York contains a drawing of the actual tomb. For the genesis of the artistic idea of the monument, see Michelangelo's drawings in the Casa Buonarroti, 19Fr/v (Barocchi, 159r/v).

273-284
347-351

10. Basilica of St. Peter, Vatican, Rome. Michelangelo was given the direction of the work in September 1546. He had four models made. (See Chapter VII above.)

285-293

11. The Capitol (Campidoglio), Rome. The first drawing for the ensemble probably dates from 1546. The Palazzo dei Conservatori was begun in 1563; the palace opposite (now the museum) and the Palazzo dei Senatori were built after Michelangelo's death. (See Chapter VII above.)

294-300

12. Farnese Palace, Rome. The palace was built according to plans by Antonio da Sangallo the Younger; Michelangelo was appointed to direct the work after Sangallo's death in the autumn of 1546. The parts constructed by Michelangelo are: the large window above the main door; the cornice (the model dates from spring 1547); the great hall on the south corner of the building; the vestibule (*ricetto*) preceding the great hall; the travertine frieze above the second story in the courtyard; the third story of the courtyard. (See Chapter VII above; and L. Frommel, *Der Römische Palastbau*, Tübingen, 1973, II, pp. 103ff.)

13. Rough sketches for the plan of the Villa Giulia, Rome, between 1550 and 1555. Vasari mentions such sketches. In the *Portrait of Michelangelo in his Workshop*, Florence, Casa Buonarroti, there is on the table a plan of the Villa Giulia, used here as an emblem of Michelangelo the architect.

14. Project for the palace of Julius III, Rome, 1551. It was never executed. The lost model is represented in a painting by Fabrizio Boschi in the Casa Buonarroti, Florence.

15. Choir of Padua Cathedral; plan by Michelangelo, 1551-1552. *301, 302* (See Tolnay, in *Festschrift H. von Einem*, Berlin, 1965, pp. 247-251.)

16. Project for the stairway in the exedra of the Cortile del Belvedere, *303-305* Vatican, 1552. The ground-plan drawing in the Scholz Scrapbook in the Metropolitan Museum, New York, was identified by Tolnay, *Akten des 21. Int. Kong. 1964*, ii, p. 69, pl. 24(3). (See Chapter VII above).

17. Plan for the church of the Gesù, Rome, 1554. (See Popp, *Münch-* *352* *ner Jahrbuch*, 1927, pp. 389ff.)

18. Plans for San Giovanni dei Fiorentini, Rome, 1559. (See Chapter *306* VII above.) *352-356*

19. Sketch for the bridge of Santa Trinita, Florence, 1560. Executed by Ammanati. (See Kriegbaum, *Rivista d'Arte*, 1941, pp. 137ff.)

20. Santa Maria degli Angeli, Rome. Plan for the transformation of *307-309* the Baths of Diocletian into a church, 1561. (See Chapter VII above.)

21. Porta Pia, Rome, from 1561 onwards. (See Chapter VII above.) *310-312* *357, 358*

22. Sforza Chapel, Santa Maria Maggiore, Rome; from about 1563 *313-317* onwards. Executed by Tiberio Calcagni. (See Chapter VII above.)

IV. DOUBTFUL ATTRIBUTIONS

These works, attributed to Michelangelo, are not mentioned by contemporary sources.

SCULPTURE

1. APOLLO AND MARSYAS
Private collection. Marble relief from an antique gem. Attributed to Michelangelo by Liphart in Bode, *J.d.p.K.*, XII, 1891, pp. 167ff. and Mackowsky, *Michelangelos frühestes Werk*, priv. pr., 1929.

2. CRUCIFIXION OF ST. ANDREW
Florence, Bargello. Marble relief, executed in the technique of Michelangelo. Mentioned for the first time as a work by Michelangelo in 1825. Attributed by Popp to Niccolò Tribolo.

3. STATUETTE OF APOLLO
Berlin, Staatliche Museum. Marble. Attributed to Michelangelo by Bode, *J.d.p.K.*, XXII, 1901, pp. 88ff.

4. MALE NUDE, PERHAPS ST. SEBASTIAN
London, Victoria and Albert Museum. Marble. Attributed to Michelangelo by Robinson, *Catalogue of the South Kensington Museum*, London, 1862. Verbal attribution to Tribolo by Middledorf. Cf. J. Pope-Hennessy, *Catalogue of Italian Sculpture in the Victoria and Albert Museum*, London, 1964, no. 464.

5. MARBLE CHILD
Hitherto attributed to B. da Maiano. Naples, Santa Anna dei Lombardi. Attributed to Michelangelo by M. Lisner, *Zeitschrift für Kunstwissenschaft*, XII, 1958, pp. 141-156.

6. DYING ADONIS
Florence, Bargello. Marble. A work by Vincenzo de' Rossi (Borghini, *Riposo*, III, p. 126).

7. BACCHUS AND AMPELOS
Florence, Uffizi. Marble. The restoration of this ancient torso was attributed to Michelangelo by Bode, *J.d.p.K.*, II, 1881, pp. 76ff. Probably the work of Giovanni Caccini (Grünwald, *Münchner Jahrbuch*, 1910, pp. 28ff.).

8. St. Jerome *382, 383*

Florence, Casa Buonarroti. Wax model, height 39 cm. Of uncertain provenance, but likely to have been part of the original group of models in the Casa Buonarroti, kept in the *pensatoio*, also called *scrittoino* in the 1684 Description of the Buonarroti Gallery. The piece has rarely been mentioned and, to our knowledge, had never been ascribed to Michelangelo before the hypothetical attribution in our guide, *La Casa Buonarroti*, 1970, pp. 62-63. Fabbrichesi's guide to the Buonarroti Gallery, first published in 1865, mentions it without an attribution; Thode (*Kr. U.*, III, p. 280, no. 2) describes it wrongly as made of stucco and says that it is undoubtedly not by Michelangelo; the same view has recently been expressed by Procacci (*La Casa Buonarroti a Firenze*, Milan, 1965, p. 198 and ill. 6), who calls it a "very beautiful work by an unknown Florentine of the sixteenth century, bearing no relation to Michelangelo."

This is an almost naked, emaciated, skeletonlike figure, with a highly expressive ascetic face. Striding forward, the saint seems to beat his breast in penitence. The figure reverts to the tradition of Donatello's representations of ascetics (for instance, his St. John the Baptist of 1423 in bronze in Berlin, the same subject in bronze of 1457 in Siena Cathedral, and the great wooden sculpture of St. Mary Magdalen from ca. 1455-1457 in the Baptistery at Florence). That Michelangelo sometimes reverted to this Donatellesque tradition can be shown by his drawing of an old woman, probably Luxury, in the *219* Louvre, Inv. 710r (see Tolnay, "Sur des Vénus dessinées par Michel-Ange," 1967).

9. Palestrina Pietà *385*

Florence, Accademia delle Belle Arti. Marble group in the round, unfinished; height 2.53 m. Formerly in the Barberini chapel of the church of Santa Rosalia in Palestrina. No contemporary document confirms its attribution to Michelangelo, though the composition is that of the master: the bodies of Christ and the Virgin are the same as in the first version of the Rondanini Pietà, but reversed; St. Mary Magdalen is a reversed figure of the Mary Magdalen in the Duomo in Florence. We believe the surface is the work of one of Michelangelo's pupils. Certain parts (for example, the Virgin's right hand and Christ's shroud) are executed in detail. Others are only rough-hewn. There is no transition between the detailed realism and the unfinished parts. The surface modeling is different from Michelangelo's originals. The block used here was originally a piece of an antique cornice, as one can see from the back.

Attributed to Michelangelo for the first time by L. Cecconi, *Storia*

di Palestrina, Ascoli, 1756; then by Grenier, *G.d.B.A.*, xxxvii, 1907, pp. 177ff. The work is also considered original, for example, by Toesca, *Le Arti*, i, 1938-1939, pp. 105ff. But Nibby, *Analisi storico-topografica della carta dei dintorni di Roma*, Rome, 1837, attributes it to the school of Bernini. Cf. John Pope-Hennessy in *Akten des 21 Int. Kong. 1964*, ii, pp. 105ff., who suggests attributing it to Niccolò Menghini, comparing it with his St. Martin, carved in 1635. A. Parronchi (*Opere giovanili di Michelangelo*, 1968, p. 189) attributes the work to F. Sangallo. Wilde (*Burl. Mag.*, 1959, p. 378) attributes the Palestrina Pietà to Michelangelo.

PAINTINGS

There is a group of paintings attributed to Michelangelo. With the exception of Nos. 5 and 9 below, they were influenced by the Sistine Ceiling, and at the same time by Bugiardini, Franciabigio, and Granacci, and were probably done around 1515. They are without doubt the work of a sculptor, probably of one of the master's *garzoni*.

1. VIRGIN AND CHILD WITH ST. JOHN THE BAPTIST

London, private collection. (Fiocco, *La Critica d'Arte*, ii, 1937, pp. 172ff.)

2. VIRGIN OF THE CANDELABRUM

Vienna, Akademie der Bildenden Künste. Also attributed to Bugiardini (Berenson) and Antonio Mini (Popp).

3. VIRGIN

Baden, Zürich, Switzerland, private collection. (Fiocco, *La Critica d'Arte*, ii, 1937, pp. 172ff.)

4. PIETÀ

Rome, Galleria del Palazzo Barberini. According to Zeri (*Paragone*, 1953), by the same master as No. 5 below. Translation of the Pietà in St. Peter's into the idiom of Botticelli.

365 ### 5. MANCHESTER MADONNA

London, National Gallery. Also attributed to Bugiardini (Berenson), Jacopino del Conte (A. Venturi), Antonio Mini (Popp), and Granacci (Frizzoni). Again attributed to Michelangelo by C. Gould, *Burl. Mag.*, 1951, and H. Ruhemann and J. Platers, *Burl. Mag.*, 1964, pp. 546ff. This painting is much superior in quality to Nos. 1-3, and seems to us after its recent restoration correctly attributed to the early Michelangelo.

6. VIRGIN AND CHILD WITH ST. JOHN THE BAPTIST

New York, private collection. (Fiocco, *Rivista d'Arte*, 1950, pp. 149ff.)

7. VIRGIN AND CHILD WITH ST. JOHN THE BAPTIST

Dublin, National Gallery. (Fiocco, *Rivista d'Arte*, XIII, 1931, pp. 3ff. and 109ff.) Attributed to Granacci by Logan and Gronau.

8. ST. JOHN THE EVANGELIST

Basle, private collection. Attributed to Michelangelo by Longhi, *Paragone*, 1958, 101, pp. 59ff. Goldscheider attributes it to the Master of the *Manchester Madonna* in *Burl. Mag.*, 1952. In the style of Granacci.

9. ENTOMBMENT 50

London, National Gallery. Attributed to Michelangelo (see C. Gould, *Burl. Mag.*, 1951, pp. 281ff.) and also to Battista Franco (Antal), Carlone (Popp), and Antonio Mini (Popp). Drawing for a figure at the bottom left in the Louvre (Popp). After its recent restoration, it seems to us that the attribution of this painting to Michelangelo's early period (ca. 1504-1505) is likely to be correct.

SELECT BIBLIOGRAPHY

THE PRESENT volume is based mainly on the author's earlier works listed below. For Michelangelo's poems, see K. Frey, *Die Dichtungen*, E. N. Girardi, *Rime*, and C. Gilbert, *Complete Poems*; for his letters, G. Milanesi, *Le Lettere*, and Poggi, Barocchi, and Ristori, *Carteggio*.

Complete (or almost complete) bibliographies are: E. Steinmann and R. Wittkower, *Michelangelo-Bibliographie 1510-1926*, Leipzig, 1927; L. Dussler, *Michelangelo-Bibliographie 1927-1970*, Wiesbaden, forthcoming.

J. S. ACKERMAN, *The Architecture of Michelangelo*, 2 vols., London, 1961, 1964, and 1966; Italian ed. Turin, 1968.

Akten des 21. Internationalen Kongresses für Kunstgeschichte in Bonn 1964, Stil und Überlieferung in der Kunst des Abendlandes, Berlin, 1967. (*Akten des 21. Int. Kong. 1964.*)

S. ALEXANDER, *Michelangelo the Florentine*, New York, 1957; Montreal, 1965.

———— *The Hand of Michelangelo*, Florence and Montreal, 1966.

H. R. ALKER, *Michelangelo und seine Kuppel von St. Peter in Rom*, Karlsruhe, 1968.

Atti del Convegno di Studi Michelangioleschi, Firenze-Roma, 1964 (various authors), Rome, 1966.

G. DE ANGELIS D'OSSAT, "Architettura," *Michelangelo artista, pensatore, scrittore*, Novara, 1965.

L. BARDESCHI CIULICH AND P. BAROCCHI, *I Ricordi di Michelangelo*, see POGGI.

P. BAROCCHI, *Michelangelo e la sua scuola: I, II. I disegni di Casa Buonarroti e degli Uffizi*, Florence, 1962; *III. I disegni dell' Archivio Buonarroti*, Florence, 1964.

———— Giorgio Vasari—*La vita di Michelangelo nelle redazioni del 1550 e 1568*, ed. with commentary P. Barocchi, I-V, Milan and Naples, 1962.

———— *Carteggi di Michelangelo*, see POGGI.

A. BARTSCH, *Le Peintre graveur*, Leipzig, 1870.

E. BATTISTI, "La critica a Michelangelo prima del Vasari," *Rinascimento*, V, 1954, pp. 117-132.

———— "La critica a Michelangelo dopo il Vasari," *Rinascimento*, VII, 1956, pp. 135-157.

———— "Il significato simbolico della Cappella Sistina," *Commentari*, VIII, 1957, pp. 96-104.

F. BAUMGART, "Die Pietà Rondanini," *J.d.p.K.*, LVI, 1935, pp. 47ff.

F. Baumgart, "Jugendzeichnungen Michelangelos bis 1506," *Marburger Jahrbuch für Kunstwissenschaft*, 1937, pp. 208ff.

Baumgart-Biagetti, *Gli affreschi di Michelangiolo nella cappella Paolina*, Vatican, 1934.

E. Benkard, *Michelangelos Madonna an der Treppe*, Berlin, 1933.

B. Berenson, *The Drawings of the Florentine Painters* (1st ed., Milan, 1903; 2nd ed., Chicago, 1938; 3rd ed.: *I disegni dei pittori fiorentini*, Milan, 1961), 3 vols.

A. Bertini, *Michelangelo fino alla Sistina*, Turin, 1942 (2nd ed., 1945).

F. Bocchi and G. Cinelli, *Le bellezze della città di Firenze, dove a pieno di pittura, di scultura, di sacri templi, di palazzi, i più notabili artifizj, e più preziosi si contengono*, Florence, 1677. (Bocchi-Cinelli.)

W. Bode, *Denkmäler der Renaissance—Skulptur Toscanas*, Munich, 1892-1905.

Bonanni, *Numismata summorum Pontificum Templae Vaticani*, Rome, 1715, 2 vols.

K. Borinski, *Die Rätsel Michelangelos*, Munich, 1908.

G. Bottari, *Raccolta di lettere sulla pittura, scultura ed architettura*, Rome, 1754-1773, 7 vols.

C. Brandi, "Forma e compiutezza in Michelangelo," *Akten des 21. Int. Kong. 1964*, ii, pp. 89-95.

———— *La curva della Cupola di S. Pietro*, Accademia Nazionale dei Lincei, Quad. 123, Rome, 1968.

A. E. Brinckmann, *Michelangelo Zeichnungen*, Munich, 1925.

M. Brion, *Michel-Ange*, Paris, 1939.

H. Brockhaus, *Michelangelo und die Medici Kapelle*, Leipzig, 1909.

F. Burger, *Geschichte des florentinischen Grabmals*, Strasburg, 1904.

The Burlington Magazine. (*Burl. Mag.*)

R. Buscaroli, *Michelangelo: La vita, la teorica sull'arte, le opere*, Bologna, 1959.

G. B. Busini, *Lettere di G. B. B. a Benedetto Varchi sopra l'assedio di Firenze*, ed. G. Milanesi, Florence, 1860.

D. R. de Campos, *Affreschi della Cappella Paolina in Vaticano*, Milan, 1951.

———— *Cappella Sistina*, Novara, 1959.

———— *La Pietà giovanile di Michelangelo*, Milan, 1964.

———— *Il "Giudizio Universale" di Michelangelo*, Milan, 1964 (2nd ed.).

———— "Das Kruzifix Michelangelos für Vittoria Colonna," *Akten des 21. Int. Kong. 1964*, II, pp. 185-187.

———— "La Madonna e il bambino . . . ," *Studi offerti a Giovanni Incisa della Rocchetta*, Rome, 1973, pp. 449ff.

D. R. DE CAMPOS AND B. BIAGETTI, *Il Giudizio Universale di Michelangelo*, Vatican, 1944, 2 vols.

E. CARLI, *Michelangelo*, Bergamo, 1941 (2nd ed., 1946; 3rd ed., 1948).

———— *Michelangelo a Siena*, Rome, 1965.

A. CHASTEL, *Art et humanisme à Florence*, Paris, 1959.

R. J. CLEMENTS, *Michelangelo's Theory of Art*, Zurich, 1961.

———— *Michelangelo, A Self-Portrait*, New York, 1963.

———— *The Poetry of Michelangelo*, Milan, 1964.

V. COLONNA, *Rime e lettere*, Florence, 1860.

———— *Carteggio pubblicato da Ferrero e Müller*, Turin, 1892.

A. CONDIVI, *Vita di Michelagnolo Buonarroti*, Rome, 1553. Quoted from edition by C. Frey, *Le vite di Michelangelo Buonarroti*, Berlin, 1887.

G. DAELLI, *Carte Michelangiolesche inedite*, Milan, 1865.

L. DOREZ, "Nouvelles Recherches sur Michel-Ange," *La Bibliothèque de l'école des chartes*, Paris, 1916-1917, 77-78.

L. DUSSLER, *Die Zeichnungen des Michelangelo*, Berlin, 1959. (Dussler, *Zeichn.*)

———— et al., *Michelangelo Buonarroti*, Würzburg, 1965, pp. 115-139.

H. VON EINEM, "*Bemerkungen zur Florentiner Pietà Michelangelos*," *J.d.p.K.*, LXI, 1940, pp. 77ff.

———— *Michelangelo*, Stuttgart, 1959; revised English ed. London, 1973.

———— "Die Medicimadonna Michelangelos," *Rheinische West-fälische Akademie der Wissenschaften*, 1973.

G. FIOCCO, "La data di nascita di F. Granacci," *Rivista d'Arte*, 1932, pp. 107ff.

———— *La Critica d'Arte*, II, 1937, pp. 172ff.

———— "Sull'inizio pittorico di Michelangelo," *Le Arti*, 1941, pp. 5ff.

———— *Rivista d'Arte*, 1950, pp. 149ff.

S. FREEDBERG, *Painting of the High Renaissance in Rome and Florence*, Cambridge, Mass., 1961.

S. FREUD, "Der Moses des Michelangelo," *Imago*, III, 1914, pp. 15ff. and *Imago*, 1927, pp. 552ff.

D. FREY, *Michelangelo Studien*, Vienna, 1920.

D. Frey, *Michelangelo Buonarroti* (*Architetto*), Rome, 1923.

K. Frey, *Die Dichtungen des Michelagniolo Buonarroti*, Berlin, 1897. New ed., Berlin, 1964. (Frey, *Dicht.*)

———— *Sammlung ausgewählter Briefe an Michelagniolo*, Berlin, 1899. (Frey, *Briefe.*)

———— *Michelagniolo Buonarroti*, i, Berlin, 1907.

———— *Die Handzeichnungen Michelagniolos Buonarroti*, Berlin, 1909-1911, 3 vols. Vol. iv published by F. Knapp, Berlin, 1925. (Frey, *Handz.*)

K. Frey, H. W. Frey, *Die Briefe des Michelangelo Buonarroti* (new ed.), Berlin, 1961.

H. Friedrich, *Epochen der italienischen Lyrik*, Frankfurt-am-Main, 1964.

C. L. Frommel, "S. Eligio und die Kuppel der Cappella Medici," *Akten des 21. Int. Kong. 1964*, ii, pp. 41-54.

———— *Der Römische Palastbau* (*Palazzo Farnese*), Tübingen, 1973, i, pp. 123ff., ii, pp. 103ff.

G. Gaye, *Carteggio inedito d'Artisti dei secoli XIV, XV, XVI*, Florence, 1839-1840, 3 vols.

Gazette des Beaux-Arts. (*G.d.B.A.*)

H. von Geymüller, *Les projets primitifs pour la basilique de Saint-Pierre de Rome*, Paris, 1875.

———— *Michelagnolo Buonarroti als Architekt*, Munich, 1904.

D. Giannotti, *Dialoghi di D. G.*, ed. D. R. de Campos, Florence, 1939.

C. Gilbert, *Complete Poems and Selected Letters of Michelangelo*, New York, 1963.

E. N. Girardi, *Michelangelo Buonarroti. Rime*, Bari, 1960.

———— "La poesia di Michelangelo," *Akten des 21. Int. Kong. 1964*, ii, pp. 149-155.

L. Goldscheider, *Michelangelo Drawings*, London, 1951, new ed. 1966.

A. Gotti, *Vita di Michelangelo Buonarroti*, Florence, 1875, 2 vols.

C. Gould, "Some Addenda to Michelangelo Studies," *Burl. Mag.*, 1951, pp. 279ff.

———— *The Battle of Cascina*, Newcastle upon Tyne, 1966.

———— *Michelangelo's Entombment of Christ*, London, 1970.

A. Grabar, *Martyrium*, Paris, 1943-1946, 3 vols.

H. Grimm, *Das Leben Michelangelos*, Hanover, 1860ff.

A. Grünwald, *Florentiner Studien*, Dresden (n.d.).

F. Hartt, *Michelangelo Pittore*, Milan and New York, 1964; *The Paintings of Michelangelo*, London, 1965.

———— *The Sculpture of Michelangelo*, London, 1970.

——— *The Drawings of Michelangelo*, London, 1971.

A. HAUSER, *Der Manierismus*, Munich, 1946; *Il Manierismo*, Turin, 1965.

——— *Social History of Art*, London, 1951; *Storia sociale dell'arte*, Turin, 1955-56, new ed. 1964.

H. HETTNER, *Italienische Studien*, Braunschweig, 1879.

M. HIRST, "Two Unknown Studies by Michelangelo for the 'Last Judgment,'" *Burl. Mag.*, CXI, 1969, pp. 27-28.

F. DE HOLLANDA, *Quatro Dialogos da Pintura Antiqua* (1548): *Vier Gespräche über die Malerei*, ed. J. de Vasconcellos, Vienna, 1899 (Portuguese with German translation).

R. HUYGHE, *Michel-Ange*, Paris, 1937.

C. A. ISERMEYER, "Die Arbeiten Leonardos und Michelangelos für den grossen Ratsaal in Florenz: Eine Revision der Bild- und Schriftquellen für ihre Rekonstruktion und Geschichte," *Studien zur Toskanischen Kunst. Festschrift L. H. Heydenreich*, Munich, 1963, pp. 83-130.

——— "Das Michelangelo-Jahr 1964 . . . ," *Zeitschrift für Kunstgeschichte*, XXVIII, 1965.

Jahrbuch der Kunsthistorischen Sammlungen des Allerhöchsten Kaiserhauses, Vienna. (*J.d.A.K.*)

Jahrbuch der Kunsthistorischen Sammlungen in Wien. (*J.d.K.S.*)

Jahrbuch der preussischen Kunstsammlungen, Berlin. (*J.d.p.K.*)

C. JUSTI, *Michelangelo*, Leipzig, 1900.

——— *Michelangelo, Neue Beiträge zur Erklärung seiner Werke*, Berlin, 1909. (Justi, *Michelangelo*, *N.B.*)

H. KELLER, *Michelangelo*, Königstein, 1966.

H. KEUTNER, "The Palazzo Pitti 'Venus,'" *Burl. Mag.*, 1958, pp. 427ff.

——— "Giovanni Bologna e Michelangelo," *Akten des 21. Int. Kong. 1964*, II, pp. 128-134.

W. KÖHLER, "Michelangelos Schlachtkarton," *Kunstgeschichtliches Jahrbuch d.K.K. Zentralkommission*, I, 1907, pp. 115ff.

W. KÖRTE, "Zur Peterskuppel des Michelangelo," *J.d.p.K.*, LIII, 1932, pp. 90ff.

F. KRIEGBAUM, *Michelangelo Buonarroti, Die Bildwerke*, Berlin, 1940.

——— "Michelangelo e il Ponte della Trinità," *Rivista d'Arte*, XIII, 1941, pp. 137ff.

——— "Le statue di Michelangelo nell'Altare dei Piccolomini," *Michelangelo Buonarroti nel IV centenario del Giudizio Universale*, Florence, 1942, pp. 86ff.

K. LANCKORÓNSKA, "Appunti sulla interpretazione del Giudizio Universale di Michelangelo," *Annales Institutorum*, V, Rome, 1933.

———— "Antike Elemente im Bacchus Michelangelos und in seinen Darstellungen des David," *Dawna Stuka*, I, 1938, pp. 183ff.

M. LISNER, "Zu Benedetto da Maiano und Michelangelo," *Zeitschrift für Kunstwissenschaft*, XII, 1958, pp. 141-156.

———— "Michelangelos Kruzifixus aus S. Spirito," *Münchener Jahrbuch der Bildenden Kunst*, 3, Series XV, 1964, pp. 7-31.

———— "Das Quattrocento und Michelangelo," *Akten des 21. Int. Kong. 1964*, II, pp. 78-89.

R. LONGHI, "Due proposte per Michelangelo Giovine," *Paragone*, 101, 1958, pp. 59-64.

W. LOTZ, "Zu Michelangelos Kopien nach dem Codex Coner," *Akten des 21. Int. Kong. 1964*, II, pp. 12-19.

H. MACKOWSKY, *Michelangelo* (6th ed.), Stuttgart, 1939-1940.

F. DE MAFFEI, *Michelangelo's Lost St. John: The Story of a Discovery*, London, 1964.

C. MALLARMÉ, *L'ultima tragedia di Michelangelo*, Rome, 1929.

M. MARANGONI, "Una scultura di Michelangelo," *Bollettino d'Arte*, XLIII, 1958, pp. 157-162.

G. MARCHINI, "The Frescoes in the Choir of Santa Maria Novella," *Burl. Mag.*, XCV, 1953, pp. 320-331.

V. MARIANI, *Poesia di Michelangelo*, Rome, 1940.

———— *Michelangelo*, Turin, 1942; 2nd ed., Naples, 1964.

–———— *Michelangelo pittore*, Milan, 1964.

W. MAURENBRECHER, *Die Aufzeichnungen des M.B. im Britischen Museum*, Leipzig, 1938.

E. MAURER, "Pontormo und Michelangelo," *Akten des 21. Int. Kong. 1964*, II, pp. 141-149.

P. MELLER, "Aggiornamenti bibliografici," *Michelangelo artista, pensatore, scrittore*, Novara, 1965 (bibliography 1961-1965).

S. MELLER, "Zur Entstehungsgeschichte des Kranzegesimses am Palazzo Farnese im Rom," *J.d.p.K.*, XXX, 1909, pp. 1ff.

MICHELANGELO, *I Ricordi*, see POGGI.

Michelangelo nel IV centenario del Giudizio Universale, Florence, 1942.

Michelangelo artista, pensatore, scrittore, preface by M. Salmi, Novara, 1965.

G. MILANESI, *Le lettere di Michelangelo Buonarroti*, Florence, 1875. (Milanesi.) Trans. E. H. Ramsden, *The Letters of Michelangelo*, Stanford, 1963, 2 vols.

———— *Les correspondants de Michel-Ange*, I, Paris, 1890. (Milanesi, *Correspondants*.)

H. A. MILLON, C. H. SMYTH, "Michelangelo and St. Peter's: I. Notes on a Plan of the Attic as Originally Built on the South Hemicycle," *Burl. Mag.*, CXI, 1969, pp. 484-501.

CH. H. MORGAN, *Michelangelo*, New York, 1960.

A. NAVA, "Sui disegni architettonici per S. Giovanni dei Fiorentini," *Critica d'Arte*, I, 1936, pp. 102ff.

J. OERI, "Hellenisches in der Mediceer Kapelle," *Basler Nachrichten*, LXI, July 3, 1905.

OLLENDORF, "Michelangelos Gefangene im Louvre," *Z.f.b.K.*, N. F. IX, 1898, pp. 273ff.

W. AND E. PAATZ, *Die Kirchen von Florenz*, Frankfurt-am-Main, 1940-1954.

E. PANOFSKY, *Die Sixtinische Decke*, Leipzig, 1921.

———— *Handzeichnungen Michelangelos*, Leipzig, 1922.

———— "The First Two Projects of Michelangelo's Tomb of Julius II," *Art Bulletin*, XIX, 1937, pp. 561ff.

———— *Studies in Iconology*, New York, 1939, new ed. 1962.

G. PAPINI, *Vita di Michelangiolo*, Florence, 1949.

K. T. PARKER, *Catalogue of the Collection of Drawings in the Ashmolean Museum: II. Italian School*, Oxford, 1956.

A. PARRONCHI, *Opere giovanili di Michelangelo*, Florence, 1968.

PASQUINELLI, "S. Maria degli Angeli," *Roma*, 1932, pp. 152ff.

———— "La Chiesa di Michelangiolo nelle Terme Diocleziane," *Roma*, 1935, pp. 257ff.

A. PERRIG, *Michelangelo Buonarrotis letzte Pietà-Idee: Ein Beitrag zur Erforschung seines Alterswerkes*, Bern, 1960.

———— "Michelangelo und Marcello Venusti: Das Problem der Verkündigungs und Oelberg-Konzeptionen Michelangelos," *Wallraf-Richartz Jahrbuch*, 24, 1962, pp. 261-294.

G. POGGI, *Kunstchronik*, N. F. XVIII, 1907, p. 299.

G. POGGI, P. BAROCCHI, R. RISTORI, *Carteggio di Michelangelo*, pub. Istituto Nazionale di Studi sul Rinascimento, 6 vols.: I, Florence, 1965; II, Florence, 1967; III. *Ricordi*, ed. L. Bardeschi Ciulich and P. Barocchi, Florence, 1970.

J. POPE-HENNESSY, *Italian High Renaissance and Baroque Sculpture*, London, 1963, 3 vols.

———— "The Palestrina Pietà," *Akten des 21. Int. Kong. 1964*, II, pp. 105-114.

A. E. POPP, *Die Medici-Kapelle Michelangelos*, Munich, 1922. (Popp, *Med. Kap.*)

———— "Unbeachtete Projekte Michelangelos," *Münchner Jahrbuch d. bildenden Kunst*, IV, 1927, pp. 389ff.

A. E. Popp, "Two Torsi by Michelangelo," *Burl. Mag.*, LXIX, 1936, pp. 202ff.

F. Portheim, "Beiträge zu den Werken Michelangelos," *Rep.f.Kw.*, XII, 1889, pp. 140ff.

P. Portoghesi, C. Maltese, F. Cataldi, eds., *Mostra delle opere michelangiolesche*, Rome, 1964.

P. Portoghesi, B. Zevi, et al., "Michelangelo architetto," *Collana Storica di architettura*, 6, Turin, 1964. (Portoghesi-Zevi.)

U. Procacci, *La Casa Buonarroti a Firenze*, Milan, 1965.

L. Puppi and B. Barbieri, *Tutta l'architettura di Michelangelo*, Milan, 1964.

J. Q. van Regteren Altena, "Zu Michelangelos Zeichnungen, besonders aus den Jahren 1530 bis 1535," *Akten des 21. Int. Kong. 1964*, II, pp. 171-180.

Repertorium für Kunstwissenschaft. (*Rep.f.Kw.*)

R. Rolland, *La vie de Michel-Ange*, Paris, 1906ff.

F. Russoli, *Tutta la scultura di Michelangelo*, Milan, 1953.

M. Salmi, *Michelangelo*, Accademia Nazionale dei Lincei, Quad. 74, Rome, 1966.

R. Salvini, et al., *La Cappella Sistina in Vaticano*, Milan, 1965, 2 vols.

——— "La battaglia di Cascina," *Studi . . . in onore di V. Mariani*, Naples, 1972.

A. Schiavo, "La cupola di S. Pietro," *Bollettino del Centro di Studi per la Storia dell'Architettura*, 6, 1952, pp. 14-26.

——— La *vita e le opere architettoniche di Michelangelo*, Rome, 1953.

——— *Santa Maria degli Angeli alle Terme*, Rome, 1954.

——— *San Pietro in Vaticano: Forme e strutture*, Rome, 1960.

——— "Il modello della cupola di S. Pietro nel suo IV Centenario," *Studi Romani*, 9, 1961, pp. 519-532.

Schmarsow, "Ein Entwurf Michelangelos zum Grabmal Julius II," *J.d.p.K.*, V, 1884, pp. 63ff.

Ch. Seymour, Jr., *Michelangelo's David*, Pittsburgh, 1967.

H. Siebenhüner, *Das Kapitol in Rom: Idee und Gestalt*, Munich, 1954.

——— "S. Maria degli Angeli in Rom," *Münchner Jahrbuch der bildenden Kunst*, VI, 1955, pp. 179-206.

——— "San Giovanni dei Fiorentini in Rom," *Kunstgeschichtliche Studien für H. Kauffmann*, Berlin, 1956, pp. 172-191.

A. Springer, *Raffael und Michelangelo*, Leipzig, 1878f., 2 vols.

R. di Stefano, *La cupola di S. Pietro*, Naples, 1963.

E. Steinmann, *Die Sixtinische Kapelle*, Munich, 1901 and 1905, 2 vols. (Steinmann, *Sixt. Kap.*)

E. Steinmann and R. Wittkower, *Michelangelo-Bibliographie*, Leipzig, 1927.

A. Stokes, *Michelangelo*, New York, 1955.

J. A. Symonds, *The Life of Michelangelo*, London, 1892f., 2 vols.

H. Thode, *Michelangelo und das Ende der Renaissance*, Berlin, 1908-1913, 3 vols.

———— *Michelangelo. Kritische Untersuchungen*, Berlin, 1908-1913, 3 vols. (Thode, *Kr. U.*)

C. Thoenes, "Studien zur Geschichte des Petersplatzes," *Zeitschrift für Kunstgeschichte*, xxvi, 1963, pp. 97-145.

———— "Bemerkungen zur St. Petersfassade Michelangelos," *Festschrift Hans Kauffmann, Minuscola Discipulorum*, Berlin, 1968.

F. Titi, *Studio di pittura, scultura e architettura delle chiese di Roma*, Rome, 1674.

C. de Tolnay, "Die Handzeichnungen Michelangelos im Codex Vaticanus," *Rep.f.Kw.*, 48, 1927, pp. 157-205. (Tolnay, *Cod. Vat.*)

———— "Eine Sklavenskizze Michelangelos," *Münchener Jahrbuch der bildenden Kunst*, n. f. v., 1928, pp. 70-84.

———— "Die Handzeichnungen Michelangelos im Archivio Buonarroti," *Münchener Jahrbuch der bildenden Kunst*, n. f. v., 1928, pp. 377-476. (*Archivio Buonarroti.*)

———— "Beiträge zu den späten architektonischen Projekten Michelangelos," *J.d.p.K.*, 51, 1930, pp. 1-48.

———— Thieme-Becker: *Künstlerlexikon*, XXIV: "Michelangelo," 1930. (Tolnay, *Thieme-Becker.*)

———— "Zu den späten architektonischen Projekten Michelangelos, II," *J.d.p.K.*, 53, 1932, pp. 231-253.

———— "Michelangelostudien: Die Jugendwerke," *J.d.p.K.*, 54, 1933, pp. 95-122.

———— "Michel-Ange et la façade de Saint-Lorenzo," *G.d.B.A.*, Jan. 1934, pp. 24ff.

———— "Studi sulla cappella Medicea," Part I, *L'Arte*, 1934, pp. 5-44.

———— "Studi sulla cappella Medicea," Part II, *L'Arte*, 1934, pp. 281-307.

———— "I disegni di Sangallo per la cappella Paolina," *Illustrazione Vaticana*, April 1934, pp. 299-302.

———— "The Rondanini Pietà," *Burl. Mag.*, lxv, 1934, pp. 146-157.

C. DE TOLNAY, "Michelangelo's Bust of Brutus," *Burl. Mag.*, LXVII, 1935, pp. 23-29.

———— "La Bibliothèque Laurentienne de Michel-Ange, Nouvelles recherches," *G.d.B.A.*, Sept.-Oct. 1935, pp. 94-105.

———— "Michelangelo: Sheet of Studies of a Horse," *Old Master Drawings*, Dec. 1935, p. 43.

———— "La volta della Cappella Sistina (Saggio d'interpretazione)," *Bollettino d'Arte*, 1936, pp. 389-408.

———— "La Théorie de l'art et Michel-Ange," *Deuxième Congrès international d'Esthétique et de Science de l'art*, Paris, 1937, III, pp. 25ff.

———— "Le Jugement dernier de Michel-Ange, Essai d'interprétation," *Art Quarterly*, Spring 1940, pp. 125-147.

———— "Le menu de Michel-Ange," *Art Quarterly*, Summer 1940, pp. 240-243.

———— "Michelangelo Studies," *Art Bulletin*, XXII, Sept. 1940, pp. 127-176.

———— "Marcello Venusti as Copyist of Michelangelo," *Art in America*, 1940, pp. 169-176.

———— "Sofonisba Anguissola and her relations with Michelangelo," *The Journal of the Walters Art Gallery*, IV, 1941, pp. 115-119.

———— "An Unpublished Record of Michelangelo," *Art Bulletin*, XXIV, Dec. 1942, pp. 380-381.

———— *Michelangelo: I. The Youth of Michelangelo*, Princeton, N.J., 1943. 2nd ed. 1947. Reissue 1969. (Tolnay, *Michelangelo I.*)

———— "Notes concerning the Youth of Michelangelo: A Reply," *The Art Bulletin*, XXVII, 1945, pp. 139-146.

———— *Michelangelo: II. The Sistine Ceiling*, Princeton, N.J., 1945. 2nd ed. 1949. Reissue 1969. (Tolnay, *Michelangelo II.*)

———— *Michelangelo: III. The Medici Chapel*, Princeton, N.J., 1948. Reissue 1970. (Tolnay, *Michelangelo III.*)

———— *Werk und Weltbild des Michelangelo*, Zurich, 1949.

———— "Note sur un Portrait de Michel-Ange demeuré inédit," *G.d.B.A.*, 1949, pp. 449ff.

———— *Michelangiolo*, Florence, 1951 (reissued). *Michel-Ange*, Paris, 1951; 2nd ed., 1970.

———— "Un dessin inédit de la façade de la chapelle Sforza de Michel-Ange," *Mélanges P. Lavedan*, Paris, 1953, pp. 361-362.

———— "Michelangelo's Pietà Composition for Vittoria Colonna," *Record of the Art Museum*, Princeton, N.J., 1953, pp. 44-62.

———— *Michelangelo: IV. The Tomb of Julius II*, Princeton, N.J., 1954. Reissue 1970. (Tolnay, *Michelangelo IV.*)

———— "Michelangelo architetto," *Il Cinquecento*, Florence, 1955, pp. 109-127.

———— "Un pensiero nuovo di Michelangelo per il soffitto della Libreria Laurenziana," *La Critica d'Arte*, 1955, pp. 237-240.

———— "Unknown Sketches by Michelangelo," *Burl. Mag.*, XCVIII, 1956, pp. 379ff.

———— *Michelangelo: V. The Final Period*, Princeton, N.J., 1960. Reissue 1971. (Tolnay, *Michelangelo V.*)

———— "Michel-Ange dans son atelier par Delacroix," *G.d.B.A.*, 1962, pp. 43-52.

———— "Poussin, Michel-Ange et Raphaël," *Art de France*, II, 1962, pp. 260-262.

———— "Un ritratto sconosciuto di Michelangelo dipinto da Rafaello," *Festschrift Fr. Gerke*, Baden-Baden, 1962, pp. 167-172.

———— "Michelangelo Buonarroti," *Enciclopedia Universale dell'Arte*, Rome, 1963, IX, pp. 263-306.

———— *The Art and Thought of Michelangelo*, New York, 1964.

———— *Disegni di Michelangelo* (preface by Salmi, introduction by Tolnay, notes by Barocchi), Milan, 1964.

———— "L'Hercule de Michel-Ange à Fontainebleau," *G.d.B.A.*, Sept. 1964, pp. 125-140.

———— "Morte e Resurrezione in Michelangelo," *Commentari*, 1964, fasc. I, pp. 3-11.

———— "Tod und Auferstehung bei Michelangelo," *Michelangelo Buonarroti*, Würzburg, 1964, pp. 7-24.

———— "Michelangelo a Firenze," *Atti del Convegno di Studi Michelangioleschi*, Florence-Rome, 1964, pp. 3-22.

———— "A Forgotten Architectural Project by Michelangelo: the Choir of the Cathedral of Padua," *Festschrift H. von Einem*, Berlin, 1965, pp. 247-251.

———— "Contributi michelangioleschi: I. Un prigione sconosciuto; II. Un bozzetto di legno di Michelangelo," *Commentari*, 1965, pp. 85-97.

———— *et al.*, *Michelangelo artista, pensatore, scrittore*, 2 vols., Novara, 1965, pp. 7-71, 509-528.

———— "Michel-Ange et la Casa Buonarroti à Florence," *G.d.B.A.*, 1966, pp. 193-204.

———— "La Venere con due Amorini già a Pitti, ora in Casa Buonarroti," *Commentari*, 1966, pp. 324-332.

———— "Zur Interpretation der Vasari-Stellen über di Blöcke des Juliusgrabes," *Zeitschrift für Kunstgeschichte*, 1966, pp. 315-317.

C. DE TOLNAY, "Proposte per un ritratto di Francesco Guicciardini di Giuliano Bugiardini alla Yale University Art Gallery," *Mitteilungen des Kunsthistorischen Instituts in Florenz*, 1966, pp. 359-365.

———— *Nuove ricerche riguardanti la casa di Michelangelo in via Ghibellina*, Accademia Nazionale dei Lincei, Quad. 93, Rome, 1966.

———— "Un bozzetto di legno di Michelangelo; Newly Discovered Drawings related to Michelangelo; l'*Hercule* de Michel-Ange à Fontainebleau," *Akten des 21. Int. Kong. 1964*, II, pp. 64ff., 71ff., 126ff.

———— "La Deposizione di Cristo, disegno attribuito a Michelangelo a Haarlem," *Pantheon*, XXV, 1967, pp. 20-26.

———— "Sur des Vénus dessinées par Michel-Ange. A propos d'un dessin oublié du musée du Louvre," *G.d.B.A.*, 1967, pp. 193-200.

———— "Il Tabernacolo per il Cristo della Minerva," *Commentari*, 1967, pp. 43-47.

———— "Une composition de la jeunesse de Michel-Ange: *Hercule étouffant le lion de Némée*," *G.d.B.A.*, 1968, pp. 205-212.

———— *Tout l'oeuvre peint de Michel-Ange* (Introduction), Paris, 1968.

———— *Le Madonne di Michelangelo. Nuove ricerche sui disegni*, Accademia Nazionale dei Lincei, Quad. 117, Rome, 1968.

———— "Le Madonne di Michelangelo, A proposito di due disegni della Vergine col Bambino al Louvre," *Mitteilungen des kunsthist. Instituts*, Florence, XIII, 1968, pp. 343ff.

———— "Donatello e Michelangelo," in *Donatello e il suo tempo*, Florence, 1968, pp. 259ff.

———— "Michelangelo e il blocco," in *Momenti del Marmo*, Rome, 1969, pp. 99ff.

———— "Nouvelles Remarques sur la chapelle Médicis," *G.d.B.A.*, 1969, pp. 65ff.

———— *Il riordinamento delle collezioni della casa Buonarroti a Firenze*, Accademia Nazionale dei Lincei, Quad. 141, Rome, 1970.

———— *La Casa Buonarroti, Le sculture di Michelangelo e le collezioni della famiglia*, Florence, 1970.

———— *Alcune recenti scoperte e risultati negli studi michelangioleschi*, Accademia Nazionale dei Lincei, Quad. 153, Rome, 1971.

———— "Ein unbekanntes Porträt des Michelangelo," *Festschrift Luitpold Dussler*, Munich, 1972, pp. 205-208.

──────── *L'omaggio a Michelangelo di Albrecht Dürer*, Accademia Nazionale dei Lincei, Quad. 163, Rome, 1972.

──────── "Ein unbekannter Ricordo des Michelangelo," *Neue Züricher Zeitung*, April 23, 1972.

──────── "I progetti di Michelangelo per la facciata di S. Lorenzo a Firenze: nuove ricerche," *Commentari*, 1972, fasc. I-II, pp. 53-72.

──────── "La Salamandra di Michelangelo," *Antichità viva*, 1973, 2, pp. 3-5.

──────── *I disegni della gioventù di Michelangelo e un suo disegno inedito nella Farnesina*, Accademia Nazionale dei Lincei, Quad. 193, Rome, 1974.

W. R. VALENTINER, "Il Cupido dormiente di Michelangelo," *Commentari*, VII, 1956, pp. 236-248.

──────── "Michelangelo's Cupid for Jacopo Galli," *Art Quarterly*, XXI, 1958, pp. 257-264.

B. VARCHI, *Orazione funerale*, Florence, 1564.

G. VASARI, *Le Vite di Michelangelo Buonarroti*, ed. Frey, Berlin, 1887. (Vasari 1550; Vasari 1568; Condivi 1553.)

──────── *Il Carteggio di G. Vasari*, ed. K. Frey, Munich, 2 vols., 1923 and 1930. (Vasari, *Carteggio*.)

──────── *La Vita di Michelangelo*, ed. Barocchi, see BAROCCHI.

Le Opere di G. Vasari, ed. Milanesi, Florence, 1878-1885, 9 vols. (Vasari, ed. Milanesi.)

A. VENTURI, *Storia dell'Arte Italiana*, Milan, IX.1, 1925; X.2, 1936; XI.2, 1939.

J. WASSERMAN, "Michelangelo's Virgin and Child with St. Anne at Oxford," *Burl. Mag.*, CXI, 1969, pp. 122-131.

M. WEINBERGER, *Michelangelo the Sculptor*, New York, 1967, 2 vols.

J. WILDE, "Zwei Modelle Michelangelos für das Juliusgrabmal," *J.d.K.S. in Wien*, n. f. II, 1928, pp. 199ff. (Cf. *Dedalo*, VIII, 1928, pp. 653ff.)

──────── "Eine Studie Michelangelos nach der Antike," *Mitteilungen des kunsthist. Instituts*, Florence, IV, 1932-1934, pp. 41ff. (Wilde, *Eine Studie*.)

──────── "Der ursprüngliche Plan Michelangelos zum Jüngsten Gericht," *Die Graphischen Künste*, n. f. I, 1936, pp. 7ff.

──────── "The Hall of the Great Council of Florence," *Journal of the Warburg and Courtauld Institutes*, VII, 1944, pp. 65ff.

──────── *Italian Drawings in the Department of Prints and Drawings in the British Museum: Michelangelo and his Studio*, London, 1953. (Wilde, *B.M. Cat.*)

J. WILDE, "Michelangelo and Leonardo," *Burl. Mag.*, XCV, 1953, pp. 65-77.

———— *Michelangelo's "Victory,"* London, 1954.

———— "Michelangelo's Designs for the Medici Tombs," *Journal of the Warburg and Courtauld Institutes*, XVIII, London, 1955, pp. 54-66.

———— "Notes on the Genesis of Michelangelo's *Leda*," *Fritz Saxl 1890-1948: A Volume of Memorial Essays from his Friends in England*, London, 1957, pp. 270-280.

———— "The Decoration of the Sistine Chapel," *Proceedings of the British Academy*, London, 1958.

———— " 'Cartonetti' by Michelangelo," *Burl. Mag.*, CI, 1959, pp. 370-381.

———— AND A. E. POPHAM, *The Italian Drawings of the XV and XVI Centuries in the Collection of His Majesty the King at Windsor Castle*, London, 1949. (Wilde, *Windsor Cat.*)

C. H. WILSON, *Life and Works of Michelangelo*, London, 1876.

R. WITTKOWER, "Zur Peterskuppel Michelangelos," *Zeitschrift für Kunstgeschichte*, n. f. II, 1933, pp. 348ff. New ed. (book), Florence, 1964.

———— "Michelangelo's Biblioteca Laurenziana," *Art Bulletin*, XVI, 1934, pp. 123ff.

R. AND M. WITTKOWER, trans. with commentary, *The Divine Michelangelo: The Florentine Academy's Homage on his Death in 1564. A facsimile edition of "Esequie del divino Michelangelo Buonarroti," Florence, 1564*, London, 1964.

H. WÖLFFLIN, "Die Sixtinische Decke," *Rep.f.Kw.*, XIII, 1890, pp. 264ff.

———— *Die Jugendwerke des Michelangelo*, Munich, 1891.

———— "Ein Entwurf Michelangelos zur Sixtinischen Decke," *J.d.p.K.*, XIII, 1892, pp. 178ff.

———— *Die Klassische Kunst*, Munich, 1898.

Zeitschrift für bildende Kunst. (Z.f.b.K.)

F. ZERI, "Il Maestro della Madonna di Manchester," *Paragone*, 43, 1953, pp. 15-27.

B. ZEVI, see PORTOGHESI.

Mention must also be made of the chapters on Michelangelo in the following general works:

M. DVOŘÁK, *Geschichte der italienischen Kunst im Zeitalter der Renaissance*, Munich, 1927-1929.

A. RIEGL, *Die Entstehung der Barockkunst im Rom*, Vienna, 1908.

L. VENTURI, *Histoire de la critique d'Art*, Paris, 1969.

INDEX

Numbers in italics refer to illustrations.

249

LIST OF ILLUSTRATIONS

GRATEFUL acknowledgments are made to individuals and heads of institutions allowing works in their possession to be reproduced here, and to those who have supplied photographs. Their names are given under each work in the list that follows. Photographs taken at the author's direction are shown under his name and that of the photographer.

SCULPTURES AND PAINTINGS

259

8. ALFONSO LOMBARDI, NICOLA PISANO, FRA' GUGLIELMO DA
 PISA, NICCOLÒ DELL'ARCA, and MICHELANGELO, Tomb of
 St. Dominic. Bologna, San Domenico
 Photo: Anderson
9. Kneeling Angel. Tomb of St. Dominic.
 Photo: Fotofast
10. St. Petronius. Tomb of St. Dominic
 Photo: Tolnay-Croci
11. St. Proculus. Tomb of St. Dominic
 Photo: Tolnay-Croci
12. St. Proculus, the head
 Photo: Tolnay-Croci
13. Venus and Two Cupids. Florence, Casa Buonarroti
 Photo: Tolnay-Bazzechi
14. Venus and Two Cupids, detail of Cupid by Venus's left leg
 Photo: G.F.S.G. Florence
15. Venus and Two Cupids, the rear Cupid
 Photo: G.F.S.G. Florence
16. Bacchus. Florence, Bargello
 Photo: Tolnay-Brogi
17. Bacchus, detail of the back
 Photo: Tolnay-Brogi
18. Bacchus, left side
 Photo: Alinari
19. Bacchus, satyr's head
 Photo: Tolnay-Cipriani
20. Bacchus, lion's mask
 Photo: Tolnay-Cipriani
21. Pietà. Vatican, St. Peter's
 Photo: Anderson
22. Pietà, detail of the Virgin, left
 Photo: Tolnay-Carboni
23. Pietà, head of Christ
 Photo: Tolnay-Carboni
24. The Bruges Madonna. Bruges, Notre-Dame
 Photo: Alinari
25. Bruges Madonna, right side
 Photo: Alinari
26. Bruges Madonna, the back
 Photo: Alinari
27. ANDREA BREGNO, Piccolimini Altar. Siena Cathedral
 Photo: Grassi, by courtesy of Professor Enzo Carli
28. St. Peter. Piccolimini Altar
 Photo: Kriegbaum-Brogi

49. *Doni Madonna*, St. John the Baptist and ephebes in right background
 Photo: Tolnay-Brogi
50. *The Entombment.* London, National Gallery
 Photo: National Gallery
51. St. Matthew. Florence, Accademia delle Belle Arti
 Photo: Alinari
52. St. Matthew, right side
 Photo: Tolnay-Brogi
53. The Sistine Ceiling, from the entrance to the Chapel. Vatican, Sistine Chapel
 Photo: Tolnay-Carboni
54. Sistine Ceiling, the five histories above the presbytery
 Photo: Tolnay-Carboni
55. *The Drunkenness of Noah.* Sistine Ceiling
 Photo: Anderson
56. *The Flood.* Sistine Ceiling
 Photo: Anderson
57. *The Sacrifice of Noah.* Sistine Ceiling
 Photo: Anderson
58. *The Fall and the Expulsion.* Sistine Ceiling
 Photo: Anderson
59. *The Creation of Eve.* Sistine Ceiling
 Photo: Anderson
60. *The Creation of Adam.* Sistine Ceiling
 Photo: Anderson
61. *The Division of Heaven from the Waters.* Sistine Ceiling
 Photo: Anderson
62. *The Creation of the Sun and Moon.* Sistine Ceiling
 Photo: Anderson
63. *The Division of the Light from the Darkness.* Sistine Ceiling
 Photo: Brogi
64. *The Creation of Adam*, hands of God and Adam
 Photo: Anderson
65. *The Creation of Eve*, head of God the Father
 Photo: Anderson
66. *The Creation of Adam*, head of God the Father
 Photo: Anderson
67. *The Division of Heaven from the Waters*, head of God the Father
 Photo: Anderson
68. *The Creation of the Sun and Moon*, head of God the Father
 Photo: Anderson

89. Putto below the Delphic Sibyl. Sistine Ceiling
 Photo: Anderson
90. Putto below Daniel. Sistine Ceiling
 Photo: Tolnay-Sansaini
91. The Dying Slave (for the Tomb of Julius II, second project).
 Paris, Louvre
 Photo: Tolnay-J. Schneider-Lengyel
92. The Dying Slave, detail of the back
 Photo: La Photothèque
93. The Rebellious Slave (for the Tomb of Julius II, second project). Paris, Louvre
 Photo: Tolnay-Archives Photographiques
94. The Rebellious Slave, detail of the back
 Photo: La Photothèque
95. Moses. Tomb of Julius II. Rome, San Pietro in Vincoli
 Photo: Gabinetto Fotografico Nazionale
96. Moses, oblique view from the observer's right. Tomb of Julius II
 Photo: Tolnay-Carboni
97. Moses, the head
 Photo: Gabinetto Fotografico Nazionale
98. The Risen Christ. Rome, Santa Maria sopra Minerva
 Photo: Anderson
99. The Risen Christ, left side and back
 Photo: Gabinetto Fotografico Nazionale
100. David-Apollo. Florence, Bargello
 Photo: Tolnay-Brogi
101. David-Apollo, the back
 Photo: Tolnay-Carboni
102. Hercules and Cacus (or Samson and the Philistine). Florence, Casa Buonarroti
 Photo: Tolnay-G.F.S.G. Florence
103. Hercules and Cacus (or Samson and the Philistine), left side and back
 Photo: Tolnay-G.F.S.G. Florence
104. Medici Chapel (Sagrestia Nuova), exterior view of the north wall. Florence, San Lorenzo
 Photo: Tolnay-Cipriani
105. Medici Chapel, interior of the dome
 Photo: Tolnay-Alinari
106. Medici Chapel, interior view of the unfinished entrance wall, with the altar in the foreground; Michelangelo's Virgin and

126. Giuliano de' Medici, the head
Photo: Tolnay-G.F.S.G. Florence
127. Virgin and Child. Medici Chapel
Photo: Anderson
128. Virgin and Child, the Virgin's head in right profile
Photo: Tolnay-Brogi
129. Virgin and Child, the Virgin's head
Photo: Tolnay-Brogi
130. Crouching Youth (for the Tomb of Lorenzo de' Medici), right side. Leningrad, Hermitage
Photo: Leningrad, Hermitage
131. Crouching Youth, left side
Photo: Leningrad, Hermitage
132. River God, small model for the Tomb of Giuliano de' Medici in the Medici Chapel. Rotterdam, Boymans-van Beuningen Museum
Photo: Boymans-van Beuningen Museum
133. River God, model for the Tomb of Lorenzo de' Medici in the Medici Chapel. Florence, Casa Buonarroti
Photo: Manelli
134-149. Urn reliefs. Medici Chapel
Photos: Tolnay-Del Turco-Cipriani
134, 135. With the Medici arms, left of Giuliano
136, 137. With the Medici arms, right of Giuliano
138, 139. With the Medici arms, left of the Virgin
140, 141. With the Medici arms, right of the Virgin
142, 143. Left of the altar
144, 145. With the Medici arms, right of the altar
146, 147. Left of Lorenzo
148, 149. Right of Lorenzo
150. Frieze of masks, detail to the left of Night. Medici Chapel
Photo: Tolnay-Brogi
151. Victory (for the Tomb of Julius II). Florence, Palazzo della Signoria
Photo: Brogi
152. Victory, the head
Photo: Tolnay-Brogi
153. Victory, the head in left profile
Photo: Tolnay-Brogi
154. Slave (for the Tomb of Julius II). Florence, Casa Buonarroti
Photo: Tolnay-Bazzechi
155. Slave, the head and shoulders
Photo: Tolnay-Bazzechi

173. The ascent of the Elect. *Last Judgment*
 Photo: Tolnay-Sansaini
174. Angels sounding trumpets and holding the books of life and death. *Last Judgment*
 Photo: Anderson
175. The Resurrection of the Dead. *Last Judgment*
 Photo: Tolnay-Sansaini
176. Charon disembarking the Damned; lower right, Minos. *Last Judgment*
 Photo: Tolnay-Sansaini
177. Bust of Brutus. Florence, Bargello
 Photo: Anderson
178. Brutus, the head
 Photo: Tolnay-Carboni
179. Brutus, the fibula
 Photo: Tolnay-Cipriani
180. ANTONIO SALAMANCA, engraving of the Tomb of Julius II by Michelangelo in San Pietro in Vincoli, 1554. Paris, Bibliothèque Nationale
 Photo: Tolnay-Bibliothèque Nationale
181. Tomb of Julius II, oblique view from the observer's right. Rome, San Pietro in Vincoli
 Photo: Tolnay-Carboni
182. Rachel. Tomb of Julius II
 Photo: Anderson
183. Leah. Tomb of Julius II
 Photo: Anderson
184. Rachel, the head in left profile
 Photo: Tolnay-Carboni
185. Leah, the head in left profile
 Photo: Tolnay-Carboni
186. *The Conversion of St. Paul.* Vatican, Pauline Chapel
 Photo: Anderson
187. *The Crucifixion of St. Peter.* Vatican, Pauline Chapel
 Photo: Anderson
188. *The Conversion of St. Paul*, St. Paul's head
 Photo: Anderson
189. *The Crucifixion of St. Peter*, St. Peter's head
 Photo: Anderson
190. Pietà (Deposition of Christ). Florence, Santa Maria del Fiore
 Photo: Anderson
191. Pietà, the back
 Photo: G.F.S.G. Florence

DRAWINGS

inscription from Petrarch, sonnet 229. Ink, between September 1501 and August 1502. Paris, Louvre
Photo: Archives Photographiques

205. Male nude, bearded head (possibly for the Moses of the Julius Tomb), and study for the right arm of the St. Matthew. Ink, ca. 1505-1506; on the recto, Fig. 202. Paris, Louvre
Photo: Giraudon

206. Study for an apostle (probably for Santa Maria del Fiore) and sketch of a battle scene (probably for the *Battle of Cascina*). Ink, ca. 1503-1505. London, British Museum
Photo: British Museum

207. Seated woman (detail) used for the Virgin in the Pitti tondo. Ink, ca. 1503-1504. Chantilly, Musée Condé
Photo: Tolnay

208. St. Anne with the Virgin and Child, inspired by Leonardo's cartoon. Ink, ca. 1501. Oxford, Ashmolean Museum
Photo: Ashmolean Museum

209. St. Anne with the Virgin and Child; sketch of a male nude and of a head in profile; inscriptions. Ink, ca. 1505-1506. Paris, Louvre
Photo: Giraudon

210. Sketches of male nudes, and of the Bruges Madonna. Black chalk and ink, ca. 1503-1504, 1506 (Madonna). London, British Museum
Photo: Anderson

211. Study of a nude, inspired by the Apollo Belvedere. Ink, ca. 1504-1505. London, British Museum
Photo: Anderson

212. Two nudes, studies for the *Battle of Cascina*. Black chalk and ink, ca. August 1504-February 1505 (Frey). Vienna, Albertina
Photo: Bildarchiv der Österreichischen Nationalbibliothek

213. First project for the decoration of the Sistine Ceiling; studies of arms and hands. Ink and black chalk on green prepared paper, ca. May 1508. London, British Museum
Photo: Anderson

214. Project for the decoration of the Sistine Ceiling; studies of a left arm and hand, and of a male torso. Ink and black chalk, ca. May 1508. Detroit, Institute of Arts
Photo: Detroit Institute of Arts

215. Study for the head of Zechariah (detail). Black chalk, ca. 1509. Florence, Uffizi
Photo: G.F.S.G. Florence

271

230. Resurrection of Christ. Black chalk, ca. 1532. London, British Museum
Photo: British Museum

231. Two episodes in the story of Moses and the Brazen Serpent, possibly for lunettes in the Medici Chapel: the Attack by Serpents, and the Healing by the Brazen Serpent. Red chalk, ca. 1530-1532. Oxford, Ashmolean Museum
Photo: Ashmolean Museum

232. Sketch for an Entombment of Christ. Red chalk, ca. 1535-1540. Paris, Louvre
Photo: Réunion des Musées Nationaux

233. Dante's Paolo and Francesca. Black chalk, ca. 1530-1532. Darmstadt, Hessisches Landesmuseum
Photo: Hessisches Landesmuseum

234. Study for the head of Leda. Red chalk. Florence, Casa Buonarroti
Photo: Brogi

235. The Punishment of Tityos. Black chalk, end of 1532. Windsor, Royal Library
Photo: by gracious permission of H.M. Queen Elizabeth II

236. The Fall of Phaeton, first version. Black chalk, autumn 1532-spring 1533. London, British Museum
Photo: British Museum

237. The Fall of Phaeton, third version. Black chalk, spring 1533. Windsor, Royal Library
Photo: by gracious permission of H.M. Queen Elizabeth II

238. Study for the *Last Judgment*, first version. Black chalk, ca. autumn 1533-spring 1534. Florence, Casa Buonarroti
Photo: Brogi

239. Studies for the Martyrs and Damned in the *Last Judgment*. Black chalk, ca. 1536. London, British Museum
Photo: British Museum

240. Study for an angel pursuing the Damned in the *Last Judgment*. Black chalk, ca. 1536-1540; on the verso, Fig. 241. Corsham Court, Lord Methuen Collection
Photo: M. Hirst, British Museum; by courtesy of Lord Methuen

241. Study for one of the Damned in the *Last Judgment*. Black chalk, ca. 1536-1540; on the recto, Fig. 240. Corsham Court, Lord Methuen Collection
Photo: M. Hirst, British Museum; by courtesy of Lord Methuen

242. Study of a right knee, for St. Lawrence in the *Last Judgment*. Black chalk, ca. 1536-1540. Vatican Library, Cod. Vat. 3211 fol. 88r
Photo: Tolnay-Sansaini

ARCHITECTURE

285. Ground plan of the Capitol, Rome, showing Michelangelo's design; engraving of 1567. Vienna, Albertina
Photo: Tolnay-Albertina

286. General view of the Capitol, facing the Palazzo dei Senatori, with the Palazzo dei Conservatori, right, and the Palazzo Nuovo, left; in the piazza, equestrian statue of Marcus Aurelius; engraving by Dupérac, 1568. Vienna, Albertina
Photo: Tolnay-Albertina

287. View of the Capitol from the Palazzo dei Senatori, showing the convex star-decorated oval at ground level
Photo: D'Agostini

288. Palazzo dei Conservatori, detail of the façade; engraving of 1568. Vienna, Albertina
Photo: Tolnay-Albertina

289. Façade of the Palazzo dei Conservatori
Photo: Tolnay-Carboni

290. Loggia of the Palazzo dei Conservatori
Photo: Tolnay-Carboni

291. Base designed by Michelangelo for antique bronze statue of Marcus Aurelius
Photo: Tolnay-Carboni

292. Equestrian statue of Marcus Aurelius and its base, left side
Photo: Alinari

293. Palazzo dei Senatori, the double stairway designed by Michelangelo
Photo: Tolnay-Carboni

294. Farnese Palace, Rome, engraving by N. Béatrizet, 1549. Vienna, Albertina
Photo. Tolnay-Albertina

295. ANTONIO DA SANGALLO THE YOUNGER, Farnese Palace; large window above the entrance and cornice by Michelangelo
Photo: Anderson

296. Detail of the cornice, Farnese Palace
Photo: Anderson

297. Third-story window and pilasters on the court façade, Farnese Palace
Photo: Anderson

298. Court of the Farnese Palace, engraving of 1560. Vienna, Albertina
Photo: Tolnay-Albertina

299. Court of the Farnese Palace: first and second stories by Antonio da Sangallo the Younger, third story by Michelangelo
Photo: Anderson

314. Ground plan of the Sforza Chapel drawn by Pier Leone Ghezzi (1674-1755). Paris, Bibliothèque Nationale
Photo: Tolnay-Bibliothèque Nationale
315. Sforza Chapel, apse drawn by Pier Leone Ghezzi. Paris, Bibliothèque Nationale
Photo: Tolnay-Bibliothèque Nationale
316. Upper elevation of diagonally placed columns in the Sforza Chapel
Photo: Gabinetto Fotografico Nazionale
317. Sforza Chapel, apse
Photo: Alinari

ARCHITECTURAL DRAWINGS

318. Project for the façade of San Lorenzo, Florence. Red chalk, ca. December 1516. Florence, Casa Buonarroti
Photo: G.F.S.G. Florence
319. Project for the façade of San Lorenzo. Red chalk, ca. December 1516. Florence, Casa Buonarroti
Photo: G.F.S.G. Florence
320. Project for the façade of San Lorenzo, probably the final version (detail). Ink over black and red chalk, ca. May 1517. Florence, Casa Buonarroti
Photo: G.F.S.G. Florence
321. Sketch of niche and statue for the façade of San Lorenzo. Red chalk. Florence, Casa Buonarroti
Photo: Tolnay-G.F.S.G. Florence
322. Project for the upper side elevation of the Tomb of Julius II. Ink, July 1516. Florence, Casa Buonarroti
Photo: G.F.S.G. Florence
323. Sketch of candelabrum, probably for the Julius Tomb. Black chalk, ca. 1542. Vatican Library (Cod. Vat. 3211, fol. 25v)
Photo: Tolnay-Sansaini
324. Project for free-standing tomb in the Medici Chapel, Florence. Black chalk, ca. end 1520. London, British Museum
Photo: British Museum
325. Project of double tomb for the Medici Dukes. Black chalk, end 1520. London, British Museum
Photo: British Museum
326. Projects for the Medici tombs, including an *arcus quadrifrons*. Black chalk, December 1520. Florence, Casa Buonarroti
Photo: Tolnay-Cipriani

339. Project for the Tomb of Julius II, and sketch by a pupil. Black chalk, ca. 1525-1526. Florence, Archivio Buonarroti (Cod. IX, fol. 539v)
Photo: Tolnay-Ciacchi

340. Projects for the Tomb of Julius II. Black chalk and ink, ca. 1525-1526. London, British Museum
Photo: British Museum

341. Projects for the fortifications of Florence. Black chalk, ca. 1529. Florence, Casa Buonarroti
Photo: Tolnay-Brogi

342. Projects for the fortifications of Florence. Black chalk, ca. 1529. Florence, Casa Buonarroti
Photo: Tolnay-Brogi

343. Projects for the fortifications of Florence. Black chalk, ca. 1529. Florence, Casa Buonarroti
Photo: Tolnay-Cipriani

344. Projects for the fortifications of Florence (Porta del Prato). Black chalk, ink and wash, ca. 1529. Florence, Casa Buonarroti
Photo: G.F.S.G. Florence

345. Projects for the tomb of Cecchino Bracci (1544), and other sketches. Black chalk. Florence, Casa Buonarroti
Photo: Tolnay-Brogi

346. Projects for the tomb of Cecchino Bracci (1544), and other sketches (central figure probably for the *Crucifixion of St. Peter*). Black chalk. Florence, Casa Buonarroti
Photo: Tolnay-Brogi

347. Rough sketch of ground plan for St. Peter's and adjacent parts of the Vatican; fragment of a poem. Black chalk. Vatican Library (Cod. Vat. 3211, fol. 92v)
Photo: Tolnay-Sansaini

348. Projects for the dome of St. Peter's and for a doorway (at the bottom, a figure for the *Crucifixion of St. Peter*). Black chalk and ink, ca. 1550. Haarlem, Teyler Museum
Photo: Teyler Museum

349. Sketches for the lantern of St. Peter's, and other architectural drawings. Black chalk and ink. Florence, Casa Buonarroti
Photo: Tolnay-G.F.S.G. Florence

350. Project for the dome of St. Peter's, with sketch of the elevation of St. Peter's and ground plan of the drum of the dome. Black chalk and ink. Lille, Palais des Beaux-Arts
Photo: Tolnay-Lagache

351. ANONYMOUS, drawing of exterior section of the wooden model

ATTRIBUTIONS, COPIES OF LOST WORKS, RECONSTRUCTIONS

361. SCHOOL OF MICHELANGELO, San Giovannino, marble (destroyed). Formerly Ubeda, Capilla del Salvador
Photo: Gomez-Moreno

362. TINTORETTO, detail of Cupid in *Mars and Venus Surprised by Vulcan*. Munich, Alte Pinakothek
Photo: Alte Pinakothek

363. ATTRIBUTED TO MICHELANGELO, Sleeping Cupid, marble. Corsham Court, Lord Methuen Collection
Photo: R. F. Wills, by courtesy of Lord Methuen

364. ATTRIBUTED TO MICHELANGELO, David with the Head of Goliath, bronze. Paris, Louvre
Photo: Giraudon

365. ATTRIBUTED TO MICHELANGELO, *Manchester Madonna*. London, National Gallery
Photo: National Gallery

366. BASTIANO DA SANGALLO AFTER MICHELANGELO, *The Battle of Cascina*, grisaille. Holkham, Earl of Leicester Collection
Photo: by courtesy of the Earl of Leicester

367. VINCENZO DANTI, seated statue of Pope Julius III, bronze. Perugia
Photo: Alinari

368. AFTER MICHELANGELO, Samson and Two Philistines, bronze. New York, The Frick Collection
Photo: The Frick Collection

369, 370. SILVIO COSINI, marble trophies, probably for the Medici Chapel. Florence, San Lorenzo, entrance to the Medici Chapel
Photo: G.F.S.G. Florence

371. JACOMO ROCCHETTI, copy of drawing attributed to Michelangelo showing 1513 project for the Tomb of Julius II. East Berlin, Kupferstichkabinett
Photo: Kupferstichkabinett

372. ATTRIBUTED TO MICHELANGELO, drawing of dead pope supported on a sarcophagus by an angel. Florence, Casa Buonarroti
Photo: K. Frey

373-376. Reconstructions of the projects for the Tomb of Julius II:
 373. First version, 1505
 374. Second version, 1513
 375. Third version, 1516
 376. Fifth version, 1532
 Reconstructions by Charles de Tolnay, drawn by Denise Fossard

377. *Leda and the Swan*, cartoon after Michelangelo. London, Royal Academy
Photo: Royal Academy

ILLUSTRATIONS

The illustrations in each section are arranged as nearly
as possible in chronological order. Information about
the works is given in the Catalogues or, for the draw-
ings, in the List of Illustrations.

SCULPTURES AND PAINTINGS

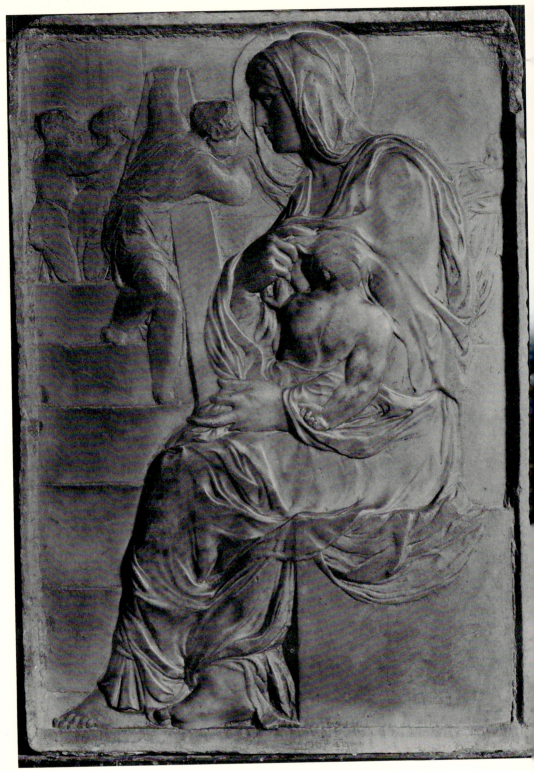

1. Virgin of the Stairs. Florence, Casa Buonarroti

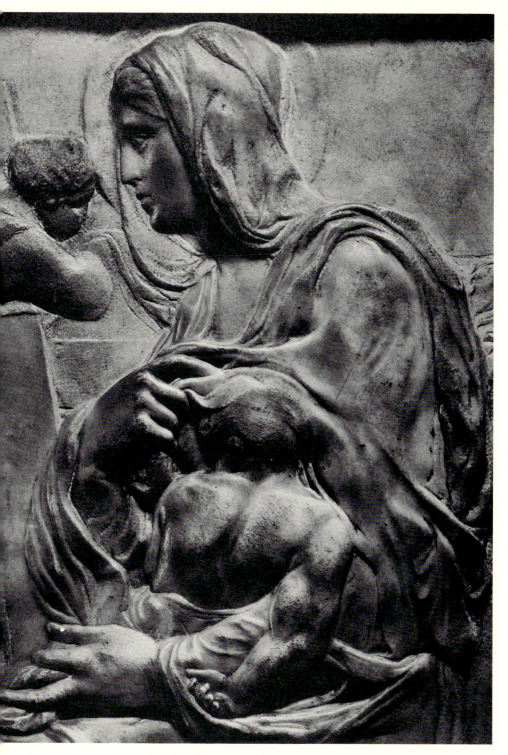

2. Virgin of the Stairs, detail

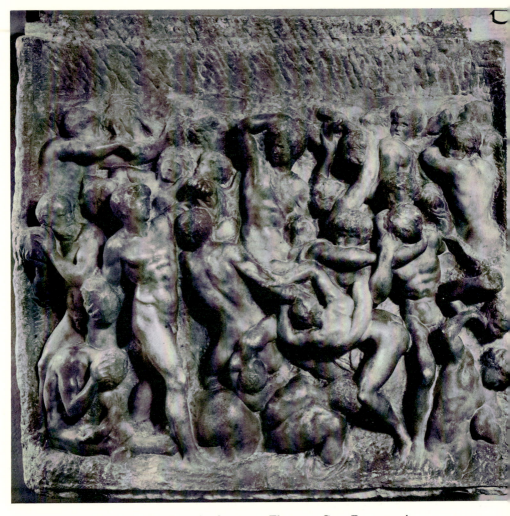

3. Battle of the Centaurs. Florence, Casa Buonarroti

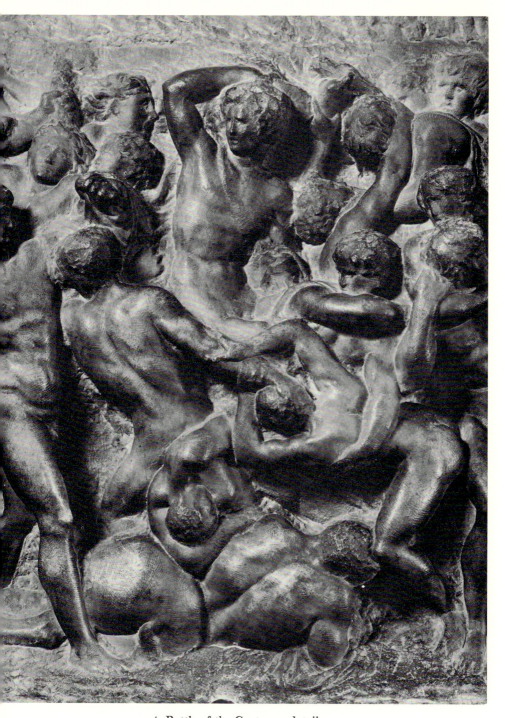

4. Battle of the Centaurs, detail

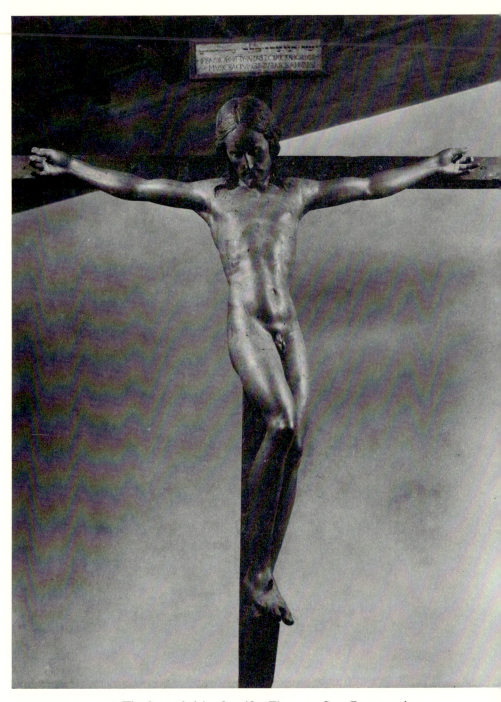

5. The Santo Spirito Crucifix. Florence, Casa Buonarroti

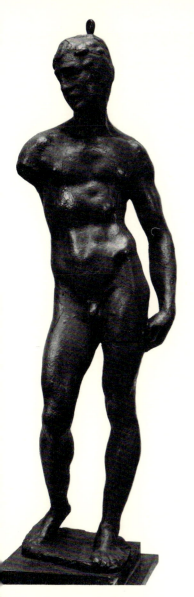

6. Hercules, wax model for
the lost marble. Florence,
Casa Buonarroti

7. RUBENS, sketch of Michelangelo's lost Hercules,
formerly at Fontainebleau. Paris, Louvre

8. ALFONSO LOMBARDI, NICOLA PISANO, FRA' GUGLIELMO DA PISA,
NICCOLÒ DELL' ARCA, and MICHELANGELO, Tomb of St. Dominic.
Bologna, San Domenico

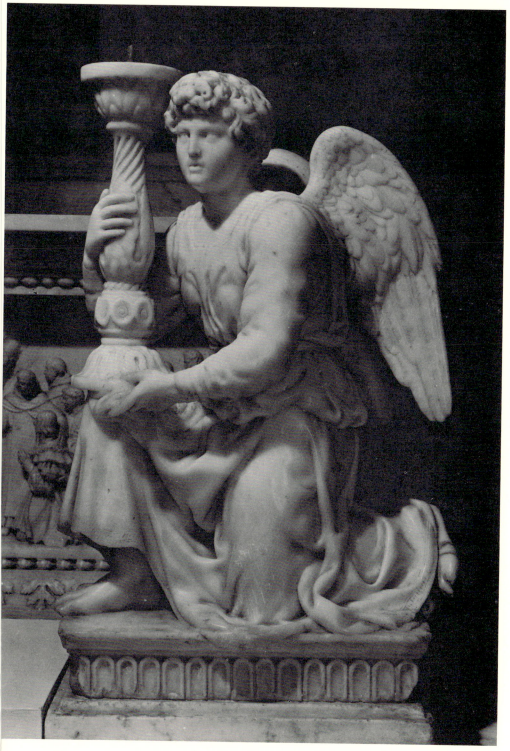

9. Kneeling Angel. Tomb of St. Dominic

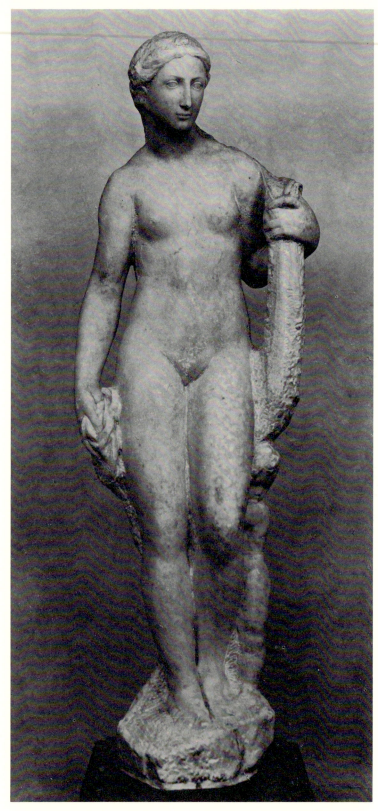

13. Venus and Two Cupids. Florence, Casa Buonarroti

14. Venus and Two Cupids,
detail of Cupid by Venus's
left leg

15. Venus and Two Cupids,
the rear Cupid

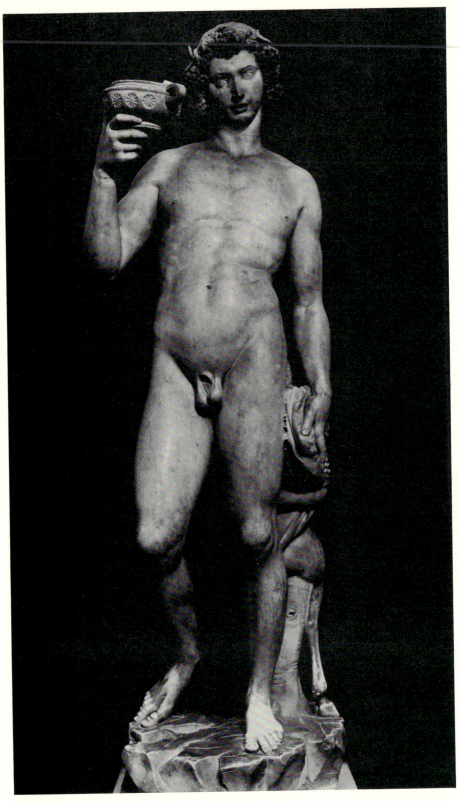

16. Bacchus. Florence, Bargello

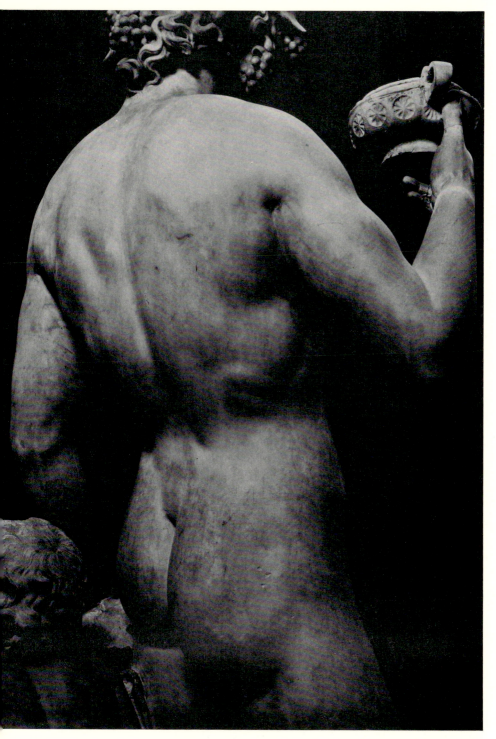

17. Bacchus, detail of the back

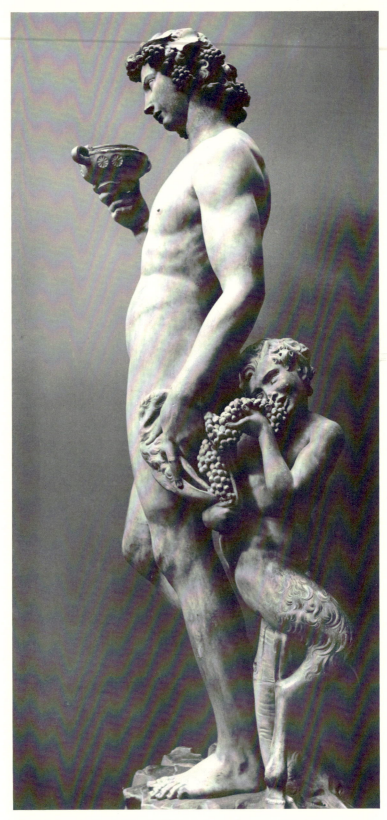

18. Bacchus, left side

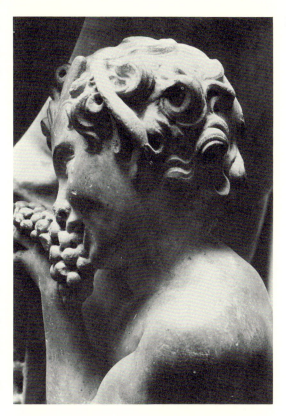

19. Bacchus, satyr's head

20. Bacchus, lion's mask

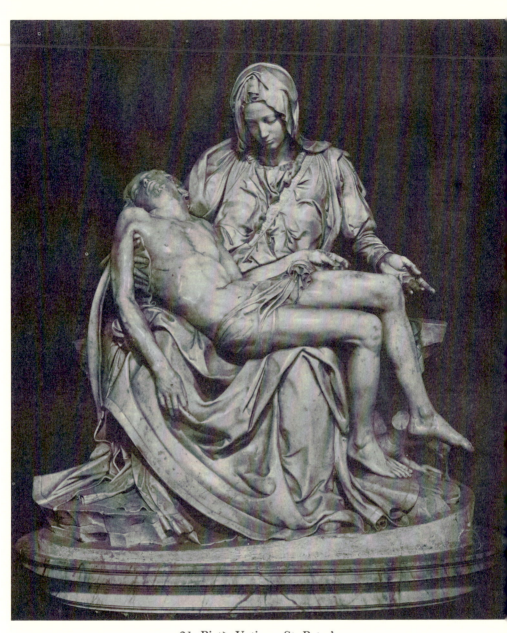

21. Pietà. Vatican, St. Peter's

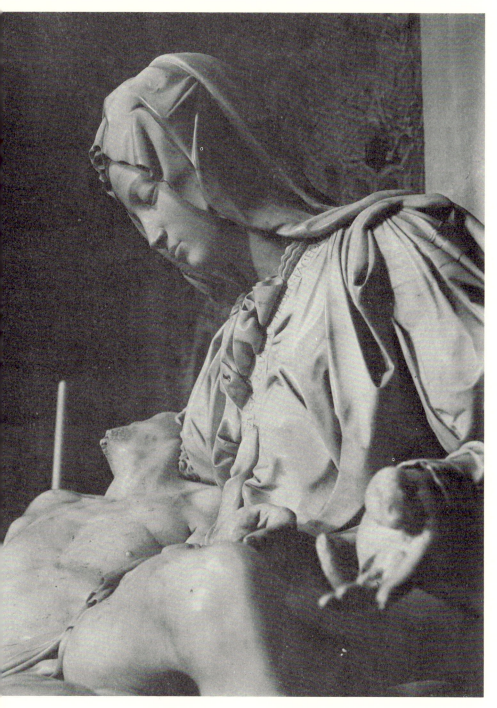

22. Pietà, detail of the Virgin, left

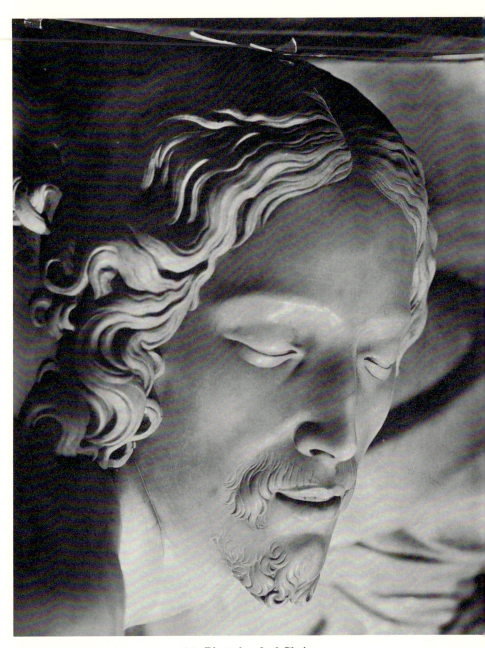

23. Pietà, head of Christ

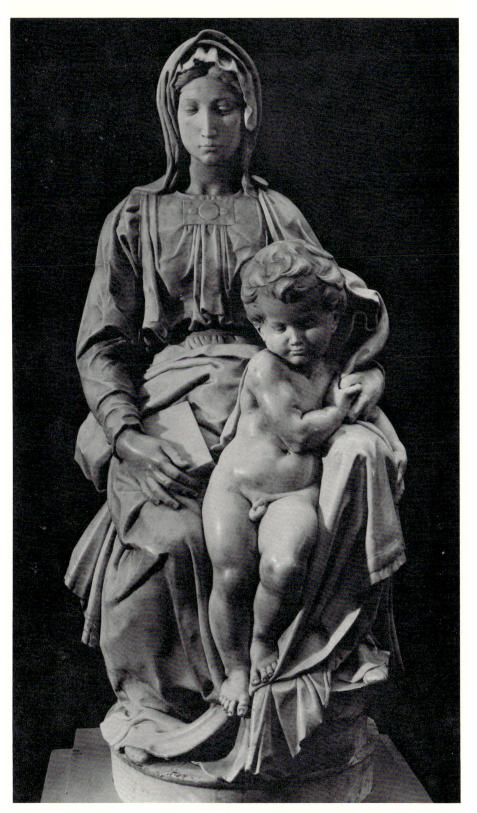

24. The Bruges Madonna. Bruges, Notre-Dame

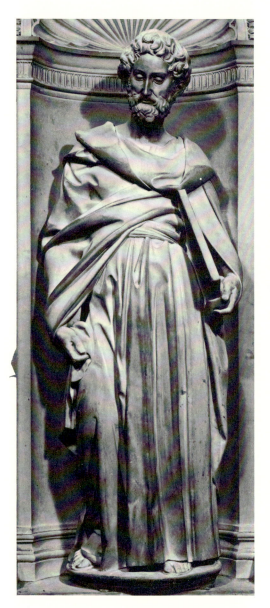

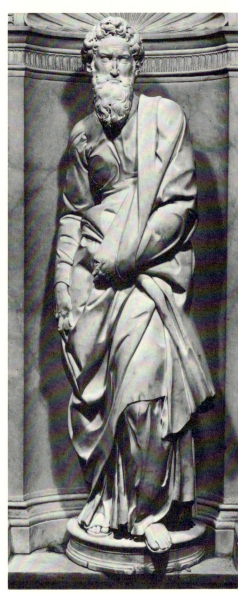

28. St. Peter. Piccolimini Altar 29. St. Paul. Piccolimini Altar

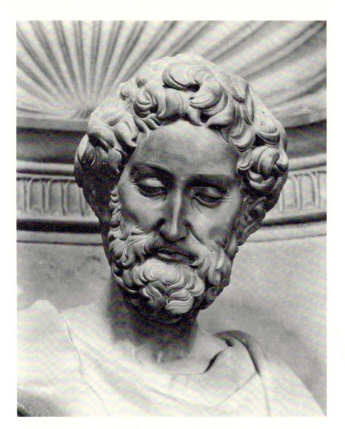

30. St. Peter, the head

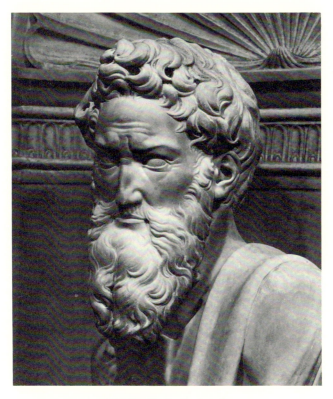

31. St. Paul, the head

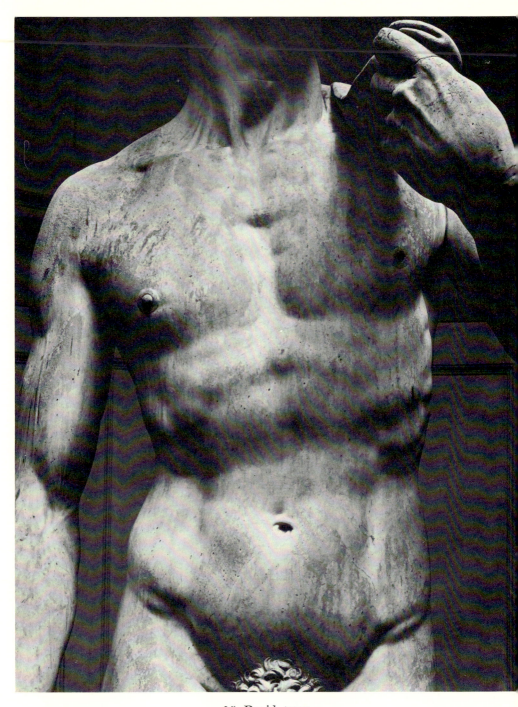

35. David, torso

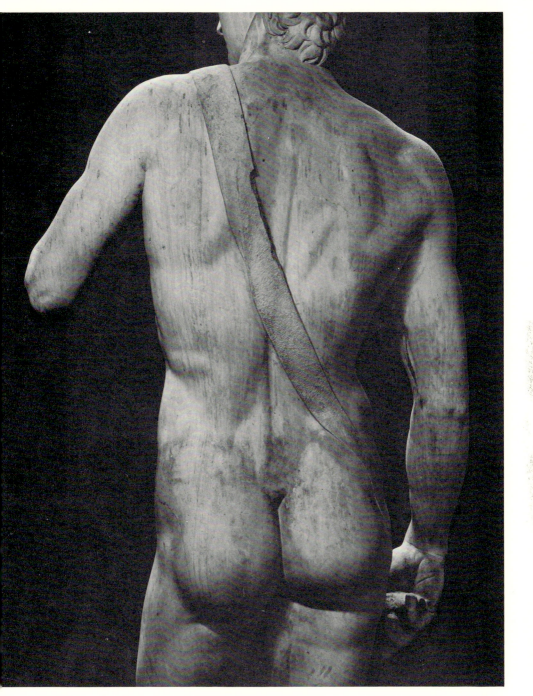

36. David, detail of the back

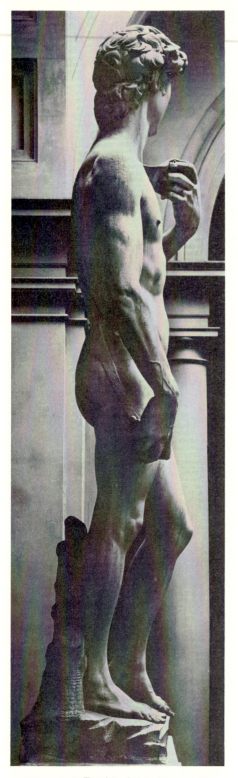

38. David, the head from the back

37. David, right side

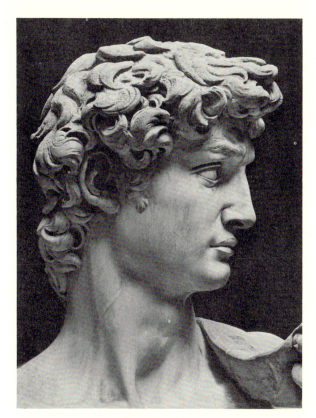

39. David, head in right profile

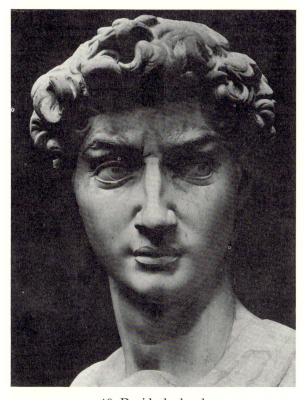

40. David, the head

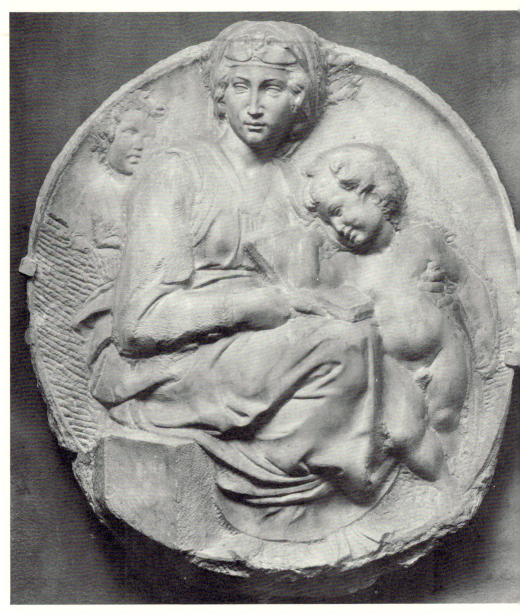

41. The Bartolommeo Pitti Madonna. Florence, Bargello

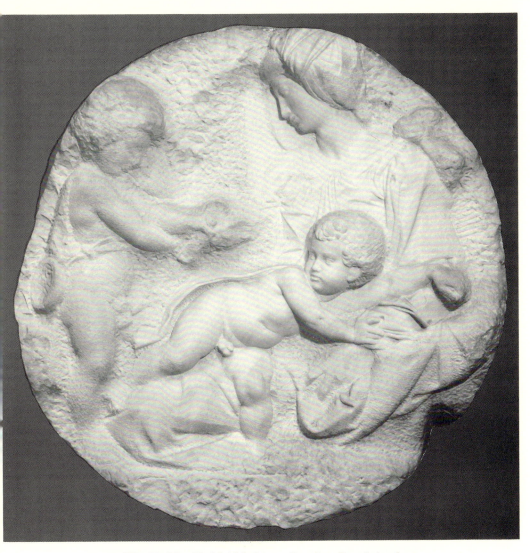

42. The Taddeo Taddei Madonna. London, Royal Academy

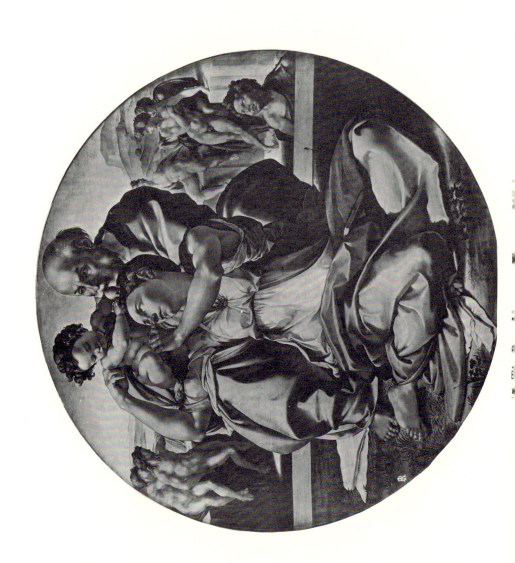

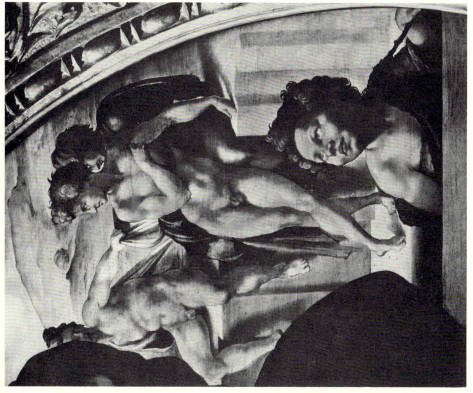

49. *Doni Madonna*, St. John the Baptist
and ephebes in right background

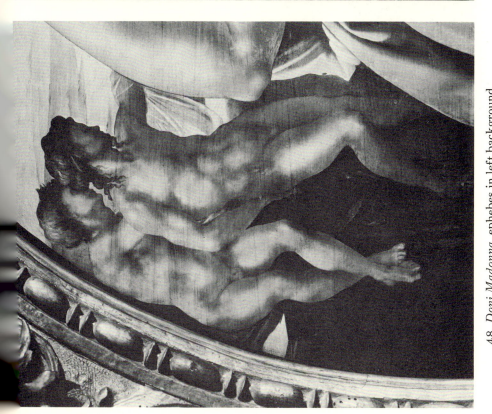

48. *Doni Madonna*, ephebes in left background

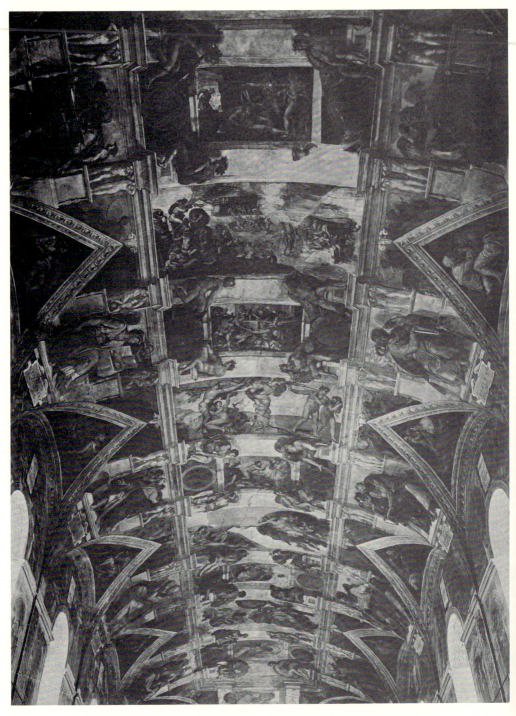

53. The Sistine Ceiling, from the entrance to the Chapel.
Vatican, Sistine Chapel

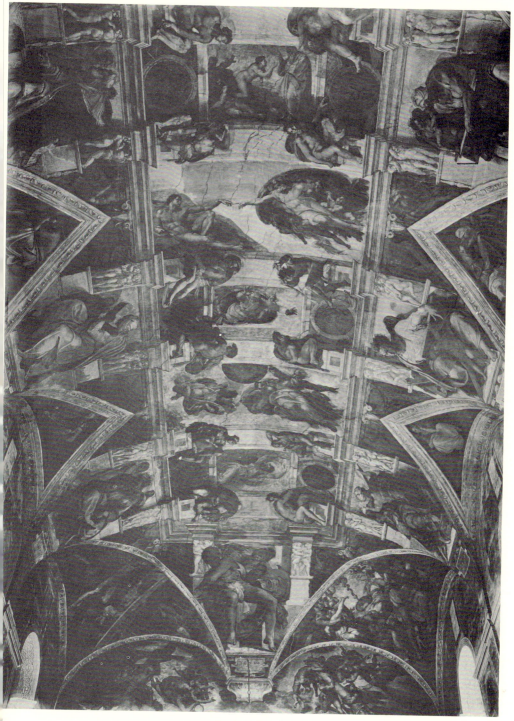

54. Sistine Ceiling, the five histories above the presbytery

57. *The Sacrifice of Noah*. Sistine Ceiling

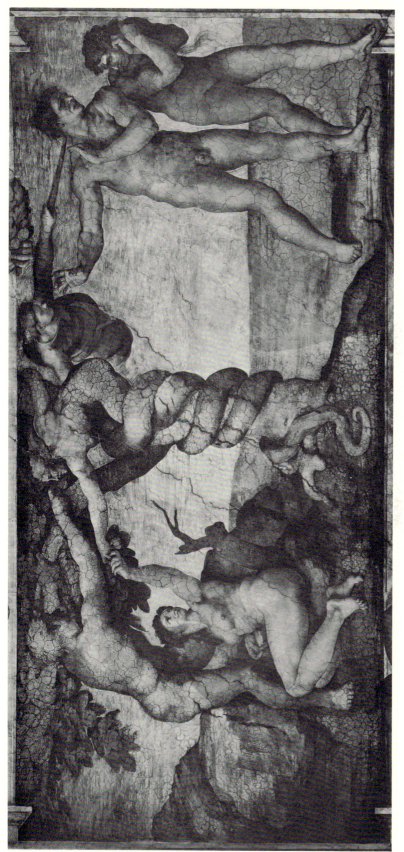

58. *The Fall and the Expulsion.* Sistine Ceiling

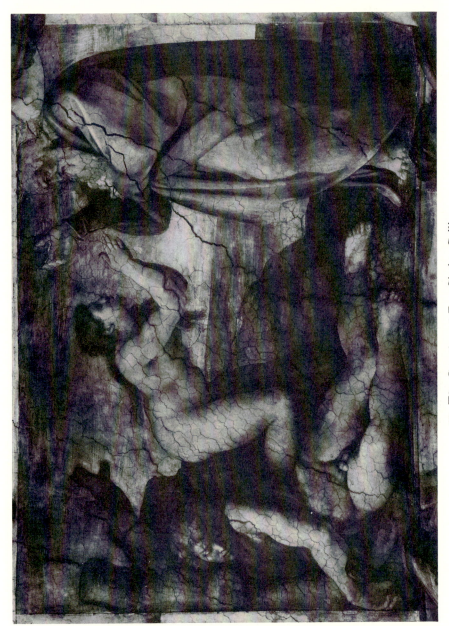

59. *The Creation of Eve*. Sistine Ceiling

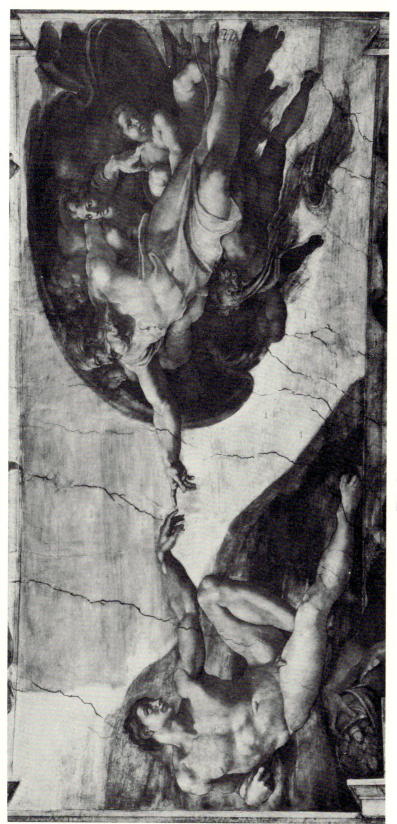

60. *The Creation of Adam.* Sistine Ceiling

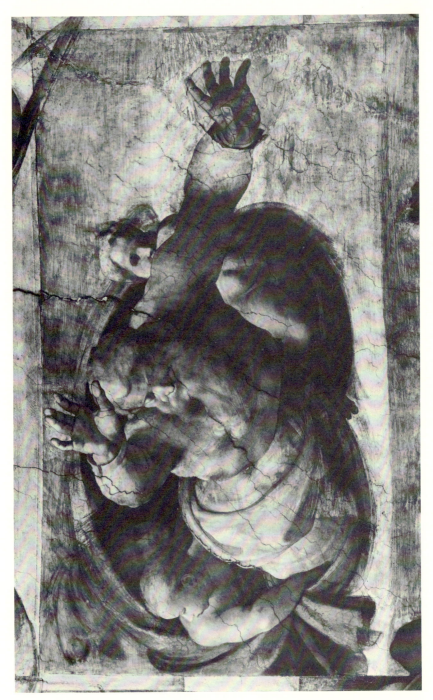

61. *The Division of Heaven from the Waters. Sistine Ceiling*

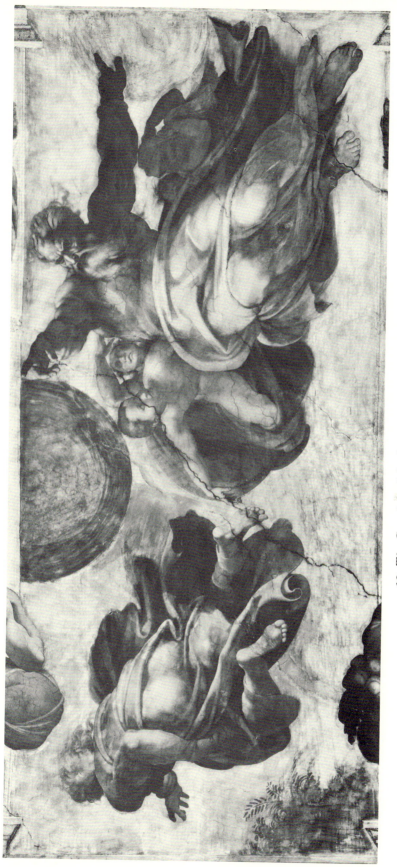

62. *The Creation of the Sun and Moon.* Sistine Ceiling

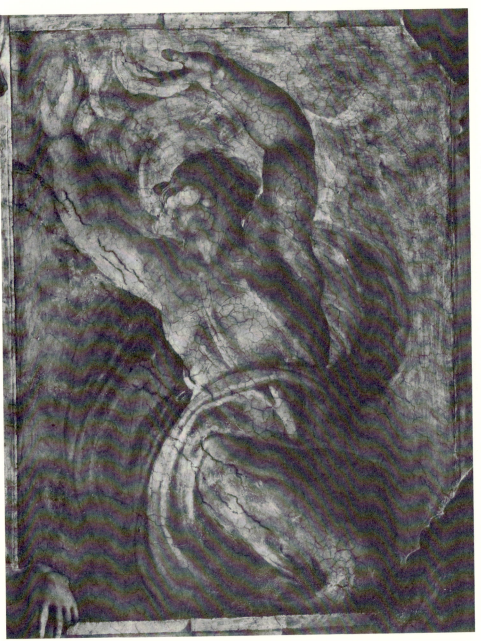

63. *The Division of the Light from the Darkness. Sistine Ceiling*

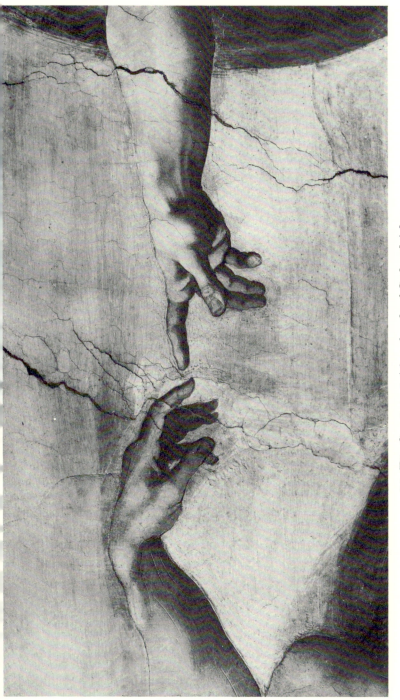

64. *The Creation of Adam*, hands of God and Adam

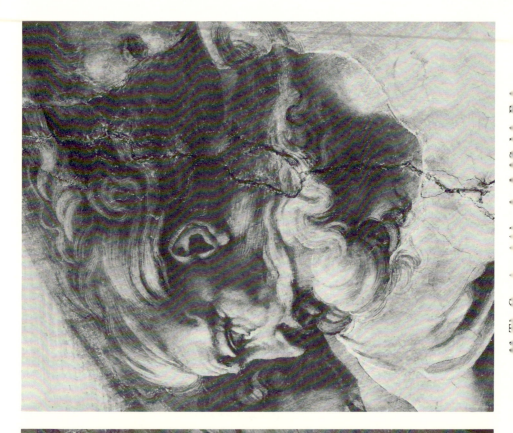

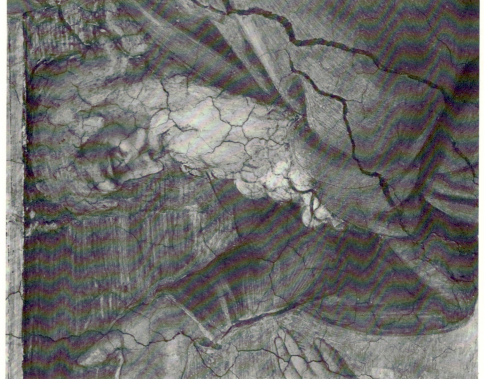

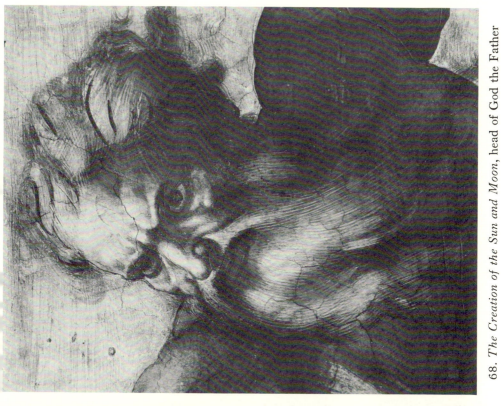

67. *The Division of Heaven from the Waters,* head of God the Father

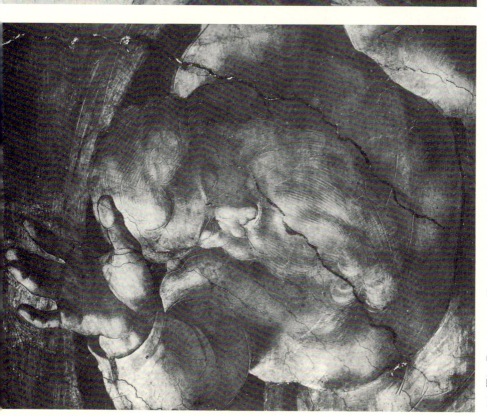

68. *The Creation of the Sun and Moon,* head of God the Father

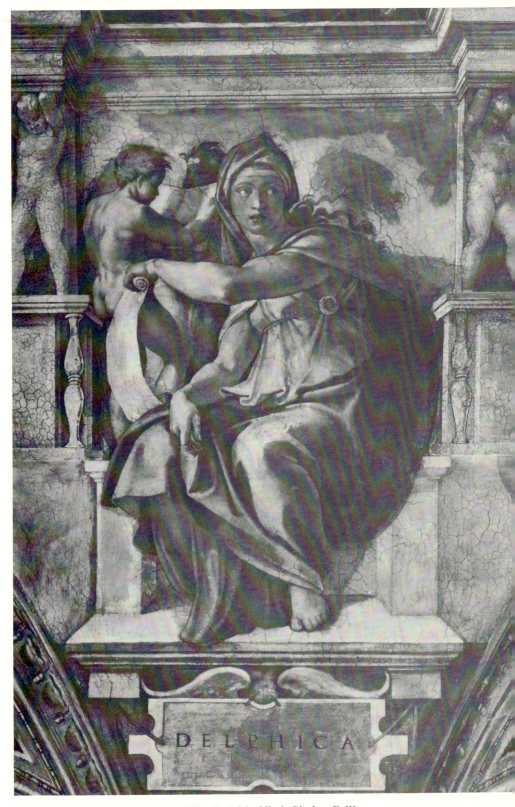

71. The Delphic Sibyl. Sistine Ceiling

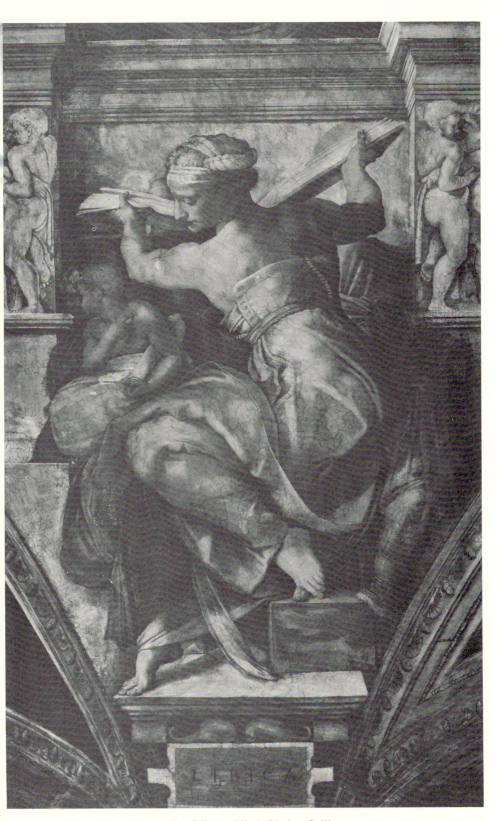

72. The Libyan Sibyl. Sistine Ceiling

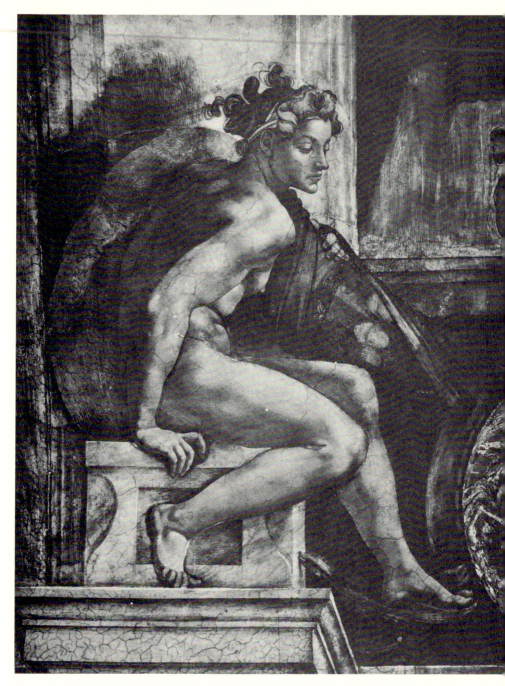

73. Nude Youth above Joel, left. Sistine Ceiling

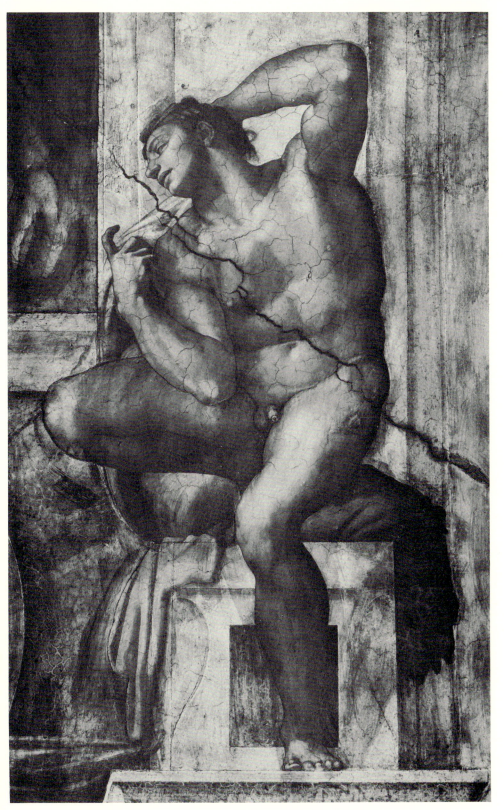

74. Nude Youth above the Libyan Sibyl, right. Sistine Ceiling

75. Bronze-colored Nude above
the Ezechias spandrel.
Sistine Ceiling

76. Bronze-colored Nude
above the Jesse spandrel.
Sistine Ceiling

77. The Ancestors of Christ: Ozias. Sistine Ceiling

78. The Ancestors of Christ: Salmon. Sistine Ceiling

79. David and Goliath. Sistine Ceiling

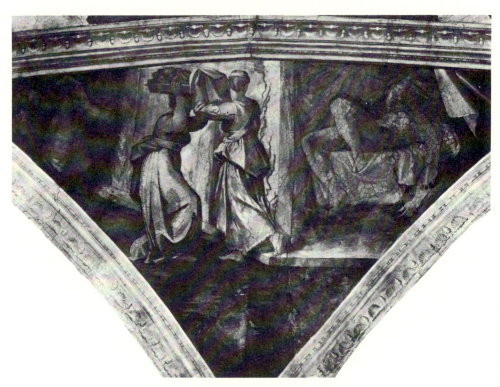

80. Judith and Holophernes. Sistine Ceiling

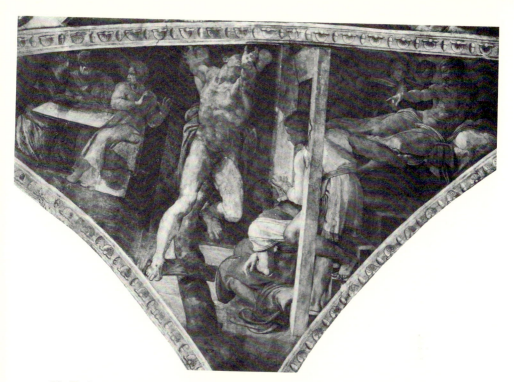

81. Esther and Ahasuerus, and the Crucifixion of Haman. Sistine Ceiling

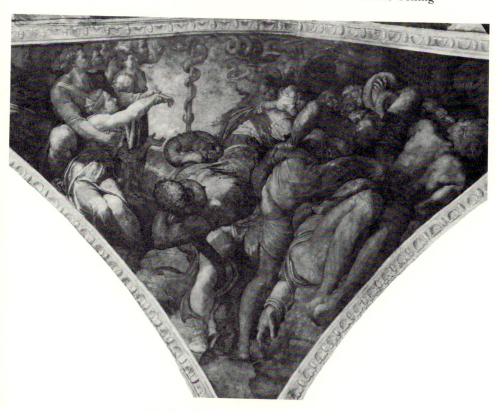

82. The Brazen Serpent. Sistine Ceiling

84. Booz and Obed lunette, Ruth and her son Obed. Sistine Ceiling

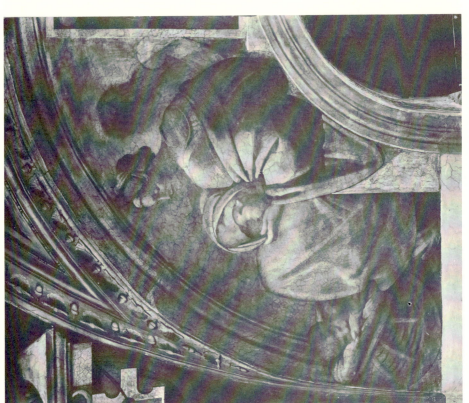

83. Manasses and Amon lunette, Amon in his mother's arms.

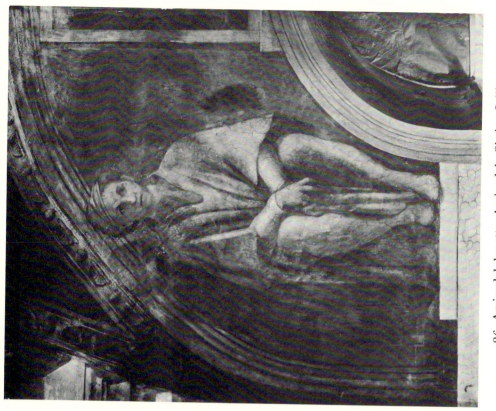

86. Aminadab lunette, Aminadab. Sistine Ceiling

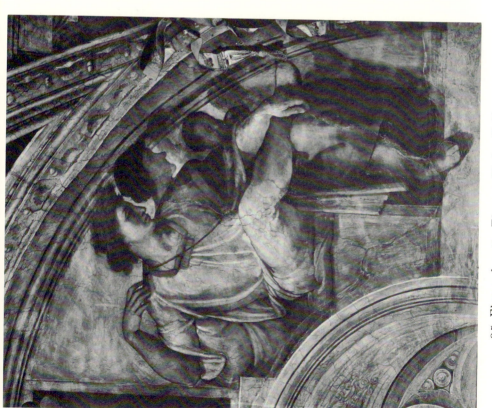

85. Eleazar lunette, Eleazar. Sistine Ceiling

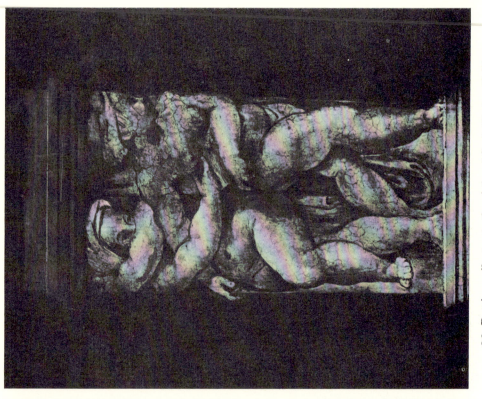

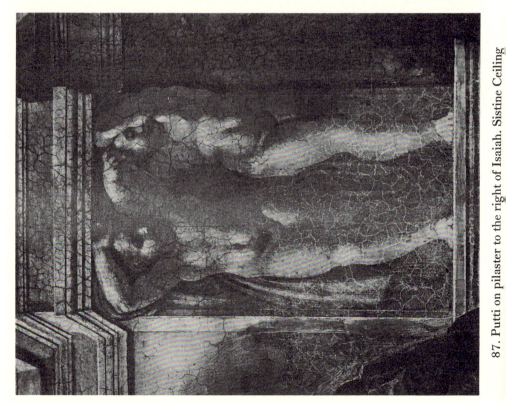

88. Putti on pilaster to the right of Joel. Sistine Ceiling

87. Putti on pilaster to the right of Isaiah. Sistine Ceiling

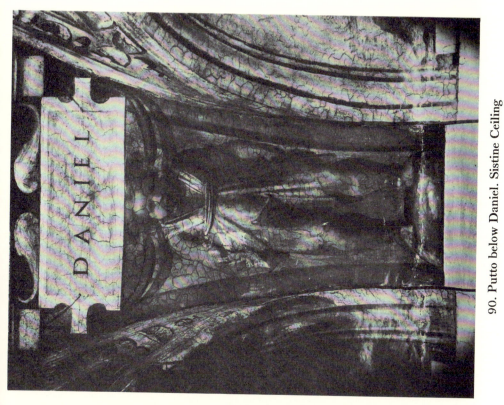

90. Putto below Daniel. Sistine Ceiling

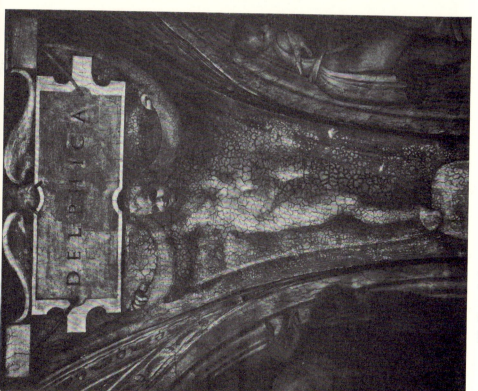

89. Putto below the Delphic Sibyl. Sistine Ceiling

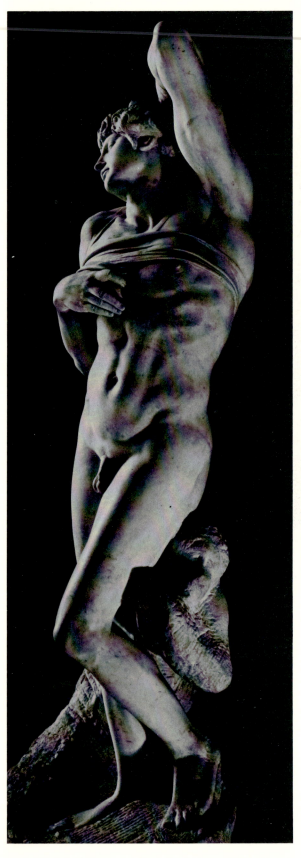

92. The Dying Slave, detail of the bac

91. The Dying Slave (for the
Tomb of Julius II, second
project). Paris, Louvre

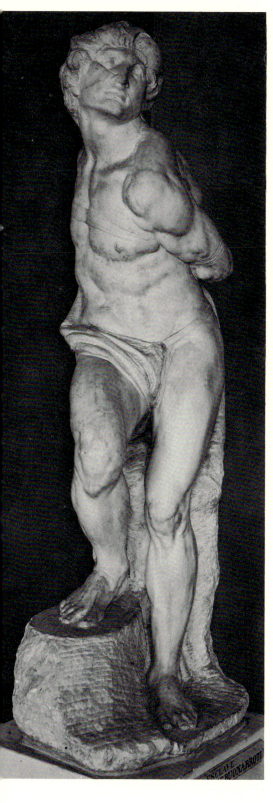

94. The Rebellious Slave,
detail of the back

93. The Rebellious Slave (for
the Tomb of Julius II, second
project). Paris, Louvre

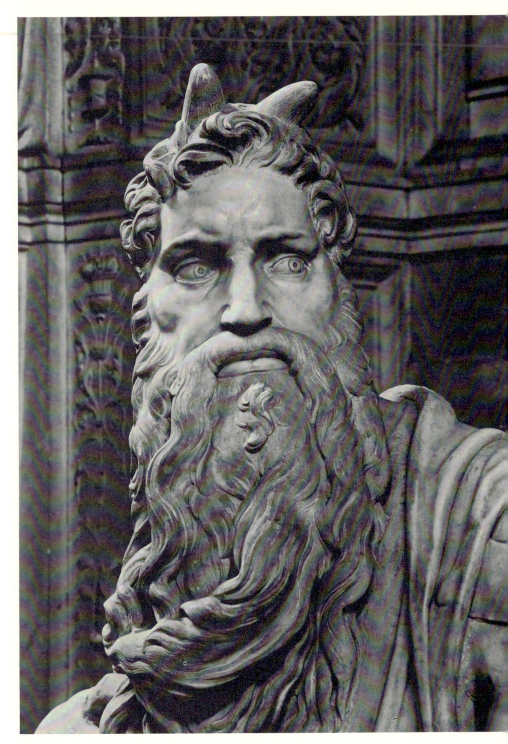

97. Moses, the head

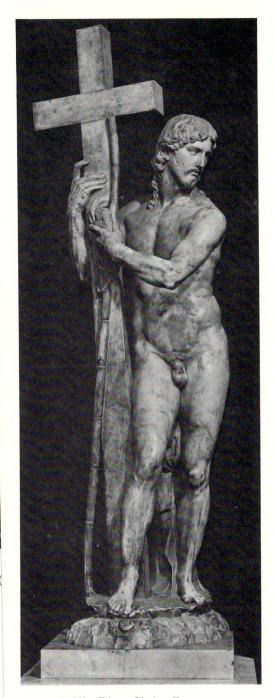

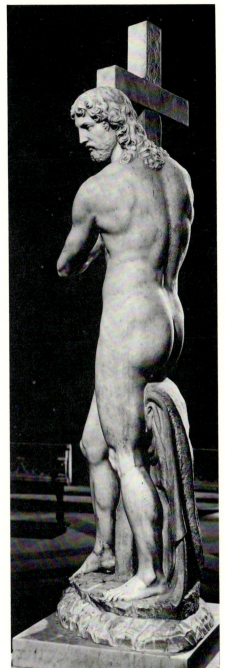

98. The Risen Christ. Rome,
Santa Maria sopra Minerva

99. The Risen Christ, left side and back

104. Medici Chapel (Sagrestia Nuova), exterior view
of the north wall. Florence, San Lorenzo

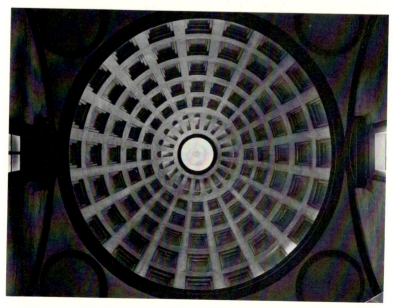

105. Medici Chapel, interior of the dome

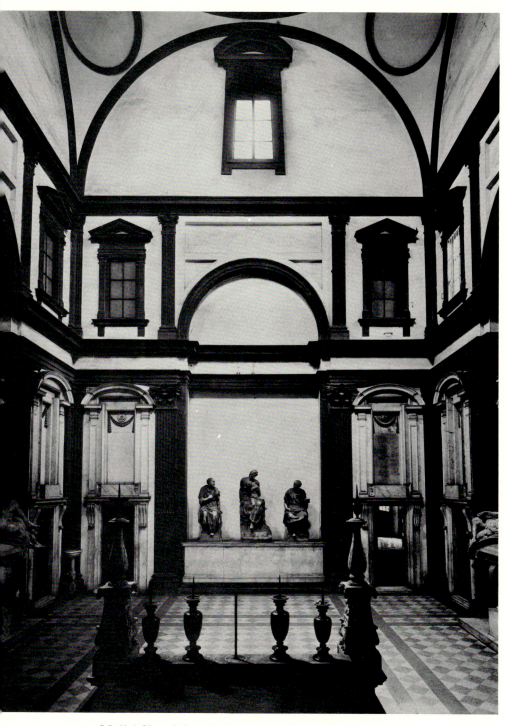

106. Medici Chapel, interior view of the unfinished entrance wall,
with the altar in the foreground; Michelangelo's Virgin and
Child between St. Cosmas (right, by Montorsoli) and
St. Damian (left, by Montelupo)

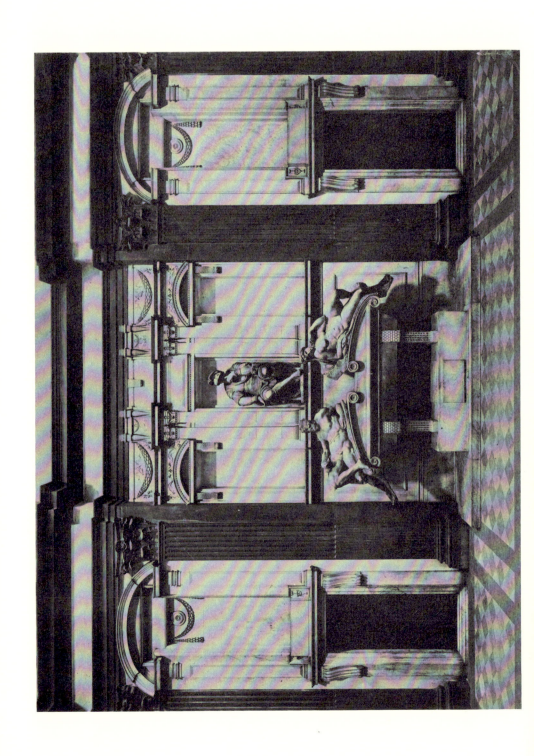

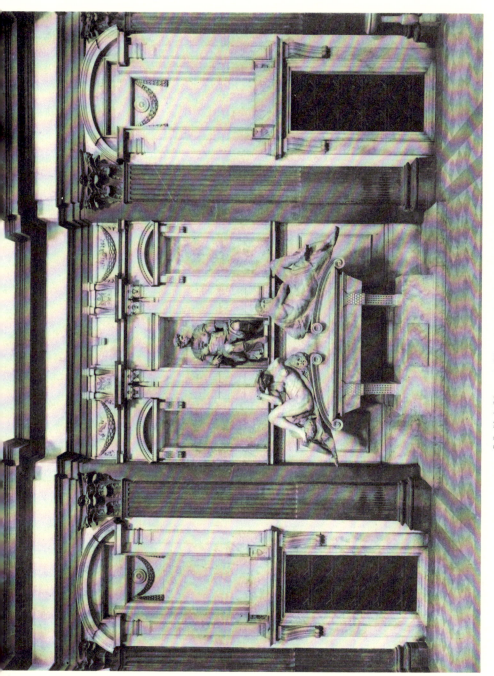

108. Medici Chapel, Tomb of Giuliano de' Medici

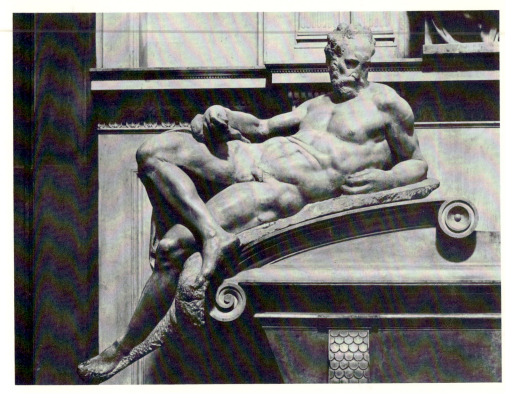

109. Dusk. Tomb of Lorenzo de' Medici, Medici Chapel

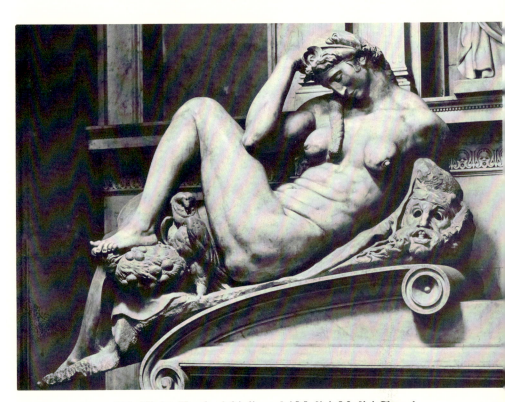

111. Night. Tomb of Giuliano de' Medici, Medici Chapel

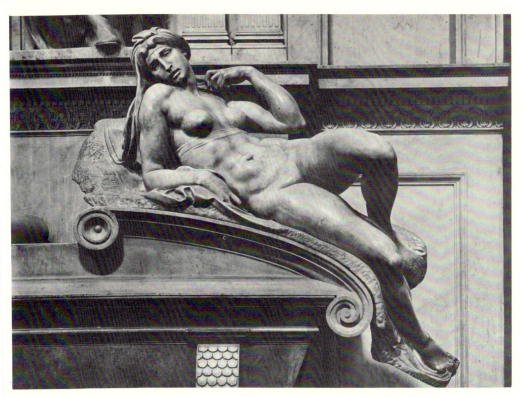

110. Dawn. Tomb of Lorenzo de' Medici, Medici Chapel

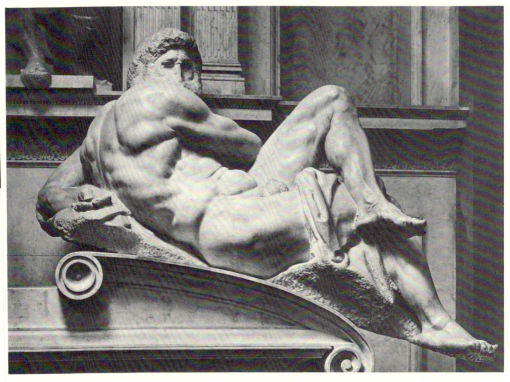

112. Day. Tomb of Giuliano de' Medici, Medici Chapel

130. Crouching Youth (for the Tomb of
Lorenzo de' Medici), right side.
Leningrad, Hermitage

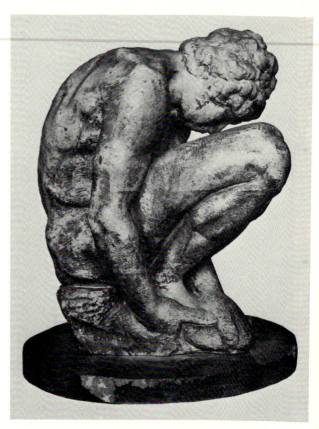

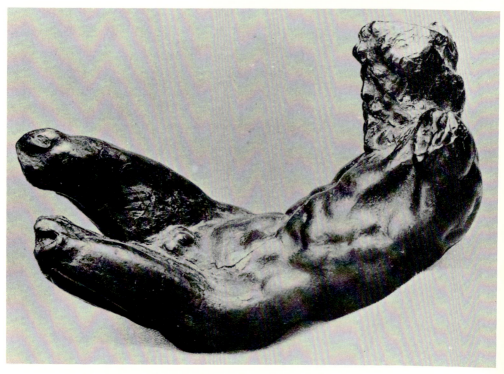

132. River God, small model for the Tomb of Giuliano de' Medici
in the Medici Chapel. Rotterdam, Boymans-van Beuningen Museum

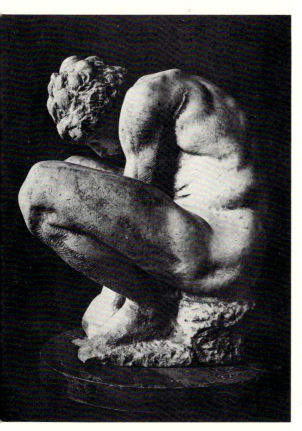

131. Crouching Youth, left side

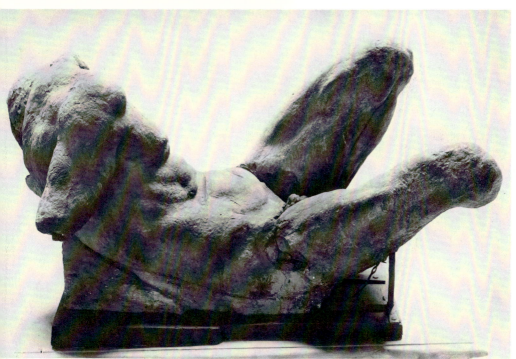

133. River God, model for the Tomb of Lorenzo de' Medici in the
Medici Chapel. Florence, Casa Buonarroti

134, 135. With the Medici arms,
left of Giuliano

136, 137. With the Medici arms,
right of Giuliano

138, 139. With the Medici arms,
left of the Virgin

140, 141. With the Medici arms,
right of the Virgin

134-149. Urn reliefs.
Medici Chapel

142, 143. Left of the altar

144, 145. With the Medici arms,
right of the altar

146, 147. Left of Lorenzo

148, 149. Right of Lorenzo

150. Frieze of masks, detail to the left of Night. Medici Chapel

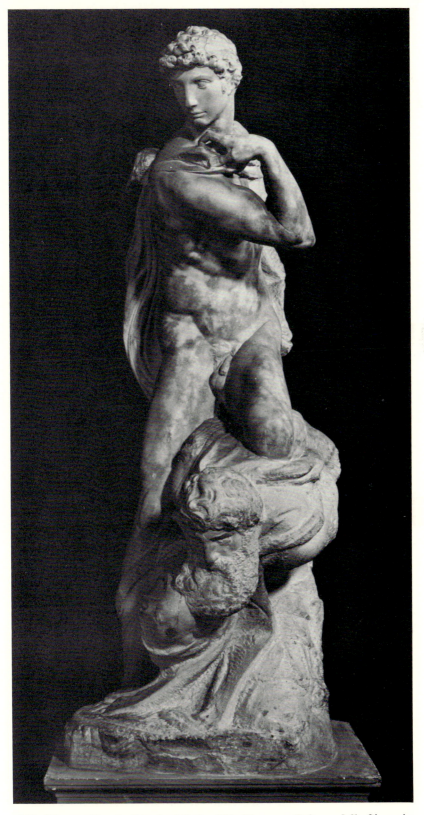

151. Victory (for the Tomb of Julius II). Florence, Palazzo della Signoria

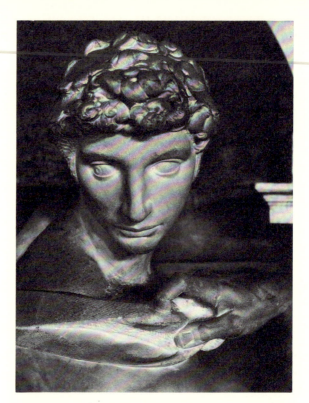

152. Victory, the head

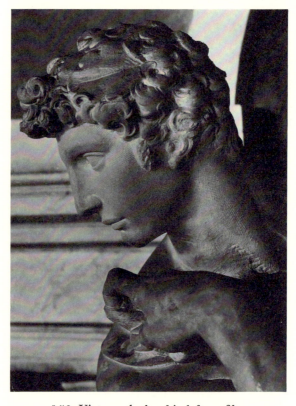

153. Victory, the head in left profile

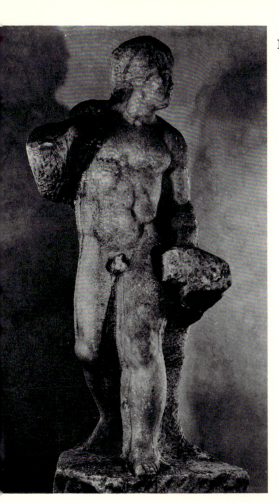

154. Slave (for the Tomb of Julius II).
Florence, Casa Buonarroti

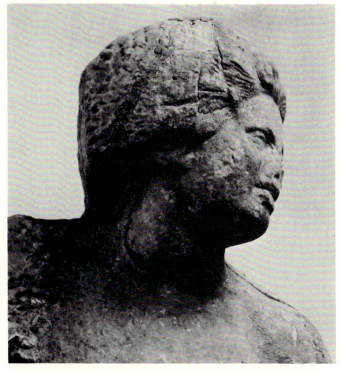

155. Slave, the head
and shoulders

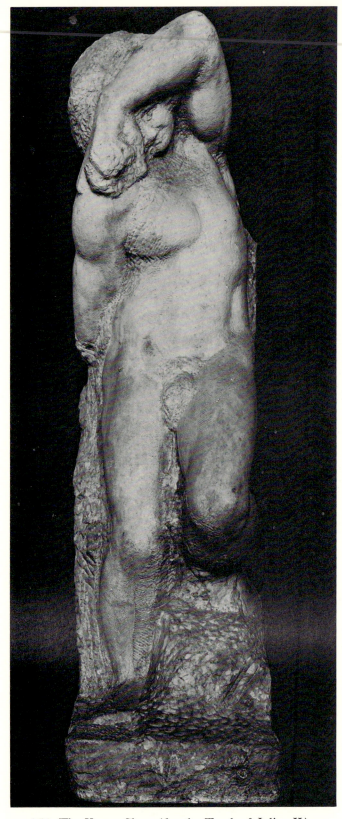

156. The Young Slave (for the Tomb of Julius II).
Florence, Accademia delle Belle Arti

157. The Bearded Slave (for the Tomb of Julius II).
Florence, Accademia delle Belle Arti

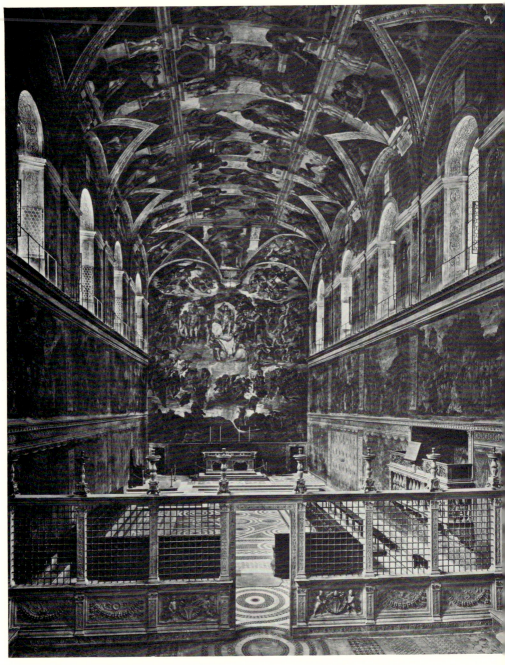

162. Sistine Chapel, interior from the entrance. Rome, Vatican

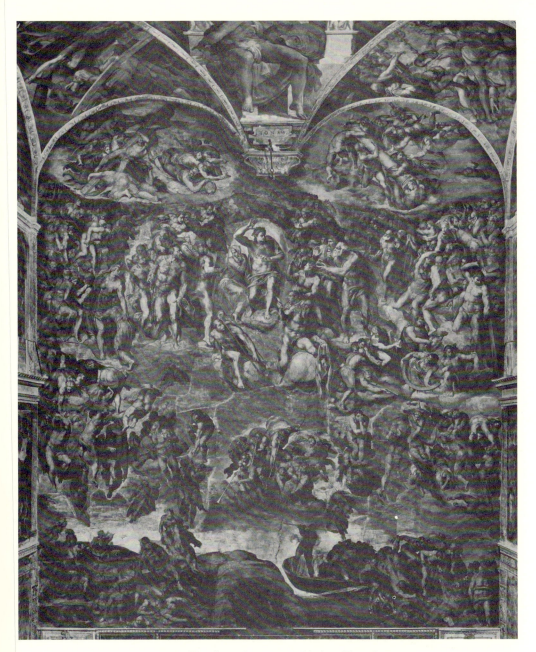

163. *The Last Judgment*. Sistine Chapel

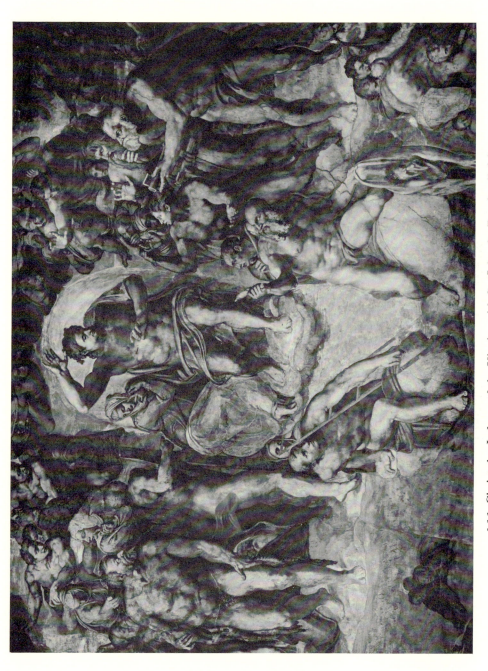

166. Christ the Judge and the Virgin, with St. John the Baptist (left),
St. Peter (right), and other apostles and saints. *Last Judgment*

168. Mask of Michelangelo, on the flayed skin of St. Bartholomew. *Last Judgment*

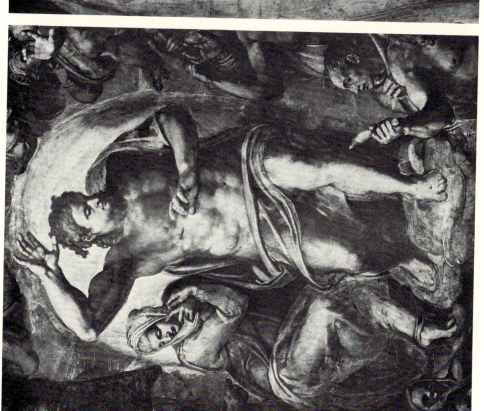

167. Christ and the Virgin. *Last Judgment*

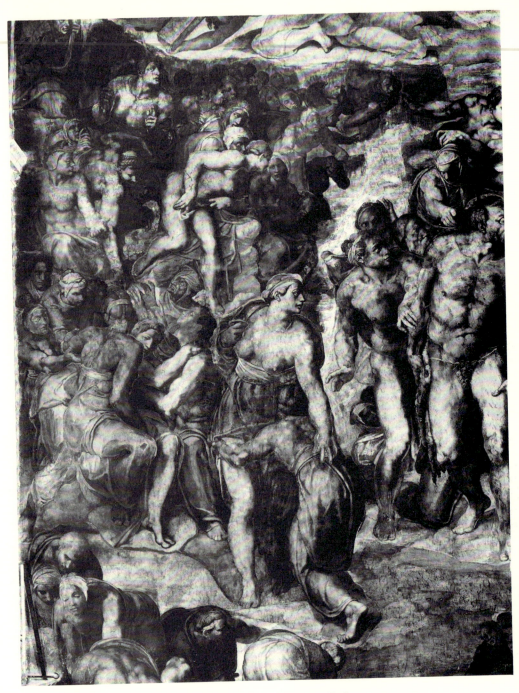

169. The "Choir of Sibyls." *Last Judgment*

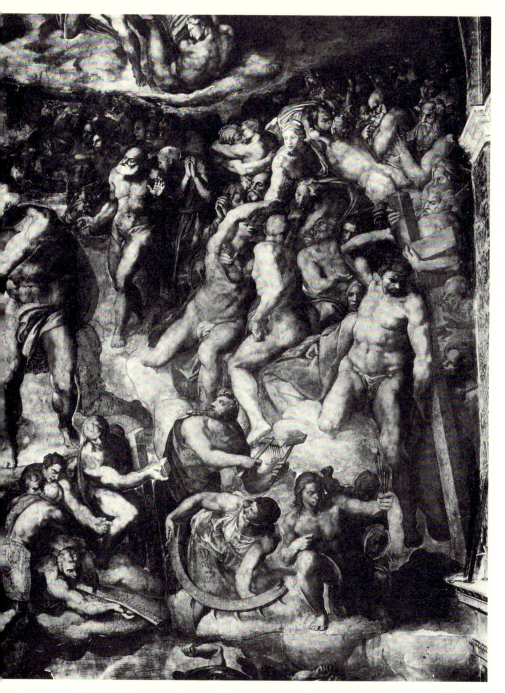

170. The "Choir of Prophets" and the Martyrs. *Last Judgment*.

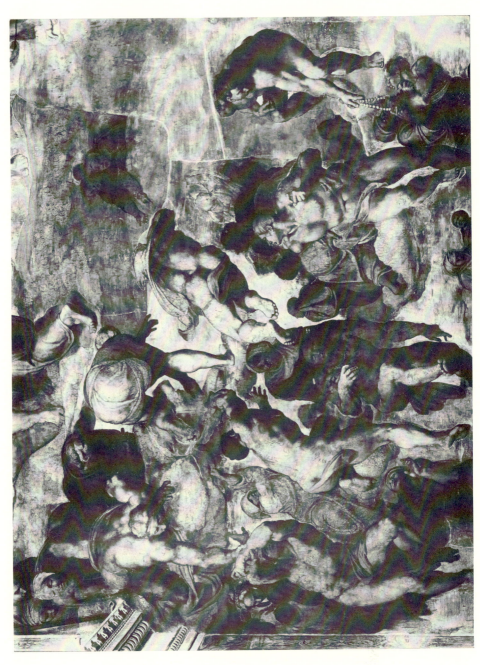

171. The Elect. *Last Judgment*

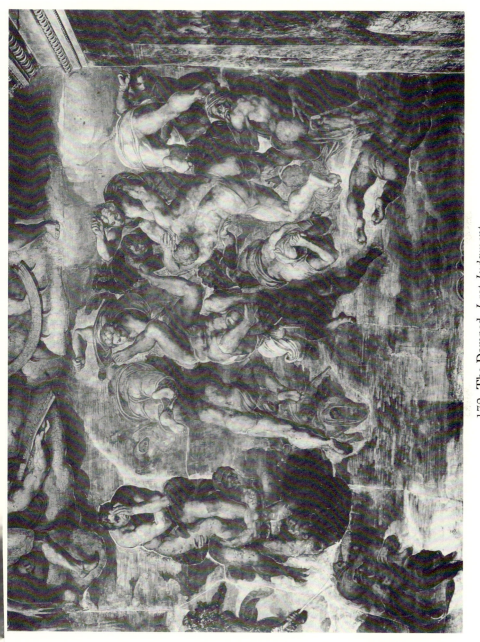

172. The Damned. *Last Judgment*

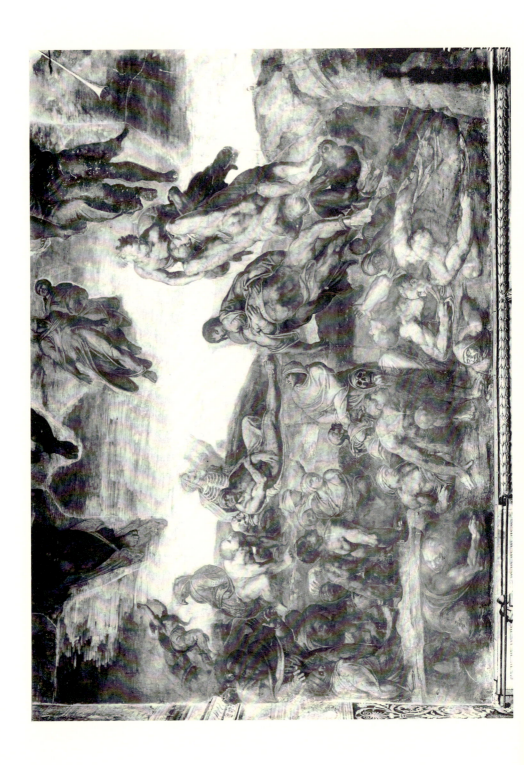

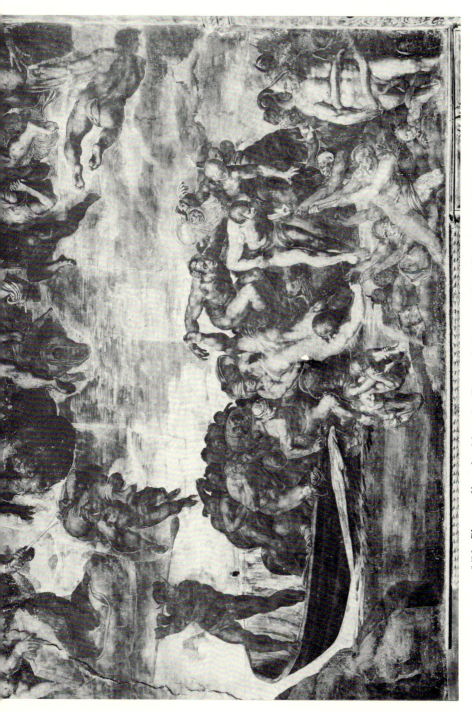

176. Charon disembarking the Damned; lower right, Minos. *Last Judgment*

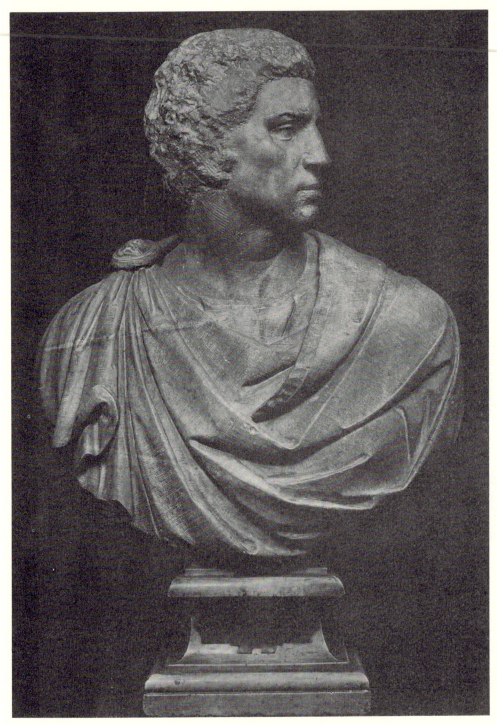

177. Bust of Brutus. Florence, Bargello

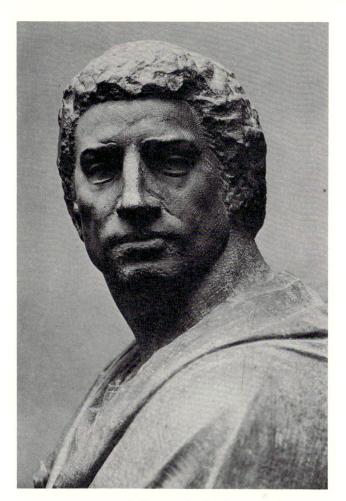

178. Brutus, the head

179. Brutus, the fibula

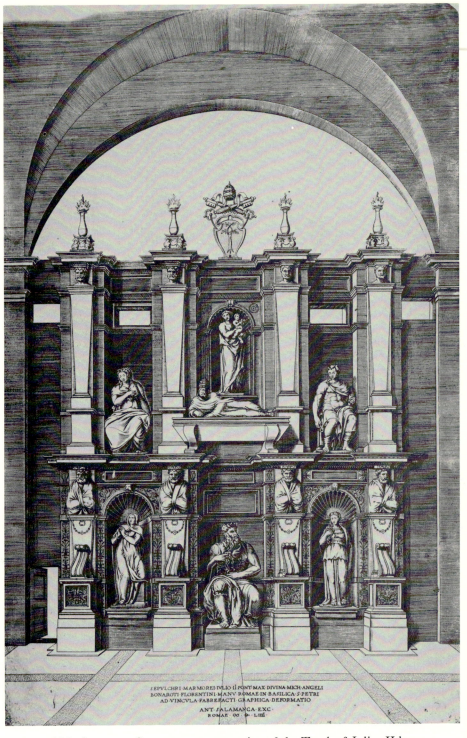

180. ANTONIO SALAMANCA, engraving of the Tomb of Julius II by
Michelangelo in San Pietro in Vincoli, 1554. Paris, Bibliothèque Nationale

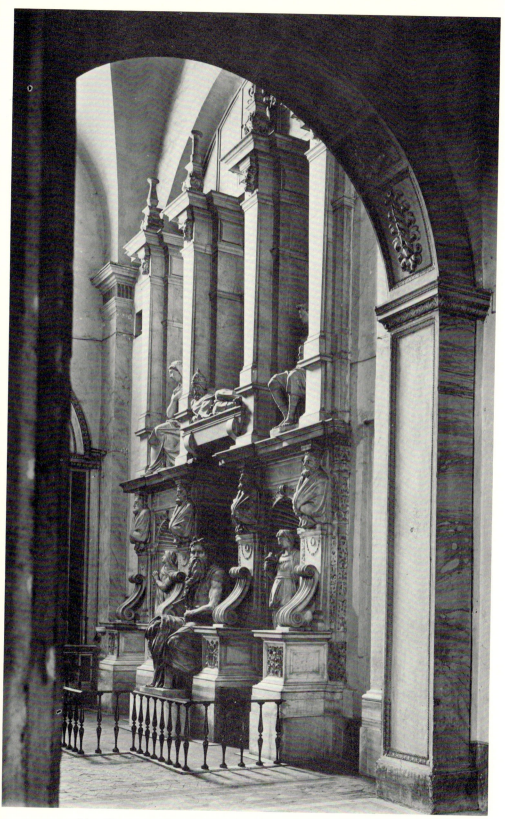

181. Tomb of Julius II, oblique view from the observer's right.
Rome, San Pietro in Vincoli

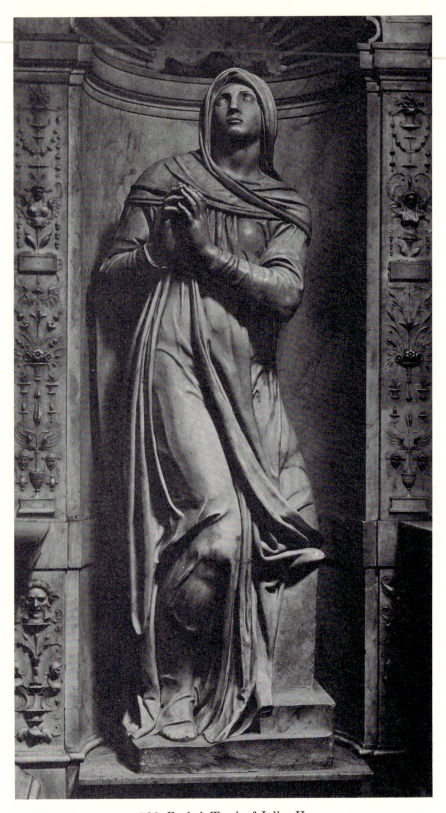

182. Rachel. Tomb of Julius II

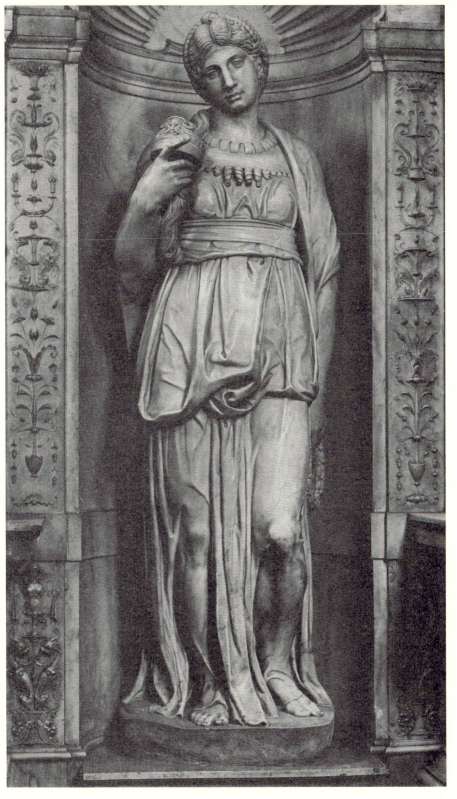

183. Leah. Tomb of Julius II

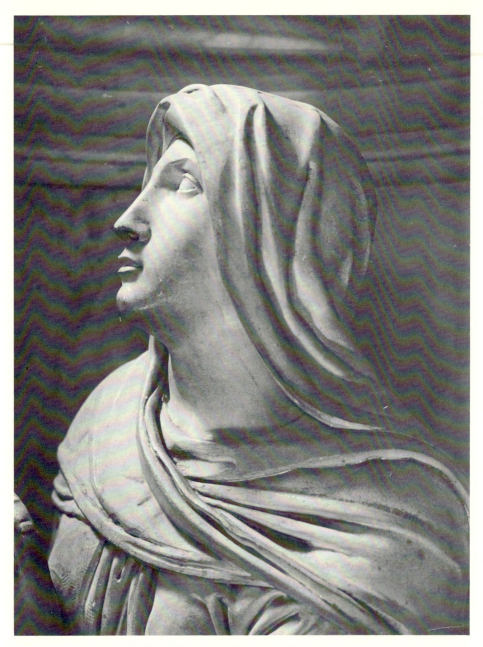

184. Rachel, the head in left profile

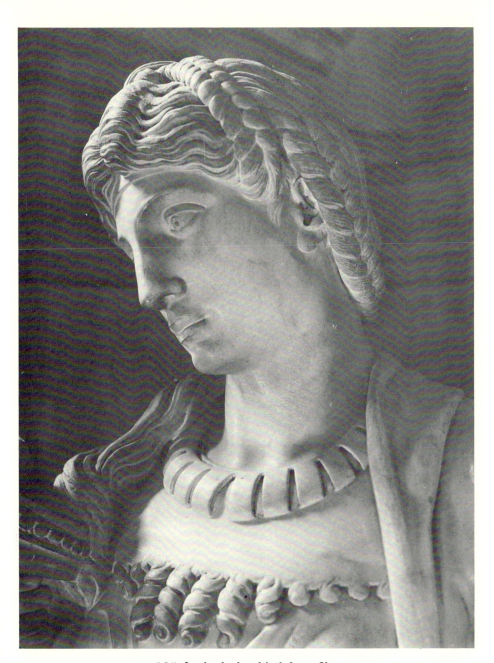

185. Leah, the head in left profile

187. *The Crucifixion of St. Peter.* Vatican, Pauline Chapel

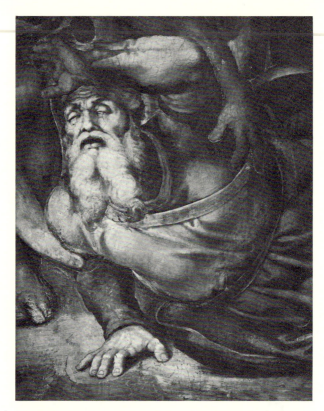

188. *The Conversion of St. Paul*, St. Paul's head

189. *The Crucifixion of St. Peter*, St. Peter's head

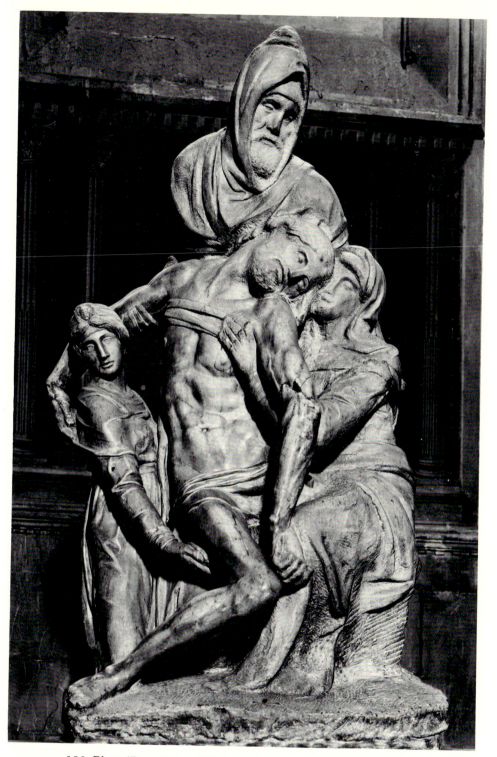

190. Pietà (Deposition of Christ). Florence, Santa Maria del Fiore

198. Three standing figures, probably copied
from a lost fresco by Masaccio in the
Carmine, Florence. Vienna, Albertina

197. Copy of two figures from Giotto's
Ascension of St. John the Evangelist,
in Santa Croce, Florence. Paris, Louvre

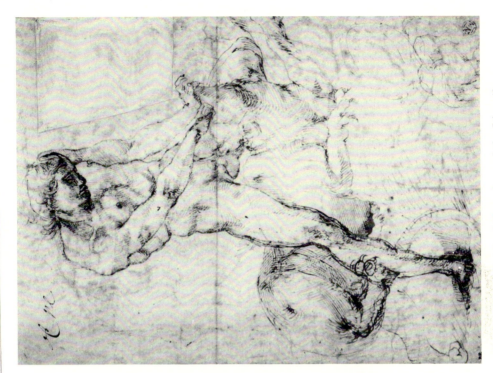

200. Sketch of Hercules and the Lion (here attributed to Michelangelo). Paris, Louvre

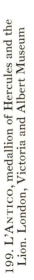

199. L'ANTICO, medallion of Hercules and the Lion. London, Victoria and Albert Museum

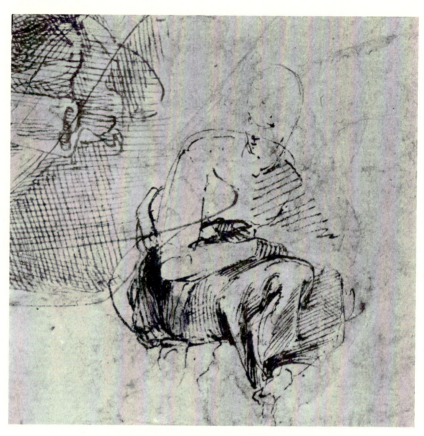

207. Seated woman (detail) used for the Virgin in the
Pitti tondo. Chantilly, Musée Condé

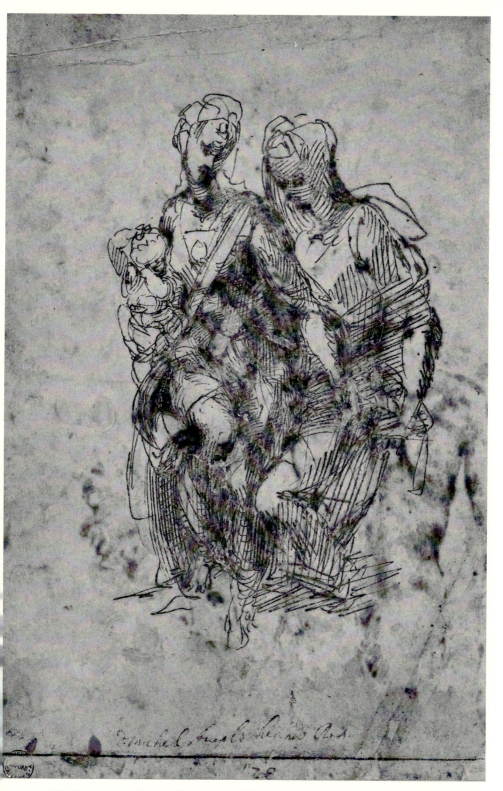

208. St. Anne with the Virgin and Child, inspired by Leonardo's cartoon.
Oxford, Ashmolean Museum

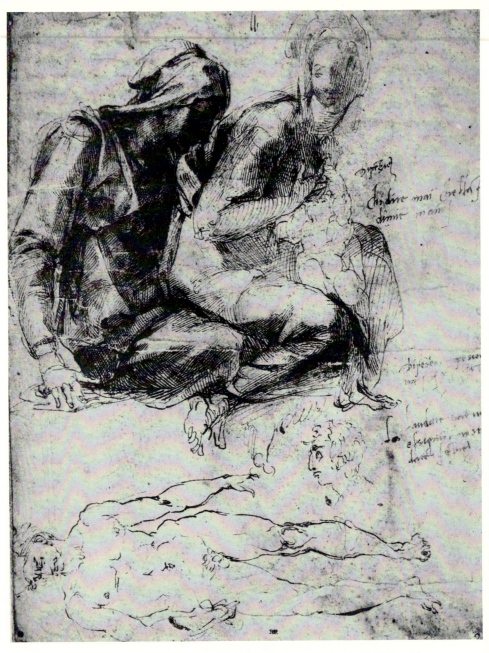

209. St. Anne with the Virgin and Child; sketch of a male nude and
of a head in profile; inscriptions. Paris, Louvre

210. Sketches of male nudes, and of the Bruges Madonna. London, British Museum

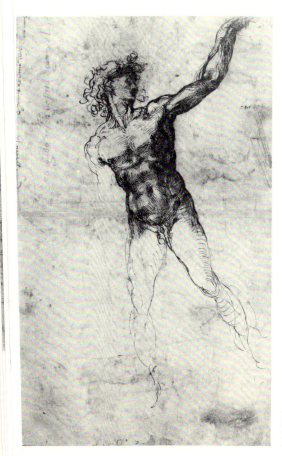

211. Study of a nude, inspired by the Apollo Belvedere. London, British Museum

229. Sketch of a guard for the Resurrection
(see Fig. 230). Florence, Archivio Buonarroti

230. Resurrection of Christ. London, British Museum

231. Two episodes in the story of Moses and the Brazen Serpent, possibly for lunettes in the Medici Chapel: the Attack by Serpents, and the Healing by the Brazen Serpent. Oxford, Ashmolean Museum

232. Sketch for an Entombment of Christ. Paris, Louvre

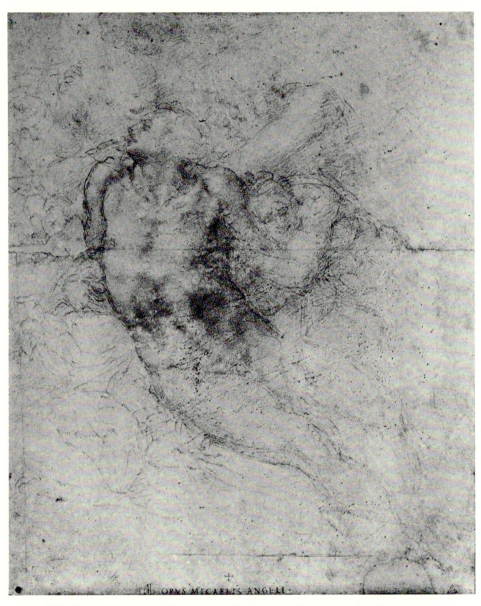

233. Dante's Paolo and Francesca. Darmstadt, Hessisches Landesmuseum

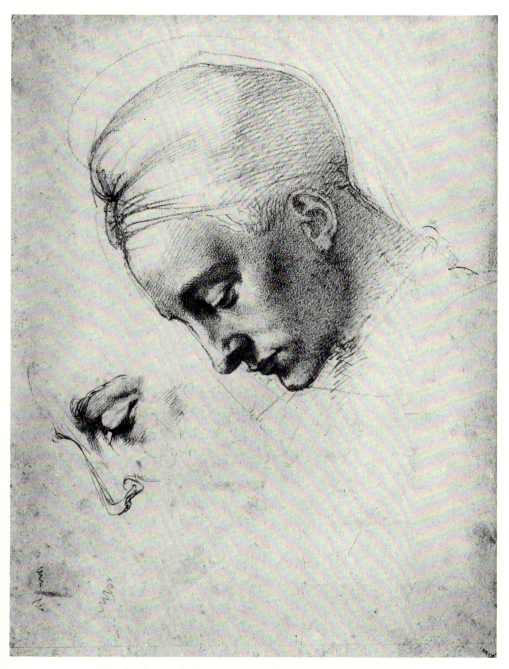

234. Study for the head of Leda. Florence, Casa Buonarroti

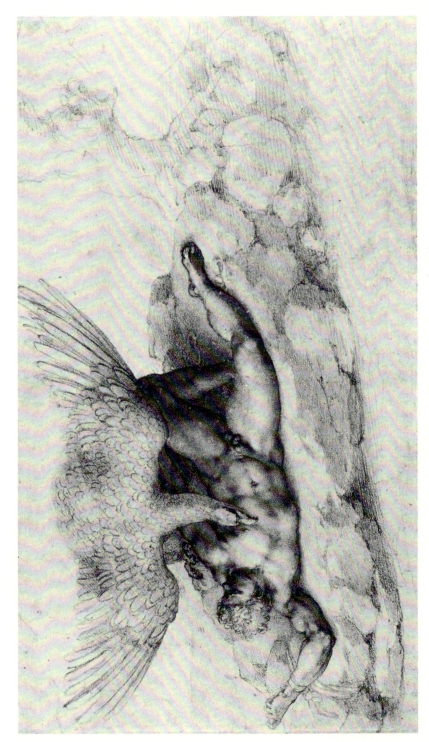

235. The Punishment of Tityos. Windsor, Royal Library

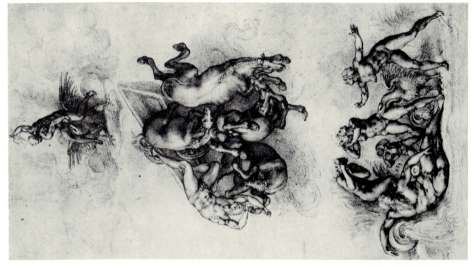

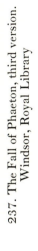

237. The Fall of Phaeton, third version.
Windsor, Royal Library

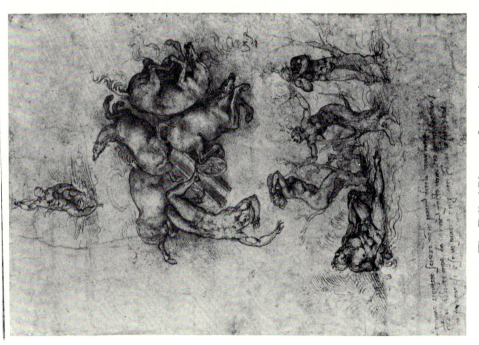

236. The Fall of Phaeton, first version.
London, British Museum

250. Christ Driving the Merchants out of the Temple.
London, British Museum

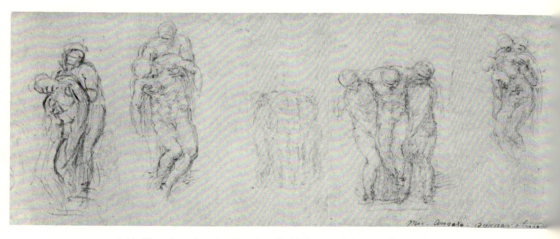

251. Sketches for the Rondandini Pietà and for an Entombment.
Oxford, Ashmolean Museum

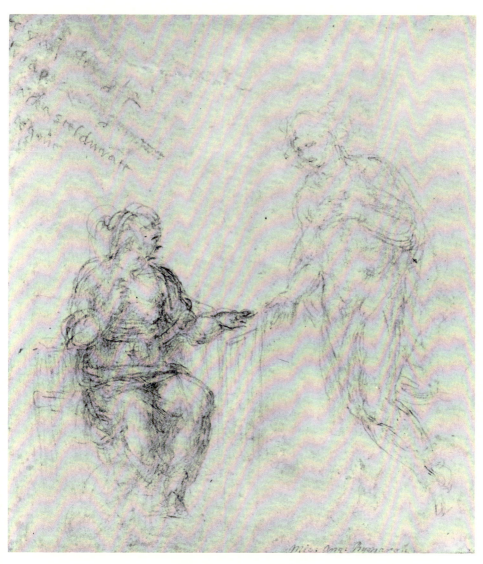

252. Appearance of the Risen Christ to his Mother (*or* Annunciation).
Oxford, Ashmolean Museum

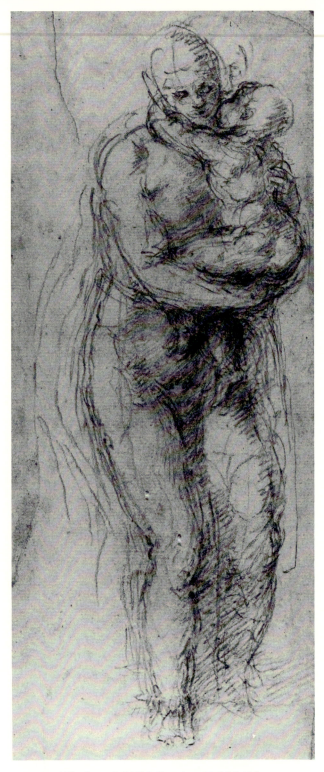

253. Virgin and Child. London, British Museum

ARCHITECTURE

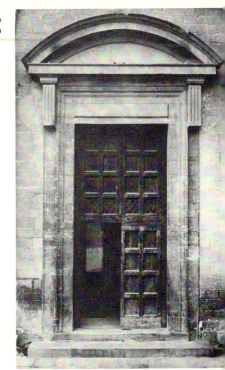

254. North door of San Lorenzo, Florence,
from a design by Michelangelo

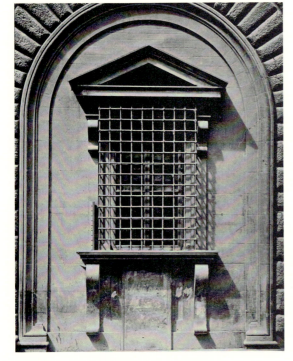

255. Ground-floor window in the
Medici Palace, Florence

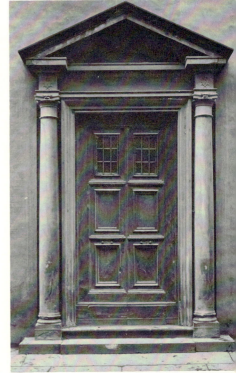

256. Entrance door to the convent,
Sant' Apollonia, Florence,
attributed to Michelangelo

258. Model for the San Lorenzo façade, detail of the upper story

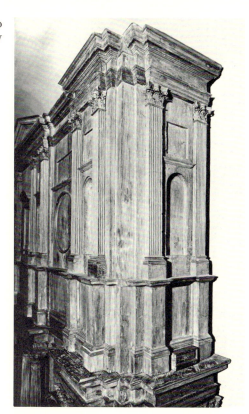

257. Wooden model for the façade of San Lorenzo, Florence. Florence, Casa Buonarroti

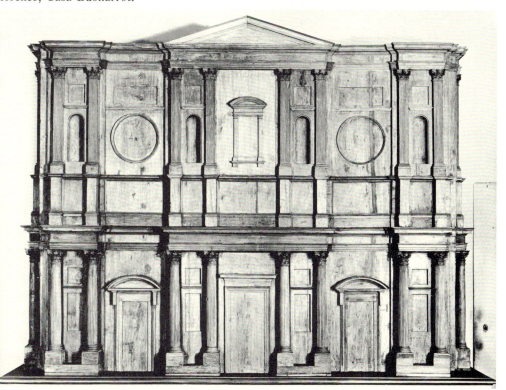

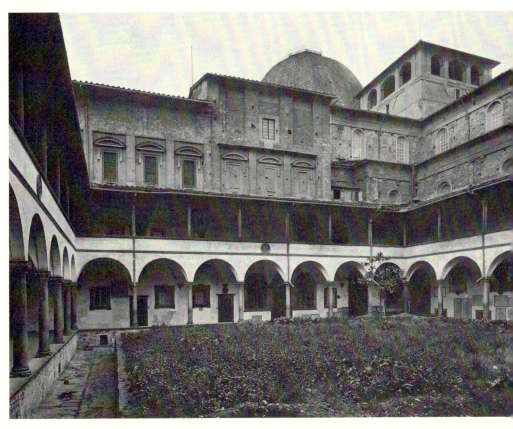

259. Cloister of San Lorenzo, Florence, showing the windows of the
Laurentian Library by Michelangelo, before restoration

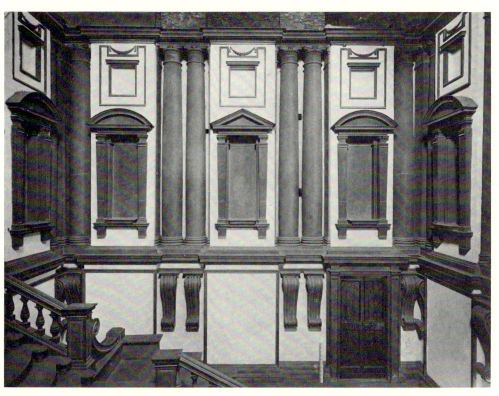

260. Vestibule (*ricetto*) of the Laurentian Library, west wall

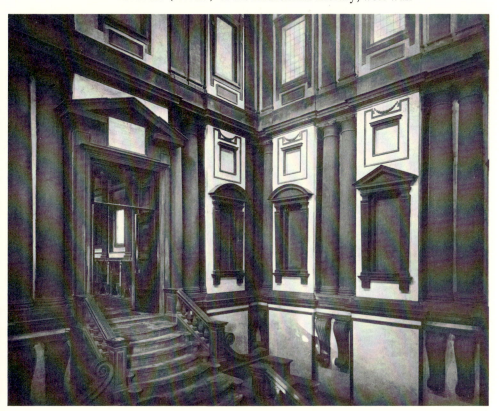

261. Vestibule of the Laurentian Library, showing the staircase
and entrance to the reading room

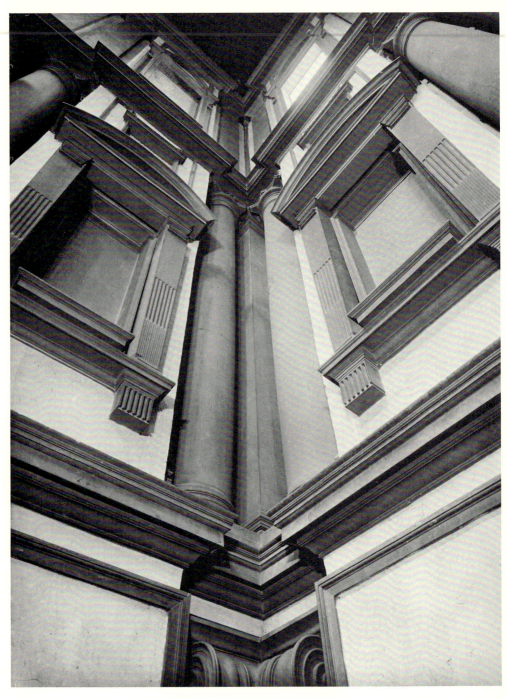

262. Corner of the Laurentian Library vestibule, seen from below

263. Tabernacle-niche in the
Laurentian Library vestibule

264. Corner volutes in the
Laurentian Library vestibule

265 Staircase leading from the vestibule to the reading room of the Laurentian Library

266. Reading room of the Laurentian Library

267. Detail of the floor decoration (yellow on red)
in the Laurentian Library reading room

268. Sketch of the first project for the ceiling of the Laurentian
Library reading room. Florence, Casa Buonarroti

269. Entrance to the reliquary tribune,
San Lorenzo, Florence (cf. Fig. 263)

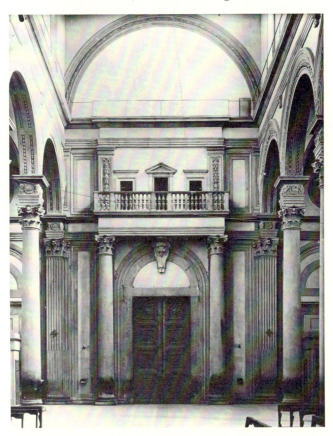

270. Reliquary tribune, San Lorenzo, Florence

272. Tomb of Cecchino Bracci in Santa Maria
in Aracoeli, Rome

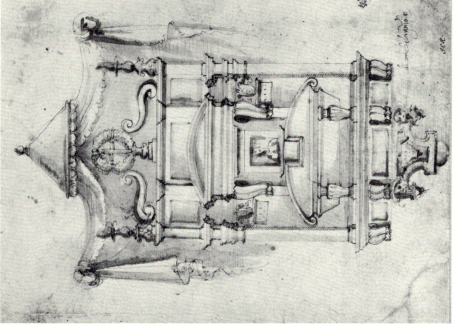

271. Tomb of Cecchino Bracci; anonymous
mid-16th-century drawing, probably after
Michelangelo's original design.
Florence, Casa Buonarroti

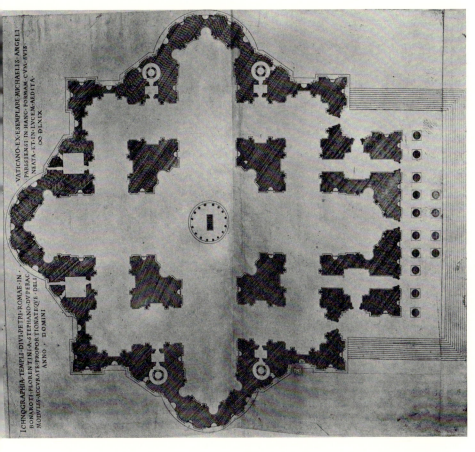

ICHNOGRAPHIA·TEMPLI·DIVI·PETRI·ROMAE·IN·
VATICANO·EX·ESEMPLARI·MICHAELIS·ANGELI·
BONAROTI·FLORENTINI·A·STEPHANO·DVPERAC·
PARISIENSI·IN·HANC·FORMAM·CVM·SVIS·
MODVLIS·ACCVRATE·PROPORTIONATEQVE·DELI
NEATA·ET·IN·LVCEM·AEDITA·
ANNO · DOMINI ∞ ⅮLXIX.

274. Ground plan of St. Peter's, after engraving
by Dupérac, 1569. Vienna, Albertina

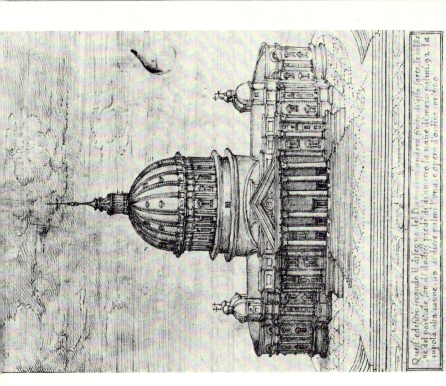

273. Drawing attributed to Dupérac, showing
Michelangelo's first model for St. Peter's, Rome.
Milan, Feltrinelli Collection

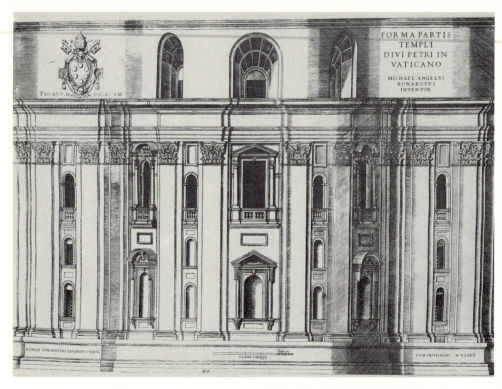

275. Choir of St. Peter's, engraving of 1564. Vienna, Albertina

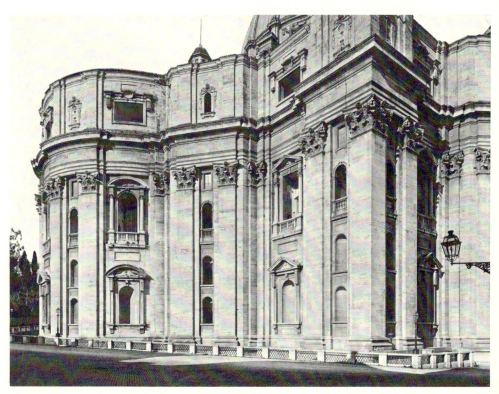

276. St. Peter's, exterior view of the south transept (Cappella del Re di Francia)

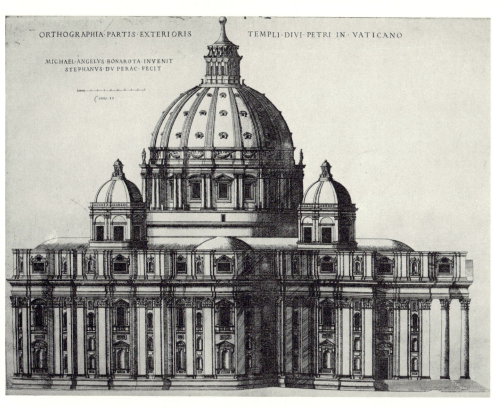

277. Exterior view of St. Peter's, engraving by Dupérac. Vienna, Albertina

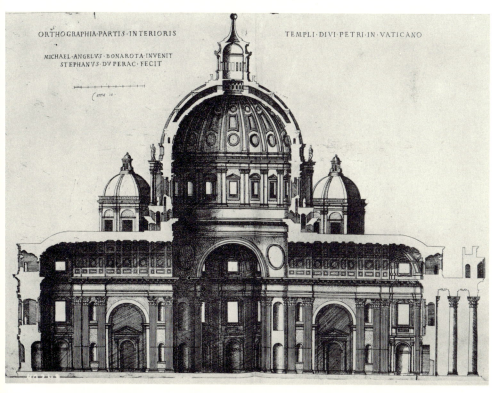

278. Cross-section of St. Peter's, engraving by Dupérac. Vienna, Albertina

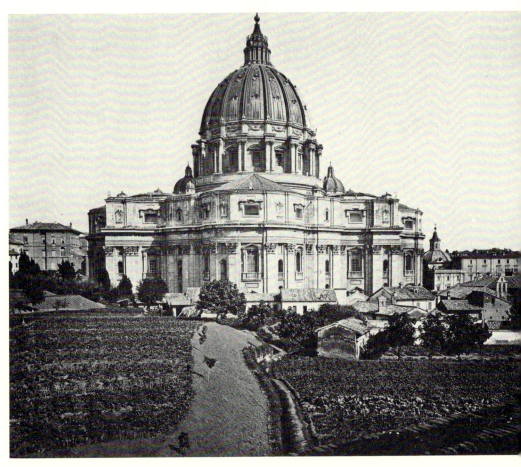

279. West end of St. Peter's, by Michelangelo

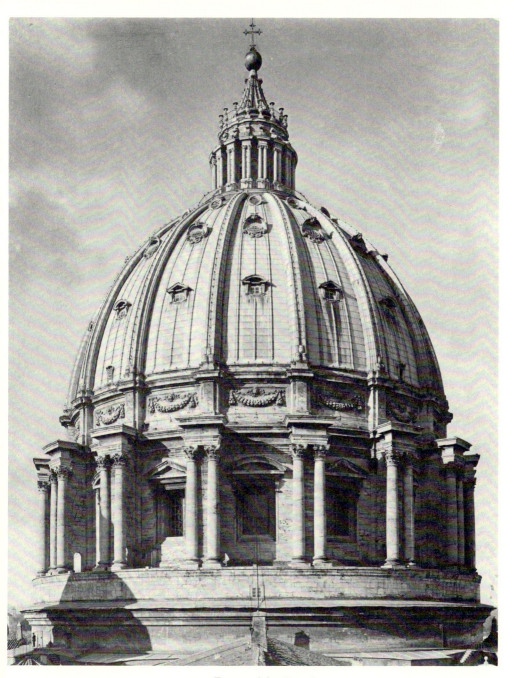

280. Dome of St. Peter's

281. Wooden model of the dome of
St. Peter's, exterior. Vatican

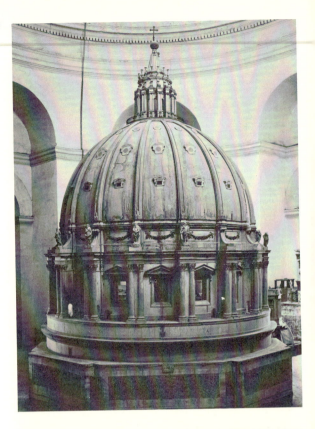

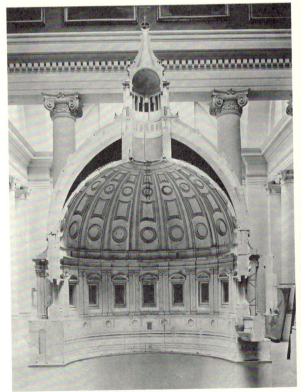

282. Wooden model of the dome of
St. Peter's, cross-section; inner calotte
and drum attributed to Michelangelo,
outer calotte to Giacomo della Porta

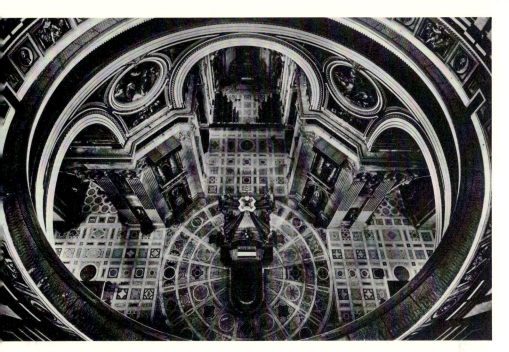

283. Interior of St. Peter's, seen from the first gallery of the dome

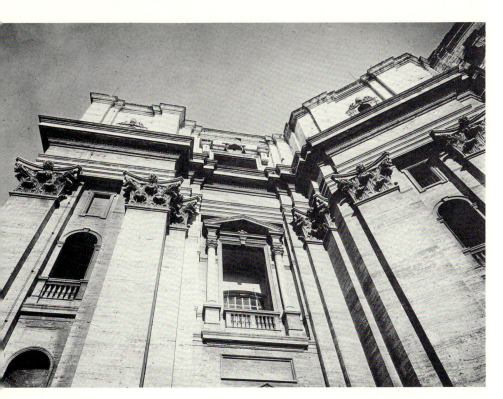

284. Exterior wall of St. Peter's, detail seen from below

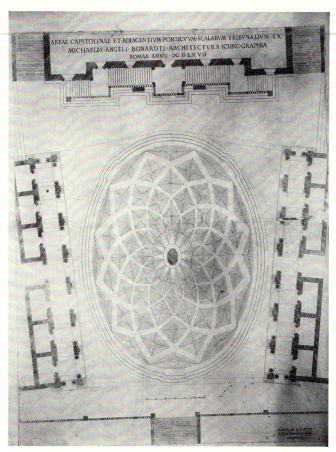

285. Ground plan of the Capitol, Rome, showing
Michelangelo's design; engraving of 1567.
Vienna, Albertina

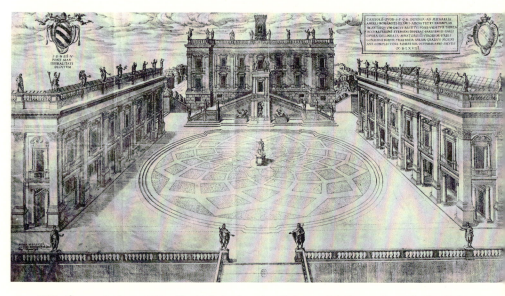

286. General view of the Capitol, facing the Palazzo dei Senatori, with the Palazzo
dei Conservatori, right, and the Palazzo Nuovo, left; in the piazza, equestrian statue
of Marcus Aurelius; engraving by Dupérac, 1568. Vienna, Albertina

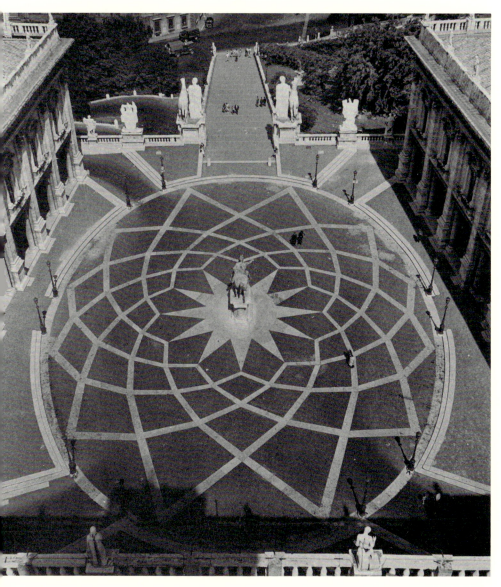

287. View of the Capitol from the Palazzo dei Senatori, showing
the convex star-decorated oval at ground level

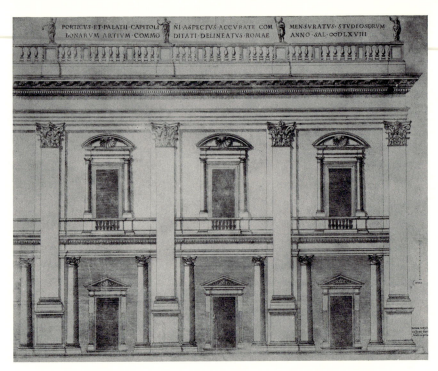

288. Palazzo dei Conservatori, detail of the façade; engraving
of 1568. Vienna, Albertina

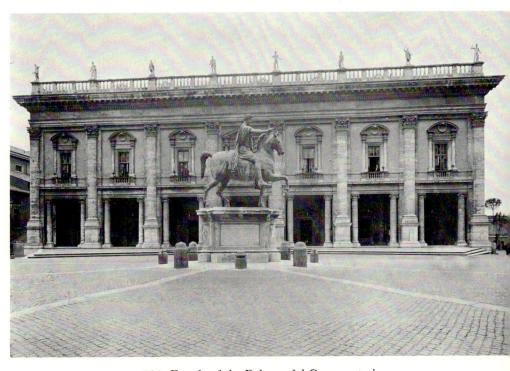

289. Façade of the Palazzo dei Conservatori

290. Loggia of the Palazzo dei Conservatori

296. Detail of the cornice, Farnese Palace

297. Third-story window and pilasters on the court façade, Farnese Palace

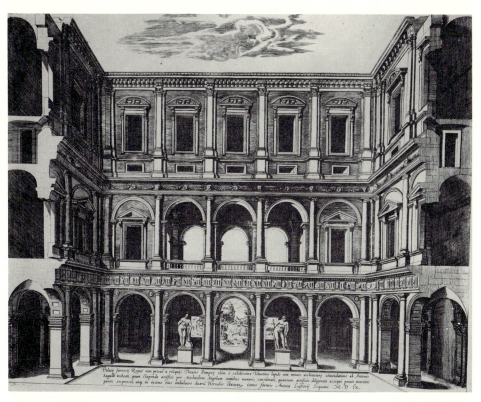

298. Court of the Farnese Palace, engraving of 1560. Vienna, Albertina

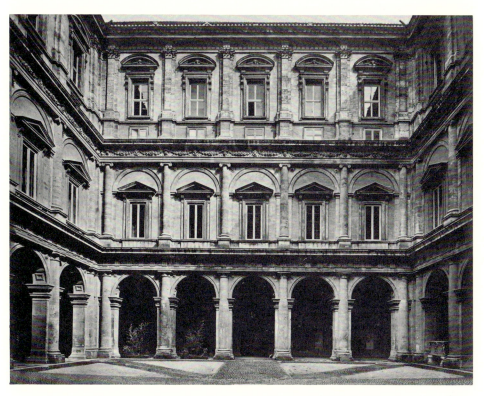

299. Court of the Farnese Palace: first and second stories by
Antonio da Sangallo the Younger, third story by Michelangelo

300. Second-story corridor of the Farnese Palace, the flattened
barrel vault designed by Michelangelo

301. Padua Cathedral, the choir

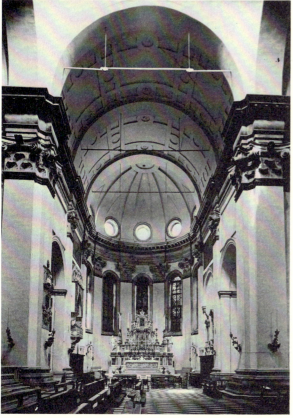

302. Padua Cathedral,
south transept

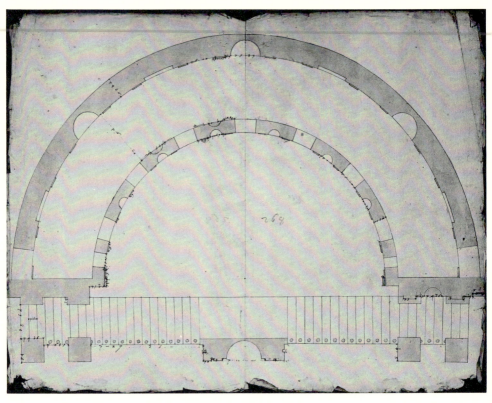

303. Cortile del Belvedere, Rome, ground plan of the exedra and stairway.
New York, Metropolitan Museum of Art (Scholz Scrapbook)

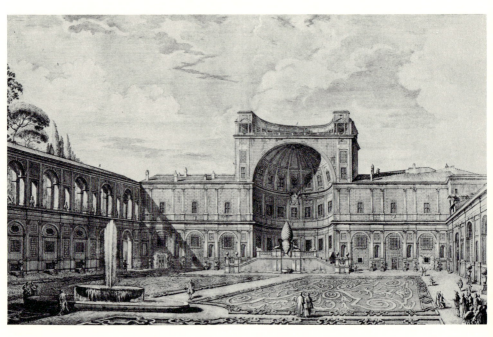

304. View of the exedra and stairway of the Belvedere, engraving of 1765 from
a drawing by Francesco Panini. Rome, Gabinetto Nazionale delle Stampe

305. General view of the Belvedere, drawing attributed to Dupérac; terraces and steps probably designed by Michelangelo. Milan, Feltrinelli Collection

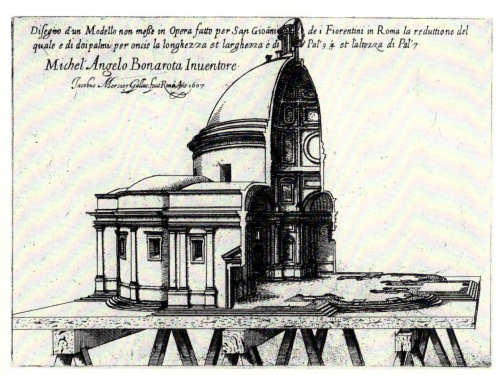

Difegno d'un Modello non meſſe in Opera fatto per San Gioāni︙ de i Fiorentini in Roma la reduttione del quale e di doi palmi per oncie la longhezza et larghezza é di ﹆ Pal' 9 ⅜ et laltezza di Pal' 7

Michel'Angelo Bonarota Inuentore.

Jacobus Mercier Gallus fecit Roma Año 1607.

306. Wooden model of San Giovanni dei Fiorentini, Rome, in cross-section; etching by Jacques Le Mercier, 1607. Vienna, Albertina

307. Santa Maria degli Angeli,
Rome, the interior as designed
by Michelangelo and before
Vanvitelli's alterations, early
18th-century engraving

308. Santa Maria degli Angeli,
the choir

309. Transept of Santa Maria degli Angeli, converted from the
tepidarium of the Baths of Diocletian

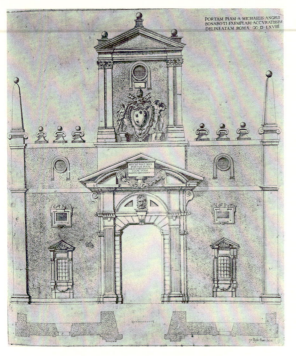

310. Porta Pia, Rome, engraving
of 1568. Vienna, Albertina

311. Right-hand window of the
Porta Pia

312. Porta Pia, upper elevation of the central opening

313. Sforza Chapel, Santa Maria
Maggiore, Rome, the façade
destroyed in 1748; late
16th-century drawing.
Milan, Castello Sforzesco

314. Ground plan of the Sforza
Chapel drawn by Pier Leone
Ghezzi (1674-1755). Paris,
Bibliothèque Nationale

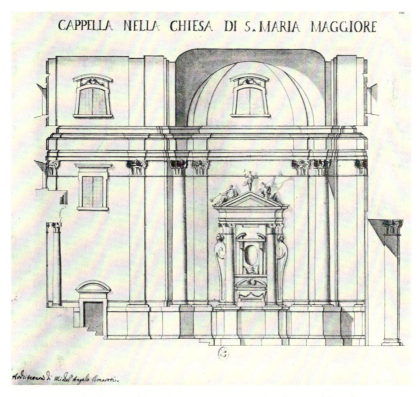

315. Sforza Chapel, apse drawn by Pier Leone Ghezzi.
Paris, Bibliothèque Nationale

316. Upper elevation of diagonally placed columns in the Sforza Chapel

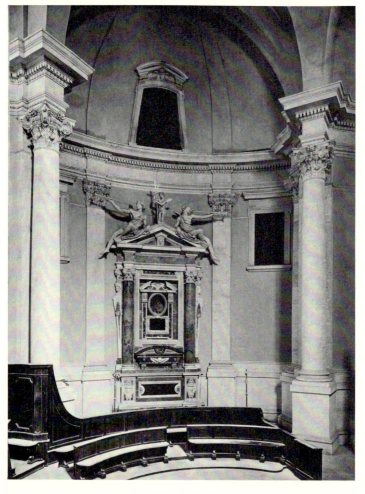

317. Sforza Chapel, aps

ARCHITECTURAL DRAWINGS

318. Project for the façade of San Lorenzo, Florence.
Florence, Casa Buonarroti

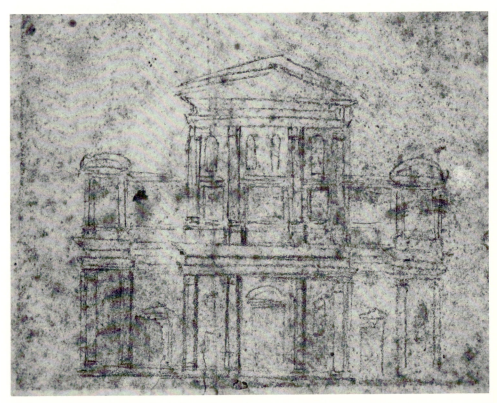

319. Project for the façade of San Lorenzo. Florence, Casa Buonarroti

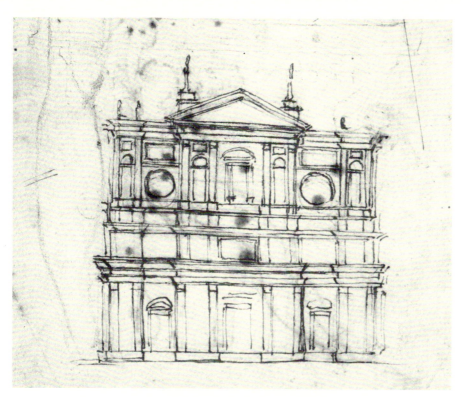

320. Project for the façade of San Lorenzo, probably the final version
(detail). Florence, Casa Buonarroti

321. Sketch of niche and statue for the façade of San Lorenzo.
Florence, Casa Buonarroti

322. Project for the upper side elevation of the Tomb of Julius II.
Florence, Casa Buonarroti

323. Sketch of candelabrum, probably for
the Julius Tomb. Vatican Library

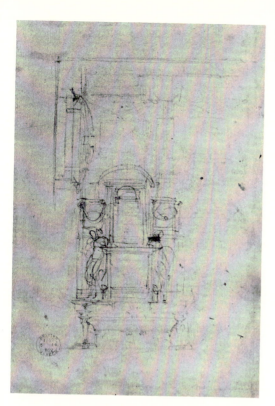

324. Project for free-standing tomb
in the Medici Chapel, Florence.
London, British Museum

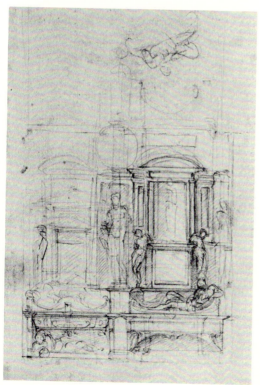

325. Project of double tomb for
the Medici Dukes.
London, British Museum

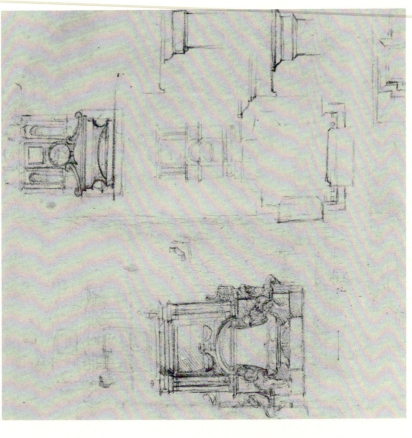

327. Projects for the Medici tombs, including an *arcus quadrifrons*. London, British Museum

326. Projects for the Medici tombs, including an *arcus quadrifrons*. Florence, Casa Buonarroti

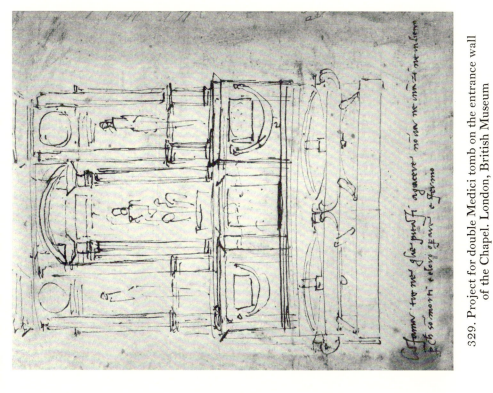

329. Project for double Medici tomb on the entrance wall
of the Chapel. London, British Museum

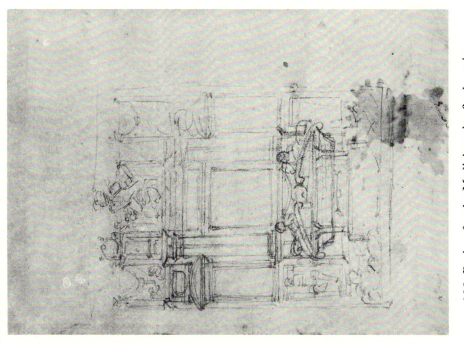

328. Project for the Medici tombs, final version.
London, British Museum

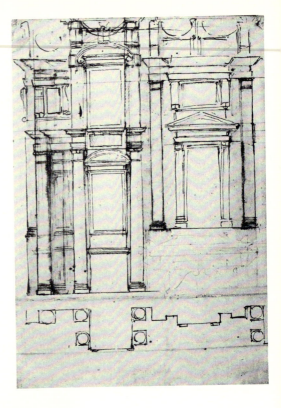

330. Project for the architectural revetment of the choir of San Lorenzo, with the tombs of the Medici popes (Leo X and Clement VII). Florence, Casa Buonarroti

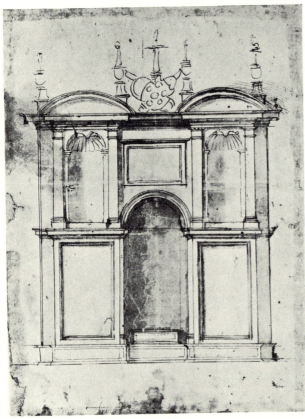

331. Project for the Medici papal tombs in the Sagrestia Vecchia. Dresden, Kupferstichkabinett

332. First sketch of the ground plan of the Medici Chapel. Florence, Archivio Buonarroti

333. Sketch of the ground plan
of the Laurentian Library
vestibule, first version.
Florence, Archivio
Buonarroti

334. Sketch of the ground plan
of San Lorenzo, showing the
Laurentian Library to the
east of the cloister (*chiostro*).
Florence, Casa Buonarroti

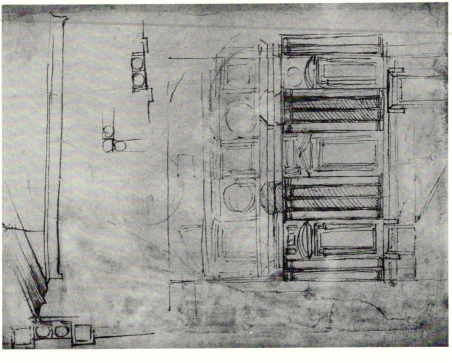

336. Project for the revetment of the Laurentian Library vestibule. Florence, Casa Buonarroti

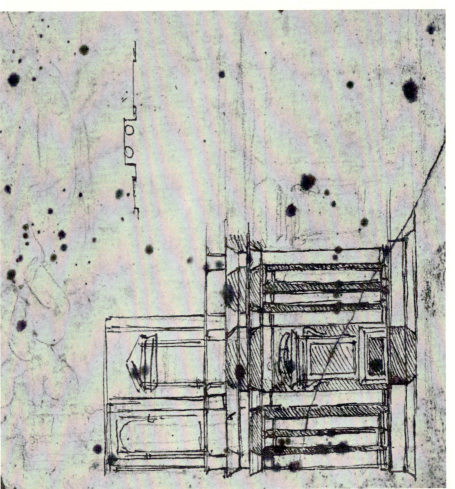

335. Project for the revetment of the Laurentian Library reading room, first version. Florence, Casa Buonarroti

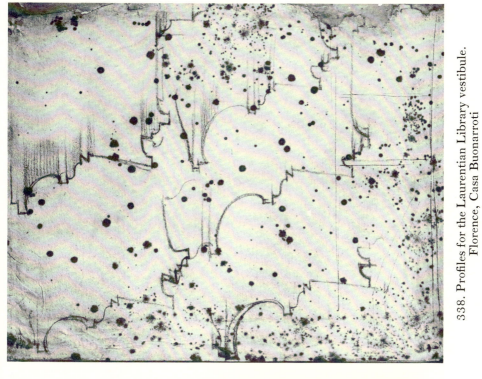

338. Profiles for the Laurentian Library vestibule.
Florence, Casa Buonarroti

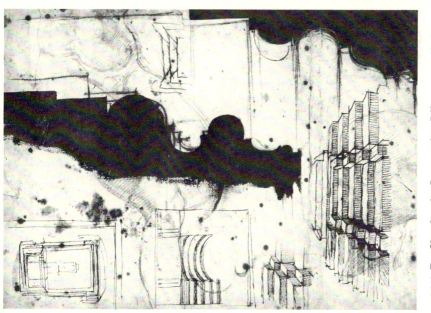

337. Profiles for the Laurentian Library vestibule.
Florence, Casa Buonarroti

339. Project for the Tomb of Julius II, and sketch by a pupil.
Florence, Archivio Buonarroti

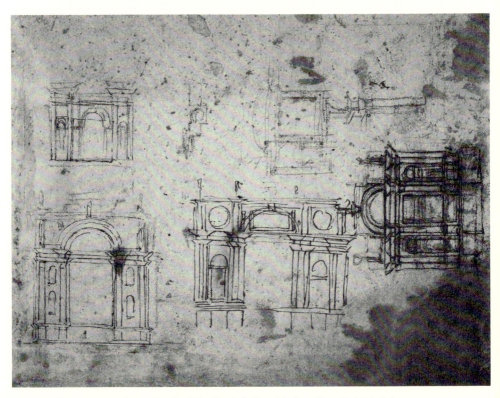

340. Projects for the Tomb of Julius II. London, British Museum

341. Projects for the
fortifications of Florence.
Florence, Casa Buonarroti

342. Projects for the fortifications of Florence.
Florence, Casa Buonarroti

343. Projects for the fortifications of Florence.
Florence, Casa Buonarroti

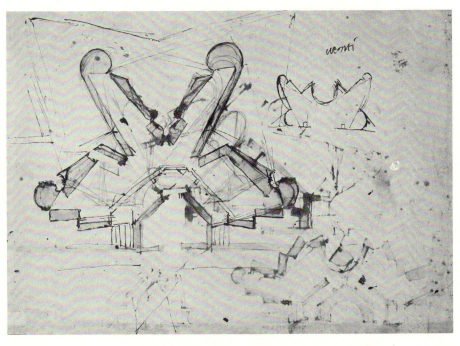

344. Projects for the fortifications of Florence (Porta del Prato).
Florence, Casa Buonarroti

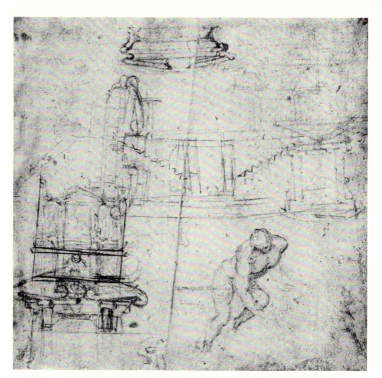

345. Projects for the tomb of Cecchino Bracci,
and other sketches. Florence, Casa Buonarroti

346. Projects for the tomb of Cecchino Bracci, and other
sketches (central figure probably for
the *Crucifixion of St. Peter*).
Florence, Casa Buonarroti

347. Rough sketch of ground plan for St. Peter's and adjacent parts
of the Vatican; fragment of a poem. Vatican Library

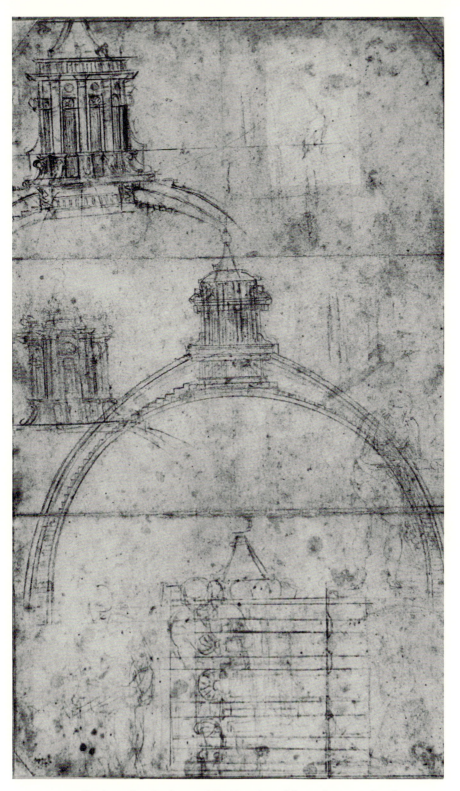

348. Projects for the dome of St. Peter's and for a doorway (at the
bottom, a figure for the *Crucifixion of St. Peter*).
Haarlem, Teyler Museum

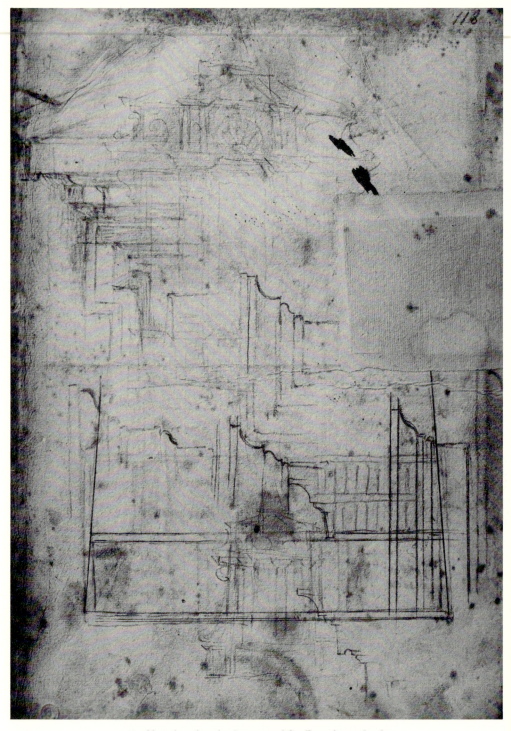

349. Sketches for the lantern of St. Peter's, and other
architectural drawings. Florence, Casa Buonarroti

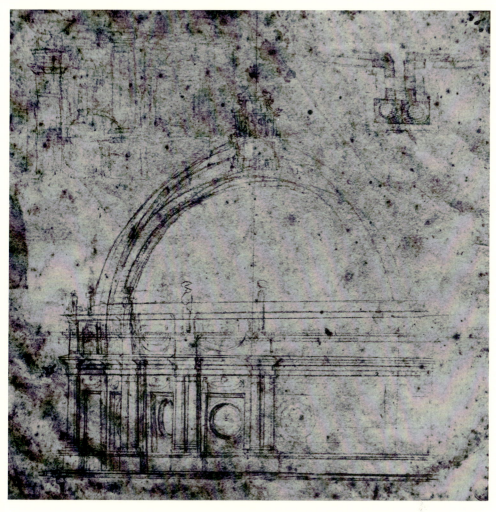

350. Project for the dome of St. Peter's, with sketch of the
elevation of St. Peter's and ground plan of the drum of the dome.
Lille, Palais des Beaux-Arts

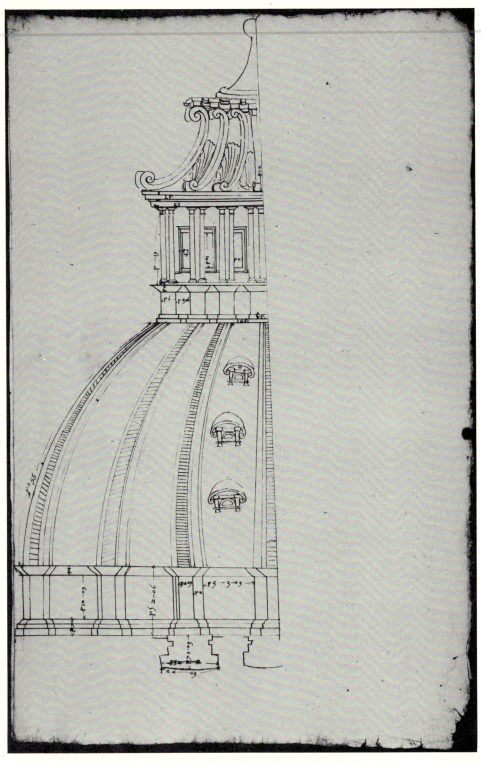

351. ANONYMOUS, drawing of exterior section of the wooden
model of the dome of St. Peter's. New York, Metropolitan
Museum of Art (Scholz Scrapbook)

352. Ground plan of the church of the Gesù, Rome; only the
lines in red chalk are by Michelangelo, probably his first
project for San Giovanni dei Fiorentini. Florence, Uffizi

354. Ground plan for San Giovanni dei Fiorentini.
Florence, Casa Buonarroti

353. Ground plan for San Giovanni dei Fiorentini,
Rome. Florence, Casa Buonarroti

356. Ground plan for San Giovanni dei Fiorentini, final version. Florence, Casa Buonarroti

355. Two sketches of ground plan for the church of San Giovanni dei Fiorentini (detail). Florence, Casa Buonarroti

358. Project for the Porta Pia.
Florence, Casa Buonarroti

357. Project for the Porta Pia.
Florence, Casa Buonarroti

ATTRIBUTIONS, COPIES OF LOST WORKS, RECONSTRUCTIONS

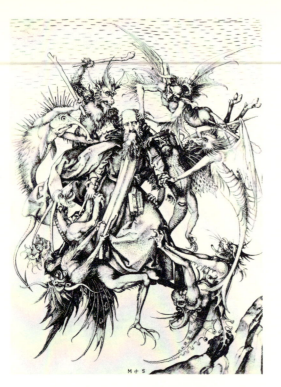

359. MARTIN SCHONGAUER,
Temptation of St. Anthony,
engraving

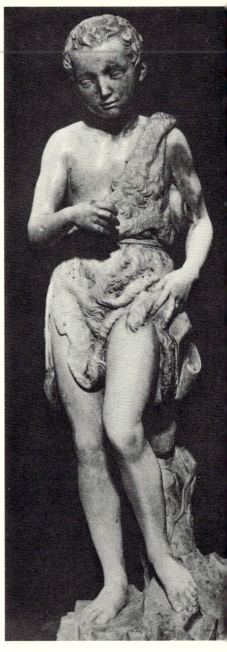

361. SCHOOL OF MICHELANGELO,
San Giovannino, marble (destroyed).
Formerly Ubeda, Capilla del Salvador

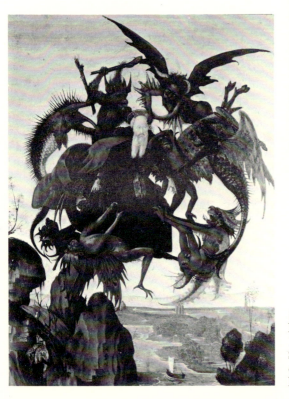

360. ATTRIBUTED TO
MICHELANGELO,
Temptation of St. Anthony, after
Schongauer's engraving. Private
collection, on loan to
Fitzwilliam Museum, Cambridge

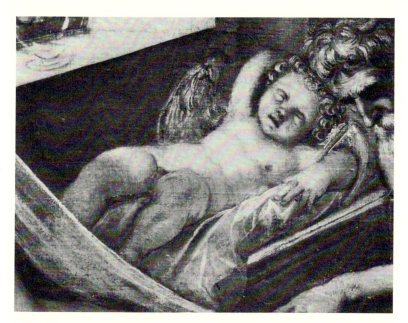

362. TINTORETTO, detail of Cupid in *Mars and Venus Surprised by Vulcan*. Munich, Alte Pinakothek

363. ATTRIBUTED TO MICHELANGELO, Sleeping Cupid, marble. Corsham Court, Lord Methuen Collection

365. ATTRIBUTED TO MICHELANGELO,
Manchester Madonna. London, National Gallery

364. ATTRIBUTED TO MICHELANGELO,
David with the Head of Goliath, bronze.

366. Bastiano da Sangallo after Michelangelo, *The Battle of Cascina*, grisaille.
Holkham, Earl of Leicester Collection

367. Vincenzo Danti, seated statue
of Pope Julius III, bronze. Perugia

368. After Michelangelo, Samson
and Two Philistines, bronze.
New York, The Frick Collection

369, 370. Silvio Cosini, marble trophies, probably for the Medici Chapel.
Florence, San Lorenzo, entrance to the Medici Chapel

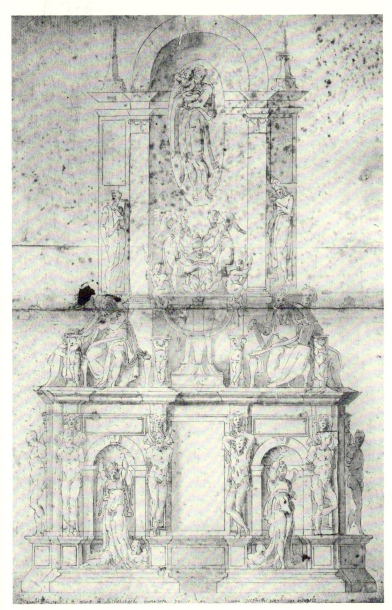

371. Jacomo Rocchetti, copy of
drawing attributed to Michelangelo
showing 1513 project for the Tomb
of Julius II. East Berlin,
Kupferstichkabinett

372. Attributed to Michelangelo,
drawing of dead pope supported on a
sarcophagus by an angel.
Florence, Casa Buonarroti

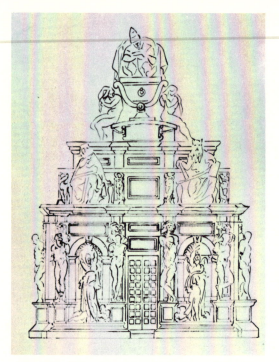

373. First version, 1505

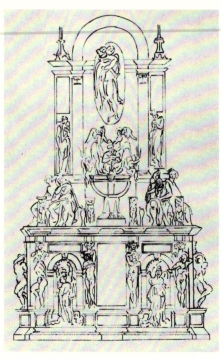

374. Second version, 1513

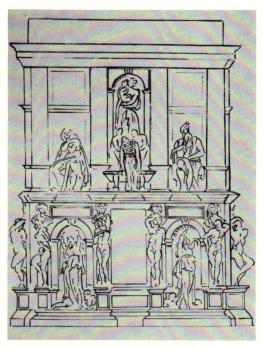

375. Third version, 1516

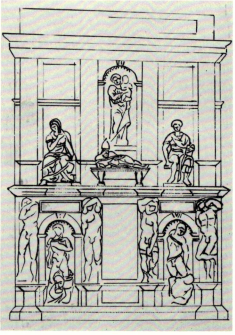

376. Fifth version, 1532

373-376. Reconstructions by Charles de Tolnay of the projects
for the Tomb of Julius II. Drawings by Denise Fossard

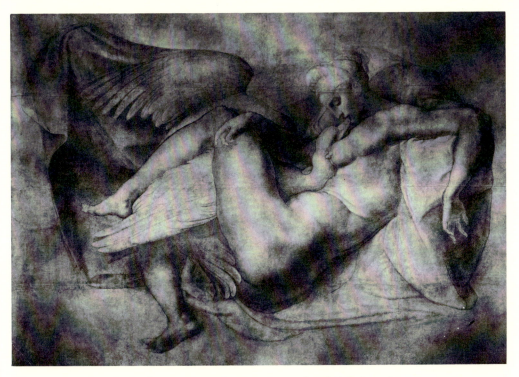

377. *Leda and the Swan*, cartoon after Michelangelo.
London, Royal Academy

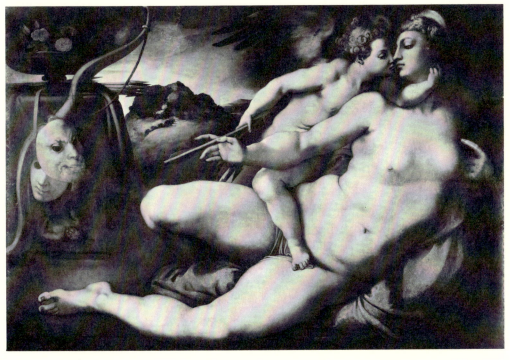

378. Pontormo, *Venus and Cupid*, after a cartoon by Michelangelo.
Florence, Uffizi

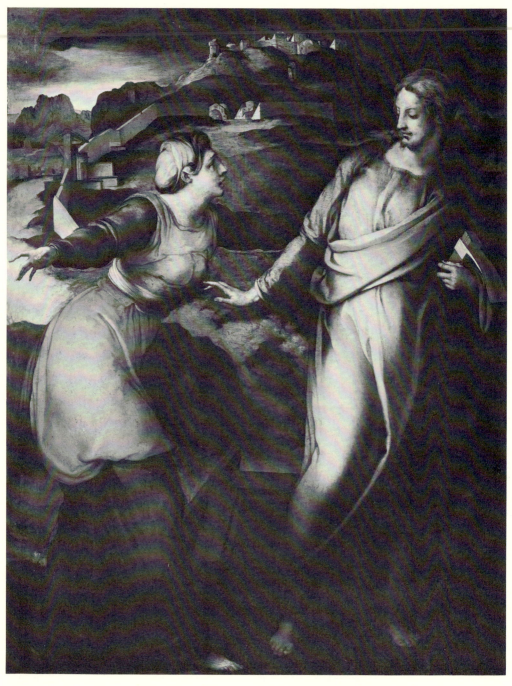

379. ATTRIBUTED TO PONTORMO, *Noli Me Tangere*, after a
cartoon by Michelangelo. Milan, Private Collection

380. Nicolas Béatrizet, engraving of *Christ and the Samaritan Woman*, after Michelangelo

381. Marcello Venusti, preparatory drawing for an *Annunciation* after Michelangelo. Florence, Uffizi

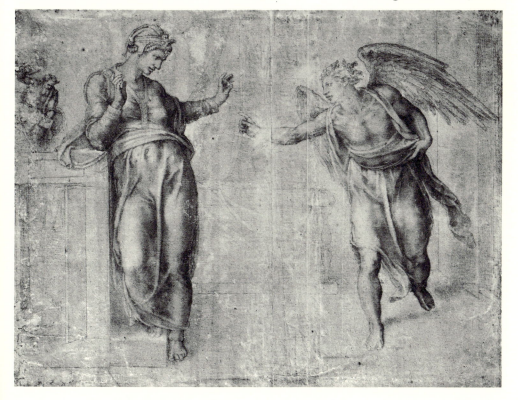

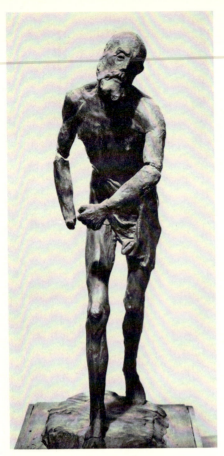

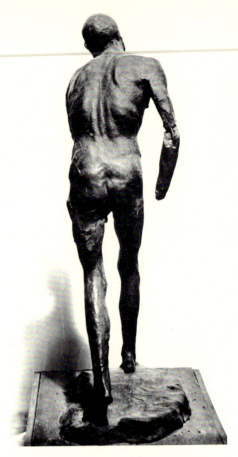

382. ATTRIBUTED TO MICHELANGELO,
St. Jerome, wax model.
Florence, Casa Buonarroti

383. ATTRIBUTED TO MICHELANGELO,
St. Jerome, the back

384. MARCELLO VENUSTI, preparatory drawing for *Christ on the Mount of Olives*
(Rome, Galleria Doria) after Michelangelo. Florence, Uffizi

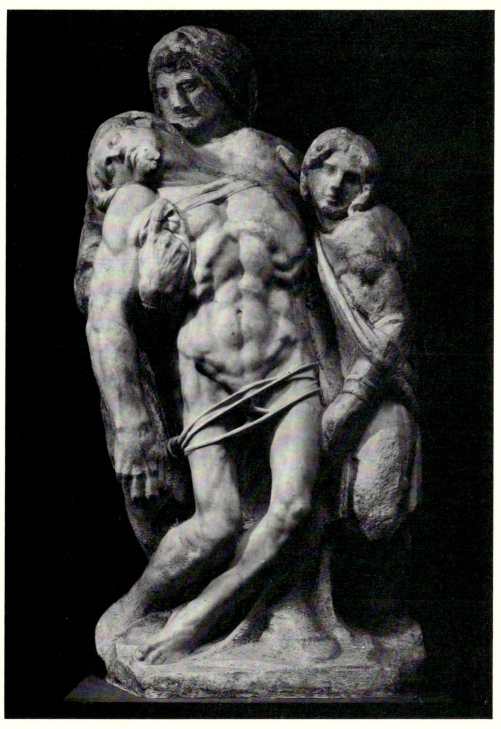

385. Attributed to Michelangelo, Palestrina Pietà.
Florence, Accademia delle Belle Arti

Library of Congress Cataloging in Publication Data

De Tolnay, Charles, 1899-
 Michelangelo; sculptor, painter, architect.

 Translation of Michel-Ange.
 Bibliography: p.
 1. Buonarroti, Michel Angelo, 1475-1564. I. Title.
ND623.B9D4313 759.5 66-11968
ISBN 0-691-03876-7
ISBN 0-691-00337-8 pbk.